New Formations

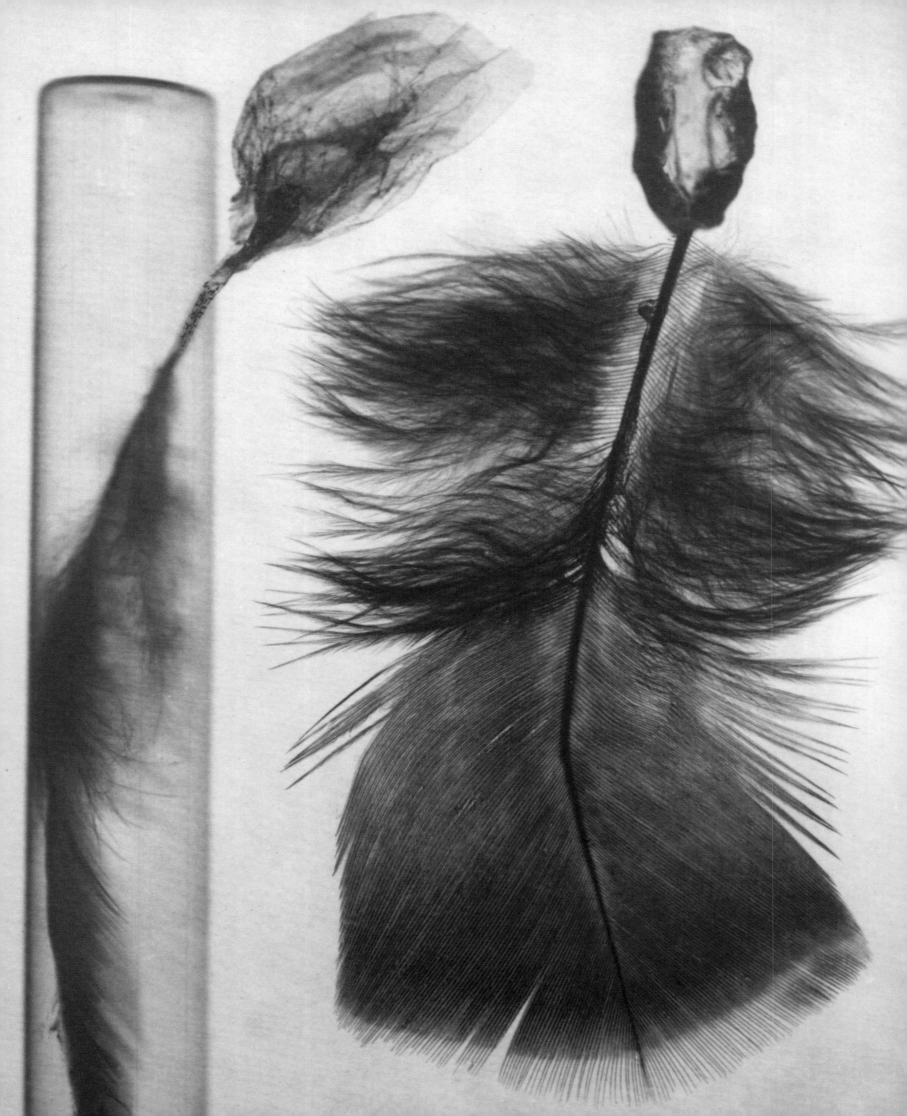

New Formations
Czech Avant-Garde Art and Modern Glass from the Roy and Mary Cullen Collection

Karel Srp and Lenka Bydžovská with Alison de Lima Greene and Jan Mergl

The Museum of Fine Arts, Houston
Distributed by Yale University Press, New Haven and London

Contents

Director's Foreword
Gwendolyn H. Goffe

New Formations: Czech Avant-Garde Art and Modern Glass from the Roy and Mary Cullen Collection tells several stories. An exemplary collaboration between collectors and curators, the catalogue and the accompanying exhibition trace the remarkable and complex evolution of Czech art and glass during the first decades of the twentieth century. At the same time, this project allows us to acknowledge the legacy of the maverick *Czech Modernism: 1900 – 1945* exhibition mounted in 1989 by the Museum of Fine Arts, Houston (MFAH), and to celebrate two extraordinary people who became both accidental revolutionaries and purposeful collectors.

Heartfelt thanks are due first and foremost to Roy and Mary Cullen. They have been our best friends and guiding spirits throughout this project, not only generous with their collection, library, and files, but also infinitely patient in devoting many hours to interviews and debates. They have traveled across the United States and Europe in support of the exhibition, forging new alliances, and more than once making it possible for the curators to meet on common ground. Most important, their exuberant vision for what their collection could achieve in bringing wider appreciation to this still underrecognized chapter of Modernism is insightful and inspiring.

Karel Srp and Lenka Bydžovská have been ideal partners and collaborators in this endeavor; not only do their essays reflect upon the importance of the Cullen collection, but their profound scholarship and creative imaginations shaped this project from the start. Their selection of period texts and their thoughtful parsing of the Cullen collection have made an enormous body of material accessible and deeply engaging. Jan Mergl is to be thanked as well for his selections from the Cullens' vast holdings in Czech modern glass and for his essay, which places these works in a historical context. Thanks are also due to Alison de Lima Greene, the MFAH's curator of contemporary art and special projects. She has served as the organizing curator of this exhibition, working closely with the Cullens and acting as a vital liaison between the guest curators and the MFAH staff. Her exacting standards of excellence, first evident in the *Czech Modernism* exhibition, have kept this project moving forward from its inception.

For the Museum of Fine Arts, Houston, I would like to acknowledge the outstanding leadership of Cornelia Long, chairman of the museum board. Exceptional contributions to this project have been made by Sarah M. Schultz, curatorial assistant, Elliott Zooey Martin, former curatorial assistant, Miranda Cardona, administrative

assistant, Charisse Weston and Kathryn Hudman, summer interns, Cindi Strauss, assistant director of programming and curator of modern and contemporary decorative arts and design, and Karen Vetter, chief administrator, exhibitions and curatorial; Amy Purvis, director of development, and Katy Bate, foundation and government grants writer; Heather Schweikhardt, senior assistant registrar for exhibitions, and Shelby Hempel, preparator; Marty Stein, photographic and imaging services manager, Will Michels, collections photographer, Matt Lawson, digital imaging projects coordinator, and Donna Kleist, cataloguer; Jon Evans, library director; Margaret Mims, associate education director, and Jay Heuman, public programs director; Wynne Phelan, conservation director, Jane Gillies, objects and sculpture conservator, and Ingrid Seyb and Tina Tan, conservation assistants; and Bill Cochrane, exhibition designer. The unstinting efforts of these individuals have made this exhibition possible. The catalogue has been supervised with wit and grace by Diane Lovejoy, director of publications, and has been edited and managed with sympathy and acumen by Heather Brand. The superb catalogue design reflects the brilliant eye and imagination of Daphne Geismar. Working in Prague, Kathleen Hayes served both as translator and ad hoc editorial assistant. Additionally, Paul Hester photographed the artworks at the Cullen house, and Evin Thayer provided a superb family portrait. Gayle Chamblee lent her ready expertise as the Cullen collection manager, and acknowledgment must also go to Rosa Ana Orlando and Rose Vandercher for their assistance.

On behalf of Roy and Mary Cullen, I would like to pay tribute to a number of friends whose enthusiasm for Czech art has been vital to the growing appreciation of the Cullen collection, including Richard Born, Eric Dluhosch, Karla Huebner, Radovan Ivšić and Annie Le Brun, Eva Matějková and Richard Willenbrink, Marilyn Oshman, Jindřich Toman, Anne Wilkes Tucker, Matthew Witkovsky, and Mitchell Wolfson, Jr. The Cullens also wish to add their personal thanks to their family for their loving support. Czech history became entwined with family history in 2007 when Dana Harper married Hana Hillerova and more than fifty members of the Cullen and Garcia families gathered in Prague to celebrate the occasion.

Three years ago, Dr. Peter C. Marzio invited Mary Cullen to lunch; from that meeting emerged the exhibition plan for *New Formations: Czech Avant-Garde Art and Modern Glass from the Roy and Mary Cullen Collection*. Elsewhere in this catalogue, Mary Cullen recounts the pride that Dr. Marzio took in *Czech Modernism:*

1900 – 1945, just one of the many groundbreaking exhibitions he took on during his remarkable tenure as director of the Museum of Fine Arts, Houston (1982 – 2010). However, Dr. Marzio's uncompromising vision for how a museum can best serve its public always led him to look to the future. He was the first to recognize the potential for fresh scholarship embedded in the Cullen collection, and we remain profoundly grateful to Roy and Mary Cullen for carrying this vision forward.

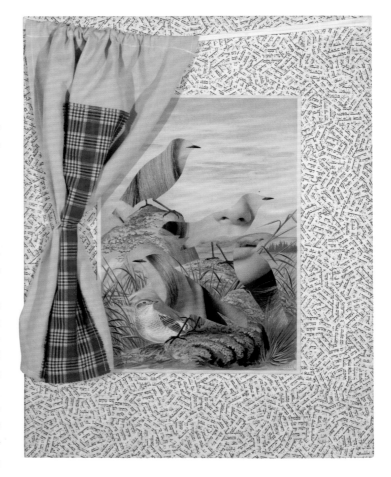

CAT. 1
Jiří Kolář
Pěkná žena myslí na zpěv [*A Pretty Woman Thinks about Song*] | 1972
Mixed media and collage mounted on board | 20 × 16 inches (50.8 × 40.6 cm)

New Formations
Czech Avant-Garde Art and Modern Glass from the Roy and Mary Cullen Collection

Alison de Lima Greene

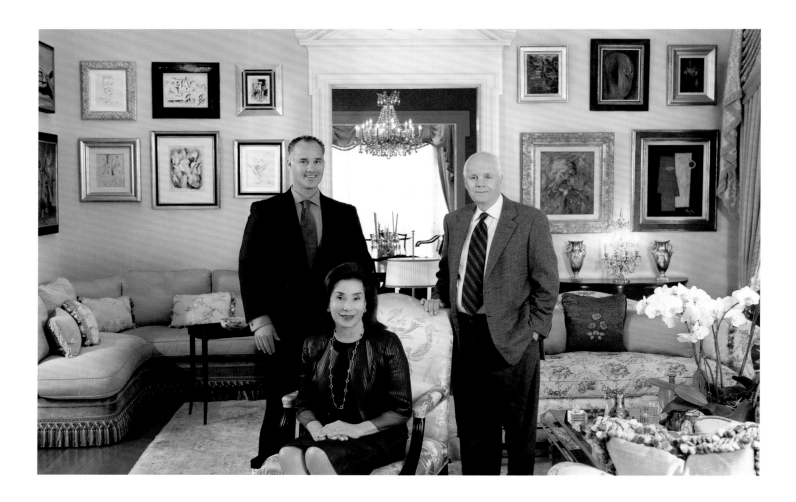

Evin Thayer
Portrait of Meredith, Mary, and Roy Cullen | 2010

In October 1989 the Museum of Fine Arts, Houston (MFAH), opened *Czech Modernism: 1900 – 1945*. This was not the MFAH's first exhibition to touch on this era; František Drtikol's photographs were the subject of a 1932 show organized by one of the artist's protégés who had settled in Texas. However, the oblivion of the Cold War era had largely erased the contributions of the Czech avant-garde from contemporary discourse, and when Anne Wilkes Tucker, MFAH curator of photography, started acquiring vintage prints by Jaromír Funke, Jaroslav Rössler, and Josef Sudek in 1979, these artists had been all but forgotten. With the encouragement of Dr. Peter C. Marzio, who joined the museum staff as director in 1982, Tucker began to consider a presentation that would place their work in the larger history of Czech Modernism. As an ambitious exhibition proposal took shape, I had the privilege of joining the curatorial team, along with independent curator Jaroslav Anděl, Willis Hartshorn at the International Center for Photography, and Ralph McKay, director of the MFAH film program. Over the course of five years of research and diplomacy, we explored museums, archives, libraries, and private collections across two continents. Ultimately the exhibition presented some 350 works of art and film, with major loans from numerous Czech institutions, as well as outstanding examples from lenders in Western Europe and the United States. Colleagues in Czechoslovakia made important contributions to the catalogue, helping us to map the complex evolution of the Czech avant-garde in the first decades of the twentieth century. In his introduction, Peter Marzio acknowledged the reconstructive nature of the exhibition: "To write new chapters in the history of creativity and to add artists to the pantheon of artistic leaders has been the mission of the Museum of Fine Arts, Houston, since it opened in 1924. *Czech Modernism: 1900–1945* is a major effort in that tradition."[1]

What none of us could have anticipated, however, were the extraordinary events that were to make 1989 a political watershed. Within weeks of the *Czech Modernism* opening, the dissolution of Hungary's borders, the fall of the Berlin Wall, and the Velvet Revolution began to redraw the map of Europe, a process that was well underway once the show traveled to New York the following spring.[2] And what had been viewed by many of our colleagues as an esoteric project suddenly drew national attention. Writing for *Artnews*, Elizabeth McBride observed: "The technical virtuosity, the historical importance, and the fineness of this work demand not only our admiration but a transformation of our vision of

modernist art."[3] The *New York Times* devoted a full page to the exhibition, with Michael Kimmelman, Andy Grundberg, and Caryn James united in praise. Kimmelman observed: "The final revelation of this exhibition is just how much richer the history of early 20th-century European art can seem with the inclusion of works from Eastern European museums, which until the recent political upheavals were so inaccessible to the West. *Czech Modernism* is a significant step in the rewriting of that history."[4] Grundberg added, "It is also a revelation of what appears to have been a fertile testing ground for the development of a new kind of photography."[5] And James concluded: "*Czech Modernism: 1900 – 1945* is more than a valuable historical program; it re-creates for jaded moviegoers the sense of newness, wonder and possibility that accompanied the growth of film in the first half of this century."[6]

Houston philanthropists Roy and Mary Cullen were among the first visitors to the *Czech Modernism* exhibition, and as world events unfolded, happenstance took them to Prague, where they witnessed Václav Havel's election by the Federal Assembly on December 29, 1989. As they have recounted, they became "accidental revolutionaries," drawn into the historic moment through family ties, friendships, and a profound commitment to democracy and freedom. Their decision to build a collection focusing on Czech avant-garde art and modern glass came about by similar happenstance several years later. Yet, as this catalogue demonstrates, they became purposeful collectors, returning frequently to the newly formed Czech Republic, combining dedication, a sense of adventure, and absolute discipline in their pursuit of artworks that could most tellingly reveal the unique and rapidly evolving aesthetics of Czech art and glass.

As the twentieth anniversary of the *Czech Modernism* exhibition approached, Peter Marzio began to discuss with the Cullens the possibility of showcasing their collection, using their holdings as a platform for new research. The intervening years had seen a number of important scholars emerging in the field, and major exhibitions had added significantly to our understanding of this era. But there still remained aspects of this history to be explored, and to our delight, the Cullens agreed to the exhibition, allowing us to invite Karel Srp, Lenka Bydžovská, and Jan Mergl to bring their extensive knowledge to bear on the collection. As we contemplated various titles that could best sum up the spirit of the Cullens' endeavor and the nature of this exhibition project, we turned to the *Artificielisme* (*Artificialism*) manifesto, published in

1927 by Jindřich Štyrský and Toyen in Karel Teige's first *ReD: Devětsil Review* [CAT. 25]. Rejecting positivist and progressive notions of the evolution of modern art, Štyrský and Toyen advocated "maximum imaginativeness," "the identification of the painter and poet," and "new formations that have nothing to do with reality or artificial nature." (For the full text of this manifesto, see pages 118–19). In the context of this exhibition, "New Formations" can also suggest the intelligent independence of collectors who are willing to explore and challenge accepted narratives, bringing together a body of works that invites more than one interpretation.

Among the Cullen collection's highlights are significant examples by artists recognized by the *Czech Modernism* exhibition, including most notably Teige, Štyrský, and Toyen. Teige's impassioned engagement with the intellectual currents of his era is eloquently distilled by the remarkable library assembled by the Cullens, while his 1947 collage [CAT. 92] is a signature example of his later work. Štyrský is tellingly represented through his inventive book collaborations with Toyen, his dreamlike illustrations for *Židovský hřbitov* (*The Jewish Cemetery*, CAT. 39), his *Erotická revue* (*Erotic Review*, CATS. 57–58) anthologies, and his ever-expanding explorations of painting, photography, and collage, including the unforgettable images for *Emilie přichází ke mně ve snu* (*Emilie Comes to Me in a Dream*, CAT. 64) and *Stěhovací kabinet* (*The Portable Cabinet*, CATS. 73 and 74). Anyone interested in Toyen's maverick career can grasp the rich arc of her achievement by studying the Cullens' sixty-year survey, which ranges from her first book covers and illustrations of the 1920s to her Poetist abstractions of 1933, to her haunting *Poselství lesa* (*The Message of the Forest*, CAT. 80) of 1936, to her heartbreaking allegories of war, and to her final work in exile among the Surrealists of postwar Paris.

However, the Cullens did not limit themselves to the *Czech Modernism* checklist. In some instances, they sought out atypical examples, such as the darkly romantic drawings of Drtikol [CATS. 5 and 6], rather than his better-known photographs. The drawings of Hugo Boettinger [CATS. 17 and 18] amplify our understanding of Milča Mayerová's contribution to modern dance, hitherto known almost exclusively through *Abeceda* (*Alphabet*, CAT. 16). And they have sought out singular caricatures by Adolf Hoffmeister [CAT. 37] and Antonín Pelc [CAT. 77] that bring such contemporaries as Tristan Tzara and Štyrský vividly to life. The Cullens have also amassed important works by later proponents of the Czech avant-garde,

including the Skupina 42 artists (František Hudeček, Bohumír Matal, and Alois Wachsman, among others), whose paintings capture the desperate twilight years of World War II. And while the history of Czech glass in the twentieth century is rarely considered in juxtaposition with that of the avant-garde, the Cullen collection suggests a larger view of visual and material culture that is both provocative and refreshing.

Another way to consider the Cullen collection is to recognize the democratic spirit that pervades their holdings. Mary Cullen has noted that her interest in books was in part motivated by the fact that, in their time, these works of art were accessible to other artists and collectors of modest means. Major documents of intellectual history and book design, these publications are fascinating objects in their own right. Taken as a whole, they chronicle evolving strategies for the modern printed book: Teige's Devětsil publications are marvels of radical typography from cover to cover. Other publications (particularly those engaged in the erotics of Surrealism) mask their contents, or deliberately misdirect the readers' assumptions, as seen in Vítězslav Nezval's anthology *Ani labuť ani Lůna* (*Neither Swan nor Moon*, CAT. 78). The slipcover of Toyen's 1967 publication *Le puits dans la tour* (*The Well in the Tower*, CAT. 110) incorporates a miniature rolling-ball game that ricochets pellets across a nude female torso. Often inscribed, these books also preserve intimate records of camaraderie and exchange. Leafing through the pages of the Cullen library, we can see dedications between friends and bookplates that reveal interesting lines of provenance; for example, a previous owner of the Cullen's first volume of the *Erotic Review* was the Nouveau Réaliste Arman [CAT. 57], and their copy of the architectural journal *MSA 3* is amply annotated by the architect Josef Havlíček, who also loosely inserted what he considered better photographs of certain buildings and interiors [CAT. 34].

Writing of Prague, Ivan Klíma observed: "A city is like a person: if we don't establish a genuine relationship with it, it remains a name, an external form that soon fades from our minds. To create this relationship, we must be able to observe the city and understand its peculiar personality, its 'self,' its spirit, its identity, the circumstances of its lives as they evolved through space and time."[7]

Forming a collection is a similar endeavor, for great collections reflect the commitment of a devouring vision. Peter Marzio and the curators who participated in the 1989 exhibition worked together to create a permanent legacy for Houston, and Czech photography

is now represented in exceptional depth at the MFAH.[8] Landmark acquisitions of a 1907 self-portrait by František Kupka and a 1912–13 bronze by Otto Gutfreund are also permanent presences in the museum's early modern galleries, while Czech modern glass and graphic design, genres overlooked by the 1989 exhibition, are now featured in the MFAH decorative arts department.[9]

But an equally great legacy lies in the dazzling collection amassed by the Cullens. Autonomous and inspiring, the story it tells is intensely personal, revealing both the artists' lives and aspirations and the generous vision of the collectors. The MFAH is privileged to present *New Formations: Czech Avant-Garde Art and Modern Glass from the Roy and Mary Cullen Collection*.

NOTES

1 Peter C. Marzio, "Director's Statement," in *Czech Modernism: 1900–1945* ed. Jaroslav Anděl and Anne Wilkes Tucker (Houston: The Museum of Fine Arts, Houston, 1989), 8.

2 After the Houston presentation (October 8, 1989–January 7, 1990), the exhibition was presented at the Brooklyn Museum (March 2–May 7, 1990), the International Center of Photography (March 2–May 13, 1990), and Anthology Film Archives (March 18–May 13, 1990). The photography segment also traveled to the Akron Art Museum (June 23–August 26, 1990).

3 Elizabeth McBride, "Czech Modernism: 1900–1945," *Artnews* 89, no. 1 (January 1990): 178. The exhibition was also discussed in the pages of *Artforum* and *Arts*, see Joan Seeman Robinson, "Czech Modernism: 1900–1945," *Artforum* 28, no. 8 (April 1990): 180–81, and Phyllis Tuchman, "Discovering Czech Modernism," *Arts* 65, no. 1 (September 1990): 60–61.

4 Michael Kimmelman, "Gallery of Unknowns in Brooklyn Exhibition," *New York Times*, March 2, 1990.

5 Andy Grundberg, "Czech Venturesomeness on View: Pictures Rooted in the Future," *New York Times*, March 2, 1990.

6 Caryn James, "The Wonder of Czech Cinema's Early Days," *New York Times*, March 2, 1990.

7 Ivan Klíma, "The Spirit of Prague," in *Prague: A Traveler's Literary Companion*, ed. and trans. Paul Wilson (Berkeley, CA: Whereabouts Press, 1995), 214.

8 At the time of this writing, the MFAH collection holds 177 prints by Josef Sudek, 35 by Jaroslav Rössler, 33 by Vilém Reichmann, 31 by Jaromír Funke, and 27 by František Drtikol, as well as notable examples by Jindřich Štyrský and František Vobecký, among others.

9 While the museum's collection of Czech modern glass is limited, the work of Johann Lötz Witwe and Ludwig Moser is represented by several prime examples. And thanks to the generosity of Radislav and Elaine Sutnar, Ladislav Sutnar's postwar graphic production is now represented in depth.

CAT. 2
Jan Matulka
View of Prague Castle | c. 1921
Watercolor on paper | 25 ½ × 20 inches (64.8 × 50.8 cm)

Accidental Revolutionaries:
A Conversation with Roy and Mary Cullen

Alison de Lima Greene

CAT. 3
František Kupka
Étude pour Blanc et noir: Printemps cosmique
[*Study for Black and White: Cosmic Spring*] | 1921
Ink and gouache on paper | 4 ¾ × 7 ⅞ inches (12 × 20 cm)

AG: Your collection tells a rich and densely layered story about Czech art in the twentieth century. Some of your works offer straightforward city views [CAT. 2], and others reveal much more enigmatic and private histories. But most important, this is an intensely personal collection, one that charts your own discovery of Czech avant-garde art, artists' books, and modern glass. Can you tell me about your first trip to Prague?

RC: It was 1989, late in the year. We were in Vienna, visiting my son Robert, who was working for the State Department. He and his wife had just had a baby, our granddaughter Leeanne, so we came over with family to meet her. Somehow our friend Miles Glaser, who had come to Houston many years earlier from Czechoslovakia, learned that we were there. Maybe he heard it at a cocktail party. Anyway, he called and said, "I want you to come and meet me in Prague."

I asked, "Why?" He replied: "We're going to throw the Communists out tomorrow." "Okay," I said. "We're coming, but I hope you succeed, or else we're all in trouble."

We got there that afternoon, and that night Miles ushered us into a small café where we met our ambassador Shirley Temple Black, former ambassador William Luers and his wife, Wendy, Václav Havel, and a handful of men, essentially the people who were getting ready to assume power. A guy sitting next to me asked, "I've been a Communist all my life; now what am I going to do? I need to become a businessman and work for my country." I said, "Come to Houston." He soon took me up on the offer, and I set up a meeting here with people I knew in industry and finance, many of whom were very interested to establish fresh ties with a new democracy. And of course it gave them a foot in the door.

So you could say we were accidental revolutionaries.

AG: How long did you stay in Prague?

MC: We were there for only about two or three days; given the restrictions on our visa, we had to return to Vienna. But everything was coming unglued throughout Eastern Europe, not just Czechoslovakia: Romania, Hungary, and East Germany, too.

RC: Once the borders opened, there was a flood of old cars coming into Vienna, and refugees were sleeping on the doorsteps.

MC: The Berlin Wall was literally coming down. In fact, when we made the decision to go to Prague, our son Meredith, who was seventeen, wanted to go to Berlin to see history in the making. He flew there with his cousin Lisa Sebastian on December 26, 1989, and we left for Prague the next day. It was all happening at once.

RC: I already had a sense that the whole fabric of the USSR and its satellites was coming apart. A year before we went to Vienna, I was invited to Kazakhstan. Mikhail Gorbachev wanted to launch some joint ventures, but I don't think he really knew what a joint venture was; he only knew that they needed to do something. So I took a trade mission composed of various businessmen into Kazakhstan to see if we could structure some deals. Before we left, however, the State Department called me. I was told: "Something is going on and we can't quite figure it out. Be careful. They're starting to have trouble."

We got over there, and there were two factions. There was the old school, who were bureaucrats but gentlemen. They were managers who could talk to our managers; their engineers could talk to our engineers. And then you had these new kids on the block, and they were a pretty unstable crew: half revolutionary, half mafia. That was our first warning of changes to come.

We also got to know our guide pretty well, and we learned from him that many Russians were up in arms about the war in Afghanistan. Too many Russian kids had died on foreign soil.

AG: Had you ever been to Eastern Europe, or what we used to call "behind the Iron Curtain," before these trips?

MC: Back in 1975 we went to Russia, and we made a stop in East Berlin en route. And I did go with Roy to Russia when he was on the Kazakhstan trade mission in 1988.

AG: But going to Prague wasn't a business trip, was it?

RC: No, not at all. We were there only because Miles had asked us to come. I guess he wanted as many Americans as possible as witnesses to what was happening. Looking back, it was probably risky to jump into a revolution behind the Iron Curtain, but it would have been inhuman not to do it. You see, we really believed in the cause, that it was time to end the Soviet domination of Eastern Europe. Ordinary Czech citizens had been taking huge risks, and the real heroes were the children who carried messages when it became

too dangerous to use the telephones. And now, at last, they could celebrate their freedom. The streets were filled with people cheering with joy, the bells were ringing, and it was a thrill to be there.

AG: And when did you return after that pivotal week in 1989?

MC: It was about three years later, in 1992, and Roy said, "Why don't we travel through Eastern Europe and see what has happened to all these countries after the fall of Communism?"

So we went to Romania, Hungary, Czechoslovakia (which had yet to separate into the Czech Republic and Slovakia), East Germany, and Poland. The rebuilding in the east had only just begun, and the roads were still in really bad shape. Probably it was most dramatic in Berlin. In East Berlin the buildings were still in shambles, and coming from the west, it was as if you had crossed into a different world.

AG: Why did you zero in on Czech art as your collecting focus? Were you inspired by what you saw in Prague in 1989?

MC: Actually, our interest came out of the *Czech Modernism: 1900–1945* exhibition at the Museum of Fine Arts, Houston. We had seen it when it first opened in Houston [October 1989], and of course once the show arrived in New York, it received national attention. I had always loved the work of the Russian avant-garde artists, and I found myself thinking, "The Czechs are every bit as good as the Russians." After we came back from our 1992 trip, Richard Willenbrink, a friend of ours on the faculty of the School of the Art Institute of Chicago, told us he was going to take a sabbatical year in Prague. Roy said, "Well then, we'll visit you."

So before six months passed, we were back in Prague again. By that time the great Veletržní Palác [Trade Fair Palace] had opened, where the National Gallery collections of modern and contemporary art are housed. Richard took us there, and it was like meeting old friends. Some of the pieces I had fallen in love with in the Houston show were hanging on the walls, and there were still whole new worlds to discover.

We were walking back to our hotel, and Roy said he was going to take a nap because we were still jet-lagged. So I asked Richard, "Do you think there is any possibility that I can buy any of this work here?" He said, "You know, there's a little gallery that just opened."

He walked me over to the gallery, and the first piece I bought was a František Kupka pastel [CAT. 4]. It is a study for *Accent noir (Femmes)*, which has also been called *Women of the Night*. You can see the larger version in the Jan and Meda Mládek Foundation, at the Kampa Museum in Prague. That's how it all started.

AG: And since then you've had front-row seats, as it were, watching the Czech Republic come into being and the renewal of Prague. Were you surprised by the economic revolution that followed the Velvet Revolution?

RC: It didn't surprise me that it blossomed so fast. From my childhood on, I knew a number of Czechs who had come to live in Texas. They were good businesspeople. Those who stayed in Czechoslovakia had incredible endurance, even when kept underfoot and ruled by dictatorship. I always felt in my heart that they were going to make rapid progress once they had their independence again.

AG: Once you got started, how did you choose which artists to pursue?

MC: The MFAH's catalogue was my bible.[1] I read it cover to cover, and carried a copy with me all around Prague as well. When I met dealers and experts who would talk about Josef Šíma, Jindřich Štyrský, Toyen, or František Vobecký, I would comb through the index and biographies. I really wanted to get a feeling for who these artists were, how their work evolved, what movements they belonged to. Were they members of Devětsil? Were they proponents of Artificialism? Did they employ photomontage? How did they shape the history of the avant-garde? That's how important the catalogue was to me.

AG: That's the best compliment any curator could have. Thank you, Mary!

But you also struck out on your own. For example, we exhibited photographs by František Drtikol, and you sought out his drawings [CATS. 5 and 6]. And whereas our exhibition focused on the generations that came of age between the wars, your collection includes many later works, including the great Jiří Kolář collage [CAT. 1].

Most important, however, you started pursuing Czech modern glass completely independently. This is an area we didn't have a chance to address when we put together the *Czech Modernism* exhibition. What sparked your interest in glass?

MC: What really got us launched was our first apartment in Chicago, which we began using as a second home in 1993. It was a loft on the south side of the city, in an old Czech neighborhood. I don't know how it came up, but we both agreed to collect Czech glass in honor of the Czechs who were there before us. We also agreed that we would collect Czech glass from the era between the wars, since it was a period of enormous creative blossoming, independence, and artistic freedom. Honestly, at first we didn't realize that our fascination with Czech avant-garde art and Czech modern glass overlapped; it all came together later.

RC: Here's something that just occurred to me. I was born in Houston in 1929 and grew up during the Depression. There were a lot of kids in our basically middle-class neighborhood, and like most boys, we were fascinated with machine tools. We knew even then that the best machine tools came from Czechoslovakia. It was common knowledge. So it was machine tools that first put Czechoslovakia on the map for me. You can make that a footnote if you like.

AG: But this is definitely more than a footnote. Because of course the machine aesthetic was one of the touchstones of the Devětsil movement and Functionalism, two of Czechoslovakia's most important contributions to European Modernism between the wars. And your collection focuses in particular on Karel Teige and the artists who first came together through the Devětsil publications and exhibitions. Was there a particular aspect of this group that caught your imagination?

MC: When the idea of building a collection took hold, I thought, "I'll start with the Cubists." And we did get some terrific work from this period, as well as a table by Vlastislav Hofman [**CATS. 7–11**]. But after exploring the galleries in Prague, I quickly realized that most of the best work by the Czech Cubists had already been snapped up. However, there were still amazing opportunities to pursue works by Czech Surrealists. Surrealism was pretty much out of fashion then, but there was something about it that just hit home for me. And then Surrealism led me back to Devětsil, and forward as well, to the Skupina 42 [Group 42] artists.

AG: Well, of course, there is a pretty good Surrealist collection here in Houston.

MC: Yes, Dominique de Menil was a tremendous inspiration. Also, having our apartment in Chicago, I got to know some of the other great Surrealist collectors: Lindy Bergman, Ruth Horwich, and Muriel Newman.

AG: Did you set yourself any specific guidelines when you started collecting?

MC: What kind of guidelines?

AG: Budget? Media? Anything.

RC: When Mary wanted to start a collection, she said: "Give me a budget." I said, "Okay, if that's what you want to do."

MC: But we didn't try to establish any kinds of guidelines or limits. I think that when a person collects, your own eye and your taste is your guideline. Unlike a museum, which builds its collections through committees, when you collect with a single vision you can be more specific. Since it was basically just Roy and me working together, we weren't tempted to go all over the place.

AG: Were there any particular collectors, curators, or art historians with whom you worked in Chicago, or in Prague? I know that Anne Tucker and I stayed in touch with you as the collection grew, but you really branched out on your own.

MC: We have made some wonderful friends through Czech art. Micky Wolfson at the Wolfsonian [at Florida International University] in Miami sponsored a Karel Teige exhibition about ten years ago.[2] We lent our Teige collage [**CAT. 92**], and when we went to the opening, I met the guest curator of the show, Eric Dluhosch. He is Czech and was teaching at MIT [Massachusetts Institute of Technology]. He had just published a major anthology on the work of Karel Teige, and Karel Srp was one of the authors. Eric asked me, "Have you ever met Karel Srp?" And I said, "No. I know who he is, but I've never met him." He said, "The next time you go to Prague, go see Karel Srp."

So the next time we went back, Roy and I introduced ourselves to Karel, and then through Karel we met Lenka Bydžovská. Karel is a brilliant art historian and curator. Once he realized how serious I was about Czech art, he became a true friend. Lenka is an exceptional art historian and writer as well, and she is one of the driving forces in the scholarship of Czech Surrealism. The two of them have helped us enormously to understand the importance of works in our collection.

Richard Born, a curator at the Smart Museum at the University of Chicago, was also interested in Teige's work; he brought the Wolfsonian's exhibition to Chicago, and he invited Karel to lecture. We have a lot of fun bouncing ideas around; Dick tells me what he thinks, and I tell him what I think, and so on and so forth.

AG: Matthew Witkovsky, who is now at the Art Institute of Chicago, has also emerged as one of the top curators promoting the Czech avant-garde, particularly in the realm of photography. You must know Matthew, no?

MC: We know Matthew very well. We met him first in Prague when he was still a graduate student. He was over there with a Fulbright scholarship and was doing his first important research on Milča Mayerová. We have followed his career ever since.

RC: He's been really instrumental, not only in Chicago, but before that at the National Gallery of Art as well.

AG: Mary, you and Roy have also become generous teachers and mentors — I know you've been fierce advocates of these artists and have encouraged a lot of young art historians.

MC: Well, you go to conferences and you get to meet all the up-and-coming scholars. I took part in the Graphic Modernism Lectures at the New York Public Library [2007 – 8]; Matthew was one of the speakers, and so was Jindřich Toman. Karel was there, too. That's where we met Karla Huebner, who was then working on her dissertation on Toyen and eroticism.[3] She came to Houston, studied our pictures, and combed through our books.

AG: Additionally, you have underwritten translations of publications that otherwise would not be available in English. While our early research may have lit the fire, I'm now learning from you.

MC: I don't think so.

AG: Keep in mind how much the times have changed. In the late 1980s it was still possible to write: "The city of Prague is lost to the modern imagination."[4] When Anne Tucker and I were exploring Prague with Jaroslav Anděl, Willis Hartshorn, and Ralph McKay in preparation for the *Czech Modernism* exhibition, people were very cautious about meeting Americans. It was extremely difficult to get access to collections and archives, and a lot of our conversations and meetings were off the record. In the end, it was only thanks to Peter Marzio's extraordinary diplomacy that we were able to secure the loans.

MC: Peter definitely was a visionary. He always used to say how proud he was of the *Czech Modernism* show; it went against the grain and popular opinion, but it also allowed the MFAH to stake out new territory that was truly important. He supported the curators when no other museum director in America would take on such an obscure project. And if the truth were known, I think he really enjoyed the negotiations with art czars like Jiří Kotalík [then director of the National Gallery, Prague].

Of course, Peter kept pushing the MFAH forward time and again. He organized the big Hispanic art show in 1987, and then he brought Mari Carmen Ramírez to Houston to create the Latin American department in 2001. He was always the one with an open mind, and he was always willing to learn from friends and collectors. He was the first museum director to recognize the importance of the African gold collection assembled by Alfred C. Glassell, Jr., and his encouragement of younger collectors committed to bringing Asian contemporary art to Houston was truly groundbreaking. The truth of the matter is that if Peter Marzio hadn't come to Houston all those years ago, this collection would not be here today.

RC: You could say that it was a perfect instance of how an institution can influence its members and audience.

AG: Well, Mary, you and Roy venture forth pretty fearlessly as well. Not only have you made friends with many of the leading curators both here and in the Czech Republic, you have also established new ties with the families and associates of the original avant-garde. Can you talk a little bit about meeting certain people and how you came to be friends?

MC: It just seems to me that, if you have an interest, it becomes a little chain, or a link. You meet more and more people, all of whom are drawn together by this common interest. For instance, I first met Jindřich Toman at a lecture at the Smart Museum of Art at the University of Chicago. This was when the Teige show was there [2001]. Dr. Toman is head of Slavic studies at the University of Michigan, and his uncle was Jindřich Heisler. That got my interest immediately. We now correspond frequently, and he has introduced me to other scholars in the field.

And then you know how we met Radoslav and Elaine Sutnar at the Art Institute of Chicago last year. I was kind of taken with him because his father [the graphic designer Ladislav Sutnar] is so

famous. It turns out that he was looking for museums that were interested in preserving Sutnar's legacy. So you contacted him, and now he has made several donations to Houston.

AG: That was a fantastic introduction. The Sutnar gifts have created a new niche in our design department, one that we hope to continue to build up in the years to come.

MC: Probably the most exciting encounter happened when I went to Paris in 2004 to attend the second major auction of André Breton's estate by Calmels Cohen at the Hôtel Drouot Richelieu. Karel had given us a head's up, and I was particularly interested in acquiring a portrait of Breton by Toyen [CAT. 109], which was overlooked when the first estate sale took place the previous year. Toyen had given it to Breton and had hung it in his atelier, above a huge bookshelf. But the nail broke, and the portrait fell down behind it.

RC: No one remembered it was there, and it hadn't seen the light of day for fifty years.

MC: By that time, I was fairly familiar with Toyen's work and life, and I knew what an important role Breton had played, as well as Radovan Ivšić and Annie Le Brun, who had been her friends and collaborators in her Paris years. I was lucky to be the successful bidder, and after the auction was over, I was standing with the dealer who had organized the auction. He was congratulating me, and just then Annie and Radovan walked up. He said, "Of course you know Annie and Radovan?" My eyes just popped open, and I said, "No! But I am so happy to meet you! I've read about you, and never in my lifetime did I believe I would meet you!"

They were so taken with my excitement at meeting them that they invited me to their home. And when I visited, Radovan said, "You know, Mary, this blue sofa you're sitting on, when Toyen was getting up in age, she'd be too tired to go home, so we'd make a little pallet for her here and she would lay down and sleep. Then the next day, when she had more energy, she would go home."

They made me feel very close to Toyen, even though we are generations apart. Toyen was twenty years older than Radovan; Radovan was twenty years older than Annie; and Annie (who is closest to my age) was a twenty-year-old girl when they first met. Annie told me that Toyen used to say, "Now Annie, we're older so you have to represent us. Draw a little star on your face, or wear fishnet stockings."

To me it was just so interesting to get a sense firsthand of the bonds that held these remarkable friends together so many years ago, and how conscious Toyen was of passing the torch to someone as young as Annie.

AG: Among the works I particularly like in your collection are the Hugo Boettinger drawings of Milča Mayerová [CATS. 17 and 18]. They complement the photographs that appear in Vítězslav Nezval's *Abeceda* and give us a much fuller sense of this remarkable dancer. Until Matthew Witkovsky wrote about the collaboration between Nezval, Mayerová, Teige, and Karel Paspa, most scholars in America (myself included, I'm afraid) overlooked the key role that Mayerová played in the creation of this book, despite the fact that her name appears on the cover [CAT. 16].[5] Can you tell me how you acquired these studies?

MC: When our friend Richard Willenbrink went to Prague for his sabbatical, he fell in love and married Eva Matějková, who happened to be Mayerová's niece by marriage. Now Richard has settled in Prague with Eva.

RC: Eva is also a very highly regarded architect.

MC: Yes, and Eva follows in the family tradition. Eva's uncle was an architect as well, and he was a member of the original Devětsil group. His name was Jaroslav Fragner, and he married Mayerová. He renovated Boettinger's villa on the outskirts of the old city for the family, but the Communists took ownership of the house in 1963 and divided it into many small apartments, one of which Milča was allowed to live in. Eva restituted the villa in 1991, but because of a long legal process, she was only able to move into the main floor in 2008.

AG: Yes, I remember visiting it with you last year. It's thrilling to now see how Eva has restored the villa.

MC: We have become very dear friends. And she's given me three of Milča's drawings, which of course touches me enormously.

AG: Do you see your collection as a means of restoring or reclaiming an overlooked chapter in the history of art?

MC: Czech art and artists were trapped in a fifty-year time capsule, and nobody, I mean *nobody*, outside of Czechoslovakia knew what was there. Nobody knew about the great art movements that had taken place, and even if you were interested, it was next to impossible to research Czech art in the West. There have been

many important shows and books in the last twenty years, but Czech art is still not fully integrated into the history of the twentieth century.

AG: And of course World War II and the subsequent era of occupation cast a shadow over this period. Some of the later works in your collection, and in particular the Skupina 42 artists [CATS. 101 – 104], reveal a profound shift in mood from the first exuberance of Czech Modernism.

MC: I really wanted to make sure that the collection tells the whole story as much as possible. Once I learned about the Skupina 42, for example, I really sought out those artists. These are extraordinary people who persevered against all odds.

What is amazing to me is that so many artists, even in the worst times, could rise above their circumstances and create something so beautiful, so powerful. Look at Heisler and Toyen. During the war, Toyen had to hide Heisler in her bathroom. And yet, Heisler ended up doing these astounding photomontages in a teeny, depressing room.

And then, of course, you can look at the amazing history of someone like Karel Teige. Teige was a great theorist. He was a writer. He was a total leftist. He was so far to the left that he didn't even fit in the leftist box. At no time would he compromise his feelings or beliefs.

When Communists took over the government in 1948, Teige was blacklisted. They banned him from publishing and tried to keep him from ever being able to write again. However, he continued to work clandestinely, and with his collages he came up with a new vocabulary and language. In 1951 he dropped dead of a heart attack. The following day, his lover and companion of many years, Josefina [Jožka Nevařilová], also died. They said that Josefina was so upset about Teige's death that she gassed herself. Ten days later, his young assistant and mistress, Eva Ebertová, also died, apparently a suicide as well. So within two weeks, three lives were lost. We may never finally know the whole truth about what happened during those dark years. What remains is the testament of the artwork itself.

AG: Among the great strengths of your collection are the artists' books and journals. They tell their own history of the avant-garde, from the radical typographies of Devĕtsil to the intimate erotica of the Surrealists to the passionate antiwar folios of Toyen. What led you to focus on printed matter?

MC: As we collected the glass and art, we realized that the books were actually a part of the same story. The books were conceived as artworks that could be available to the proletariat. If you could buy an inexpensive book made by a wonderful artist, you could be an art collector too.

AG: Where do you find these books now?

MC: I have found most of them through galleries and rare-book dealers, including Jerri Zbiral with the Collected Image in Chicago and Michael Weintraub in New York. Then I've found many in Prague, of course, and also in smaller cities like Kutná Hora.

AG: You've described how you first discovered Czech glass near your apartment in Chicago. Have you ever explored the glass workshops in the Czech Republic?

MC: I've been to Kamenický Šenov, but I didn't go into the factories. I went into the museums, and, of course, some of the gift shops. That's where we got the chandelier for the living room — we were just building this house then.

RC: We also went to the great Glass Museum in Passau, right across the German border. It is huge, floor after floor of nothing but glass. The collection has everything, from historic pieces to the everyday.

MC: It is where everyone goes to study Bohemian glass; it is one of the great collections in the world, if not the greatest. They have also published a huge catalogue of the collection, some seven volumes, which we have in Chicago.

AG: Every collector is a bit of a hunter. Besides Chicago, Paris, and the Czech Republic, where else have you discovered works for your collection?

MC: I've found Czech glass all over. I have to admit that I'm a great junker. I love to go to flea markets. I love to explore. Roy and I were going to Antarctica, and en route we had a stopover in Santiago, Chile. While Roy was taking a rest, I just had to check out the local flea market, and I jumped into a taxi. And there I saw two Czech pieces, in fact one of them is in the show, the vase by Ludwig Moser & Sons, made in 1925, in Karlovy Vary [CAT. 142]. It's signed, and I recognized it immediately.

I asked the man how much it was, and he told me. Well, I didn't have enough Chilean money with me. I told him: "I'll write you a check and I'll be back in three and a half weeks, by then I'm sure my check will clear." He didn't even have a business card; I had to ask him to write down the exact address so I could find him again.

We went to Antarctica, then we came back to Santiago, and I returned to the stall. The man said to me, "Your check hasn't cleared." And I said, "I'm sure it's going to clear. Let me give you a little more money, so you can mail it to me in the United States." Four or five weeks later, my Moser vase arrived.

AG: That means it ultimately traveled over twelve thousand miles, or halfway around the globe! Nothing could speak more clearly to the fact that Bohemian glass reaches audiences everywhere.

MC: Of course, many of the glass factories exported their wares, but a lot of the glass went to South America with immigrants who had to flee Europe. You can find examples not only in Chile, but in Brazil and Argentina as well.

AG: We have talked a fair amount about the chase and capture of artworks. Now that you live with so many outstanding examples, can you point to any special favorites?

MC: I only hang things on the wall that I love, so everything here is a favorite. A few are a little more historically important though. For example, Jindřich Štyrský's *Roots* [CAT. 75] was in the first *International Surrealist Exhibition* that was organized by Roland Penrose and André Breton [London, 1936]. It has a nice provenance too, since it went from Štyrský to Breton. And then we were able to acquire it at the 2003 Breton sale in Paris.

RC: Karel Teige's collage was the one that woke me up, the one with the fighter planes [CAT. 92]. It went to Micky Wolfson's Teige exhibition at the Wolfsonian, and we followed it down there. It was at that moment that everything started coming together for me. I was picking up bits and pieces up to then.

AG: So, this was your "aha" moment?

RC: It's more than that. I could recognize at once what it stood for. I knew the background of it, knew the time when these British Spitfires were flying.

My favorite, however, is Toyen's *The Message of the Forest* [CAT. 80]. It would have to be.

MC: The first time I saw *The Message of the Forest*, I was with my nearest and dearest friend, Marilyn Oshman. We were in Prague together, and when I saw it, it grabbed me. It's a tough piece, and even after looking at it all these years, it still has a double edge. I can ask, "Does the owl have such a grip on her that she lost her head over him?" Or, "Is he so wounded that the only place he can find refuge is with her?"

Marilyn is a terrific collector, and she had the foresight to acquire major paintings by Frida Kahlo and Diego Rivera early on. She also fell in love with Toyen, and she later acquired two of her paintings and a work by Štyrský. For me, this was a great compliment and vote of confidence. I thought well, goodness, if Marilyn loves Toyen, then I must be on the right track.

AG: Did you acquire it right away then?

MC: At the time, *The Message of the Forest* wasn't on the market. It was featured in the major Toyen retrospective organized by Karel Srp for the City Gallery Prague [Galerie hlavního města Prahy, 2000]. I asked, "Who owns this painting?" And Karel told me that it was from a private collector in Caracas, Venezuela. And I said, "Karel, if he ever wants to sell this piece will you please tell him to contact me?"

After a few months or so, I heard that the owner wanted to sell the painting. We negotiated by telephone, and for us at the time it was a little costly. I told Roy, "I have a feeling about this. You just have to trust me." We wired the money overseas and within two weeks the painting was hanging in our apartment in Chicago. We later learned that the owner had been very ill, and he passed away not long after.

AG: The last time I looked at *The Message of the Forest* with you was when we were all in Germany for the opening of the *Surrealism Paris-Prague* exhibition.[6] And I know from your many loans to the MFAH and to many other institutions that you are very generous when it comes to sharing artworks. Can you comment on what it is like to send your collection out into the world?

MC: If it is a legitimate project, we are always willing to share because we enjoy this work so much. If we enjoy it, someone else should enjoy it too.

AG: Are there still works you hope to acquire? Do you have a wish list?

MC: I think at this point we're kind of trying to cherry-pick. At first, I was just so excited because I knew the names and I recognized the art. Now, if something truly wonderful should come up, we would buy it.

AG: At the beginning of our conversation, you described yourselves as accidental revolutionaries. From what you have said, it sounds like you became collectors by accident as well. What do you think you have learned from creating this collection?

MC: From myself, about myself? What I think I've learned is that I'm a Modernist. I was born in a modern era so maybe that's why I have always gravitated toward Modernism. It goes back to when I was a kid, growing up in Los Angeles and Guadalajara. I loved to explore the museums with my sisters and brothers, and we adored the José Clemente Orozco murals at the governor's palace and the Hospicio Cabañas. Then we moved to Chicago, and I remember how excited we were when the Picasso went up in Daley Plaza [1967]. It wasn't something we learned from our parents, but somehow all five of us (Alice, Ron, Tom, Nancy, and I) were passionate about art.

Roy and I have built several collections in addition to Czech avant-garde art and modern glass. We tend to focus on areas that we can connect to personally: Surrealism, Latin American art, the L.A. Beat generation, the Chicago Imagists, Texas art. We enjoy getting to know the artists. However, more than any one artist, what really interests me is to look at a certain moment or movement in a specific period of time and place. That's what I've learned about myself.

RC: Until Mary prompted me, it never occurred to me to be a collector in the real sense of the word. Our family was always involved in supporting the museums in Houston, helping both the institutions and the city become stronger. It wasn't my frame of mind to be a collector. My frame of mind was to know art, to appreciate it. I didn't think it was necessary to make a collection.

However, art was around. We always had pieces of art everywhere that we'd accidentally acquired, if not collected in the strictest sense. And when I was a kid, my grandmother would always leave art books around for me to read while I drank Coca-Colas at her house, so by osmosis I acquired a pretty good education in art history. By the time I got to Europe in my twenties, I knew most of that stuff. And then, once the family created the Agnes Cullen Arnold Endowment at the MFAH [1970] and the Lillie and Hugh Roy Cullen Sculpture Garden opened [1986], our ties to the museum were pretty close.

But I would like to say that Mary was the one who put this together. I knew enough about art to know that she was doing a good job. So I encouraged her and stayed out of the way. What I've learned over the past twenty years is that the collector is a very valuable instrument in the art world. While I've always known that, now I've seen it firsthand and understand much better how that plays out. Mary's had a big effect on bringing recognition to Czech art, glass, and books. The collection overall makes a real statement, one that both scholars and the average person can appreciate. I have learned so much through that.

Houston, Texas
February 2011

NOTES

1 Jaroslav Anděl and Anne Wilkes Tucker, eds., *Czech Modernism: 1900–1945* (Houston: The Museum of Fine Arts, Houston, 1989).

2 *Dreams and Disillusion: Karel Teige and the Czech Avant-Garde*, at the Wolfsonian, Florida International University, in Miami, November 16, 2000–April 1, 2001.

3 Karla Tonine Huebner, "Eroticism, Identity, and Cultural Context: Toyen and the Prague Avant-Garde" (doctoral dissertation, University of Pittsburgh, 2008).

4 Alison de Lima Greene, "Czech Modernism: 1900–1920," in *Czech Modernism: 1900–1945*, 35.

5 Matthew S. Witkovsky, "Staging Language: Milča Mayerová and the Czech Book 'Alphabet,'" *Art Bulletin* 86, no. 1 (March 2004): 114–35.

6 *Gegen jede Vernunft: Surrealismus Paris-Prag [Against All Odds: Surrealism Paris-Prague]*, at the Wilhelm-Hack-Museum and Kunstverein Ludwigshafen, in Ludwigshafen, Germany, November 14, 2009–February 14, 2010.

CAT. 4
František Kupka
Étude pour Accent noir (Femmes)
[*Study for Black Accent (Women)*] | c. 1918 – 20
Pastel on paper | 14 ¾ × 10 ¼ inches (38.5 × 29 cm)

CAT. 5
František Drtikol
Untitled | 1918
Charcoal on paper | 17 ¼ × 11 ½ inches (48 × 29 cm)

CAT. 6
František Drtikol
Untitled | 1919
Charcoal on paper | 17 × 11 ¼ inches (43.2 × 28.6 cm)

CAT. 7
Josef Čapek
Ženská hlava [*Head of a Woman*] | 1917
Linocut | 8 ⅛ × 5 ¾ inches (21.6 × 14.6 cm)

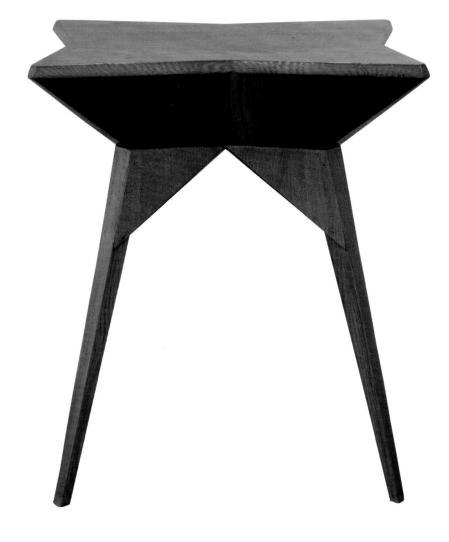

CAT. 8
Vlastislav Hofman
Table | c. 1912
Wood | 29 ¼ × 17 ¼ inches (74.3 × 43.8 cm)

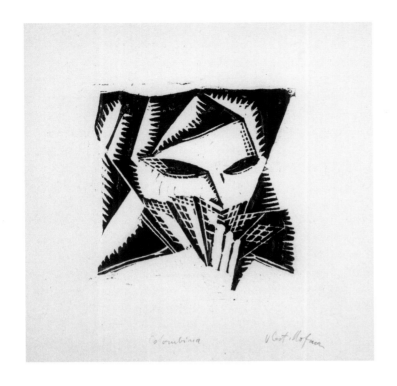

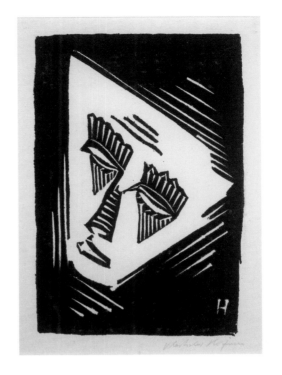

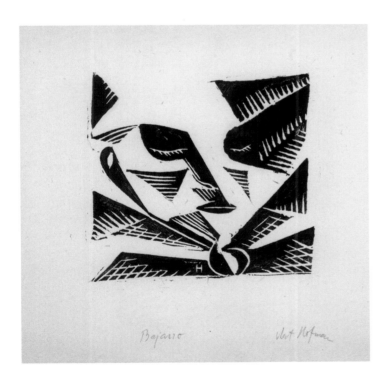

CAT. 9
Vlastislav Hofman
Bajazzo [Jester] | 1918
Linocut | 9 ¼ × 9 ¼ inches (23.5 × 23.5 cm)

CAT. 10
Vlastislav Hofman
Colombina [Colombine] | 1918
Linocut | 9 ¼ × 9¼ inches (23.5 × 23.5 cm)

CAT. 11
Vlastislav Hofman
Maska [Mask] | 1918
Linocut | 8 ½ × 6 inches (21.6 × 15.2 cm)

The New Alphabet

Karel Srp and Lenka Bydžovská

The Devětsil Artistic Association was founded in the Prague Union Café on October 5, 1920. It was not until two months later, however, that the public was informed of its existence. On December 6, 1920, on the second page of *Pražské pondělí* (*Prague Monday*), members of Devětsil issued a declaration that heralded the ascent of a new generation: "The era has split in two. The old times lie behind us, condemned to rot in libraries, while before us a new day glitters. Everyone must speak up. But everyone must also begin to build the new life."[1]

Thus a group that would profoundly influence the shape of Czech twentieth-century art raised its voice and demanded to be heard. This association would exist for roughly ten years, until 1931, which is generally regarded as the date when Devětsil finally dissolved, although some former members would establish another generational association in the 1930s. Broad in its ambitions and orientation, Devětsil went through significant changes in terms of its stated aims and membership. It had an impact on all areas of the arts — literature, visual art, theater, architecture, film, typography, criticism, and art theory — and a wide range of opinions were expressed and artistic media were explored by Devětsil artists.[2] An essential aspect of Devětsil was the demand for renewal. After the First World War, young artists were united by the need to set themselves apart from everything that had come before, whether from formerly innovative art movements such as Cubism, Expressionism, or Futurism, or from the lifestyle of the bourgeoisie.

The word "Devětsil" has two meanings in Czech: it refers to the butterbur, a field flower, and its literal meaning, "nine forces," suggests concentrated energy. At one time or another, more than one hundred people were associated with the group. The only person to be closely connected with Devětsil from its founding to its dissolution was Karel Teige (1900 – 1951).[3] He soon became the spokesperson for the group, and provided the organizational glue that held it together. Although the significance of Devětsil cannot be reduced to Teige alone, his name is tied to all of the activities of the group. Indeed, it is impossible to separate the force of this one proponent from the direction of the association as a whole.

Teige began his artistic career at the age of seventeen, when the German Expressionist magazine *Die Aktion* (*The Action*) published one of his landscape linocuts. His first ambition was to be a painter; about 1920, however, he came to the conclusion

that avant-garde art was headed in a different direction from easel painting. Teige gradually came to focus on applied graphic art; as far as he was concerned, this field was the only one in which he could put into practice his ideas about the new kind of art. After he had shed the influences of Cubism and Expressionism, and, like El Lissitzky, had moved from the linocut to mechanical printing, Teige found enduring inspiration in applied graphic art. This medium was ideally suited to the techniques of accidental typography and photomontage.

Teige was an uncompromising critic of bourgeois culture, which he regarded as a threat to modern art in general. From the very beginning, he was a strong advocate of leftist views and an admirer of the USSR after the victory of the Communist Revolution in 1917, although he was not a member of the Communist Party of Czechoslovakia. He knew that he would never accomplish anything as an independent art critic and theorist. He had to have a group in whose name he could speak and organize various projects, such as anthologies, special issues of magazines, and exhibitions. At the same time, after 1918, Teige began to cultivate contacts abroad systematically. He corresponded and was friends with most of the advocates of the avant-garde from Paris to Weimar to Moscow. This does not mean, however, that he endorsed their programs wholeheartedly. He did not hesitate to point out their weaknesses, as he perceived them. He criticized, for example, André Breton's *Le manifeste du surréalisme* (*Surrealist Manifesto*), the Bauhaus, about which he had always had reservations, and the Paris-based artists of Le Grand Jeu. Instead, from the beginning of the 1920s, Teige's ideal was a sophisticated dialectic of opposites, Constructivism and Poetism, which inspired the unique intellectual model that was the Czech avant-garde's most outstanding contribution. He promoted an ingenious synthetic model, which was based on study of the possibilities of sense perception. In accordance with their relative importance, the senses of sight, hearing, smell, touch, and taste all had an impact on this model. Thus, Teige's importance cannot be reduced to his role as expert commentator on the international scene, although he went to great lengths to acquaint his compatriots with developments abroad. Indeed, he was the only advocate to remain faithful to the progressive ideas of the avant-garde for the entire span of Devětsil's existence. To the very end, he continued to influence the group's program, although he had parted ways with almost all of its original members.

Devětsil Revolutionary Anthology

Devětsil's first publication was the eponymous anthology on which its members began to collaborate in the spring of 1922. It was not published, however, until the end of 1922 [CAT. 12]. It was largely the work of Teige and the poet Jaroslav Seifert. Ilya Ehrenburg's book *A vse-taki ona vertitsia* (*And All the Same the World Goes Round*), which was published in the spring of 1922 and proclaimed the end of art, had an impact on the visual style of the *Devětsil* anthology, as did Teige's first holiday trip to Paris in the summer of 1922. This journey fundamentally changed his outlook on art and society. In Paris, Teige met all of the important representatives of the avant-garde. He also encountered their many journals and manifestos, the visual style of which influenced his ideas of what the *Devětsil* anthology should look like. Prior to this anthology, Teige had worked on the design and illustrations of two books by members of Devětsil: Ivan Suk's *Lesy a ulice* (*Forests and Streets*), 1920, and Jaroslav Seifert's *Město v slzách* (*City in Tears*), 1921. It was in the *Devětsil* anthology, however, that he developed the essential aspects of his approach to typography. These aspects, in turn, served as the starting point for subsequent typographic designs, in terms of the selection of type as well as other features such as the flat, abstract, geometrical shapes that replaced traditional ornamentation. Teige believed that typographical design should be as comprehensible as possible, after the model of train timetables, the naval code of flag signals, and Morse code. Under the title of the *Devětsil* anthology, he placed a simple circle, which he repeated on the back cover and inside the anthology. The circle continued to be his dominant typographic sign, and he often incorporated it into his designs.

Even the first readers of the *Devětsil* anthology might have noticed a distinct discrepancy between the literary and the visual components. All of the important members of Devětsil contributed stories, poems, and essays. In contrast, the reproductions included almost no artwork by Devětsil artists, except the architect Jaromír Krejcar's design of a central market hall, and Teige's *Paris*, which combined ink drawing and collage. This omission was partly due to the fact that, in the months when he was working on the anthology, Teige had fallen out with most of the painters who had founded Devětsil and who had exhibited their work at the first *Jarní výstava Devětsilu* (*Spring Exhibition of Devětsil*) in 1922. He was critical of their naive, primitivist approach, which he had previously endorsed. The omission also was due partly to the

fact that he had grown increasingly suspicious of easel painting, which he regarded as representing the end of art. In Teige's view, painting was to be replaced by the photograph and by film, to which a great deal of space was devoted in the anthology. Teige's belief in the imminent death of the painting — a conviction that turned out to be indefensible — was made manifest in the mass-produced postcards that were reprinted in the anthology in place of more conventional illustrations. In the layout of Seifert's "Paříž" ("Paris"), photography was paired with poetry for perhaps the very first time in Czechoslovakia. The flow of the poem was interrupted by postcards showing familiar Parisian sites much admired by Devětsil at the time: La Grande Roue (the monumental Ferris wheel erected for the 1900 Paris Exposition) and the Eiffel Tower. Ironically, Seifert had written the poem, which compares the ambiance of Prague and Paris, without ever having visited the "city of light."

Teige's iconoclasm went even further in the Devětsil anthology when, emulating Ehrenburg, he reproduced images of an American snowplow locomotive and the deck of the Standard steamship. Teige promoted these images, along with the aforementioned photographs of Paris, as examples of a utilitarian "new beauty," which was a part of life as it was lived, served a function, and was entertaining at the same time. The American snowplow train and the view of the deck of the Standard steamship can also be interpreted as examples of the transition of prewar visual art to the modern present.

With these new ideals, Teige criticized all art that had come before, and simultaneously hinted at what would become his passion for Purism. (He had met representatives of this movement, Le Corbusier and Amédée Ozenfant, in Paris in 1922.) Both of the examples suggest Devětsil's interest in technology, which was also manifest in the early work of Josef Šíma. While he was living in Brno after the war in 1918–20, Šíma concentrated on the subject of the train in motion. In one of the preparatory drawings [CAT. 14] for the painting *Vlak a skladiště v Brně* (*Train and Depot in Brno*, Moravská galerie v Brně [Moravian Gallery, Brno]), c. 1920, Šíma came to terms with the slanted planes of Cubism. The drawing shows a view of the main hill with the Church of St. Peter, as seen through the suburban factory chimneys and the conspicuous motif of the locomotive crossing the bridge. The drawing is typical of Šíma's artwork immediately prior to his departure, on January 1, 1921, for Paris, where he

settled permanently. In his new home, he became acquainted with the main representatives of the Parisian avant-garde, the Purists and the Surrealists, and by the end of the decade he had become a member of the avant-garde group Le Grand Jeu.

On the Waves of TSF

The collaboration between Teige and Seifert was so close that the latter entrusted the former with the typographic design of his third collection of poems, published at the beginning of 1925 under the telling title of *Na vlnách TSF* (*On the Waves of TSF*) [CAT. 15]. The abbreviation TSF (Télégraphie sans fil), referring to wireless telegraphy and radio, was a favorite of the Dadaists and Futurists; they used it in all manner of typographic designs. Teige conceived of Seifert's collection as an integrated, boldly executed whole; he assumed that, in his contribution, he could literally do what he wanted with the textual component and thereby support, or alternately undermine, the meaning of the poems themselves. To a certain extent, he was inspired by his friend Filippo Tommaso Marinetti, whose collection *Les mots en liberté futuristes* (*Futurist Words in Liberty*) was published in Czech translation in 1922. *On the Waves of TSF* was far removed from the established idea of what a collection of poems should look like. It was an example of playfulness and joy, two key tenets of Poetism.

Teige had published the first Poetist manifesto, *Poetismus* (*Poetism*), the previous year. With his design for Seifert's poems, Teige created an extraordinary book that was exceptional in the context of the European avant-garde at that time. It underscored the visual character of words and thus gave the literary work a further, visual component. With a multitude of typographical poems, poetic anecdotes, aphorisms, and rebuses, Teige reexamined the poetry collection and changed the relationship between title and poem. He worked with italics and bold type. He alternated horizontal and vertical positions of typesetting. Sometimes he made use of emphatic underlining. Naturally, Teige had to provide a detailed description of the design of the collection to the printer, or it would have been impossible to set the type. Years later, Seifert recalled:

Mr. Obzina's respectable printing house in Vyškov had to use almost all of the types that it had in its cases to set the book. What's more, it had to throw out all of the classical rules of typography, which had been handed down and perfected since

the time of Gutenberg, until it arrived at a modern standard of book design. All sorts of types were used for the titles and texts of the poems. Every poem was set in a different way. One page was up high, another was along the length. The old gentleman in Vyškov shook his head over this kind of work, but he complied. Young people today would describe Teige's exertions as a typographical rodeo.[4]

On the Waves of TSF remains a milestone to which typographers return as an example of an original treatment of a literary text. Never again was Teige to have such an opportunity. With this radical book, he gave unique expression to Devětsil principles: "[the typographical revolution] demands that as an expression of modern spirit the book should break traditional typographic harmony — that is, the monotony and symmetry that are at odds with the ebb and flow of the poetic text rippling on the page. [It] demands the use of a variety of colors and types, the selection of which, as in the case of posters, should be dictated by legibility, coherence, and simultaneity of visual perception."[5]

For all that, Teige's theoretical principles were not applied literally in his conception of *On the Waves of TSF*; his personal contribution predominated over clarity and ease of reading. This contribution gave the poems a different dimension, which conflicted with Teige's later interest in normalization and scientific discoveries in the physiology of perception.

Alphabet

The unusual design of Vítězslav Nezval's *Abeceda* (*Alphabet*) was a masterful example of Poetism in book form [CAT. 16]. Nezval wrote the collection of short poems treating the various letters of the alphabet at the beginning of the 1920s as an informal response to Arthur Rimbaud's reflections on the colors of vowels. Even before Teige started to design the unique book, the text had become a primer among the members of Devětsil. The poems were quintessential examples of the kind of free-associative ideas of early Poetism, a free play of the imagination. *Alphabet* was so popular that it was performed in April 1926 at *An Evening with Vítězslav Nezval*, directed by Jiří Frejka at the Osvobozené divadlo (Liberated Theater), which at that time was located in the Na slupi theater. The poems were recited by the popular actress Jarmila Horáková and accompanied by a performance by the dancer Milča Mayerová, a student of Rudolf von Laban.

It was only a small step from the theatrical treatment of *Alphabet* to the realization of a book that would be a synthesis of various disciplines. The poems, which were intended to be read aloud, so inspired Teige that, in designing the book, he created a compelling monument, a turning point in his own typographical development, which grew more famous year by year. As published, *Alphabet* was the result of collaboration among several artists: Nezval provided the text, and Mayerová provided the physical interpretation of each letter and poem, which Karel Paspa photographed. Uniting the fields of poetry, dance, photography, and typography, Teige gave the work its overarching design. He created a book distinguished by its visual simultaneity. Each two-page spread is devoted to a single letter. The title and text of each poem appear on the left; the typographical design, linking photography and typography, appears on the right. Teige offers the readers-viewers several levels of perception. On the left side, they can see the relationship between the poem and its title; on the right side, they can see the relationship between Mayerová's position and the typographical treatment of the letter of the alphabet. At the same time, however, the images on the left and right pages intersect, heightening the effect of the design. Crucially, Mayerová's position can be interpreted with a view to the text of the poem. When the two are compared, it is clear that Mayerová's gestures did not always imitate the shape of the letters, but rather were often based on motifs in the poems. This is most obvious with the last letter, Z, for which she imitated the shape of the Eiffel Tower, which is mentioned in the last line of the accompanying poem. Likewise, in his typographical creations, Teige challenged the accepted typographic style when he set the titles of the poems as bold, uppercase letters. The only exception to this was the poem on the letter G, where he used a lowercase "g," the shape of which suggested to him a "cowboy" gesture (in the original versions of the poem, published in 1923 and 1924, it was a lasso from the movies of Douglas Fairbanks). The motion of throwing a lasso inspired Mayerová's remarkably open posture. Some of her body positions are loose variations on established gestures, such as the letter T suggesting the crucifixion, the letter S the *figura serpentinata*, and the letter U the submissive orant gesture. With the other letters, the body expresses the popular relationship between the horizontal and the vertical (F, L), the diagonal (A, B, D, F, G, L, V, X, W), and even the circle (C). It is important that Mayerová, in making the shapes of the

letters, avoided looking directly at the camera. Her full face is not captured anywhere; often, however, she worked with the "language of gestures" and with "frozen motion" at its most striking moment. In her postures, extreme tension alternated with complete ease. Teige channeled the photographs into his own typographical conception. He did not copy the bodily gestures with his letters. In a few cases, he tried to incorporate the photographs into the composition of the letters (for example, D, E, I, L, N, T, Z). In each instance, he defined the photograph on at least one side with a black, orthogonal, flat band. This heightened the impression of spatial depth, which was often further enhanced by the shadow cast by the physical gesture.

Just as Nezval's *Alphabet* was a "poem about a poem," the entire book, under Teige's direction, was a "book about a book." It could be described as a "typo-photo," to use the terminology of László Moholy-Nagy. The twenty-six two-page spreads soon won Teige a place among the most important European typographers. Nonetheless, the book's significance was not fully appreciated until it was published in translation, although Teige showed it at the groundbreaking Stuttgart exhibition *Film und Foto* (*Film and Photo*, 1929).[6]

Alphabet was released by the extremely conservative publishing house of Jan Otto, which did not usually represent avant-garde artists. The book's publication was probably a matter of personal connections: Mayerová was related, on her mother's side, to Otto's family. Mayerová was also the niece of Hugo Boettinger, one of the representatives of Czech modern art from before the First World War, who had a long-standing interest in the motif of the dancer. Mayerová was, for him, an ideal type. Although Mayerová was mostly famous for her role in *Alphabet*, Boettinger's drawings [CATS. 17 and 18] show another side of her art as a dancer.

Photomontage
About the mid-1920s, as Teige's designs for *On the Waves of TSF* and *Pantomima* (*Pantomime*), 1924, demonstrate, book covers and layouts were dominated by the antithetical styles of abstract geometry and photomontage. Both offered considerable freedom. The red, yellow, and blue cover of Guillaume Apollinaire's *La femme assise* (*The Seated Woman*, in Czech *Sedící žena*), 1925, [CAT. 20], which was based on the alternation of geometrical surfaces recalling café awnings and accidental type, was designed by Teige and Otakar Mrkvička. It can be compared with Teige's cover for Vladimír Lidin's *Mořský průvan* (*Sea Breeze*), 1925 [CAT. 19], executed as a photomontage, a technique that allowed the layering of overlapping materials. In the latter cover, Teige contrasted photographic close-ups of a warship with rectangles showing the surface of the sea, clippings from a Soviet newspaper, and a near-worthless hundred-mark banknote.

Photomontage facilitated the rise of metaphor — seemingly random visual jumps from one meaning to another. The technique was popular in particular with Jindřich Štyrský and Toyen, who lived in Paris from 1925.[7] They created some of the landmark covers of Czech book art of the 1920s. In their cover for Nezval's *Falešný mariáš* (*Cheating at Whist*), 1925 [CAT. 21], red, abstract, geometrical shapes constitute the background for a photomontage showing a coiled snake, above which rises a hand holding cards. These cards are held face up, giving viewers the impression that they are the player. Štyrský and Toyen were particularly interested in the typographical rendition of card suits, moving from black spades to red hearts. The red and black colors apply to the cover as a whole; at that time, covers were often composed of a combination of these two colors, in part due to cost considerations.

A year later, in another collaborative project, Štyrský and Toyen went a step further toward Surrealism. Still working in Paris, they provided the cover for Karel Schulz's collection of short stories, *Dáma u vodotrysku* (*Lady at the Fountain*), 1926 [CAT. 22]. On the cover, one sees a montage of relationships transcending causal connection. A young woman holding a sunflower is set inside the wheel of an automobile. Like Nezval in his poems, Štyrský and Toyen heightened the visual metaphor by adding other motifs that were not logically connected. On the one hand, there is a contrast between the immobile woman and the wheel, which suggests motion (at that time anything to do with automobiles was a popular symbol of speed). On the other hand, there is a contrast between the woman's overly small, smiling face and the man's enlarged fingers, which aggressively try to take possession of her. The figure of the woman, who seems to stand in a void, was probably Toyen's contribution; the fingers suggest Štyrský's work. Similar close-ups of a hand and an open palm appear on the covers of Štyrský's *Fantômas*, 1929.

Images of showgirls were among the most popular Devětsil themes in the 1920s. One appears on Štyrský and Toyen's cover

for Jindřich Honzl's collection of essays on theater, *Roztočené jeviště* (*The Unfolding Stage*), 1925. A showgirl appears on the cover that both artists created for Nezval's *Menší růžová zahrada* (*A Smaller Rose Garden*), 1926, and a whole chorus line on the cover of the guidebook *Paříž* (*Paris*), 1927 [CAT. 23], which they compiled with Vincenc Nečas while living in the French capital. The showgirl motif was used most extensively on the cover of Nezval's first prose work, *Karneval: Romaneto* (*Carnival: A Novel*), 1926 [CAT. 24]. It reflected the fascination that members of Devětsil shared with the Surrealists for dancers, the circus, and acrobats. Honzl spoke for all when he summarized Devětsil's interest in burlesque: "The sexuality of the variety show is a confirmation and assertion of vitality, its powerful exaltation. The music hall is a theater of passion. The variety show is the only place where one can feel the presence of another person as a suggestive current of vital forces, as life enriched with powerful and elemental emotions."8 While the cover of *Carnival* is highly suggestive, evoking images of a music-hall striptease, the identity of the designer is obscured under the name of "J. Don," an unknown individual who is not credited with any other design. Clearly this was a pseudonym for one of the members of Devětsil, perhaps for the author of the book, Nezval, or for the publisher. The title page was the work of Teige and Mrkvička.

ReD

For the first years of its existence, Devětsil sporadically published anthologies like *Devětsil*, 1922, *Život II* (*Life II*), 1922, and *Fronta* (*Front*), 1927, and small journals like *Disk* (*Disc*), which had only two issues, in 1923 and 1925, and *Pásmo* (*Zone*), 1924–26, prepared by the Brno section of Devětsil. However, not until *ReD* (an abbreviation of *Revue Devětsil*) was launched, in 1927, did the association produce a periodical that met Teige's exacting standards for design and content [CAT. 25]. From 1927 to 1931, thirty issues (three volumes) of *ReD* were published. From the start, Teige made it a crossroads of the European avant-garde. He introduced each issue with a declaration of principles. In October 1927, he described *ReD* as a "synthetic journal of international cultural production."9 It presented, according to him, an unambiguous ideological challenge: "*ReD* is a red beacon of the coming new cultural epoch."10 In the introduction to the third issue in September 1929, Teige once again made clear which side *ReD* represented: "It understands the word 'modern' in the most direct,

rigorous and radical sense, just as it attributes the broadest meaning to the word 'international.'"11 *ReD* was supposed to be "the last word in international modernism, modern restraint, and modern will: revolution."12 From these introductory proclamations, it is clear that Teige was still faithful to the ideas that informed the first Devětsil declaration of December 1920, as well as to the avant-garde's increasing support of the Left and its criticism of bourgeois society.

While *ReD* functioned as the group's monthly periodical, it was first and foremost a direct reflection of Teige's theoretical and artistic interests. He was responsible for the entire design of *ReD*, including the binding and the related advertising materials. Teige paid particular attention to the cover typography, which matched the international standards for an avant-garde magazine in the late 1920s. The overall cover design successfully connected three essential elements: striking type, abstract graphic organization, and photographic reproduction.

ReD immediately aligned itself with the avant-garde magazines of the late 1920s, which had inspired its content and form. A year before *ReD* appeared, the monthly *Das Neue Frankfurt* (*The New Frankfurt*), designed by the siblings Grete and Hans Leistikow, was published. Teige later described it in *ReD* as "one of the best cultural periodicals in Germany today."13 Other landmark periodicals of this era included *Novy LEF* (*New LEF*), 1927–28, designed by Alexander Rodchenko; *Dokumentum* (*Document*), 1926–27, published in Hungary and designed by the editor Lajos Kassák; and *Dźwignia* (*Lever*), 1927, published in Poland with contributions from Mieczysław Szczuka, Teresa Żarnoweröva, and Karol Hiller.

The content of some of the special issues of *ReD* also gives an idea of how extensive and far-flung Teige's contacts were. One thinks, for example, of the issues devoted to Russian art (*ReD* 1, no. 2, 1927), international contemporary architecture (*ReD* 1, no. 5, 1928), Marinetti and international Futurism (*ReD* 2, no. 6, 1929), the Bauhaus (*ReD* 3, no. 5, 1930), and the group Le Grand Jeu (*ReD* 3, no. 8, 1930).

Teige deliberately preserved continuity with the early 1920s ascent of the avant-garde by adopting a bold, sans-serif letter heading in the title of *ReD*; this element of the design remained unchanged for the entire run of the journal. Year by year, however, he strikingly altered all of the other typographical features on the cover. Although he approached each individual issue from

a fresh perspective, he established a basic typographical motif for each of the three volumes, a motif that was developed from issue to issue. For most of the issues of the first volume, a reproduction fills two-thirds of the cover. A list of contributors or a list of topics fills the remaining third. These lists are sometimes introduced by the popular sign of the pointing finger, or, in the majority of cases, by the heading "collaborators," given in three languages. The orthogonal, asymmetrical composition, with the subtitle "Měsíčník pro moderní kulturu" ("Monthly for Modern Culture") printed in the top half, defined the look of the first volume of the publication. For the second volume of *ReD*, Teige used a narrower, abstract, geometrical ground tint, with the name of the magazine centered in the upper half of the right side of the cover, emphasized by a thick horizontal band in which the subtitle was printed. A narrow, vertical line intersects the design, running down the entire cover. The design was further simplified in the last volume. Teige set the title of the magazine closer to the center of the cover and eliminated the numerous headings concerning the collaborators and content that had filled the covers of the preceding volumes. Some of the covers had only essential information on the cover, without any abstract patterns (for example, the September 1930 issue, vol. 3, no. 9). Teige's changing design of the covers of the three volumes of *ReD* corresponded to shifts in opinion on the physiology of vision, which showed, according to Jan Tschichold's theories, that only the narrow line on the left edge was necessary as a starting point for the movement of the eyes.

The bold heading "ReD" is a powerful visual focus, immediately attracting the eye. It determines the relationship to the reproduction, which is only one of the components of the cover, rather than its predominant feature. In response to the purifying aims of the new typography, the title of the magazine was moved across the cover from the left corner to the right center; this creates a key tension between the thin line of color emphasizing the left spine and the heading on the right edge. In the covers of *ReD*, Teige gave expression to all of the possible ways of avoiding axial symmetry, one of the main enemies of the new typography, while at the same time he developed an ideal of asymmetrical equilibrium.

As the editor, Teige occasionally published his own artwork on the covers of *ReD*, thus inserting himself into the ranks of the Prague avant-garde of his generation, alongside Jaroslav Rössler,

Jindřich Štyrský, Adolf Hoffmeister, and Jaromír Krejcar, as well as artists of other nationalities such as Fernand Léger, Le Corbusier, Jean Arp, and Imogen Cunningham. Whereas the works of these artists appeared at most only twice on the covers of *ReD*, Teige published his own work three times — twice in the first volume and once in the second. In the first volume, his art even appeared on the covers of two succeeding issues — in November 1927 with Lenin on the globe, and in December with the "typographical composition" from Konstantin Biebl's collection *S lodí, jež dováží čaj a kávu* (*On the Ship Bringing Tea and Coffee*). The latter pointed to another dimension of Teige's typography, which had a distinctly Poetist orientation. Teige included another example of his book art in the April 1929 issue, using the frontispiece of Pierre Girard's book *Connaissez mieux le coeur des femmes* (*Fathom the Hearts of Women*; *Poznejte lépe srdce žen*) on the cover of the magazine. Unlike the cover, the design of the inside of *ReD* magazine did not change much over the three volumes. Like the cover, however, it reflected Teige's views on typography. As needed, he alternated one, two, and three columns of typesetting. He separated texts from reproductions by using a thick line that ran the length of the page, or a large dot.

Motion Pictures on a Page

Teige's theoretical views on contemporary typography were realized in the designs of the three volumes of *ReD*. Nonetheless, he was capable of self-contradiction, in particular in regard to his statements concerning the rejection of precious, limited-edition books. In his 1927 essay "Moderní typo" ("Modern Typography"), Teige rejected bibliophilism as a useless luxury that was beyond the reach of most readers. However, in the late 1920s, as well as in the following decade, Teige was one of the main designers of bibliophile book covers, usually first editions of poetry collections, for which he was even awarded a national prize. At the turn of 1927 – 28, the first and second editions of Biebl's collection *On the Ship Bringing Tea and Coffee* were published in quick succession. Teige designed the cover and provided illustrations for the collection. The blue cover of the first edition is intersected by bands of color in which are set, in lowercase, the name of the author, the title of the collection, and its genre. In the printed illustrations, Teige also used watercolor. He restricted himself, however, to various thick horizontal bands. A month before the publication date, a red-and-black advertisement showing the

frontispiece of the collection was published in the November issue of *ReD*. The advertisement asserted that there would be "100 numbered and signed copies on Van Gelder paper. Kryl & Scotti dichromic print. Typographic design and illustrations by K. Teige. The first 25 copies will be colored by hand and signed by the designer. Each book will be registered." For the cover of the second edition of *On the Ship Bringing Tea and Coffee* [CAT. 26], Teige chose the same type. In the same spirit as the cover, four geometrical illustrations loosely connected with the text appear in the book. In these, Teige was pushing the limits of his own theoretical convictions. The illustrations resemble some of the typographical compositions by the Dutch architect Piet Zwart from the mid-1920s, in particular his *Omaggio a una giovane donna* (*Homage to a Young Woman*). In his illustrations for Biebl, Teige risked criticism that he had brought the foundations of new typography to the verge of decorativeness. It was as if he had fallen victim to an imitation of Constructivism, which he had rejected that same year in his essay on modern typography.

Yet the main proponents of the new typography made no criticism of the decorative features of Teige's typographical designs. On the contrary, they raved about them. According to Christopher Burke, author of the most recent monograph on the maverick German typographer and designer Jan Tschichold, Teige's work influenced Tschichold's iconic sketch of Josephine Baker.[14] The brothers Heinz and Bodo Rasch, architects and publishers of the anthology *Gefesselte Blick* (*Captured Gaze*), commented on Teige's designs of Biebl's poetry collections: "These pictures are typographical montages, little 'motion pictures on a page.' The eye wanders over them, discovering ever new perspectives. It wanders frontward and backward, up and down, and what it gains is a certain impression, a certain idea, a certain rhythm."[15]

For these designs, in comparison with his previous book designs, Teige now gave depth to the bare surface; it became an open field for him, running in every direction, filled only with elements to be found in the typographical equipment of the composing room. He worked with loosely articulated, orthogonal compositions, the repetition of shapes, and transitions and shifts, heightened by the rhythmical alternation of two colors. For the second edition, the headings and geometrical features were red and blue against the yellow background of the cover. The illustrations were printed in pink and black. The cover for the collection *On the Ship Bringing Tea and Coffee* is a perfect

example of Teige's balanced "asymmetrical harmony," based on the rejection of symmetry and the central axis: "Asymmetry is not a new structural fashion, as in the Art Nouveau. It is the necessary outcome of the correct understanding of our method of reading from left to right, which demonstrates the illogicality of the central axis. . . . Dynamic type design should correspond to the movement of the reading eye. It should deliberately lead the reader from word to word, from group to group."[16]

On the cover, however, Teige avoided direct expression of the diagonal. It emerges from the relationship between the two red circles and the headings. While the circle suggests the sun, corresponding to Biebl's poem "Slunce se kloní k obzoru" ("The Sun Dips to the Horizon"), the rows of lines refer to water. The three full-page illustrations, prefigured by the frontispiece and title page, refer directly to the three parts of the collection: "Začarovaná studánka" (The Enchanted Well"), "S lodí, jež dováží čaj a kávu" ("On the Ship Bringing Tea and Coffee"), and "Protinožci" ("The Antipodes"). All three are characterized by the interconnection of geometrical shapes and letters or headings. Teige's compositions make direct reference to Biebl's stay on Java, to the ship named *Yorck* that sailed the Pacific, and to jazz. Among the geometrical features, one sees the isolated letters A, O, and Z transformed into general signs. Teige created a visual poem without even hinting at the Far East.

Teige's collaboration with Biebl developed ideas that he had used earlier in the design of Seifert's collection *On the Waves of TSF*, where Teige had worked with the typographic features to be found in the cases of typesetters, exploiting the emotional power of typographical features, directing the eye over the surface of the page. The extent to which he hovered on the border between abstract and realistic idioms is suggested by the illustration with the headings "Yorck" and "Jazz," which includes ideograms that were current among the members of Devětsil—a compass rose, the deck of a steamship, a railing, and a raised flag. Biebl also treated one of the key themes of Devětsil, the farewell, developed by Teige in film scripts and picture poems: "And for a long, long while he waved a white handkerchief at the Yorck." In the last illustration for *On the Ship Bringing Tea and Coffee*, Teige surrounded the black circle with stars, which he also sprinkled over the entire illustration. The black circle referred to the dark side of the sun, seen in the Antipodes, which provided the title for the last poem in Biebl's collection. Clearly by coincidence, it also

appeared in one of Štyrský's illustrations for Lautréamont's *Les chants de Maldoror* [CAT. 40].

However, Teige was open to outside influences as well, as is demonstrated by his response to El Lissitzky's design of Vladimir Mayakovsky's *Dlia Golosa* (*For the Voice*). In the first illustration for the poem "Nash marsh" ("Our March") in this collection, El Lissitzky had formulated a typographic expression for a ship, which Teige picked up on as well. A year after the publication of *On the Ship Bringing Tea and Coffee*, a revised edition of Biebl's poetry collection *Zlom* (*Break*) was issued, in October 1928 [CAT. 27], that also reflected El Lissitzky's influence. However, in contrast to the striking, strident, almost billboard-like style of El Lissitzky's illustrations, Teige's illustrations were characterized by a spiritual and lyrical quality. For the title of the collection, Teige chose the Grotesque typeface. He printed the illustrations in red and black on yellow stock. The first illustration closely copied its literary model. Between a starry sky and a surface of water, one sees cemetery crosses and rectangles representing empty graves to which a question mark is assigned rather than names. The references to musical instruments in the second illustration introduce the section "Hledání ztracené hudby" ("The Search for Lost Music"). The last illustration is the most abstract. In it, the diagonal, descending line segments seem to express the word "break" ("zlom") in the title of the final section of the collection.

The covers for the thirty issues of *ReD* magazine and the illustrations for Biebl's poetry collections constitute the peak of Teige's typographical output. They had an impact on Teige's covers for *Bragožda*, 1928 [CAT. 28], by Stanislav Kostka Neumann, *Markéta Lazarová*, 1929, *Pekař Jan Marhoul* (*The Baker Jan Marhoul*), 1929 [CAT. 29] by Vladislav Vančura, and *Ze světa do světa* (*From One World to Another*), 1929 [CAT. 30], by Ladislav Dymeš. These publications feature Teige's favorite typographical elements, such as the arrow and compass, as well as devices such as the alternation of red and black letters in the titles. Teige, however, was not indifferent to the most recent proclamations made by his colleagues in Germany, including Moholy-Nagy and Herbert Bayer at the Bauhaus in Dessau, and Tschichold in Munich. Their proclamations concerned the use of the diagonal and of lowercase type, promoted in almost all avant-garde publications at the end of the 1920s (and ultimately embraced by Teige in both theory and practice in the 1930s). The first two publications in the *MSA* series (*Moderní soudobá architektura* [*Contemporary*

Modern Architecture]), which Teige wrote and edited, illustrate his response to these new requirements. The cover of *Mezinárodní soudobá architektura* (*International Contemporary Architecture*), 1929 [CAT. 32], was designed to stress the orthogonal relationship between the headings and the surfaces, based on the alternation of red and white. In contrast, on the cover of *Moderní architektura v Československu* (*Modern Architecture in Czechoslovakia*), 1930 [CAT. 33], the headings and surfaces were slanted diagonally after the fashion promoted by the international typographical avant-garde. A precedent for Teige's cover can be found in the work of the Bauhaus typographer Fritz Heine, and, in the colophon of *Modern Architecture in Czechoslovakia*, Teige acknowledged his debt to one of Heine's layouts. Teige's embrace of the new international style was very well received abroad. When Theo van Doesburg reviewed *Modern Architecture in Czechoslovakia*, he expressed his admiration: "Typographically, the book meets the most important requirements for a modern publication: clarity, orderliness, and esthetic effect."[17]

Shadows and Sign

Although his approach to typography became increasingly simplified, Teige was still open to trying other artistic techniques, such as those of experimental black-and-white photography. At the beginning of the 1930s, Teige made a unique cover for the *Almanach Kmene* (*Kmen Almanac*), 1930 – 31 [CAT. 35], with the collaboration of the photographer Josef Sudek, who photographed Teige holding the magazine *Kmen* in his hands. (Teige designed the second volume of the magazine.) The photograph was altered in such a way that Teige's body vanished and all that remained were glasses, a pipe, shoes, and hands holding the magazine, on which the title, *Kmen*, was prominent. At the same time, the absent figure was represented by its shadowy reflection, which created a distinct tension between the two halves of the image. Teige was here elaborating on the experimental approaches of Jindřich Honzl's theater productions, in which reflections of reality were almost ghostly. The cover may also have been influenced by the cover of Heinz and Bodo Rasch's book *Der Stuhl* (*The Chair*), 1928, which portrays a seated man writing, but no chair or table. Teige reversed the situation on the front and back cover of *Kmen Almanac*. Whereas the Rasch brothers made objects disappear, Teige caused the body to vanish. He thought highly of the *Kmen Almanac* cover, which he reproduced in his

essay "O fotomontáži" ("On Photomontage"), 1932, and included in the comprehensive selection of his most recent typographic work for the exhibition *International Reklamedruck*, organized by Ring neue Werbegestalter (Circle of New Advertising Designers) at the Stedelijk Museum, Amsterdam.

NOTES

1 "U. S. Devětsil" ("Artistic Association Devětsil"), *Pražské pondělí* (*Prague Monday*) 2, no. 49 (December 6, 1920): 2.

2 For an overview of the Devětsil movement, see *Devětsil: Czech Avant-garde Art, Architecture and Design of the 1920's and 1930's*, ed. František Šmejkal and Rostislav Švácha (Oxford: Museum of Modern Art, 1990) and *The Czech Avant-Garde and Czech Book Design: The 1920s and 1930s, An Exhibition Drawn from the Emma Linen Dana Czech Avant-Garde Book Collection*, ed. Blanka Stehlíková (Madison, NJ: Fairleigh Dickinson University, n.d. [1996]).

3 See Eric Dluhosch and Rostislav Švácha, eds., *Karel Teige/1900–1951: L'Enfant Terrible of the Czech Modernist Avant-Garde* (Cambridge, MA, and London: MIT Press, 1999).

4 Jaroslav Seifert, *Všecky krásy světa* (*All the Beauties of the World*) (Prague: Československý spisovatel, 1983), 259–60.

5 Karel Teige, "Modern Typography," trans. Alexandra Büchler, in *Karel Teige/1900–1951*, 102.

6 Martin Parr and Gerry Badger, *The Photobook: A History, Volume I* (London: Phaidon Press, 2004), 94.

7 Toyen's given name was Marie Čermínová. It is not clear why she adopted the pseudonym "Toyen." The standard explanation is that the pseudonym is derived from the French word *citoyen* (meaning "citizen").

8 Jindřich Honzl, *Roztočené jeviště* (*The Unfolding Stage*) (Prague: Odeon, 1925), 166.

9 Karel Teige, "ReD," *ReD* 1, no. 1 (October 1927): 2.

10 Ibid.

11 Karel Teige, "ReD," *ReD* 3, no. 1 (September 1929): 1.

12 Ibid.

13 Karel Teige, "Das neue Frankfurt" ("The New Frankfurt"), *ReD* 2, no. 9 (May 1929): 296.

14 Christopher Burke, *Active Literature: Jan Tschichold and New Typography* (London: Hyphen Press, 2007), 123.

15 *Gefesselter Blick* (*Captured Gaze*), ed. Heinz and Bodo Rasch (Stuttgart: Wissenschaftlicher Verlag Dr Zaugg, 1930), 94.

16 Karel Teige, "Moderní typografie" ("Modern Typography"), *Rozpravy Aventina* (*Aventinum's Newsletter*) 7 (October 1931): 20.

17 Theo van Doesburg, *On European Architecture*, trans. Charlotte I. Loeb and Arthur L. Loeb (Basel: Birkhäuser Verlag, 1990), 317–18.

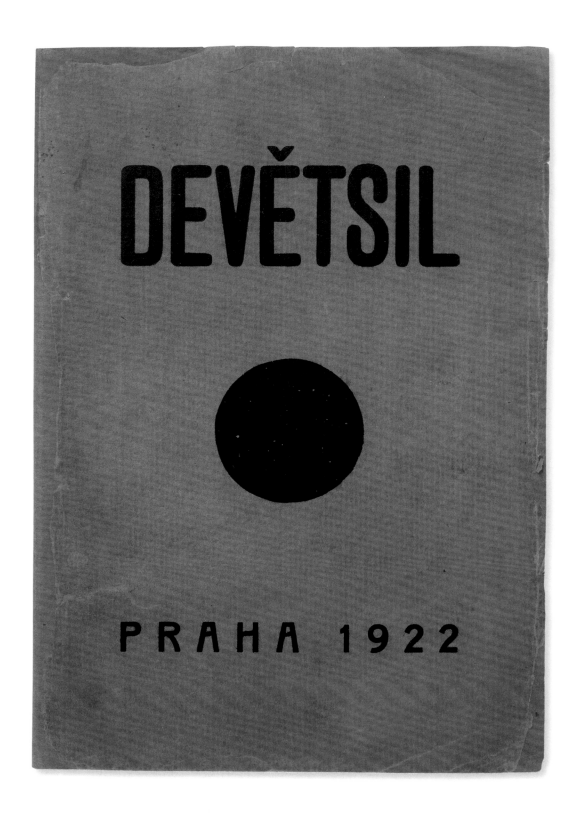

CAT. 12
Jaroslav Seifert and Karel Teige (eds.)
Revoluční sborník Devětsil [Devětsil Revolutionary Anthology] | 1922
Cover and typography: Karel Teige and Jaroslav Seifert | Prague: Večernice (V. Vortel)
9 ½ × 6 ½ inches (24 × 16.5 cm)

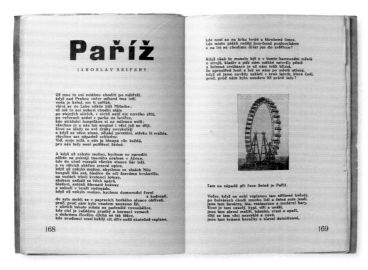
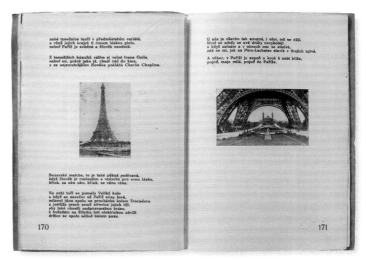
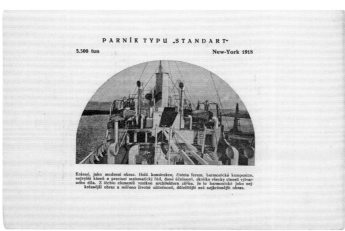
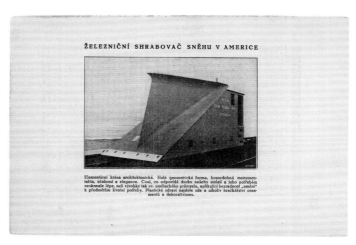

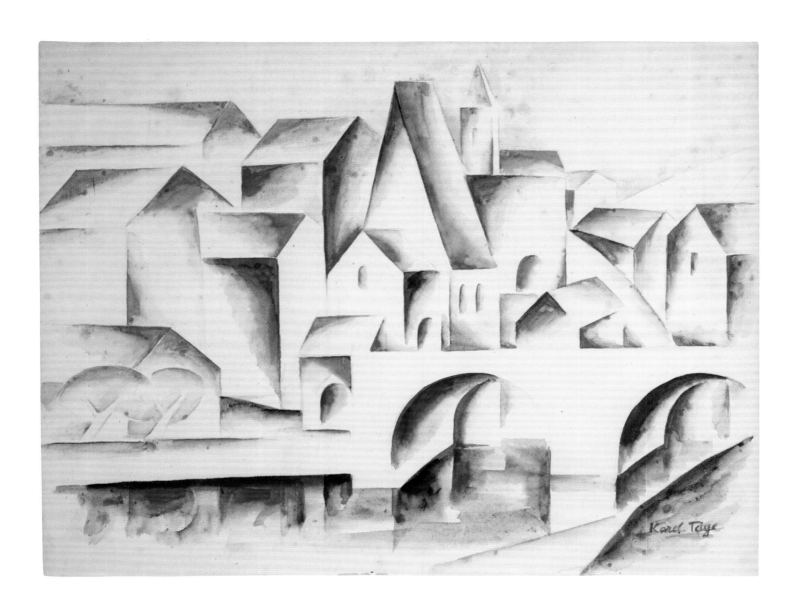

CAT. 13
Karel Teige
Město u řeky [*City by a River*] | 1918
Watercolor on paper | 9 ¾ × 12 ¾ inches (25.2 × 32.5 cm)

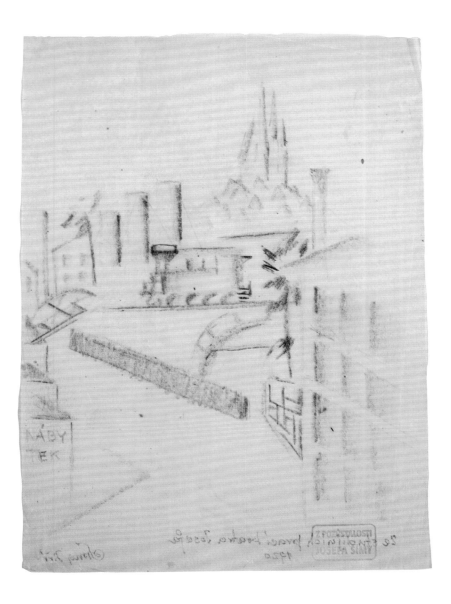

CAT. 14
Josef Šíma
Studie pro Vlak a skladiště v Brně [*Study for Train and Depot in Brno*] | c. 1920
Graphite on paper | 8 7/8 × 6 1/2 inches (22.5 × 16.5 cm)

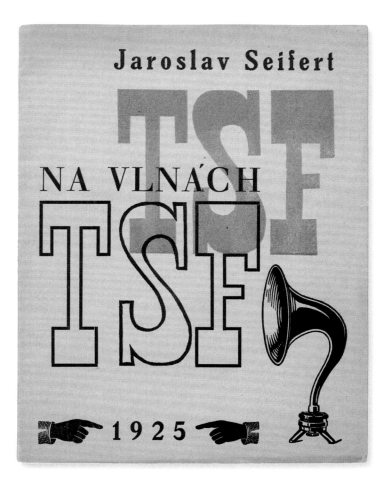

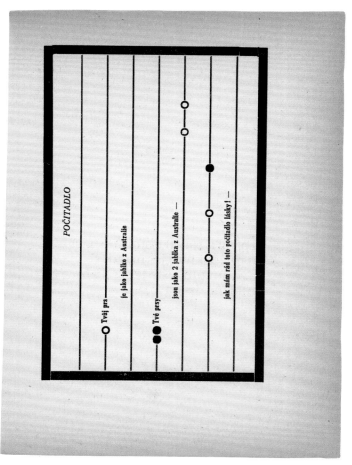

CAT. 15
Jaroslav Seifert
Na vlnách TSF [*On the Waves of TSF*] | 1925
Cover and typography: Karel Teige | Prague: Václav Petr
9 × 6 ⅞ inches (22.8 × 17.5 cm)

Rebus

ČTVERÁK ŠTĚSTÍ

ČTVERÁK ŠTĚSTÍ

ČTVERÁK ŠTĚSTÍ

ČTVERÁK ŠTĚSTÍ

ČTVERÁK ŠTĚSTÍ

(Čim větší čtverák — tim větší štěstí)

40

OBJEVY

Roku 1492 objevil Janovan Krištof Kolumbus neznámé

ostrovy

Děkuji pane!

Já kouřím cigarety!

Láska

umírající cholerou
vydechují vůni
 konvalinek
vdechujíce vůni
 konvalinek
umíráme láskou

50

FILOSOFIE

vzpomeňte moudrých filosofů
život není nic než okamžik
a přece když čekávali jsme na své milenky

byla to věčnost

CAT. 16
Vítězslav Nezval
Abeceda [*Alphabet*] | 1926
Cover and typography: Karel Teige | Choreography: Milča Mayerová | Photography: Karel Paspa | Prague: J. Otto
12 ¼ × 9 ½ inches (31 × 24 cm)

Vítězslav
Nezval

ABECEDA

Taneční komposice: Milča Mayerová

PRAHA
1 9 2 6

A

nazváno buď prostou chatrčí

Ó palmy přeneste svůj rovník nad Vltavu

Šnek má svůj prostý dům z nějž růžky vystrčí

a člověk neví kam by složil hlavu

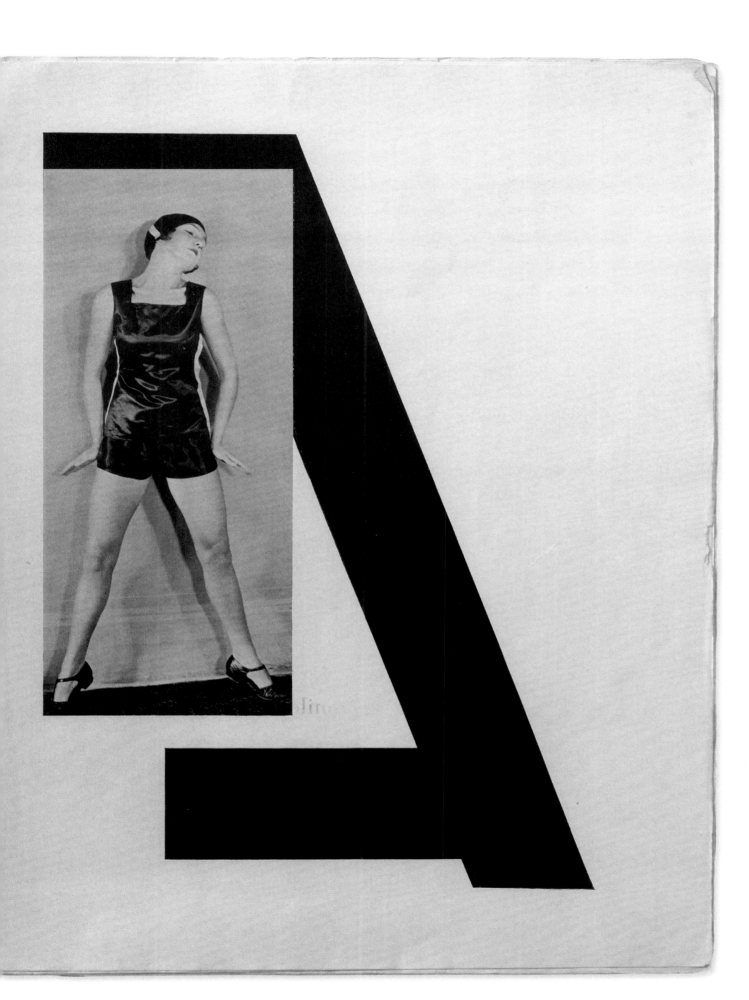

B

oranžový plod lampion mléčné záře
jímž matka poprvé opojí v kolébce syna
B druhé písmenko dětského slabikáře
a obrázek psu milenčina

8

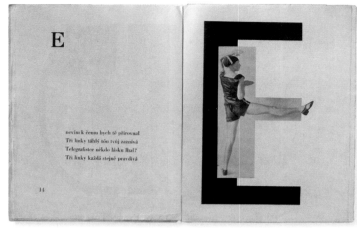

C

září jako měsíc nad vodou
Ubývej shasni měsíci veliký
romance gondoliérů navždy mrtvy jsou
tož vzhůru kapitáne do Ameriky

10

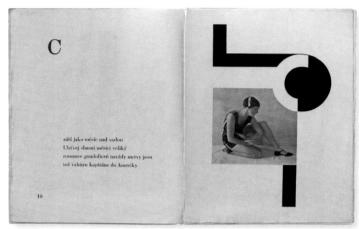

D

luk jenž od západu napíná se
Indián shlédl stopu na zemi
Poslední druhové zhynuli v dávném čase
a měsíc dorůstá prerie kameni

12

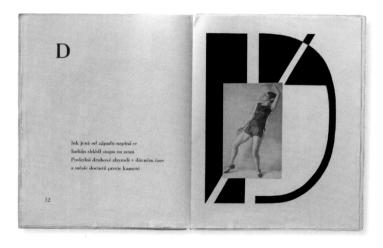

E

nevím k čemu bych tě přirovnal
Tři linky táhlý tón tvůj zaznívá
Telegrafistce někdo lásku lhal?
Tři linky každá stejně pravdivá

14

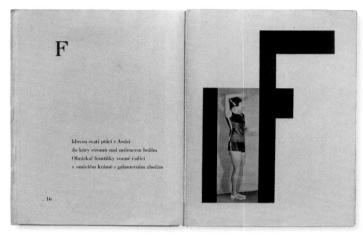

F

klovou svatí ptáci v Assisi
do kůry stromů nad milencem božím
Obrázku! františky vonné řadící
v omšelém krámě s galanterním zbožím

16

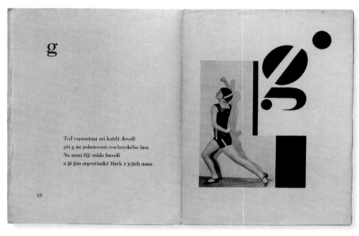

g

Teď vzpomínat mi každý dovolí
při z na polostvosti cowboyského lasa
Na zemi řijí stádo buvolí
a já jim argentinský řízek z jejich masa

18

H

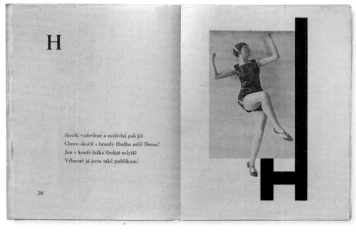

člověk vydechne a nedýchá pak již
Clown skočil s hrazdy Hudba mlčí Drum!
Jen v koutě laška tleskat uslyší
Výborně já jsem také publikum!

20

K

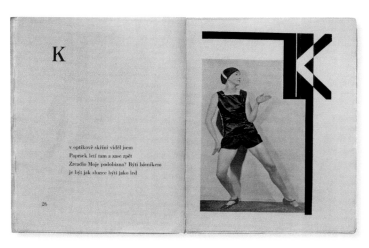

v optikově skříni viděl jsem
Paprsek letí tam a zase zpět
Zrcadlo Moje podobizna? Býti básníkem
je býti jak slunce býti jako led

26

I

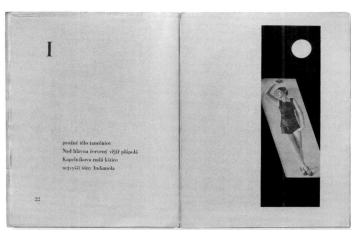

pružné tělo tanečnice
Nad hlavou červený vějíř plápolá
Kapelníkova rudá kštice
nejvyšší tóny Indianola

22

L

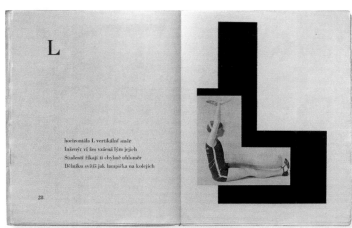

horizontála L vertikální směr
Inženýr ví že s vzená lýra jejich
Studenti říkají ti chybně úhloměr
Dělníku svítíš jak lampička na kolejích

28

JQ

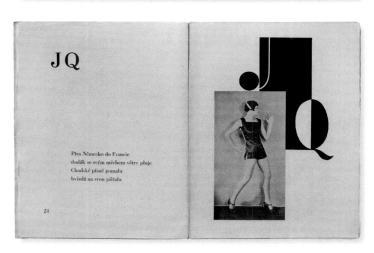

Přes Německo do Francie
dudák se svým měchem větry pluje
Chodské písně pomalu
hvízdá na svou píšťalu

24

M

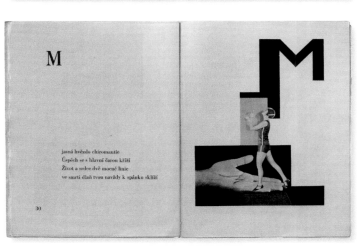

jasná hvězdo chiromantie
Úspěch se s hlavní čarou kříží
Život a srdce dvě mocné linie
ve smrti dlaň tvou navždy k spánku skříží

30

N

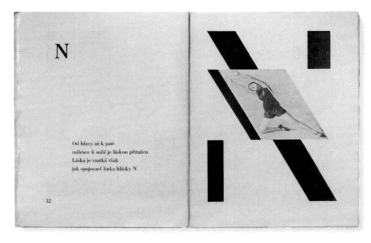

Od hlavy až k patě
milenec k milé je láskou přitažen
Láska je vratká však
jak spojovací linka hlásky N

32

RRRʀʀ

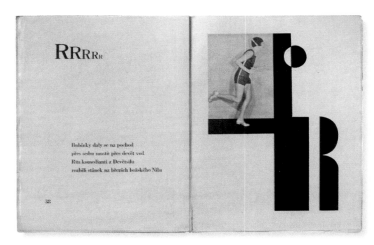

Babičky daly se na pochod
přes sedm moustů přes devět vod
Rita komediantú z Devětsilu
rozbili stánek na březích božského Nilu

38

O

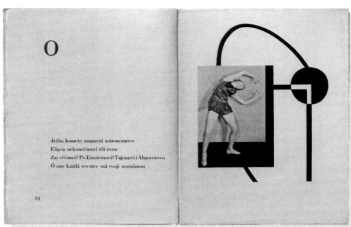

dráha komety znamení astronomovo
Elipsa nekonečnosti též zvou
Zas věčnost? Po Einsteinovi? Tajemství Ahasverovo
Ó ano každá rovnice má svoji neznámou

34

S

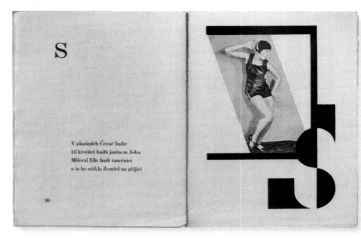

V planinách Černé Indie
žil krotitel hadů jménem John
Miloval Elis hadí tanečnici
a ta ho uštkla Zemřel na přijici

40

P

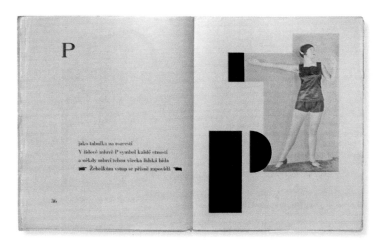

jako tabulka na rozcestí
V tiskové mluvě P symbol každé ctnosti
a někdy mluví jehon všecka lidská bída
■ Žebrákúm vstup se přísně zapovídá ■

36

T

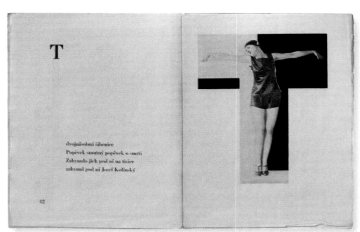

dvojnásobní šibenice
Popěvek smutný popěvek o smrti
Zakymalo jich pod ní na tisíce
zahynul pod ní Josef Kolínský

42

U

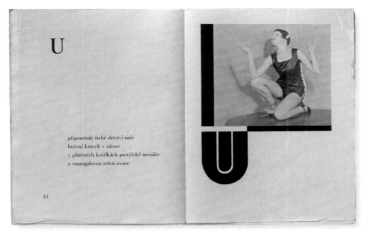

připomínáš tiché dětství naše
bučení kravek v zátoce
v plátěných košilkách pastýřské mesiáše
a smaragdovou zeleň ovoce

44

X

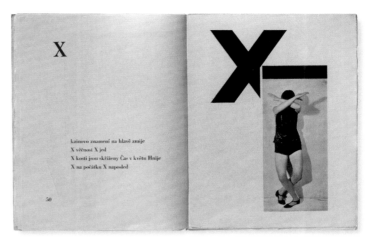

kainovo znamení na hlavě znije
X věčnosti X jed
X kosti jsou skříženy Čas v květu Hnije
X na počátku X naposled

50

V

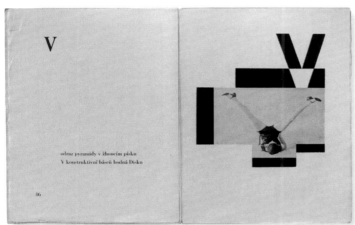

odraz pyramidy v žhoucím písku
V konstruktivní báseň hodná Disku

46

Y

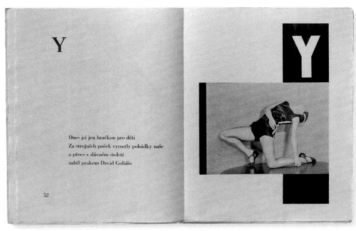

Dnes jsi jen hračkou pro děti
Za strojních pušek vyrostly pohádky naše
a přece v dávném století
zabil prakem David Goliáše

52

W

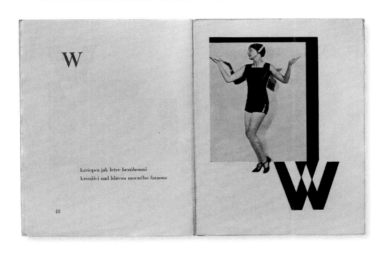

kaviopea jak letcv bezúhonná
kroužíci nad hlavou mocného faraona

48

Z

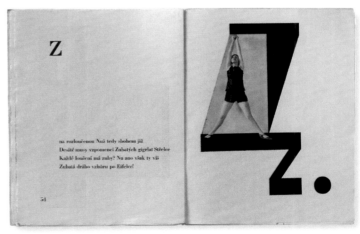

na rozloučenou Nuž tedy sbohem již
Desáté musy vzpomeneš Zubatých gigrlat Střelce
Každé loučení má zuby? Nu ano však ty víš
Zubatá dráho vzhůru po Eiffelce!

54

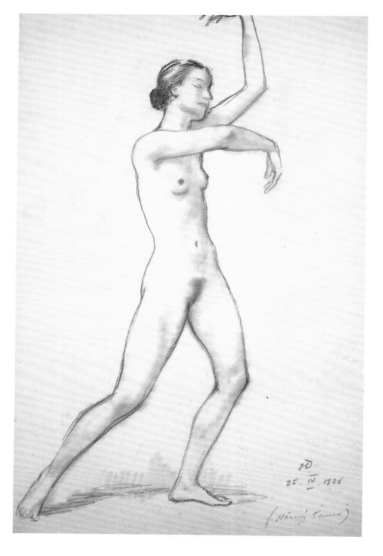

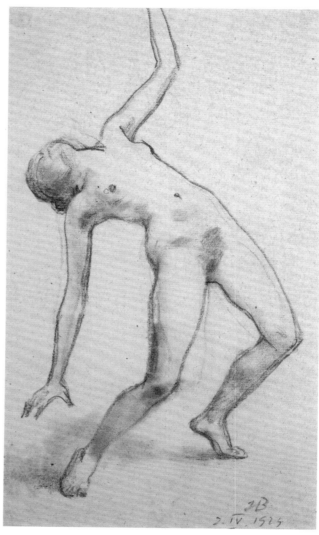

CAT. 17
Hugo Boettinger
Studie aktu Milči Mayerové [*Nude Study of Milča Mayerová*] | 1925
Graphite on paper | 14 ¾ × 10 ¾ inches (37.5 × 27.3 cm)
Gift of Eva Matějková-Willenbrinková, 1998

CAT. 18
Hugo Boettinger
Studie aktu Milči Mayerové [*Nude Study of Milča Mayerová*] | 1929
Graphite on paper | 16 ¾ × 11 ¾ inches (42.6 × 29.9 cm)
Gift of Eva Matějková-Willenbrinková, 1998

CAT. 19
Vladimír Lidin
Mořský průvan [*Sea Breeze*] | 1925
Cover: Karel Teige | Prague: Aventinum
8 ¼ × 5 ¼ inches (21.5 × 13.3 cm)

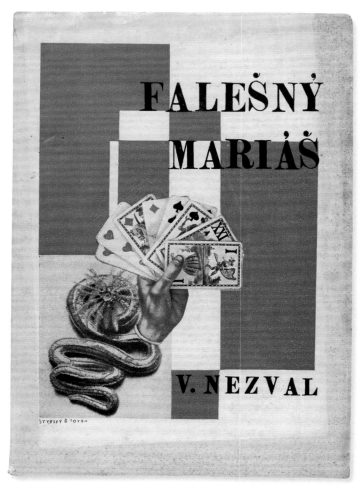

CAT. 20
Guillaume Apollinaire
Sedící žena [La femme assise; The Seated Woman] | 1925
Cover: Karel Teige and Otakar Mrkvička | Prague: Odeon
7 ⅝ × 5 ½ inches (19.5 × 14 cm)

CAT. 21
Vitězslav Nezval
Falešný mariáš [Cheating at Whist] | 1925
Cover: Jindřich Štyrský and Toyen | Prague: Odeon
7 ¾ × 5 ½ inches (19.5 × 14 cm)

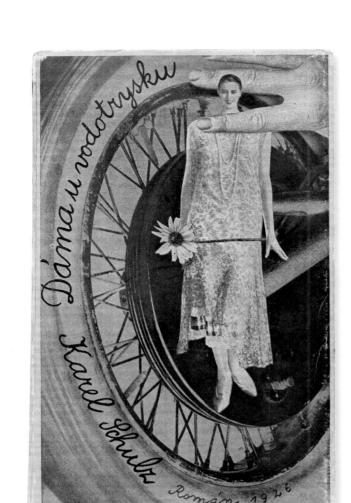

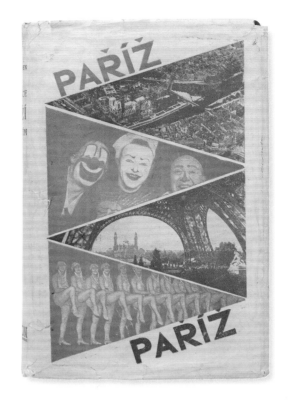

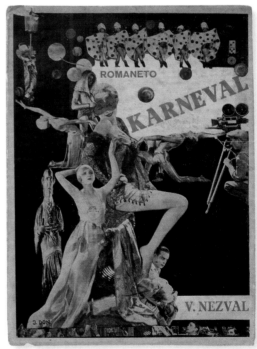

CAT. 22
Karel Schulz
Dáma u vodotrysku [*Lady at the Fountain*] | 1926
Cover: Jindřich Štyrský and Toyen | Prague: Ladislav Kuncíř
7 × 4 ⅜ inches (17.8 × 11 cm)

CAT. 23
Jindřich Štyrský, Toyen, and Vincenc Nečas
Paříž [*Paris*] | 1927
Cover: Jindřich Štyrský | Prague: Odeon
7 ⅛ × 4 ½ inches (18 × 11.5 cm)

CAT. 24
Vítězslav Nezval
Karneval: Romaneto [*Carnival: A Novel*] | 1926
Cover: J. Don | Prague: Odeon
7 ¾ × 5 ½ inches (19.5 × 14 cm)

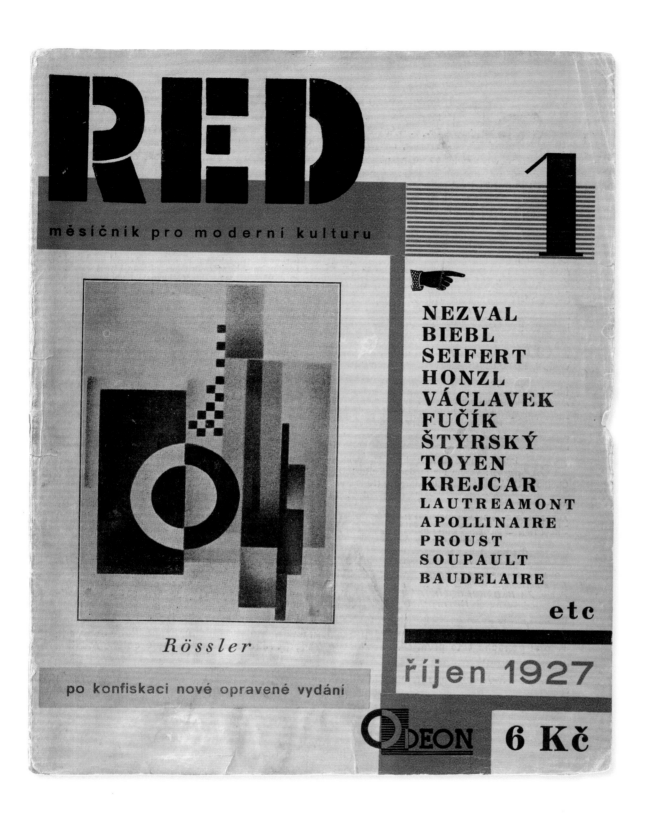

CAT. 25
Karel Teige (ed.)
ReD: Revue Svazu moderní kultury Devětsil [*ReD: Review of the Union for Modern Culture, Devětsil*]
Volume 1, nos. 1–10, 1927–28 | Volume 2, nos. 1–10, 1928–29 | Volume 3, nos. 1–10, 1929–30 | Covers and typography: Karel Teige | Prague: Odeon
7 × 9 inches (17.8 × 22.9 cm)

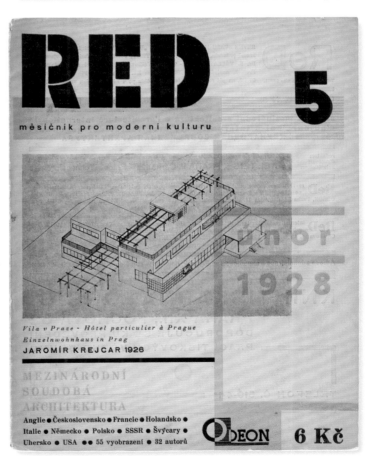

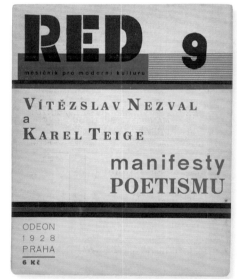

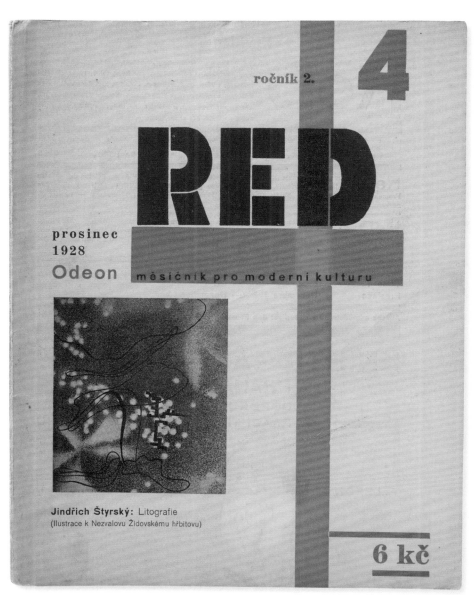

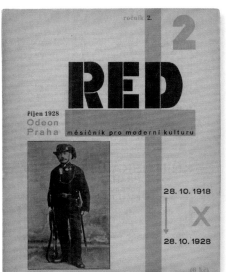

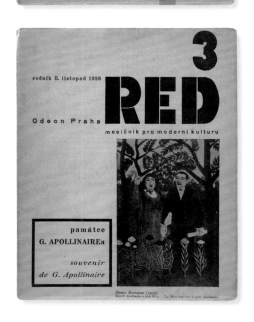

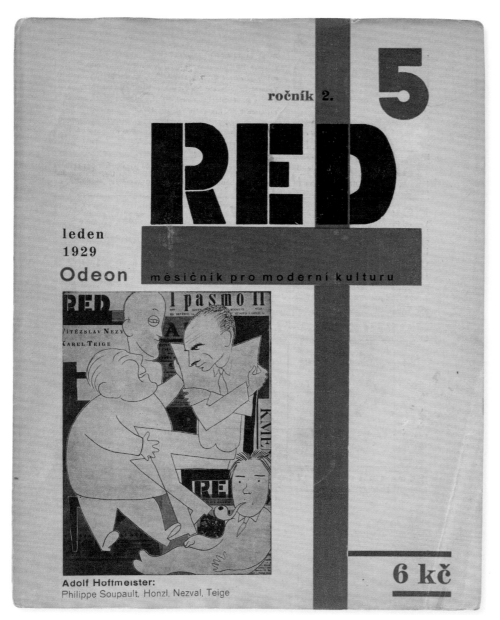

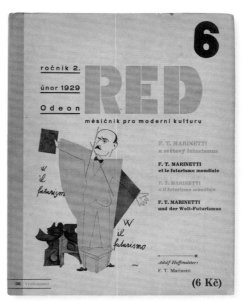

ročník 3
listopad
1929

RED

měsíčník pro moderní kulturu

Odeon

2

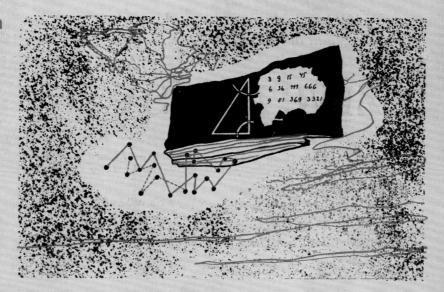

Jindřich Štyrský: Kresba k Maldororovi.

(6 Kč)

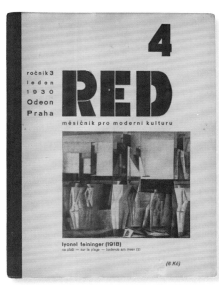

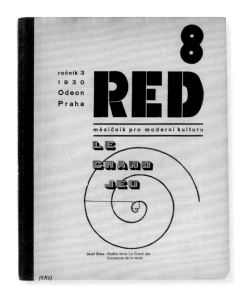

CAT. 26
Konstantin Biebl
S lodí, jež dováží čaj a kávu [*On the Ship Bringing Tea and Coffee*]
1928 | Cover, illustrations, and typography: Karel Teige | Prague: Odeon
7 7/8 × 5 3/4 inches (20 × 14.5 cm)

U kaple písková socha
 ta korunovaná vrabčím hnízdem
 pamatuje řadu lásek

Večer jdou milenci k lesu
 a za nimi v patách se líbají modré stíny

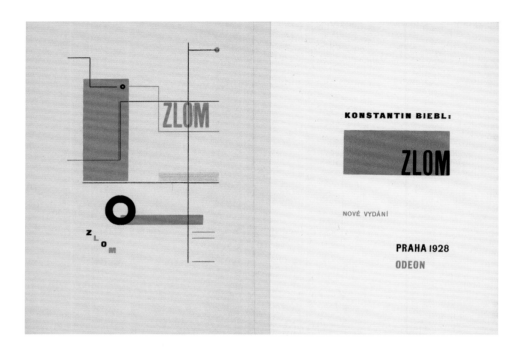

CAT. 27
Konstantin Biebl
Zlom [*Break*] | 1928
Cover, illustrations, and typography: Karel Teige | Prague: Odeon
7 5/8 × 5 1/2 inches (19.5 × 14 cm)

CAT. 28
Stanislav Kostka Neumann
Bragožda | 1928
Cover: Karel Teige | Prague: Odeon
7 ¾ × 5 ½ inches (19.8 × 14 cm)

CAT. 29
Vladislav Vančura
Pekař Jan Marhoul [*The Baker Jan Marhoul*] | 1929
Cover: Karel Teige | Prague: Odeon
7 ¾ × 5 ½ inches (19.8 × 14 cm)

CAT. 30
Ladislav Dymeš
Ze světa do světa [*From One World to Another*] | 1929
Cover: Karel Teige | Prague: R. Rejman
7 ⅞ × 4 ⅞ inches (20 × 12.5 cm)

CAT. 31
František Halas
Kohout plaši smrt [*The Cock Scares Death*] | 1930
Cover: Vít Obrtel | Frontispiece: Jindřich Štyrský
Illustration: Toyen | Prague: R. Škeřík
8 ½ × 5 ⅜ inches (21.5 × 13.5 cm)

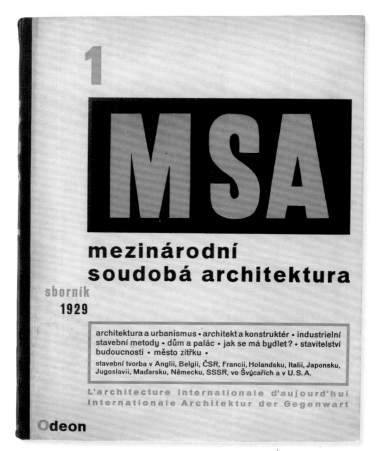

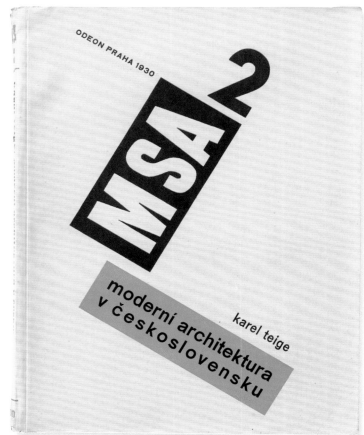

CAT. 32
Karel Teige (ed.)
MSA 1: Mezinárodní soudobá architektura
[*MSA 1: International Contemporary Architecture*] | 1929
Cover: Karel Teige | Prague: Odeon
9 ¼ × 7 ¼ inches (23.5 × 18.5 cm)

CAT. 33
Karel Teige
MSA 2: Moderní architektura v Československu
[*MSA 2: Modern Architecture in Czechoslovakia*] | 1930
Cover: Karel Teige and Fritz Heine | Prague: Odeon
9 ¼ × 7 ¼ inches (23.5 × 18.5 cm)

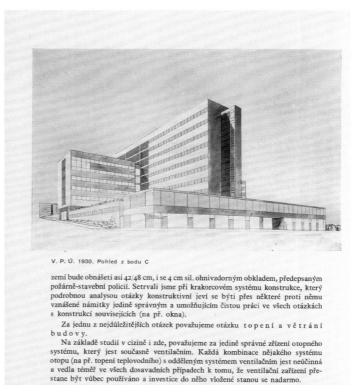

V. P. Ú. 1930. Pohled z bodu C

zemí bude obnášeti asi 42/48 cm, i se 4 cm sil. ohnivzdorným obkladem, předepsaným požárně-stavební policií. Setrvali jsme při krakorcovém systému konstrukce, který podrobnou analysou otázky konstruktivní jeví se býti přes některé proti němu vznášené námitky jedině správným a umožňujícím čistou práci ve všech otázkách s konstrukcí souvisejících (na př. okna).

Za jednu z nejdůležitějších otázek považujeme otázku t o p e n í a v ě t r á n í b u d o v y.

Na základě studií v cizině i zde, považujeme za jedině správné zřízení otopného systému, který jest současně ventilačním. Každá kombinace nějakého systému otopu (na př. topení teplovodního) s odděleným systémem ventilačním jest neúčinná a vedla téměř ve všech dosavadních případech k tomu, že ventilační zařízení přestane být vůbec používáno a investice do něho vložené stanou se nadarmo.

122

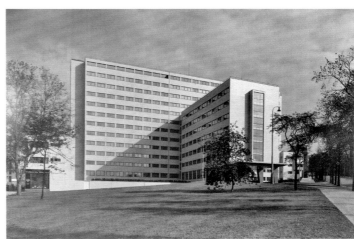

CAT. 34
Josef Havlíček and Karel Honzík
MSA 3: Stavby a plány [MSA 3: *Buildings and Projects*] | 1931
Cover and typography: Karel Teige | Prague: Odeon
9 ¼ × 7 ¼ inches (23.5 × 18.5 cm)

CAT. 34 a
Josef Havlíček
Všeobecný penzijní ústav v Praze [General Pensions Office, Prague] | 1933
Gelatin silver photograph | 6 ⅛ × 8 ½ inches (15.6 × 21.6 cm)
Inserted by Havlíček into his personal copy of *MSA 3*

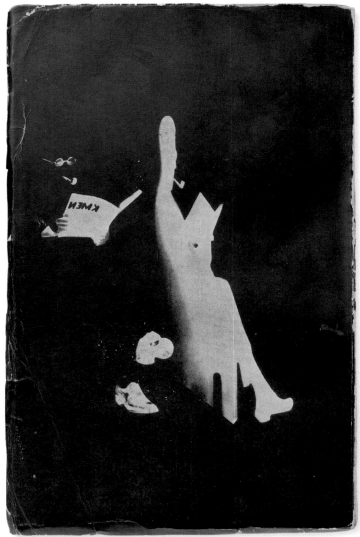

CAT. 35
F. X. Šalda (ed.)
Almanach Kmene [*Kmen Almanac*] | 1930–31
Cover: Karel Teige | Photography: Josef Sudek | Prague: Kmen
7 ⁵⁄₈ × 5 inches (19.5 × 12.5 cm)

almanach

kmene

1931·32

CAT. 36
Josef Hora (ed.)
Almanach Kmene [*Kmen Almanac*] | 1931–32
Prague: Kmen
7 5/8 × 5 inches (19.5 × 12.5 cm)

Jaroslav Seifert's poem "Paříž" ("Paris") reflects the influence of Guillaume Apollinaire on the new generation of young Czech poets who were members of Devětsil. The poem expresses admiration for Paris as an inspiring city where all of the important developments in art had taken place. It was also a kind of manifesto in verse, touching on most of Devětsil's favorite themes. Seifert published the poem in the first major Czech avant-garde anthology of his generation, *Devětsil* (1922), which he edited in collaboration with Karel Teige.

From *The Early Poetry of Jaroslav Seifert*, translated by Dana Loewy (Evanston, IL: Hydra Books/Northwestern University Press, 1997). English translation © 1997 by Dana Loewy. Compilation © 1997 by Hydra Books/Northwestern University Press. Originally published as "Paříž" ("Paris"), in Jaroslav Seifert and Karel Teige, eds., *Revoluční sborník Devětsil* (*Devětsil Revolutionary Anthology*) (Prague: Večernice [V. Vortel], 1922), 168–71.

Jaroslav Seifert

Paris

To Ivan Goll

I no longer feel like strolling along the riverbanks,
when over Prague misty darkness is hovering,
the water is murky, it has no meaning,
it empties into the Elbe somewhere near Mělník;
I no longer delight in roaming
the same streets with nothing new to see,
and in sitting on a bench in the park at night,
where police peek at couples with a flashlight;
here everything is so sad, even things taking place,
life never derails in its trace,
and if something comes to pass, some uprising, strike, or killing,
all will again conspicuously grow chilly.
My sweet, isn't everything here rather silly,
there is no delight for us in this place.

And since it was not granted to me to be born
somewhere on the verge of a dark African jungle,
where the white heat of the sun inflames all into fire
and in the branches auburn monkeys tumble,
since it was not granted to us in the waves of the Nile
to bathe our bodies, looking into the eye of a voracious crocodile,
on the waters to pluck lotus blossoms,

leaping to escape from lion's fangs,
when hungry, to feast on juicy coconuts
and to slumber in the tempest of waterfalls,
since it was not granted that we, natives black and curly,
could to our heart's content bask in the rays of the blazing sun,
why, why did fate mete out to us to live our life
in the streets of this town on the fiftieth parallel line,
where foreign to all is any fierce and fiery swing
and good people breathe with such difficulty,
where all emotion must wither before it even inflames,
where people's necks are encased in stiff starched collars,
where instead of birds we rather listen to jazz bands
and to see lions we go only to the menagerie?

Since it was destined to be and in this stony city
around machines, hammers, and levers hardened soft fists
and iron civilization already means so much to us,
that amidst trees and meadows the city we will miss,
since we are forever bewitched in labyrinths of factories, which reek,
why, why did fate mete out to us to live our life just here?

There in the west on the Seine is Paris!
At night, when the skies there light up with silver stars,
on the boulevards stroll crowds amongst numerous cars,
there are cafés, cinemas, restaurants, and modern bars,
life there is jolly, it boils, swirls, and carries away,
there are famous painters, poets, killers, and Apaches,
there new and uncommon things occur,
there are famous detectives and beautiful actresses,
naked danseuses dance in a suburban *varieté*,
and the perfume of their lace with love addles your brain,
for Paris is seductive and people cannot withstand.

Of the local poets I treasure very much Ivan Goll,
for he likes the cinema as well as I,
and believes the saddest of all men to be Charlie Chaplin.

Boxing matches, that too is a nice show,
when man is wistful and sighs for all his devotion,
clank, an eye for an eye, clank, a blow for a blow.

In the sky slowly the Great Wheel is revolving
and when at sunset Paris is already dim with shadow,
lovers are taking walks together along the Trocadéro,
and if earthly dust weighs down their shoes

so that heavenly beauty they may also taste,
to the stars up the Eiffel they fly in an electric lift,
holding one another gently around the waist.

Here everything is so sad, even things taking place,
life never derails in its trace,
and when I fall asleep as night darkens in the window,
I dream that at Père-Lachaise in the thujas the nightingale sings.

And, really, Paris is at least one step closer to heavenly spheres,
come, my love, let's go to Paris.

In his essay "Malířství a poesie" ("Painting and Poetry"), published in the first issue of *Disk* (*Disc*, 1923), Karel Teige expressed his key ideas on the nature of picture poems, which were Devětsil's main contribution to the groundbreaking exhibition *Bazar moderního umění* (*The Bazaar of Modern Art*, Prague, 1923). He also outlined his early reflections on the relationship between Poetism and Constructivism. These two artistic trends would subsequently constitute the basic polarity in Teige's thought, to which he returned repeatedly until his untimely death in 1951. Following in the wake of the anthologies *Devětsil* (1922) and *Život II* (*Life II*, 1922), the first issue of the journal *Disk* presented a more extreme avant-garde position, moving beyond early Primitivism and Naive art. The second issue of *Disk* did not appear until 1925.

Karel Teige, "Painting and Poetry," in *Between Worlds: A Sourcebook of Central European Avant-Gardes, 1910–1930*, trans. Michael Henry Heim, ed. Timothy O. Benson and Éva Forgács (Cambridge, MA, and London: MIT Press, 2002), 367–69. Originally published as "Malířství a poesie," *Disk* (*Disc*) 1 (May 1923): 19–20.

Karel Teige

Painting and Poetry

Insofar as modern visual, literary, and musical productions are modern, that is, insofar as they have true value, they are based entirely on Cubism.

Contemporary Cubism differs, of course, from the Cubism of 1909 or 1913. The camera abolished the social contract between painting and reality. An enormous amount of work was accomplished from Cézanne to Picasso; visual production was cleansed of representation, decoration, and anecdote; abstraction and geometrization reached their high point; reality, which used to be the point of departure, was deformed and turned into totally autonomous, primary geometric forms and expressive colors dominated by specific pictorial laws of composition and construction, and a powerful poetry grew out of their harmony. Now an opposing trend has come into being: concretization. Cézanne turned bottle into cylinder to make it comply with the pictorial composition; Juan Gris makes the cylinder called for by his pictorial composition into a bottle to maintain contact with reality. Here and there, the geometrical composition of the picture is vivified by contacts with raw reality, arousing powerful emotions in the spectator. It is a minimalist poetry, a poetry of intimation, of code. The mechanical age of the electric century proposes new forms to enchant the eye that has received a modern education; it makes a deep impression on our sensitivity. The Italian Futurists try to create a mechanical art (though they were not completely logical

about it); artists like Léger, Archipenko, Lipchitz, Laurens, and Gleizes try to represent the monumentality of the machine. Live spectacles in the streets, sport, biomechanical beauty, the perpetual drama on the surface of the globe that we see in newspapers and especially in the cinema increase the dramatic component in people's lives. Aesthetics has become photogenic and lively.

Nonobjective compositions that study pure forms and their mutual relationships are a deviant consequence of Cubism: Mondrian, van Doesburg, Suprematism, and the like risk turning into decoration.

What is the problem of the new picture? Will it remain a picture? Surely not forever. The picture is either a poster — that is, public art, like the cinema, sports, and tourism, with its place in the street — or a poem, pure visual poetry, without literature, with its place in the book, a book of reproductions, like a book of poems. It is always wrong to hang a picture on the wall of a room. The traditional framed picture is being gradually abandoned and is losing its true function.

Marinetti freed poetry from the fetters of syntax, punctuation, and so on; in Apollinaire's ideograms, poetry acquired an optical and graphic form. The poem, once sung, is now read. Recitation is becoming nonsense, and the economy of poetic expression is first and foremost optical, plastic, and typographic, never phonetic or onomatopoeic.

A poem is to be read like a modern picture.
A modern picture is to be read like a poem.

Sculpture has been rejected by modern architecture. All that remains is a cabinet object running counter to modern aesthetic feelings. Archipenko and Laurens have attempted to transform sculpture into painting, to enrich it with pictorial elements — sculptural painting; Lipchitz has turned it into monumental architecture. Visual art in its existing forms is disappearing, just as frescoes and mosaics disappeared, and just as the novel and drama and the traditional concept of the image are fading.

Hence the logical conclusion: the fusion of modern images with modern poetry. Art is one, and it is poetry. In *Disk* 2 you will see picture poems that represent the solution to the problem: the association of painting and poetry. Sooner or later this fusion will lead to the liquidation of traditional modes of making pictures and writing poetry. Picture poems conform precisely to contemporary requirements. Mechanical reproduction provides the means for making picture books. Books of picture poems will need to be published. Methods of mechanical reproduction will assure the wide popularization of art. It is not museums or exhibitions but print that mediates between artistic production and the spectator. Old types of exhibitions are on their way out; they look like mausoleums. A modern exhibition should resemble a bazaar (a trade fair, a world fair). It is a modern production, the manifestation of the electric and mechanical century. Mechanical reproduction and print will finally make the original superfluous; after all, once we print a manuscript we toss it into the wastepaper basket.

Constructivism

Contemporary architecture is dominated by the aesthetic of Purism; it is Constructivist, it is neither decorative nor applied art. Modern constructions and materials (concrete, glass, and iron), subjected to the laws of economy and function, have given us harmonious groupings and proportions, a lofty and poetical beauty worthy of its time.

Poetism

Thanks to Cubism, painting and poetry, once dominated by ideology, have become pure poetry. The picture poem is born.

Bioscopic Art

Biomechanics is the only dramatic spectacle of the present: sport, cinema.

New art has stopped being art. New fields are being born. Poetry is pushing its limits, overflowing and uniting with the multifarious forms of modern life all over the globe.

Teige's pioneering essay on modern typography appeared in the professional journal *Typografia* (*Typography*), the earlier volumes of which had tended to promote more conservative approaches to graphic design and typography. The editorial board showed considerable openness in printing Teige's extensive study, which was subsequently published in German translation and played a crucial role in promoting the "new typography" outside of Czechoslovakia.

Originally published as "Moderní typo," *Typografia* 34, nos. 7–9 (1927): 189–98. Translated by Alexandra Büchler and reprinted as "Modern Typography," in *Karel Teige/1900 – 1951: L'Enfant Terrible of the Czech Modernist Avant-Garde*, ed. Eric Dluhosch and Rostislav Švácha (Cambridge, MA, and London: MIT Press, 92 – 105.

Karel Teige

Modern Typography

Modern typographic methods, described and labeled as "constructivist" — that is, methods that apply constructivist concepts in the area of typography and book production — have taken root in our country over the past few years. Spontaneous demand for "constructivist" graphic design is becoming more and more common, and customers ask printers to use it especially in the case of commercial and advertising material, such as posters, leaflets, brochures, catalogues, letterheads, and press advertising. They can see that constructivist design makes their promotional material clear, easy to read, noticeable, and effective, thus fulfilling its commercial function. Constructivist book design is becoming just as popular, and the modern Czech book industry boasts a remarkable number of interesting contemporary realizations, not just on book covers, title pages, and colophons but in the entire layout and typographic arrangement of the text. There are a number of books that, as a whole, represent a truly new form of book design. As printers can observe, constructivism is today a significant movement, which in any case deserves close attention. It is therefore necessary to grasp the essence and principles of this movement precisely and correctly, to be able to avoid the errors, mistakes, imitations, and other examples of quasi-constructivist design, which are becoming alarmingly widespread due to several eclectic epigones, who apply certain modern forms and methods in a superficial and meaningless manner, with no rhyme and reason and without any justification. With this unreasonable approach, they threaten to compromise the serious and revitalizing efforts of true constructivism. What we need today, above all, is the application of strict criteria to distinguish true, pure constructivism from the decorative, formalistic pseudo-

constructivism that borrows forms from constructivist artworks, using them irrationally, unfunctionally — that is, decoratively. There is a need for accurate criticism capable of distinguishing the correct and the pure from the inadequate and false, and able to tell something intrinsically modern from what appears to be so only on the surface.

Constructivist typography and graphic arts are in many ways contrary to the ideals and rules of that modern typography whose father is William Morris. The English Pre-Raphaelites, led by their apostles *John Ruskin* and *William Morris*, began to preach the return to handcraft production at a time when crafts were experiencing a serious decline or disappearing altogether, which was also a time of the most serious decline of taste and aesthetic sense. This was caused by the introduction of machine production at the beginning of the Industrial Revolution, which brought about a substantial drop in production quality as machines provided consumers with cheap but deeply unattractive and inferior goods that were a bad imitation of crafted objects. The aim of the Arts and Crafts movement, and above all their apostles *John Ruskin* and *William Morris*, was to renew medieval artisanship, to elevate crafts to the sphere of artistic creation on the one hand, and on the other — by joining art with craftsmanship and artisan work — to give artistic creation a certain social justification. Today it is a widely known fact that such an idealistic and admirable endeavor was an error and a fallacy, that it was foolish to try to stand in the way of industrial production, which was bound to win, having reached an advanced stage in which standardization, economic and rationalized planned serial mass-production can offer products that are cheaper, but also more functional and technically and aesthetically more perfect, than handcrafted products. The most masterly work of a wheeler or a saddler cannot compete in perfection and in its practical and aesthetic qualities with the elegance of modern automobiles.

Yet the attempt to popularize art by joining it with crafts had a paradoxical outcome: the application of artistic criteria to craft production of objects of daily use resulted not in the popularization of art but in making craft objects more aristocratic and costly. Modern architects were faced with the urgent duty to reject Ruskin's aesthetic errors and fallacies relating to architecture and interior design. Today's constructivist architects pay no heed to the problematic achievements of the past decades of decorativism and "art-and-craftism."

What has happened in the area of arts and crafts applies also to typography. The decline of typography in the nineteenth century was just as tragic as the decline of the crafts. When Morris appeared with the seductive and worthy slogan of revival, the English Arts and Crafts movement found itself at the beginnings of a renaissance of book printing. Ruskin, Walter Crane, and William Morris founded a printing workshop where they created their beautiful books. For them, however, a beautiful book meant a return to the Middle Ages, an ideal they set against monotonous, grey, badly articulated and designed typography,

which tired the reader's eye, its narrow margins making the characters appear not as a black drawing on white — with the black highlighted, reflected, and relieved against the white background — but rather as white tissue emerging from a black sea, where the spaces clashed with the reading eye and dominated the grisaille of the background and against a print whose excessively economic production did nothing for the reader's eye or for his taste. Against all this Morris wanted to achieve a return to medieval typographic work. He followed the example of incunabula with their sharp contrast of form and color, and his printed works came close to medieval missals in their appearance. To achieve that, Morris traced and modified old types, arriving at fantastic Gothic and fashionable Roman type designs. His typographic work was then further developed by art nouveau, the so-called free style that resulted in the most extravagant typographic design executed with no regard for the tectonic aspect of the book.

Thus the modern renaissance of typographic culture was threatened at its very beginnings by two dangers: the *danger of archaism* and the *danger* of art nouveau's eccentric, illogical, *fantastic, and willful decorative mania*. We witness both these fallacies at the beginnings of the movement, which aimed to create modern Czech fine books; on the one hand, there was the art nouveau extravagance of the circle around the *Moderní revue* (*Modern Review*), promoted by Arnošt Procházka, and on the other, the archaic design of Vilém Mrštík's *Pohádka máje* (*Fairy Tale of May*) by Zdenka Braunerová. Modified by the passage of time, these dangers are still present today; the temptation of archaism or pseudo-classicist academism and the temptation of illogical pseudo-modern decorativism threaten the most recent typographic work. The idle fashions emerging from the schools of decorative arts are to be blamed. And there is a third danger; the danger of excessive bibliophilia and collectors' snobbism. The movement, seeking to renew the tradition of fine book typography, was supported by sympathetic book lovers and collectors who were certainly able to give it substantial backing. But the collecting mania, chasing after unique prints, *stood in the way of a popularization of fine book design*, supporting everything that gave the book an exclusive and luxury character, usually expressed by excessive decorativeness. Constructivist typography must therefore avoid these three stumbling blocks that have so far hindered the development of modern book design.

And this is precisely what can be criticized about Morris's work; its archaism and arbitrary imagination, the way he modified old types according to his fantasy. Today we are convinced that it would have been better if he had modified his imagination, adjusting it to the possibilities of the most perfect old types, selected with a critical, careful eye and deliberation. *There is no reason why a beautiful form that has been widely used and suits our needs should be changed*, if it is objectively impossible to improve on it. It is wickedly uneconomical to

change the shape of furniture to suit changing fashion: any change that does not bring an objective and essential perfection should be avoided. A perfect shape remains changeless for centuries. That is why Peignot Jr. has made such a substantial contribution to new typography by recasting old, almost perfect types, such as Garamond, Plantin, Elzévir, Didot, or Nicholas Cochin. After Morris, art nouveau artists and architects inclined toward the Arts and Crafts movement designed new types that could not compete with classic ones as to their shape and legibility; these were design fantasies that have by now lost their charm. We can find stocks of such fantastic art nouveau types or fakes that deform and distort classical alphabets in every printing workshop: Viennese Grotesque, Colibri, Bernhard Antique, Medieval, Gensch, Behrens, Tieman, Ehmke, Linear Antique, Watteau, Perkeo, Lo, Herold, etc. They are unattractively designed types, at odds with contemporary cultivated taste, types that are on their way out. On the other hand, there is no satisfactory selection of suitable, perfect types. The decorative Arts and Crafts types have excluded themselves from the development of typography: after all, for centuries, true development and progress has moved toward a simple, clearly legible geometric form. From the capricious flowers of Gutenberg's Fraktur, which had been already simplified, standardized, schematized, and horizontally extended by Dürer to make it more legible and optically connective, typography further developed toward Plantin's types, and from there to Didot, who turned Plantin's regularity into clear, attractively curvaceous lines. There were many reasons why Gothic and Fraktur letter forms had to fall; among other things, they were essentially ornamental and bizarre, and their peculiar character simply had to give way to Didot's clear form of architectural beauty.

Today, from a chaotic variety of types, we select those that are perfectly constructed. During wartime requisitioning of metal, printers gave up their stocks of the most beautiful old but worn types and kept their questionable treasures, the fashionable, far from beautiful, mostly German-manufactured types. Yet modern typography requires beautiful, austere, simple, lapidary, and well-balanced types of geometric construction, free of any superfluous appendages, hooks, and curlicues. Some classic types possess truly majestic proportions and harmony worthy of the Parthenon, or of the work of Ingrés or Beethoven. We understand that such perfectly constructed types are something we have no right to change without careful thought, something we are only allowed to perfect further. The ultimate question of critical conscience is how perfection could be further perfected.

The first task of modern typography is to *revise available types and select ones that are suitable and properly delineated*. Types must then *be chosen to suit the typeset text*, to achieve a *correspondence between the character of the type and text*, so that the printed form would be the result of its function and contents. Every type has its character, a living, active personality, an accent that may be difficult to define but is easy to understand, as in spoken

language. The light, supple, rhythmical curves of italic scripts are like something improvised, soft, and lyrical next to the austere, monumental Grotesque, Egyptienne, or Empire types that signify architectural weight and static calm. We could speak of a sense of the magic of form as developed through centuries of education. Therein resides the very meaning of typographic intuition and clarity of vision. For us, certain curves, balances, and structures bear an almost esoteric significance. Some typographic shapes have an evocative, associative power: we know that a single strong typographic sign can contain the whole message of a particular poster.

It was advertising typography and its advancement that made the *effectiveness of optical relationships between various type styles* clear to us. Advertising typography, subjected to the dictate of its purpose, determined by industry, ignored aesthetic as well as "calligraphic" academic or decorative prejudice. It simply served the elementary requirement of promotional functionalism, seeking out types legible at a distance, simple in their geometric protoform, such as Egyptian (an army design from the time of Napoleon I) and Grotesque, as well as Empire and Second Empire types. Advertising typography was also enriched by several kinds of stencil lettering, which was increasingly simplified and composed of geometrical archetypes — the square, triangle, and circle — from which the connecting lines had disappeared, with the mass of the characters arranged next to each other without being connected but still remaining clear. Apart from that, advertising typography and posters utilized *contrasts of light* (black and white) and *color in the optical articulation of space*. Typographic-synoptic layout was thus cultivated not so much in book printing but rather in advertising and occasional printed matter. Grey lettering had been turned into a colorful symphony full of contrasts. Typography has ceased to be a mere auxiliary mediator, a joining link between the contents and the reader; it is no longer an interpretation and reproduction but an independent construction, precisely by virtue of its ability to grasp the optical significance of typographic shape, size, color, and composition. It does not interpret or reproduce the given text but constructs it optically, using it as a basis for the creation of a visual composition. To this aim it *uses freely all types, sizes, degrees, geometrical shapes, and basic colors*, achieving elasticity, variability, and freshness of the typeset text. Besides, advertising has created a *perfect combination of typography and photography*, producing what Moholy-Nagy calls *typofoto*. Typo: communication by means of the printed word. Foto: communication by means of the image of what is visually comprehensible. Typofoto: visually most exact and complete communication.

Posters and even neon advertising use all possible techniques — contrasting shapes and colors, creating a synoptical typography that is not satisfied merely with conveying the content but creates its own visual message. In the case of advertising and commercial

typography working with synoptic forms and compositions, it became clear *that the blank space has its own strong aesthetic value*, which functions in relation to the printed areas, that it is an active factor, not only a neutral background, just as modern architects and sculptors understood that empty spaces and openings — for example, windows — are not just passive gaps but active plastic agents, and that only through a careful balancing of these equivalent positive and negative values can one achieve the required equilibrium. Advertising, the visiting card and signature of business, has become concerned with making the right impression. It wanted to surprise with the novelty and intensity of proportions as well as with visual composition. It used, without prejudice, all the available modern means, inventions, and possibilities of communication. It used typography that was not mere reproduction and illustration but an autonomous visual realization of the text. In most cases it could do without any decorative ballast or fashionable gimmicks. Where it reached for an image, it preferred using photography and photomechanical images to drawings, woodcuts, etc. It preferred simple, impersonal types that find better application than unusual, original "artistic" scripts with all the bad characteristics of illegible handwriting. It preferred to utilize existing types rather than have individual lettering custom-made for the purpose.

Advertising and industrial typography for posters and brochures worked its way to clean shapes that were the *result of a perfectly fulfilled function*: that is, their form was *justified and functional*. It did not let itself be misguided by the prejudice of tradition and by academic and decorative aesthetic sensibilities. Modern book typography can learn a useful lesson from it. Sometimes, of course, even advertising typography succumbed to the decorative vogue of the time and its promotional function was sacrificed to aesthetic demands.

Modern typography, having learned a lesson from the achievements of promotional and advertising design, must free itself from artistic, decorative, and academic prejudice. It must not be afraid to defy the ideals of snobbish bibliophiles. We do not want rare books; what we demand is that the modern book become a perfect work of typography available at an accessible price. Many applied art fantasies of the last decade were at our expense, making the book more costly and trying our patient eyesight. Today we know that reading badly written books is not half as damaging as reading books that are badly designed. The first is a waste of time, the second wastes our eyesight. Nearsightedness is a damning verdict on bad typography and the only people it benefits are opticians who get rich on it. The issue is not to treat nearsightedness, but to prevent it. Not small type but bad typography, unsuitable composition, and type forms with all manner of curlicues have a detrimental effect on eyesight. That is why the very first requirement for modern typography is order, good work, and legibility. That is nothing new, yet this simple requirement is often not heeded.

Typography is visual communication. Its rules must therefore be based on optical rules. The modern way of seeing, educated by urban civilization and by the spectacle of contemporary life, new color spectra and strong colors ordered geometrically and orthogonally, is characterized by heightened perceptiveness. The angle of vision is widening. Posters achieve *simultaneous communication by means of a suitable layout of their surface* and the use of *varied type* that makes it possible to *regulate coherent reading*. The modern way of seeing is sophisticated, capable of rapid accommodation, penetrating, fast on its feet. We need to realize that today's books are read by eyes differently organized and trained than those that used to read incunabula. And these eyes demand that the book be constructed not according to decorative fashion but as an *articulated, rhythmical, comprehensive visual system, easy to orient oneself in*, in the same way a letter sorter, the keyboard of a piano, typewriter, or calculator, catalogues, price lists, and transport schedules are perfect visual systems.

We need to adjust the unchangeable or little-changing laws governing our ways of seeing, perceiving, and reading to the demands of a modern trained eye. We need to try out the possibilities of modern typography without the fallacies of archaism and decorativism, and to subject its products to visual justifications and requirements. To use all the suitable types, *symbols, lines, arrows, and so on* not as fashionable ornaments but as *elements arranged in a composition to achieve a greater visual clarity and legibility*.

From the elementary laws of optics we can learn about book formats and their standardization, about the layout of the page and the proportions of text in relation to the margins, about the balance between black and white, the mutual influence of colors and their complementary and spatial effects. Modern painting can offer typography, which is after all also a visual discipline, significant lessons. It is the so-called objectless and abstract painting that has abandoned any imitation of the subject and wants to be nothing but a balance, a harmony of colors and shapes, mostly geometrical, on the plane of the canvas, something like a music of colors — painting that realizes its balance and harmony according to optical laws and laws governing the interrelationship of colors and shapes, and, having discovered the possibilities of decimal balance, as I would call it, has, as a result of multiple forces, found other forms of equilibrium than symmetry, multifaceted and active. The abstract beauty of modern painting achieved as a result of much experimentation is akin to balance on extremely sensitive scales, where it is necessary to administer color and shape values in doses proportional to their quality and quantity, and where the slightest change would upset the equilibrium achieved. Modern abstract painting deals with its material (color) and its spatial arrangement in a manner as elementary as the way in which a technician or a mechanic works with his own material, dealing with it according to its factual, scientific-

ally tested qualities, according to the physical and psychological laws of color and its appearance, its physical, physiological, and optical qualities that are unconditional, objective, and constant. The composition of colors and shapes in a modern painting is governed by objective (unfortunately as yet only superficially explored) laws. It is possible to realize color harmony only in accordance with these laws, which are as binding as the laws of chess. And just as the laws of chess do not exclude imagination, invention, and originality, just as there are an infinite number of possible moves in chess, these *optical laws used in the construction of the picture place no limitations on the liveliest imagination, intuitive ideas, invention, and originality*, allowing for an infinite number of the most diverse solutions. On the contrary, an imagination that obeys such laws becomes more flexible and cultivated, avoiding many errors. Such laws are not manacles but regulators.

What has been said about modern abstract painting applies, of course, in full to modern typography, as balance on canvas is the same in its nature as balance on the printed page. The same proportions and geometrical composition, the same contrast of black and white, and the same relationships of colors. And the same need for clarity of arrangement, for legibility. Even the influence of modern literature, especially of modern poetry, on typography needs to be mentioned here, although there is no space to explain it in detail. We shall therefore mention only the most significant facts. Mallarmé simplified the laws of the poetic, written word, creating poems of precise lines and crystal-clear graphic arrangement, and abolishing punctuation. In his book *Un coup de dés jamais n'abolira le hasard* he used a special typographic layout. Marinetti, in his *Parole in libertà*, arrives at a true typographic revolution. He demands that as an expression of modern spirit the book should break traditional typographic harmony — that is, the monotony and symmetry that are at odds with the ebb and flow of the poetic text rippling on the page. He demands the use of a variety of colors and types, the selection of which, as in the case of posters, should be dictated by legibility, coherence, and simultaneity of visual perception — that is, by the aims intended by the poet. *Guillaume Apollinaire* realizes that modern poetry is no longer Verlaine's "music above all," that it is read, perceived visually and not aurally, and therefore is an optical entity. He takes this visual aspect of poetry even further, composing his poems in special patterns, called "ideograms." Later, some Czech poets such as the proponents of "*poetism*," Seifert and Nezval, take the visualization of poetry even further, creating visual poems in which image and poem merge by means of photography, photomontage, or typography.

Modern book typography is also influenced by language reforms and changes in spoken and written language brought about by the impact of literary works, as well as by the interaction of foreign languages. Modern times need an international language of communication, and along with it an *international, generally accepted letter format*.

The German Gothic script has disappeared and so will, sooner or later, the Russian, Greek, Chinese, and Turkish scripts, causing, of course, certain structural changes in the relevant languages. At the same time our own alphabet will have to be revised: there is a remote but certain movement toward the construction of a communication alphabet based on a different principle, which would correspond better to the structure of words, as has been suggested by Moholy-Nagy in his article "Zeitgemässe Typographie" ("Contemporary Typography"). But these changes are still far away. Industrial economy with its slogan "time is money" demands the introduction of a universal phonetic alphabet. As it will not be sufficient to eliminate our capital letters to achieve this aim, some typographers, such as H. Bayer, have been trying to create a *universal design without capitals and lowercase serifs and minusculi*. Let us mention here that the anthology *Fronta* is the first significant publication printed consistently without capitals. Bayer's type, used by the author of this essay several times for book cover design, will have to be further refined, but it is already a justified new form aiming to perfect type in the sense of desirable simplification. Progressive simplification is the meaning of long-term development. Discarding ornaments. Simplifying the range of characters. Several centuries ago, French typography used 250 symbols, while today it uses 150 and these are still too many. A typesetting machine with a complicated keyboard is a monster.

Let us reiterate what constructivist typography means and presupposes:

1 *Liberation from tradition and prejudice: overcoming archaism and academicism, eliminating all decorativism*. Ignoring academic and traditional rules that are not optically justified, being mere fossilized formulas (e.g., the golden section, unity of type).

2 *Selection of types with clearly legible, geometrically simple lines*: understanding the spirit of each type and using them according to the nature of the text, contrasting the typographic material to emphasize the contents.

3 The perfect grasp of the *purpose and fulfilling the brief. Differentiating between the purpose of each typographic task*. Advertising billboards, which should be visible from a distance, have different requirements than those of a scientific book, which are again different from those of poetry.

4 *Harmonious balancing of space and arrangement of type according to objective optical laws; clear, legible layout and geometrical organization.*

5 Utilization of all possibilities offered by new technological discoveries (linotype, emulsion print, photo typesetting), *combining image and print into "typofoto."*

6 *Close collaboration between the graphic designer and printer* in the same way it is necessary for the architect to collaborate with the building engineer, the developer, and all those who participate in the realization of a building; *specialization and division of labor* combined with the *closest contact* among the various experts.

Finally, I would like to add several comments on my own practice in the area of "polygraphy" (as it is called in Russia) or book design, examples of which are published in this issue. I see the book cover, which I design usually in collaboration with O. Mrkvička, as the *poster for a book*; and, as any publisher will confirm, that is its true commercial purpose. It is therefore desirable for the cover to make a strong impact. This will be achieved by an *energetic and active evocation of a balance between color and form*; the requirement of strong impact eliminates monotonous symmetry. For the strongest impact of this desirable effective balance on a poster, I usually favor *basic colors* and *geometrical shapes*, as I believe that *orthogonal forms* are best suited to balancing an orthogonal plane: the square and the oblong, with the circle offering itself as the shape most pleasing to the eye. For the realization I choose all the *photomechanical media* fitting the particular task: block making, halftone, gravure, photolithography, photomontage. In recent years, linocut book covers have become very fashionable. But linoleum is suitable for floor cover, not for graphic design, where its lack of line precision presents a problem; it is simply a poor substitute that should be rejected today when, ten years after the war, zinc plates are no longer unaffordable. The modern taste will naturally prefer the photomechanical process to linocut or woodcut, which, with their lack of precision and handcrafted character, do not correspond to the nature of books, which are also not handwritten but mechanically printed. Our distrust of woodcut or linocut on book covers is borne out by the ugliness of their formal treatment, leading to sketchiness and decorativism, and by the illegibility of the hand-cut letters. Instead of flowers and curlicues cut in lino we have to demand a harmonious, clean, and strictly immaculate design with the legibility and effectiveness of a poster. The same applies to the *title page*, which also acts as a *poster for the book*. Its visual structure and composition, the selection of type and colors, should become a *visual transcript of the book's literary content*. The colophon, bibliographically the most important page, should be a detailed identity certificate and therefore requires *well-arranged rubrics*. Any ornaments, stars, or crosses, typeset or drawn, are out of the question here. The page is arranged by composing the type, and this composition can be emphasized by strong lines, arrows, basic geometrical shapes, or a suitable contrast of colors. *The typographic realization of the text* is conditioned by the nature, rhythm, and flow of the text itself. In the design of Nezval's *Pantomima* (*Pantomime*) of 1924, and Seifert's collection of poems *Na vlnách TSF* (*On the Waves of the Telegraph*) of 1925,[1] it was important for the typography to complete the poetic process and transpose the poems into the visual sphere. In Nezval's *Abeceda* (*The Alphabet*), a cycle of poems based on the shapes of letters, I tried to create a "typofoto" of a purely abstract and poetic nature, setting into graphic poetry what Nezval set into verbal poetry in his verse, both being poems evoking the magic signs of the alphabet.

1

Na vlnách TSF is translated here literally as *On the Waves of the Telegraph*. The translation used elsewhere in this book is *On the Waves of TSF*. The term *TSF* includes radio and, more generally, wireless technology. *Ed.*

In selecting type I am often limited by the stocks held at the particular printing plant the publishers ask me to work with, and often forced to accept ones that are not entirely suitable, especially when my task is to create typography for poetic texts, which require a complicated visual image and a rich typesetting material full of contrasts. For advertising and commercial typography, the best types are simple but strong versions of Grotesque combined with thick lines, which emphasize the plasticity of the typeset text.

3 Mirrors without Images

Karel Srp and Lenka Bydžovská

In the 1920s, Paris was the city upon which the eyes of the members of Devětsil were set. Some settled there permanently; many stayed for at least a few years in the 1920s and 1930s. Paris was also an important source of inspiration; Parisian modern and avant-garde artists had a fundamental impact on Czech art of this interwar period. The internationalist spirit of these years is wittily distilled in the caricatures of Adolf Hoffmeister. One of the original founders of Devětsil and a figure at large on the European scene, Hoffmeister traveled frequently and was in contact with all of the most important artists of the day. He transformed caricature into a vivid diary of his generation, more evocative than documentary photography, addressing both the important political and cultural events. *Tristan Tzara bloumá po Paříži* (*Tristan Tzara Saunters around Paris*), 1931 [CAT. 37], is a typical example of Hoffmeister's production. The figure of the Dada poet and entrepreneur, with his distinctive monocle, is sketched in black ink. He is flanked by four Picassoesque abstract personages, resembling letters, drawn in red ink. Two of the figures' heads are represented by ideograms that could be seen in the pages of the first Devětsil anthology of 1922: the pentagram and the circle.

For Christmas 1927, Aventinum released the anthology *Paříž* (*Paris*), the second volume in its bibliophile series Miselanea Privata [CAT. 38]. The anthology was composed of short extracts, ranging from the representatives of French Symbolism to many of the contemporary Parisian poets who had inspired Devětsil writers. The texts were accompanied by eighteen hand-colored etchings by Josef Šíma, who had made his home in Paris as early as 1921. The tenth print in this series was particularly important to Šíma, as it was intended to illustrate "Paříž prší" ("Paris Rains"), by one of his lifelong friends, the writer Pierre Jean Jouve. The fleeting nature of time, represented by the woman's face, with a crooked building and footprints behind her, eloquently captures the atmosphere that permeates Jouve's evocation of the city streets: "He hurries. The city is dirty, full of monuments that need to be washed daily. I look for her. My sun is at the end of the street. Humanity has gone mad, its institutions are cruel. How strange our love is, he says. But she understands everything he says. The place is the attic of a building in 1890. O flames, flickering eternally."[1]

Paris also had a profound influence on two other members of the Devětsil avant-garde: Jindřich Štyrský and Toyen. Together with Šíma, Štyrský and Toyen engaged in the cosmopolitan cultural life of Paris; in December 1925, all three participated in

the international survey *L'Art d'aujourd'hui* (*Contemporary Art*). However, unlike Šíma, who followed an independent path, Štyrský and Toyen tried to create an artistic style, Artificialism, that could connect with the Poetism of Nezval and Teige. Artificialism was a pointed reaction to the contemporary art, both abstract and surrealist, that Štyrský and Toyen first encountered on their arrival in Paris. After a year of intense work, they held an exhibition of paintings titled *Artificielisme* (*Artificialism*) in their studio on rue Barbès 51, in the Montrouge quarter, in the autumn of 1926. On the occasion of the exhibition, they printed the leaflet "Axiome: L'artificialisme est l'identification du poète et du peintre" ("Axiom: artificialism is the identification of the painter with the poet"). The exhibition so impressed young Parisian gallery owners that Štyrský and Toyen were given an opportunity in November that very same year to show their paintings in one of the most important private galleries of that time, La Galerie d'art contemporain, at boulevard Raspail 135, where Paul Klee also exhibited.

In 1927 Štyrský and Toyen continued to work systematically on developing Artificialism. They funded their stay in Paris by working on the extensive guidebook *Paříž* (*Paris*), 1927, also called *Průvodce Paříží a okolím* (*Guide to Paris and Environs*). The book was designed by Štyrský, amply illustrated with photographs of the city, and published by Odeon. The Odeon publishing house was established by Jan Fromek in 1925. Teige was its main advisor. Indeed, Teige designed Odeon's famous logo as a wedding present for Fromek. The publishing house concentrated on Czech literature by the Devětsil group. It also published French literature translated into Czech.

Štyrský and Toyen collaborated on the design of book covers, most often for the books of their friends from Devětsil, as mentioned above. Yet they focused primarily on their paintings, elaborating the ideas behind Artificialism. The main innovation of Artificialism that set it apart from other trends was its strong emphasis on reminiscence, which struck a virtually Proustian note in the Artificialist manifesto. For that matter, at the turn of the 1920s and 1930s, Marcel Proust's *À la recherche du temps perdu* (*In Search of Lost Time*) was published by the Odeon publishing house in Czech translation, with a design by Karel Teige. As Štyrský and Toyen declared in 1927, the Artificialist painting was supposed to be based on a reminiscence that was independent of memory: "The process of deducing reminiscences without engaging memory or experience means that the painting is based on a concept,

the essence and concentration of which exclude any kind of reflection and place reminiscences in the integral spaces. Reminiscence is the prolongation of perception. If perceptions are transfigured as they occur, they become abstract reminiscences."[2] Štyrský and Toyen further elaborated on the relationship between reminiscence and memory in "Básník" ("The Poet"), a lecture given at the first Artificialist exhibition in Prague in June 1928: "The poet does not operate with reality. He is enticed by poetry, which fills in the gaps between real forms and the emptiness that radiates from reality. He reacts to the poetry concealed in the interior of forms. He invents and creates their exteriors. The imagination has lost interest in what is born and dies. It deduces reminiscences, reminiscences of reminiscences, not bound by memory or experience. Memory and reminiscence are as executioners to one another."[3]

The role of reminiscence in the creation of Artificialist paintings was connected with the repeated emphasis on imagination, stripped of the influence of the associative ideas that had been central to much Cubist art. Reminiscences changed concrete empirical perceptions into abstract ideas moving in a void, freed from the context of space and time. Memory was understood as too mechanical, a succession of individual moments in which one followed the other. Reminiscence, by contrast, involved a spontaneous retrieval of previously glimpsed perceptions. The main contribution of Artificialism, as it was absorbed by critics of the period, was the concept of "the process of the identification of the painter with the poet," which was "internal, indivisible, and simultaneous."[4] With this principle, Štyrský and Toyen harked back to one of the most important legacies of Parisian Symbolism, which the Surrealists developed from another angle.

At the same time, Artificialism was connected with the synthesis, undertaken in the early 1920s by Teige, of picture and poem in "picture poems," which were intended to replace both the framed easel painting and the printed poem. After the mid-1920s, Štyrský and Toyen introduced the innovations of the picture poem to book-cover design. They claimed that, in Artificialism, they were trying to find their bearings among the many different trends of the period. They rescued painting by identifying it with poetry. It is no coincidence that Štyrský and Toyen titled their lecture "The Poet," although it did not concern poetry but rather the aesthetics of Artificialism. The "identification of the painter with the poet" was intended to be absolutely concrete and objective. It was not, as Štyrský and Toyen wrote, "the fusion of

painting and poetry, the fusion that was asynchronous, external and divisible,"[5] still manifest in picture poems. Artificialism was, according to its representatives, poetizing without words, poetizing as a current of uninhibited lyrical spontaneity. In Artificialism, which abandoned direct references to the world outside the painting, there was a much closer, internal connection between image and poem. On the interwar avant-garde scene, Artificialism carved out a distinct position for itself, a position that was consolidated by the second exhibition that Štyrský and Toyen held at Max Berger's Galerie Vavin in Paris at the end of 1927 and beginning of 1928. The poet Philippe Soupault, who was in touch with Devětsil in the mid-1920s, wrote the introduction to the catalogue.

The Jewish Cemetery

In 1928 Štyrský and Vítězslav Nezval collaborated with Karel Teige on a remarkable project that brilliantly achieved their shared ambitions for Poetism and Artificialism, *Židovský hřbitov* (*The Jewish Cemetery*) [CAT. 39], named after one of the most legendary and frequented sites in the Prague Jewish ghetto. Two hundred and twenty numbered copies of *The Jewish Cemetery* were printed, with a typographical design by Teige. Nezval dedicated his text, in which an impression of the "profound connection between eroticism and death" evokes a "dreamy, lyrical ecstasy," to Štyrský, for whom the theme had a special personal resonance.[6] (For his entire life, Štyrský was obsessed with eros and thanatos.) The poems, in turn, inspired Štyrský's six Artificialist lithographs, created through Štyrský's favorite technique of these years, which he applied to both printmaking and painting. Using a spray gun, he was able to silhouette disparate objects against a neutral ground, achieving an unusual and tenebrous luminosity. The black-and-white lithographs, which were also hand-colored in an edition of twenty, have a peculiar graininess and suggest a tremulous nighttime space, with scattered matches, nails, and other small items transformed into out-of-focus, nebulous shapes. A game of free-flowing lines is played out in this setting as well. In the fifth and sixth prints in particular, one sees a disturbing relationship between the white lines, created by the negative imprint of threads, and their black shadows, which start to follow their own course. Additionally, among the abstract shapes that appear in the chiaroscuro illustrations for *The Jewish Cemetery*, one can identify the outlines of standing tombstones.

Maldoror

Štyrský took on another major book project in 1928, illustrating the comte de Lautréamont's *Les chants de Maldoror* (*The Songs of Maldoror*) [CAT. 40]. Thanks to the efforts of Soupault, Teige, and Jindřich Hořejší, three hundred numbered copies of the Czech translation of this proto-Surrealist masterpiece were published by Odeon in the spring of 1929, with a typographical design by Teige. Štyrský contributed twelve drawings as illustrations, and he hand-colored and signed twenty-five copies in a separate edition as well. However, *Maldoror* was promptly confiscated by the Czech censor, who insisted that Lautréamont's text be blacked out in six places. This act of suppression provoked an immediate wave of protests, summarized in the September 1929 issue of *ReD*. Teige, in his role as editor, reprinted the Czech censor's decision, as well as protests against the confiscation of Lautréamont's work by Soupault, Georges Ribemont-Dessaignes, Roger Gilbert-Lecomt, and members of Le Grand Jeu, among other luminaries of the Paris avant-garde.

Štyrský's illustrations for the work beloved by the Surrealists — sharp, precise pen-and-ink drawing on a bright, white ground — suggest impressions of aggression, sadism, and destruction while maintaining the linear delicacy typical of his Artificialist compositions. They are extreme manifestations of the desire "to attain the infinite, even by the most insensate means."[7] In each plate, in addition to the contrast of black and white, one of two colors is used, either blue or red (in the book reproductions, red-brown). These colors are used in the same way as the black — in lines, in sprayed sections, and in flat, covered forms. The introductory drawing is connected with Štyrský's paintings from 1927, in particular *Nálezy na pláži* (*Finds on a Beach,* Galerie umění Karlovy Vary [Karlovy Vary Art Gallery]) and *Hnízdo rajek* (*Nest of Birds of Paradise,* Prague, private collection). At the same time, the drawing is a loose interpretation of Lautréamont's line "By moonlight in lonely places near the sea when you are plunged in bitter reflections you see that everything assumes a yellowish appearance."[8]

The subsequent *Maldoror* drawings usher in a new creative phase in Štyrský's work, in which Artificialism is interspersed with Surrealist elements, although Štyrský continued to reject the principles of Surrealism in his written statements of this era. The genesis of these illustrations can be traced to Štyrský's dreams, which he had begun to record in 1925. Shortly before his untimely death in 1942, he collected them in a unique book, titled

simply *Sny* (*Dreams*), which connects written and drawn entries. Lautréamont's texts frequently describe transformations from the human to the animal state. Štyrský expresses this mutability in ambiguous new formations, which might equally represent a plant, an animal, or an object: microscopic views, fragments of entrails, and skeletal remains. His drawings portray the rampant growth of peculiar organisms and the coiling of ropes, as well as violence and bloodshed. Spilt blood and the lacerated body are abstracted into subtle forms; barbarous deeds are interlaced with decorative arabesques. With a symbiosis of loveliness and cruelty, Štyrský's illustrations anticipate Salvador Dalí's cycle of etchings for *The Songs of Maldoror* and later illustrations by a host of Surrealists for Lautréamont's collected works.

From the drawings for *The Songs of Maldoror*, the way led directly to Surrealism. Štyrský's next step on this road was made manifest in the differences between the frontispieces for Konstantin Biebl's prose work *Plancius*, 1931 **[CAT. 41]**, and František Halas's poetry collection *Tvář* (*The Face*), 1932 **[CAT. 42]**. Although the two frontispieces were made only a year apart, one can see in them Štyrský's abrupt switch from a biomorphic style, revealing the genesis of nature, to Surrealist mannequins, oscillating between the figurine and the human body.

The Faces of Women

Toyen's illustrations — usually simple, very realistic ink drawings — were at the other extreme from Štyrský's unusual creations for Nezval's *The Jewish Cemetery* and Lautréamont's *The Songs of Maldoror*. In her unique designs for covers and illustrations for bibliophile prints, she elaborated on the principles of the Artificialist poetics that she and Štyrský developed in their paintings. On the title page for *The Purple Land* (*Purpurová země*), 1930, by W. H. Hudson, she depicted a map, one of the favorite themes of the picture poems of the early Devětsil. Within the outline of South America, she included, in addition to geographical names, a luxuriant ornament composed of tropical fruit, such as one sees in her paintings from that period. At the same time, however, Toyen was searching for a way to depict the human body, which was excluded from Artificialist paintings. This transition is clear in her illustrations for Nezval's poetry collection *Sylvestrovská noc* (*New Year's Eve*), 1930. In one of the three illustrations for the book, she used the striking motif of a hand fumbling along the spines of books; the other illustrations show a paperweight in the shape of a girl's

hand. In these, Toyen emphasized the Artificialist, transparent outlines of the drawing, so that both the figural and objective planes intersected. The frontispiece for the story *Dvojí stín* (*Double Shadow*), 1930, by Karel Konrád, was also based on Artificialist poetics. The story offered the artist an opportunity to develop her favorite idiom, drawing all different sorts of intersecting spatial fields and networks, variously delineated in ink.

Toyen developed a subtle and precise drawing style in the twenty-two full-page, black-and-white illustrations for Charles Vildrac's *L'Ile rose* (*Růžový ostrov; Rose Island*), 1930 **[CAT. 43]**. One drawing portrays Vildrac's child-hero Lian under the palm trees on a Mediterranean island. Another employs a distinct bird's-eye perspective, from which Lian regards the beach with its little figures. Yet another develops a steep diagonal composition with Lian's boat in the middle of the sea. The plot of *Rose Island* offered Toyen an opportunity to revive the poetics and iconography of the Devětsil group, which was slowly disintegrating. She linked the world of children's games and duties in the poor Parisian quarter with journeys in search of adventure, with the charm of exotic lands, automobiles, ships, airplanes, and aerial views of the mainland and the island.

Toyen's next book project was a collaboration with Teige, the Editio princeps bibliophile edition of Stanislav Kostka Neumann's poetry collection *Žal* (*Grief*), 1931 **[CAT. 44]**. Teige was awarded the national prize for this publication, and one sees a unique harmony in his and Toyen's contributions. Teige's design for *Grief* illustrates the convictions expressed in "Modern Typograhy": "Progressive simplification is the meaning of long-term development. Discarding ornaments. Simplifying the range of characters."[9] Teige's iconoclastic ideals, which called for a purified design, served as a foil for Toyen's refined illustrations. There was a complementary contrast between his principled approach, which was only gradually gaining wider currency, and her turbulent drawings. On the frontispiece for *Grief*, transparent drapery covers a female torso without arms or a head. This image can be interpreted as the embryo of her subsequent Surrealist phantoms, foreshadowing the twisted bodies that would populate Toyen's work at the end of the decade. The lightened frontispiece for *Grief* was followed by three separate illustrations showing fragments of the female body. For the poem "Píseň" ("Song"), which begins with the line "a pale profile, a sad, pale profile," Toyen drew a girl's head in profile. For the

poem "V bludném kruhu" ("In a Vicious Circle"), which refers to dark eyes, she used a free-floating female eye. For the poem "Noc touhy" ("Night of Desire"), she depicted a detached torso. Throughout these drawings, the liberated Artificialist line has assumed firm contours, gathering in abstract linear clusters that suggest perspectival spaces. Toyen also chose to introduce the technique of frottage in certain plates, a rare strategy in her book works. The defining feature of the illustrations for *Grief* is the constant flow of reminiscences, rescuing from oblivion the fleeting traces of sense experience. The illustrations express a time of unrequited, wasted desire, precisely reflecting the atmosphere of the various poems. In the illustration for "Song," Toyen captured the rising and falling cadence of the verses. In the illustration for "In a Vicious Circle," her lines express the gliding motion of a tear running down a face, loosely suggesting the yin-and-yang symbol. In the succession of impressions, the only constant is the recurring motif of the elusive woman, represented as a phantom that has assumed corporeal form. In the illustrations for *Grief*, Toyen did not depict a woman's face looking forward. Or rather, when she did so, she reduced the face to a single eye. At the beginning of the 1930s, the tension between the face and the eye was a source of inspiration for her, in particular in her book art.

During this time, Toyen honed her talent as an illustrator. She often focused on the depiction of the mask, for example in the illustrations for Molière's play *Le médecin volant* (*The Flying Doctor*, in Czech *Příležitost dělá lékaře*), 1931, and on the fragmentation of the female face. In the frontispiece for Josef Kajetán Tyl's *Rozervanec* (*The Misfit*), 1932 [CAT. 45], likewise designed by Teige for Editio princeps, all that is visible in the outline of the head is a pair of eyes looking upward. According to Štyrský, "We encounter the eyes of Tyl's misfit on the low wall of a village tavern, in the middle of the summer, somewhere in Bavaria. And we will never again be able to imagine him without those romantic eyes, looking back into emptiness, as dark as his past."[10] Toyen divided the face into two parts in the frontispiece for Apollinaire's *Alcools* (*Alcohols*, in Czech *Alkoholy*), 1933 [CAT. 46], and in Halas's *Hořec* (*Gentian*), 1933 [CAT. 47]. The latter was published as the sixth volume of Editio princeps; the restrained typographical design was by Štyrský, who used lowercase letters on the cover, as advocated by proponents of the International Style and as Teige had done before him.

Given the character of the books that she was commissioned to illustrate, Toyen frequently focused on the theme of women's experiences and transformations. She produced five robust illustrations for Marcel Aymé's *La jument verte* (*The Green Mare*, in Czech *Zelená kobyla*), 1934 [CAT. 48], and remarkable drawings for the second edition of Marie Majerová's *Mučenky — Čtyři povídky o ženách* (*Passion Flowers — Four Stories about Women*), 1934 [CAT. 49]. In six full-page illustrations, she concentrated on the details of a woman's face, in particular the eyes: closed or looking upward; disappearing under the lines of a body of water with the leaves of water lilies; sinking under subtle hatching; merging with vegetation or with weightless abstract shapes; imprisoned in a mesh of barbed wire. Only in one face did Toyen emphasize the mouth, from the corner of which trickles blood, hardening into an ornament. The mouth is both part of a face and the center of an irregular oval. The strong outline of the oval stands out from the drawing and is reflected in the forms delineated with hatching. Because of the sophistication of the illustrations, *Passion Flowers* is one of the most important books illustrated by Toyen.

The Modern World

Children's books were a consistent feature of Toyen's work in the 1930s. One extraordinary project was the collaborative book by two women, Zdenka Marčanová and Toyen, titled *Náš svět* (*Our World*), 1934 [CAT. 50]. Ladislav Sutnar, one of the few graphic artists that Teige respected, was responsible for the modern Functionalist design. *Our World* was published in 2,200 copies, a large print run for the 1930s. The design and the colors are typical of Sutnar's graphic work, which, from the late 1920s to the 1960s, maintained the bold Constructivist features of the International Style. The names of the two women were printed next to each other on the book cover, emphasizing the equality of their artistic contributions. Their aim was to acquaint children, using poems and pictures, with items of contemporary civilization, to create a primer for the new world in which the miracles of modern technology stimulate the imagination more than the creatures of fairy tales. Marčanová was a teacher who specialized in children's poetry. Her sister was the Slavophile Marie Marčanová, the partner of the translator and poet Bohumil Mathesius. Zdenka wrote eighteen poems for *Our World*, each of which concerned a modern phenomenon. The name of the object appeared only in the title of the related poem.

Although the illustrations that Toyen created for *Our World* are thematically related to mechanistic motifs found in her collages and picture poems, as well as in the larger vocabulary of the 1920s Devětsil artists, the publisher's demand that the book be illustrated by drawings presented a fresh challenge to her. She did not attempt to provide simple depictions of the modern era; rather, like Marčanová's poems, her illustrations portray the benefits of the machine age by focusing on the functions of the various objects and the settings with which they were associated. Following the poem and illustration about the book are poems about the car, the bus, the lightbulb, the gramophone, film, the tram, the typewriter, the telephone, the train, the radio, the airship, the airplane, the steamship, the telegraph, the crane, the rotary press, and the tractor. Sutnar gave the book an alternating sequence of colors — red, yellow, white, black, and blue — combining color surfaces and the color of the script in which each poem was printed. He assumed that the choice of rhythmical colors, even in the design of the table of contents, would appeal to young readers. These colors, more than the page numbers, constitute a kind of key by which one can look up the individual poems. In addition, on the page with the table of contents, he clearly made use of the Functionalist asymmetry promoted by Teige, arranging the titles of the poems vertically at the right edge of the page. An advertisement in the magazine *Panorama* identified Soviet culture as the inspiration for *Our World*:

Three artists have collaborated to create for our little ones a new type of illustrated children's book such as has already been tried out in Russia. Hungry children's eyes will feast for a long while on these eighteen wonders that have transformed and enlarged the world of recent generations. Toyen has painted these new achievements for them in a fun and colorful style. The poet Z. Marčanová, who knows children so well, has written dear little verses about them, which are a pleasure to listen to. L. Sutnar has unified both contributions in a book, the quality of which is not often seen here. [11]

Marčanová added her own commentary: "Even the child's world is changing. Our children have different interests and experiences than we did. . . . They are more pragmatic and, it would seem, more cheerful than our generation was. . . . Our children want their childish world to be part of the adult world."[12] Toyen accompanied these children's poems about civilization with concise, colorful illustrations that were easily comprehensible and instructive. Some of them, incidentally, seem to foreshadow the style of Pop Art; for example, the columns of a classical temple, in the illustration for the poem "Vlak" ("Train"), call to mind Roy Lichtenstein's paintings from the 1960s. This publication was not the first time that Toyen had treated the theme of the achievements of civilization in illustrations; she included them in a subtler form in the drawings for Vildrac's *Rose Island*.

Our World, the collaborative work of three artists, is not as famous as Teige's design for Nezval's *Alphabet*, yet, from the perspective of book art of the 1930s, it is at least equally important. For those who grew up with this book, *Our World* was so engraved in memory that, as adults, many thought of Toyen as the creator of colorful icons of progress, rather than as the Surrealist painter she was to become. *Our World* gave her an opportunity to reflect on her naive period from the mid-1920s, which was loosely inspired more by Henri Rousseau than by the programmatic aesthetics of Devětsil.

On the Threshold of Surrealism

One of founding figures of Devětsil in 1920 was Alois Wachsman. He abandoned the association two years later in protest against the change in orientation, which was increasingly opening up to the art world abroad. Nonetheless, he remained faithful to the modern style, which, at the turn of the 1930s, was in transition from Cubist influences to Surrealism. In 1932, Wachsman participated in the most important exhibition of contemporary art held in Czechoslovakia in the interwar period, titled *Poesie 1932* (*Poetry 1932*). In addition to Czech artists such as Šíma, Toyen, and Štyrský, artists from abroad, including Max Ernst, Salvador Dalí, Joan Miró, and Yves Tanguy also participated, making this exhibition one of the major statements of Surrealism outside of Paris. Indeed, *Poetry 1932* can be interpreted as a forerunner of the numerous international exhibitions of Surrealism, in which the only participating Czech artists would be Štyrský and Toyen.

A small drawing by Wachsman, from 1931, shows this critical period of transformation in his work [CAT. 51]. The left part of the supine female figure holding a branch is executed in a flat, Cubistic style. In contrast, Wachsman probably added in the figure's massive legs, separate from the body, a few years later, when he was working on monumental paintings such as *Středověk* (*The Middle Ages*, 1934, Galerie hlavního města

Prahy [City Gallery Prague]), *Pád andělů* (*The Fall of the Angels*, 1934, private collection), and *Život a smrt* (*Life and Death*, 1934, Národní galerie v Praze [National Gallery in Prague]). In these, he often depicted human limbs separate from the torso. Thus, in the drawing of the human figure, the paradoxical collision of two contradictory styles is apparent. Wachsman used a fine pencil to delineate the Cubistic torso, whereas the limbs are drawn with a strong contour line.

Wachsman was also one of the few artists to introduce Surrealist motifs to stage design, a field in which he worked in the late 1930s. Surrealism even infiltrated the stage designs that Wachsman created for the Národní divadlo v Praze, the premier National Theater of Czechoslovakia. One of Wachsman's most successful productions at the National Theater was Shakespeare's *The Tempest*, performed under the title *Prospero*. The production debuted on November 4, 1937, and was directed by Karel Dostál, with music by Miroslav Ponc, choreography by Joe Jenčík, and set design by Alois Wachsman. For this production, Wachsman developed an illusive, almost Dalíesque, paranoiac-critical method to great effect, with a draped tree suggestive of the human torso and a lone ship on a bank waiting for imaginary passengers [CAT. 52].

Poetry 1932 sent a clear signal to Czech artists that the post-Cubist period had come to an end and that European painting was headed in a different direction. The work of Štyrský and Toyen also underwent an unmistakable transformation. At the end of the 1920s, they returned to Prague from Paris, ending their four-year sojourn abroad. *Poetry 1932* essentially marked the end of their long-standing interest in Artificialism, which was already showing the first significant traces of Surrealism. An untitled pencil drawing by Štyrský from 1933 [CAT. 53] was based on his painting *Finds on a Beach*, 1927, the motif of which also reappeared in the frontispiece for Lautréamont's *The Songs of Maldoror*, 1929: along a river, which winds through an empty landscape, are placed the ruins of a collapsing structure, literally taken from an Artificialist painting. Štyrský introduces Surrealist elements into the Artificialist setting by contrasting a sheer rock wall, which defines the foreground, with an elaborate, empty picture frame. The scene is closed off by the motif of the airship, which appears on the horizon.

Toyen went through a similar transition from Artificialism to Surrealism in her watercolors and ink drawings of 1932–33 [CATS. 54 and 55]. Her natural shapes started to assume the form of parts of the human body. The multiplied shapes, layered on top of one another, look like cracked bark; the spheres resemble fruit and detached human eyes. In 1933 Toyen even returned to the technique of frottage, which she used to break up the illusive space, and allude to the human body.

NOTES

1 Josef Šíma and Philippe Soupault (eds.), *Paříz* [*Paris*] (Prague: Aventinum, 1927), n.p.

2 Jindřich Štyrský and Toyen, "Artificielisme" ("Artificialism"), *ReD* 1, no. 1 (October 1927), reprinted in *Jindřich Štyrský, Texty* (*Jindřich Štyrský, Texts*), ed. Lenka Bydžovská and Karel Srp (Prague: Argo, 2007), 17.

3 Jindřich Štyrský and Toyen, "Básník" ("The Poet"), *Rozpravy Aventina* 3, no. 20 (1927–28), reprinted in *Jindřich Štyrský, Texty*, 26.

4 Štyrský and Toyen, "Artificielisme," 18.

5 Štyrský and Toyen, "Básník," 23.

6 František Götz, "Nezvalův Židovský hřbitov" ("Nezval's Jewish Cemetery"), *ReD* 2, no. 8 (April 1929): 268.

7 Comte de Lautréamont, *Les chants de Maldoror* (*The Songs of Maldoror*), trans. Guy Wernham (New York: New Directions, 1965), 9.

8 Ibid., 12

9 Karel Teige, "Modern Typography," trans. Alexandra Büchler, in *Karel Teige/1900–1951: L'Enfant Terrible of the Czech Modernist Avant-Garde*, ed. Eric Dluhosch and Rostislav Švácha (Cambridge, MA, and London: MIT Press), 103.

10 Jindřich Štyrský, "Inspirovaná ilustrátorka" ("The Inspired Illustrator," 1932), reprinted in *Jindřich Štyrský, Texty*, 99.

11 "Tři umělci se spojili" ("Three Artists United"), *Panorama* 12 (1934): 122.

12 Zdenka Marčanová, "I dětský svět" ("Even the Child's World"), *Panorama* 12 (1934): 122.

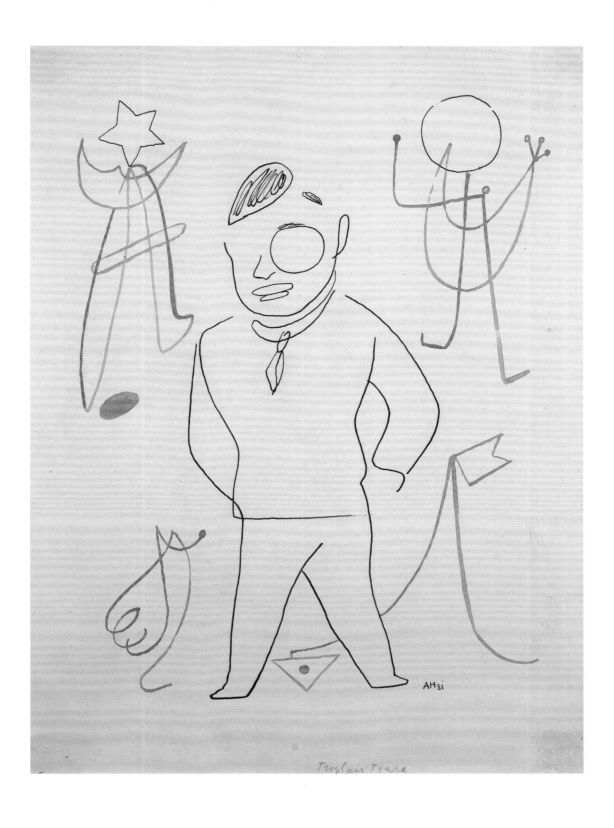

CAT. 37
Adolf Hoffmeister
Tristan Tzara bloumá po Paříži [*Tristan Tzara Saunters around Paris*] | 1931
Ink on paper | 15 ½ × 11 ½ inches (39.4 × 29.2 cm)

CAT. 38
Josef Šíma and Philippe Soupault (eds.)
Paříž [*Paris*] | 1927
Cycle of eighteen drypoints (hand-colored): Josef Šíma | Prague: Aventinum
15 ¼ × 12 ½ inches (38.7 × 31.8 cm)

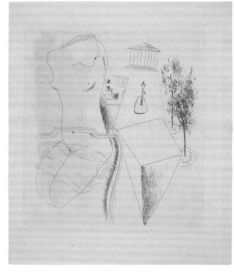

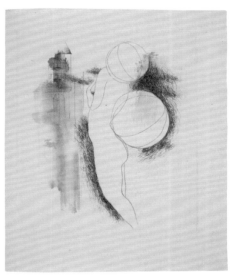

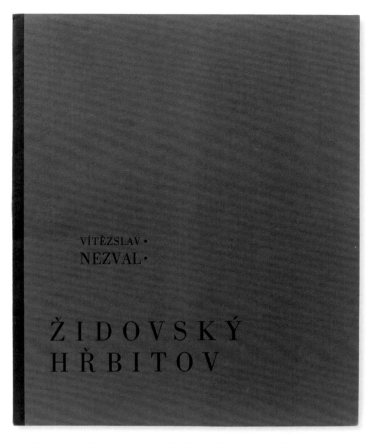

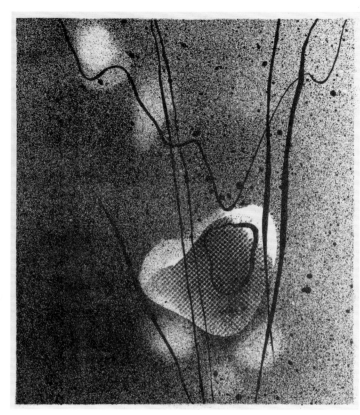

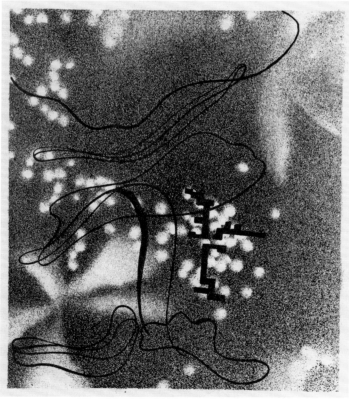

CAT. 39
Vítězslav Nezval
Židovský hřbitov [*The Jewish Cemetery*] | 1928
Illustrations: Jindřich Štyrský | Typography: Karel Teige | Prague: Odeon
11 ¾ × 9 ¾ inches (30 × 24.8 cm)

Isidore Ducasse
comte de Lautréamont

MALDOROR

Odeon
1929

CAT. 40
Isidore Ducasse, comte de Lautréamont
Maldoror [*Les chants de Maldoror; The Songs of Maldoror*] | 1929
Illustrations: Jindřich Štyrský | Typography: Karel Teige | Prague: Odeon
7 ½ × 5 inches (19 × 12.8 cm)

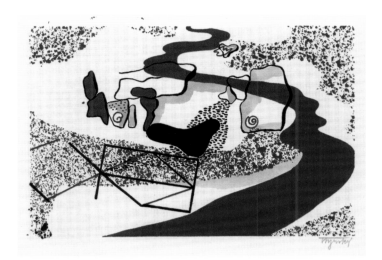

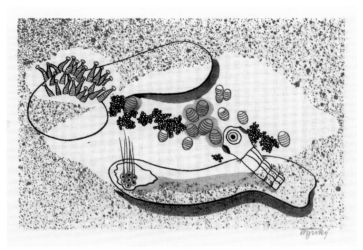

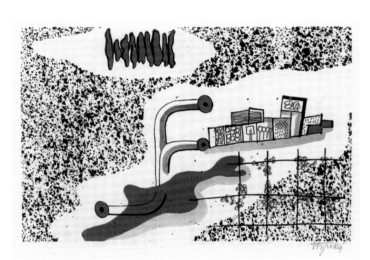

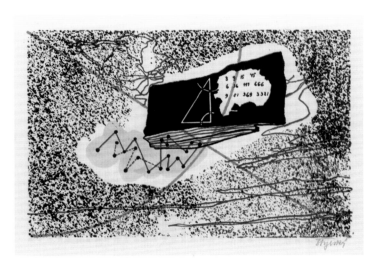

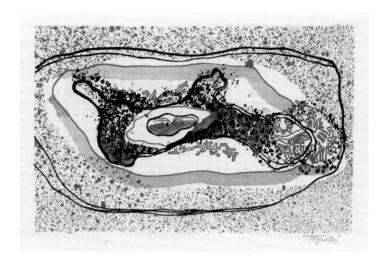 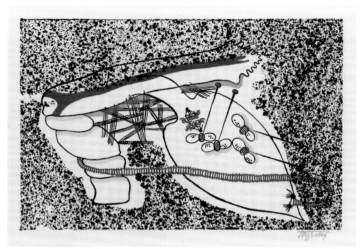

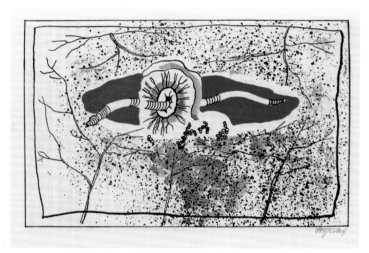 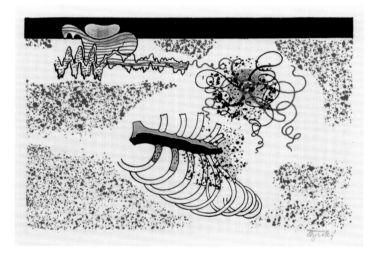

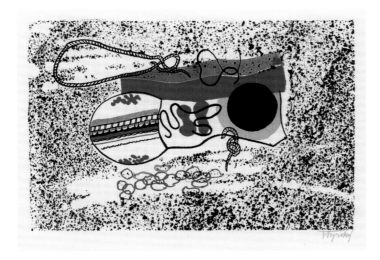

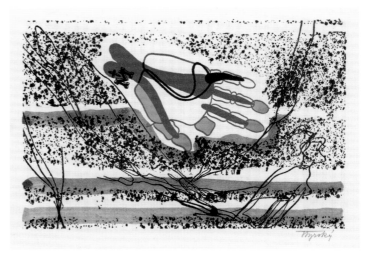

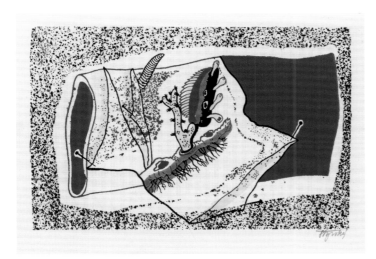

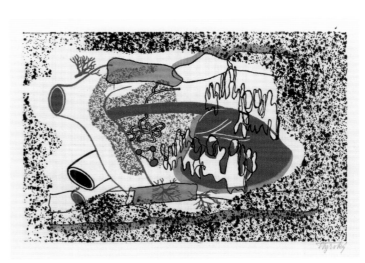

CAT. 41
Konstantin Biebl
Plancius | 1931
Frontispiece (hand-colored): Jindřich Štyrský | Prague: Sfinx (B. Janda)
7 ⅞ × 5 ⅝ inches (20 × 14.24 cm)

CAT. 42
František Halas
Tvář [*The Face*] | 1932
Frontispiece: Jindřich Štyrský | Prague: Družstevní práce
7 ½ × 4 ⅞ inches (19 × 12.3 cm)

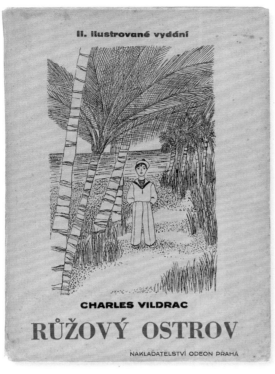

CAT. 43
Charles Vildrac
Růžový ostrov [*L'Ile rose; Rose Island*] | 1930
Cover and Illustrations: Toyen | Prague: Odeon
8 ¼ × 6 inches (21 × 15 cm)

CAT. 44
Stanislav Kostka Neumann
Žal [*Grief*] | 1931
Frontispiece and illustrations (hand-colored): Toyen | Typography: Karel Teige | Prague: E. Janská
9 ⅝ × 6 ½ inches (24.3 × 16.5 cm)

stanislav k. neumann:

žal

básně

Rozervanec

Novela

od

Josefa Kajetána Tyla

GUILLAUME APOLLINAIRE

Alkoholy

CAT. 45
Josef Kajetán Tyl
Rozervanec [*The Misfit*] | 1932
Frontispiece: Toyen | Typography: Karel Teige | Prague: E. Janská
7 ¾ × 5 ⅛ inches (19.5 × 13 cm)

CAT. 46
Guillaume Apollinaire
Alkoholy [*Alcools; Alcohols*] | 1933
Frontispiece: Toyen | Typography: Jindřich Štyrský | Prague: A. Jirout – K. Teytz
5 ¼ × 7 ⅞ inches (13.5 × 20 cm)

František Halas

hořec

CAT. 47
František Halas
Hořec [*Gentian*] | 1933
Illustrations: Toyen | Typography: Jindřich Štyrský | Prague: E. Janská
9 ³/₈ × 6 ³/₈ inches (24 × 16 cm)

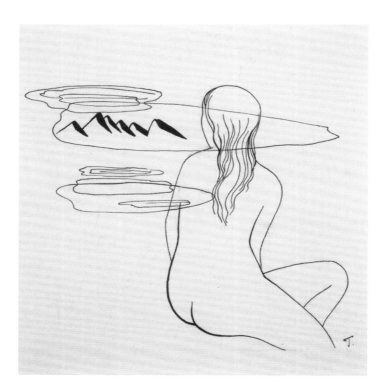

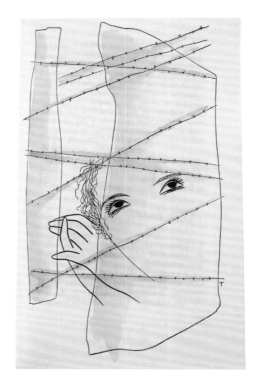

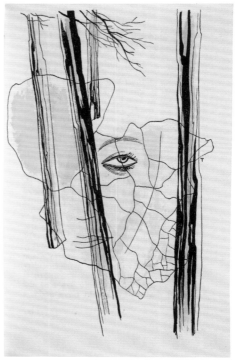

CAT. 48
Toyen
Study for the cover of Marcel Aymé's *La jument verte*
[*Zelená kobyla; The Green Mare*] | 1934
Ink and watercolor on cardboard
4 ½ × 4 ½ inches (11.5 × 11.5 cm)

CAT. 49
Marie Majerová
Mučenky—Čtyři povídky o ženách
[*Passion Flowers—Four Stories about Women*] | 1934
Illustrations (hand-colored): Toyen | Prague: Čin
7 ¼ × 4 ⅞ inches (18.5 × 12.5 cm)

CAT. 50
Zdenka Marčanová
Náš svět [Our World] | 1934
Cover and illustrations: Toyen | Typography: Ladislav Sutnar | Prague: Družstevní práce
9 × 12 ¼ inches (23 × 31 cm)

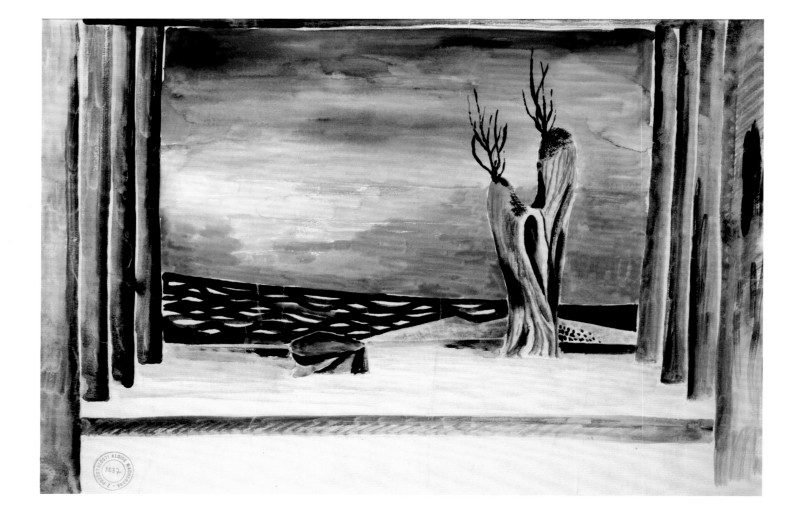

CAT. 51
Alois Wachsman
Untitled | 1931
Graphite on paper | 5 ¼ × 8 ¼ inches (13.3 × 21.0 cm)

CAT. 52
Alois Wachsman
Prospero (stage design) | 1937
Watercolor on paper | 11 ½ × 16 ⅝ inches (29.2 × 43 cm)

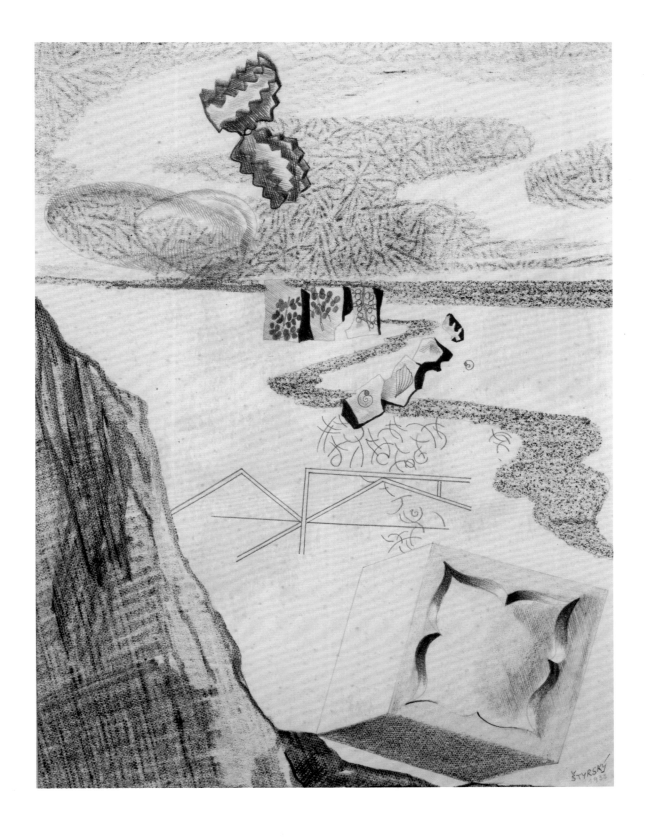

CAT. 53
Jindřich Štyrský
Untitled | 1933
Graphite on paper | 11 ½ × 8 ⅞ inches (31.5 × 23.5 cm)

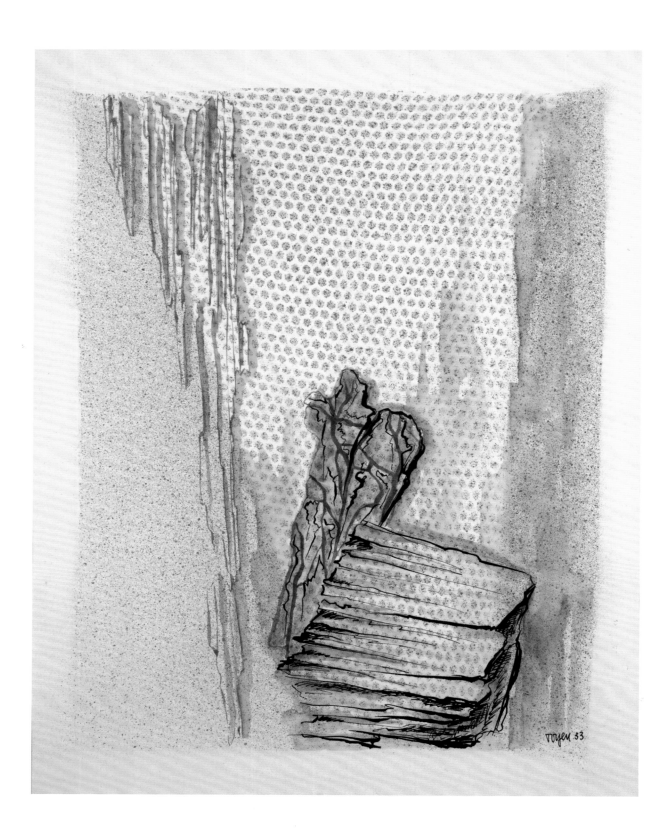

CAT. 54
Toyen
Untitled | 1933
Watercolor on paper | 17 ¾ × 12 ½ inches (45.1 × 31.8 cm)

CAT. 55
Toyen
Untitled | 1933
Ink and watercolor on paper | 19 × 13 inches (48.3 × 33 cm)

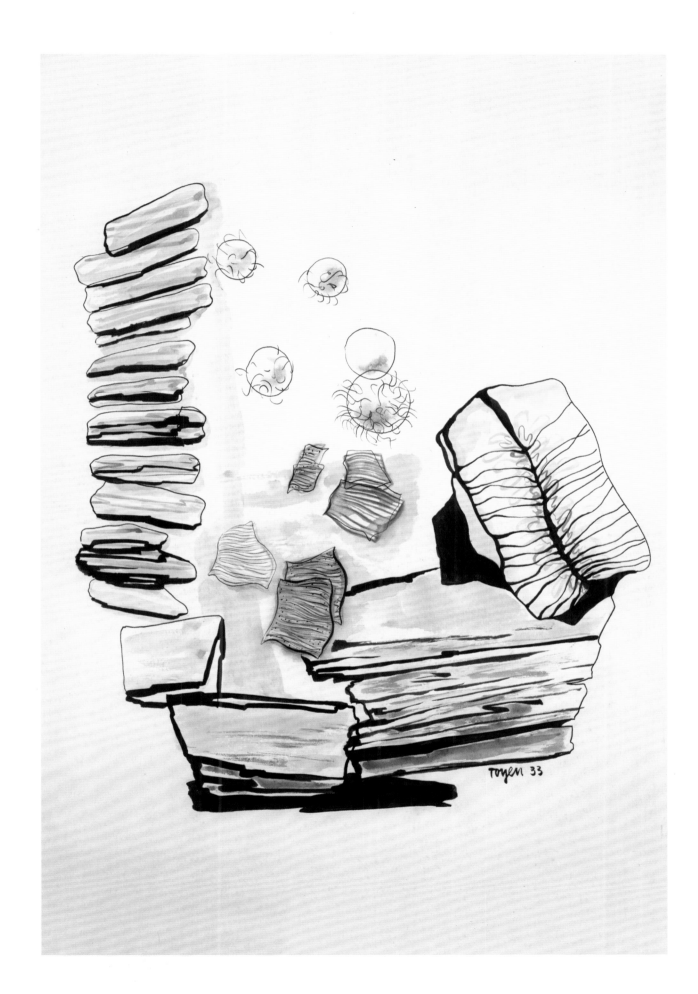

Jindřich Štyrský and Toyen published "Artificielisme" as a joint declaration of their new artistic creed in the first issue of the journal *ReD: Revue Svazu moderní kultury Devětsil* (*ReD: Review of the Union for Modern Culture, Devětsil*). Edited by Karel Teige, the three volumes of *ReD* (1927 – 31) presented the central line of development of the Czech avant-garde and its international context. In their proclamation, Štyrský and Toyen formulated their own approach to painting, distinguishing it from abstract art and Surrealism. Artificialism, which advocated the identification of the painter with the poet, constituted an important artistic trend within the broader framework of Poetism. The latter was the brainchild of Teige and Vítězslav Nezval, who promoted Poetism in a number of manifestos and other texts in the 1920s.

Originally published as "Artificielisme," *ReD* 1, no. 1 (1927 – 28): 28 – 30. Translated and reprinted as "Artificialism," in *Between Worlds: A Sourcebook of Central European Avant-Gardes, 1910 –1930*, trans. Alexandra Büchler, ed. Timothy O. Benson and Éva Forgács (Cambridge, MA, and London: MIT Press, 2002), 589 – 90.

Jindřich Štyrský
Toyen

Artificialism

Cubism was the outcome of the traditional division of painting into figurative, landscape, and *nature morte*, where the main difference consisted in descriptive thoroughness. Essentially, it was a new method and technique of depiction, replacing the illusion of optical perspective by the illusion of reality distributed in space. It generally looked at painting through a model. Formally, the painting coincided with the appearance of reality, and where this was not possible, the result was deformation. Analysis of reality led to its mirroring and duplication. Cubism turned reality around, instead of spinning imagination. When it reached maximum reality, it realized that it lacked wings. The eyes that had become sensitive kept glancing back at the horizon of their origin, with the result that what came next was an illogical "return to nature." Yet, Cubism offered painting *unlimited possibilities*.

Artificialism comes with a reverse perspective. Leaving reality alone, it strives for *maximum imaginativeness*. Without manipulating reality it can still enjoy it, without an ambition to liken a clown's cap to a body that may not have any other charm than that of abstract infallibility, which nevertheless suffices when it comes to satisfying poets well versed in mystification. Mirror without image. Artificialism is the *identification of painter and poet*. It negates painting as a mere formal game and entertainment for the eyes (subjectless painting). It negates formally historicizing painting (Surrealism). Artificialism has an abstract consciousness of reality. It does not deny the existence of reality, but it does not use it either. Its interest focuses on *poetry* that fills the gaps between real forms and that

emanates from reality. It reacts to the latent poetry of interiors of real forms by pursuing positive continuity. The exterior is determined by poetic perception of memories (negative continuity). Remembrance of memories. Imagination loses real connections. Deduction of memories without the aid of memory and experience prepares a concept of painting, the essence of which excludes any mirroring, and positions memories into imaginary spaces.

Memories are prolonged perceptions. If perceptions are transfigured as they are born, memories become abstract. They become the result of a conscious selection that denies imagination, and pass through consciousness without leaving an imprint and without disappearing.

The outcome of abstract visual memories at the stage when they permeate one another is new formations that have nothing to do with reality or with artificial nature. This stage does not coincide with the receptive and passive state of artificial paradise or with the erratic logic of abnormal individuals.

The function of the intellect is external and final. It organizes and disciplines and to some extent chisels the mass of emotional response. The process of identification of painter and poet is internal, indivisible, and simultaneous.

An artificial painting is not bound to reality in time, place, and space, and for that reason it does not provide associative ideas. Reality and forms of the painting repulse each other. The greater the distance between them, the more visually dramatic is the emotiveness, giving birth to analogies of emotions, their connected rippling, echoes all the more distant and complex, so that, at the moment of confrontation between reality and image, both feel entirely alien in relation to each other.

An artificial painting elicits not only optical emotions and arouses not only visual sensibility. It leads the viewer away from the merry-go-round of his usual imagination, dismantling the systems and mechanisms by which ideas connect. Artificialism abstracts real spaces, giving birth to a universal space, which is often replaced with surface distances, so that forms are connected by means of distance. The color itself has gone through a light process, and is therefore not affected by the anomalies of diffused and condensed light. The value of nuances and transpositions creates a lyrical atmosphere.

The composition of a painting, based on lack of interest in reality, presupposes complete consciousness and is dependent on concrete logic of artificial painting. It is entirely definitive, unchangeable, and static. The forms in the painting coincide with images of memories. Giving the painting a title is not an act of describing or naming its subject, but of characterizing and giving direction to emotion. The subject is identified with the painting and its forms become self-explanatory.

Jindřich Štyrský and Toyen met in 1922 on the island of Korčula, in the former Yugoslavia, and they quickly became close collaborators. Štyrský's perceptive analysis of Toyen's illustrations was published in *Almanach Kmene (Kmen Almanac)*. Issued by the Kmen association of publishers at the end of each year, the almanac included contributions by modernist writers, illustrators, and book designers. At the turn of the 1920s and 1930s, Toyen worked consistently on illustrations and book covers. These publications spanned a broad range, from children's literature to fashionable novels and poetry collections by the major artists of her generation. Concurrently, Toyen's erotic art was published in bibliophile editions.

Translated by Kathleen Hayes. Originally published as "Inspirovaná ilustrátorka" ("The Inspired Illustrator"), in *Almanach Kmene (Kmen Almanac)*, ed. František Halas (Prague: Kmen, 1932), 71–74.

Jindřich Štyrský

The Inspired Illustrator

An ice cube, like a dirty piece of glass, lay in the shade. Then, lit up by the sun, it flashed and melted, sparkling in a fire of refracting beams. It vanished in *a state of radiance*. In Toyen's book illustrations, reality and imaginary forms, poetry and plots, are captured and conveyed in this *state of radiance*. They vanish, becoming invisible as *objects*, so that they might reappear transformed as arabesques and provocative interconnected points, lines, and surfaces. The words and the atmosphere of poetry are recast as visual forms.

There are two kinds of readers. The first are essentially indifferent to a book, even though they turn the pages and read diligently, even though they comment on the story according to their taste, compare the ideas in the book with their own outlook, and test the psychology by identifying with the protagonist, even though they think about the book for so long that it becomes their best friend. They are conscious readers, textbook readers, pillars of culture. They prefer a solid illustrator who faithfully reproduces the reading material. An illustrator who does not unsettle them. An illustrator who has a reliable *cliché* for every subject.

But that sort of illustrator would portray the lover from *Les lettres portugaises* as one of the Three Musketeers.[1]

The opposite of the conscious reader is the person for whom poetry is a passion. The fanatic. The passionate reader equal to the poet. Someone who loves a beautiful book, who will buy it even during the worst economic crisis because he does not buy it out of a desire to be educated. This kind of reader loves only those illustrations in a book that enhance his excitement, that thrill him without paralyzing his *creative* approach to the reading material. *Inspired* illustrations.

1

Les lettres portugaises (The Letters of a Portuguese Nun) was published anonymously in Paris in 1669. The work was later attributed to Gabriel-Joseph de La Vergne, comte de Guilleragues. *Trans.*

The inspired illustrator is more excited by the personality of the poet and by the atmosphere of the work than by external plot, ostentatious gestures, or literary genre. If I were to describe approximately the position of the inspired illustrator, I would place it at the point where, figuratively, the line representing the character of the poet and the line representing the character of one of his works intersect.

An illustration should echo the reader's impressions. Toyen's drawings for books are just this sort of gamble in the *game* of reading. In the books illustrated by her, we never find a disparity between the content and the visual collaboration. Her drawings stir us and complete our imaginative powers, which, be they ever so rich and independent, never shake off her influence. It is as if we are marked by her diaphanous drawings; the memory of them stretches back before the beginning and beyond the end of the stories. Thus, we encounter the eyes of Tyl's misfit on the low wall of a village tavern, in the middle of the summer, somewhere in Bavaria.[2] And we will never again be able to imagine him without those romantic eyes, looking back into emptiness, as dark as his past.

In her drawings, Toyen has managed to fill in part of the universe of modern man. An intense, evocative power is concealed in the concise and precise style of the drawings, which are so peculiar and artificial, and yet so unified because of the *consistency* of her development. In a perpetual welding of analogies and identical real forms, vague memories and appalling naturalistic images that appear between the lines of poems, and in allusions that overlap with the eloquent narratives, she captures for us the poet and his stories from unusual angles.

Thus, she created for Delteil an analogous horrifying legend of a Don Juan who suffered while bringing with him everywhere confusion and horror.[3] Thus, she created that inexpressible *doom*. We will never forget that ecstatic and rotten face. It will follow us along the cemetery walls. It will be with us whenever we think of our *future* — because it is our supreme likeness.

When we read *The Heptameron*, an extravagant wealth of tales in a constant state of metamorphosis, when we take in this incredible reservoir of human characters, and when we compare the atmosphere in this work with the rich set of drawings that Toyen created for it, we see that the illustrations for the book could not have been entrusted to more felicitous hands.[4] Toyen succeeded in creating a type of modern romantic illustration. In her drawings, we find one predominant fondness: a fondness for girlish beauty. Torsos of women, noble eyes full of romantic ennui, terrifying eyes rolled back at the moment of orgasm, eyes gently dimmed at the hour of death, breasts veiled by a flying cloud, stabbed by a dagger, the shadow of a crotch casually covered by lace, the gesture of a hand on a pillow, the string of a bodice undone, the lustful mouth of a vagabond monk, a graceful foot, the bare shoulders of a girl bent over a sleeping youth, the entire repertoire of fawning details that make up the romantic game. Only when our eyes roam over the contours of this world of women, often *dressed* only in a smile, do we dream the stories of *The Heptameron* in their full intensity, stories that capture the surface and the underside of life so uniquely.

2

Josef Kajetán Tyl's novella *Rozervanec* (*The Misfit*, 1840) was published with illustrations by Toyen in 1932 [CAT. 45]. *Trans.*

3

Toyen illustrated Joseph Delteil's *Don Juan* (1930) in 1931. *Trans.*

4

The Heptameron (*L'Heptaméron*, 1558), by Marguerite de Navarre, was illustrated by Toyen in 1932 [CAT. 62]. *Trans.*

4 Under Covers

Karel Srp and Lenka Bydžovská

At the turn of the 1930s, the Prague Devětsil avant-garde turned to a new subject, one that had also attracted the Parisian Surrealists: the taboo realm found primarily in eroticism and pornography. In part in reaction to the censors' suppression of the first Czech edition of Lautréamont's *The Songs of Maldoror*, Štyrský founded two publication series that would focus exclusively on eroticism: *Erotická revue* (*The Erotic Review*) and *Edice 69* (*Edition 69*) [CATS. 57 – 58, 60 – 61]. There was little advertisement for either series, which he published at his own expense. Interested readers learned of them from discreet notices printed in magazines, which listed the address of the publisher from whom one could order *The Erotic Review* and *Edition 69*. Three volumes of *The Erotic Review* were published. The first consisted of four issues (published from October 1930 to May 1931); the second and third were published as almanacs (May 1932 and April 1933). A simple example can give an idea of how great the gap was between private and public life: sexual intercourse was depicted for the first time ever in film in 1933, in Gustav Machatý's *Extase* (*Ecstasy*). Eroticism was, for a long time, suppressed in public media, including books and magazines.

Štyrský, as both editor and publisher of *The Erotic Review*, determined the literary and artistic content of the magazine. Poems and short stories, drawn from a great variety of periods and cultures, mingled with theoretical interpretations of erotic life by Sigmund Freud, Georg Groddeck, and, most important for the Czech avant-garde, Bohuslav Brouk, a psychoanalyst who at the age of seventeen launched his career in the pages of *ReD* in 1930. Brouk's subsequent books were often designed and illustrated by Teige, Štyrský, and Toyen, and he contributed an important study, "Onanie jakožto světový názor" ("Onanism as a World Outlook"), to the first issue of *The Erotic Review*. He later elaborated on the subject of the essay in books that were pioneering in the Czech setting (for example, *Autosexualismus a psychoerotismus* [*Autosexuality and Psycho-eroticism*], 1935). Rather than condemning masturbation, which was generally viewed as a harmful vice, Brouk identified it as one of the basic sources of the creative imagination:

Onanism as physical gratification increases intellectual productivity, but it also has a qualitative impact on one's psyche, causing sexual excitement not with an object . . . but with the entire imagination. Therein lies the advantage of onanism over normal coitus, which has no qualitative impact, being tied exclusively to physical

emotions, which only subsequently change into mental qualities. In coitus, the quality of the mental processes depends upon reality as it is perceived, whereas with onanism there is free movement of the mind, which is of great emotional intensity, being independent, in sensory terms, of the perfection of the object. The onanist achieves the greatest excitement because reality can in no way approach the beauty of a vision, which, as an indestructible mental image, does not become commonplace or spoiled over time. The more onanism concentrates on objective excitement, however, the further removed it is from its purpose, degenerating into the conjuring of a woman's crotch.[1]

The Parisian Surrealists always associated onanism with a male or a female object, without which it was inconceivable to them. Brouk, by contrast, understood onanism as a purely creative matter, independent of visualization of the sexual organs. This broader conception of onanism reflected Brouk's view that our fundamental relationship with reality was libidinous rather than objective. Therefore onanists did not have to restrict themselves to imagining the sex organs; any object at all could excite them. Brouk wrote: "Thus mental, sexual life acquires perverse forms, extending the libidinous relationship to the entire world with the same intensity. And therefore the original objects do not lose their value; rather, while preserving a certain measure of emotivity, they become equal to other objects. The penis and breasts are integrated into 'ordinary' reality because they no longer have a special function. The body of a woman captivates us with its beauty in the same way as the poetry of a ring does."[2] Indeed, taken to a logical extreme, anyone who arrived at the state of mind exalted by Brouk would not even need to subscribe to *The Erotic Review* or to *Edition 69*, since "through onanism we have achieved a poetic sensibility and thus we do not need any more poets, who are anyway just so many older brothers initiating us into the first delights."[3]

In addition to Brouk's explorations of psychosexuality, the most significant literary contribution made by *The Erotic Review* was its function as a popular dictionary of eroticism. The poets and translators of the Devětsil generation who published their work in *The Erotic Review* — Vítězslav Nezval, František Halas, Jaroslav Seifert, Jindřich Hořejší, František Hrubín, and Vilém Závada — made important contributions to this rich field of expression. Additionally, Štyrský sought out translations of French literature, such as short stories from the eighteenth and nineteenth

centuries, as well as the writings of the Parisian Surrealists. The latter included their first two important inquiries, published under the title "Pátrání surrealistů v oblastech sexuálních" ("The Investigations of the Surrealists into Sexual Matters"), excerpts from Louis Aragon's novel *Le con d'Irène* (*Irene's Cunt*, in Czech *Kunda Irenina*), and from André Breton and Paul Éluard's *L'Immaculée conception* (*The Immaculate Conception*, in Czech *Neposkvrněné početí*). One cannot imagine these growing contacts with the Parisian Surrealists occurring without the simultaneous development of personal relationships, although these have not been documented for the period of 1929 – 30. Nonetheless, at that time, the first important translations of Breton, Aragon, and Éluard began to appear in all sorts of Czech avant-garde journals, in particular *Zvěrokruh* (*The Zodiac*) and *ReD*.

The illustrations and art supplements were a fundamental component of *The Erotic Review*. In addition to reproductions of works by Aubrey Beardsley and Félicien Rops, and famous Japanese woodcuts, there were contributions from about fifteen Czech artists. Many of them, however, like some of the writers, published their work under various ciphers or initials. It is not clear if this anonymity was motivated by moral concerns, or if it was merely a kind of social game. Certain artists, like Štyrský, Toyen, Hoffmeister, František Bidlo, Vratislav Hugo Brunner, Antonín Pelc, Václav Mašek, and Rudolf Krajc, signed their work with their full names. Yet many drawings were published in *The Erotic Review* under ciphers such as LL, F.K., I.B., 2 x V, jh, and XX. Over the years, the three most important of these have been deciphered: LL was the cipher for the main representative of Czech Cubism, Emil Filla, who had struck up a friendship with Štyrský at the beginning of the 1930s. Alois Wachsman used the cipher 2 x V. In this period, both of these artists, along with Štyrský and Toyen, took part in the influential exhibition *Poetry 1932*. The most mysterious signature was XX; the anonymous artist was said to be a poet whose work differed, in terms of style, from most of the drawings of the early 1930s. Because some of the originals have been preserved, it has been possible to ascertain that these were early works by Toyen, dating from her primitivist period in 1923 – 25, before she became a proponent of Artificialism or interested in Surrealism. Toyen was responsible for perhaps the most important illustrations in *The Erotic Review*. She later collected many of her drawings, published in color in the luxury edition of *The Erotic Review*, in a special album. This album was commissioned in 1938 by Bohuslav Brouk as a

wedding gift for his brother Jaroslav.[4] Toyen titled the album *Jednadvacet* (*Twenty-one*), as the album contained twenty-one drawings. The drawings in this collection present the basic repertoire of erotic motifs that she used in many variations from the end of the 1920s on. Unlike Štyrský, who was straightforward and even coarse, Toyen played with erotic motifs as if they were poetic fragments.

Toyen's erotic drawings admit her femininity. This does not mean, however, that they reveal her understanding of eroticism in her personal life. It is important that these drawings are the work of a woman, who at that time would not have been expected to treat such themes. Yet she had a distinctive approach to the world, manifest even in her pseudonym. It was as if Toyen, through her masculine alter ego, was able to shed all of the conventional inhibitions that might have otherwise constrained her. Her treatment of erotic themes did not conform to a passive "femininity," nor to a domineering "masculinity." Under the neutral pseudonym Toyen, she was able to consider sex through the eyes of both men and women, without giving either of them priority. In this respect, Toyen adopted an ambivalent stance. Both sexes were equally important. Nonetheless, a more detailed analysis might suggest that Toyen tended to frame her drawings from a male perspective. Perhaps this was partly because men were the main subscribers of *The Erotic Review*.

In the autumn of 1931, Štyrský launched the *Edition 69* series. Unlike *The Erotic Review*, which was popular and inclusive, *Edition 69* had a distinctly aristocratic stamp. Six volumes were published from 1931 to 1933, each with a unique design. Three presented original Czech works illustrated by Štyrský: Nezval's *Sexuální nokturno* (*Sexual Nocturne*), 1931; Halas's *Thyrsos*, 1932 [CAT. 60]; and Štyrský's own *Emilie přichází ke mně ve snu* (*Emilie Comes to Me in a Dream*), 1933. The other three presented historic works taken from the larger world of erotic literature: a selection from Pietro Aretino's *Ragionamento*, published in Czech as *Život kajícníc* (*The Life of Penitents*), 1932, and the Marquis de Sade's *Justine*, 1932 [CAT. 61], both with illustrations by Toyen; and *Ruské lidové povídky* (*Russian Folktales*), *Edition 69*, volume 5, illustrated by František Bidlo.

Toyen's Eroticism

In the essay "The Inspired Illustrator," the first important reflection on Toyen's book art, Štyrský noted that her illustrations were the opposite of descriptive. They were made by an artist "for whom poetry is a passion."[5] According to Štyrský, literary and artistic works, printed side by side in a single book, should be of equal quality, complementing and augmenting one another. Toyen's drawings were intended for the sort of reader who "only loves those illustrations in the book that enhance his excitement, that thrill him without paralyzing his *creative* approach to the reading material. *Inspired* illustrations."[6] Štyrský's observations apply in particular to the illustrations for private print runs of poetry collections. He might not have said the same of the erotic series that were not supposed to be sold to the general public. For Toyen, there were two categories of erotic illustrations — idealized renderings for books of mass consumption and more explicit depictions intended for bibliophile publications — and she adapted her imagery accordingly. She thus initiated a kind of dialogue with the reader and viewer about the boundaries of the sensual, rejecting restrictions on what could or could not be depicted. In the early 1930s, both types crystallized in distinctive works: her contributions to *Edition 69* and her illustrations for mass-market editions by well-established publishing houses such as Družstevní práce (Cooperative Work). In December 1932, this publisher printed 5,400 copies of *The Heptameron* by Marguerite de Navarre, designed by Ladislav Sutnar with seventy-six illustrations by Toyen [CAT. 62]. In terms of the number of drawings, this book was Toyen's most extensive illustrated work. Toyen illustrated covers and frontispieces for a number of popular novels about love and the erotic during this era as well. Translations of works by D. H. Lawrence were particularly successful and printed in several editions: *Lady Chatterley's Lover* (*Milenec lady Chatterleyové*), 1930, 1931, and 1932; *Women in Love* (*Zamilované ženy*), 1932; and *The Virgin and the Gypsy* (*Panna a cikán*), 1934. The same was true of the translations of Radclyffe Hall, *The Well of Loneliness* (*Studna osamění*), 1931 and 1933, and Louis Charles Royer, *Love on the Isle of Port-Cros* (published in Czech as *Lásky na ostrově Port-Cros*), 1932 and 1933. Although these mass-market publications treated questions of sexuality more openly than the books of the 1920s, Toyen's interpretations of these themes in her illustrations did not fundamentally change, and her depiction of the erotic was restrained, allusive. For the five drawings featured in *The Virgin and the Gypsy*, Toyen focused mainly on the faces of Lawrence's protagonists.

Seen as a whole, Toyen's illustrations of these years mark an important transition in her handling of the figure. In her Artificialist

period, covering almost eight years of steady work, Toyen had actually ruled out figuration. As soon as she started to work on illustrations, her artwork was enriched by a new dimension. Her lack of inhibition in her treatment of human sexuality was unique among artists of her generation. From 1930 to 1933, she guided the reader through all aspects of erotic life, captured in minute detail. She broke boundaries, expanded the limits of what could be depicted, rejected the established customs, and freed eroticism from any suggestion of the ironic, the grotesque, or the obscene. She concentrated on the human body as literally as she could, rejecting outdated prejudices. She knew what emotions she wanted to evoke. When capturing the atmosphere of a text in her illustrations, she focused on physical function, the essence of which clearly attracted and delighted her.

A new feature that appeared in most of Toyen's illustrations from 1932 and 1933 was a closed linear frame-within-a-frame device, which interfered with the straightforward representation. This device filled out, or, on the contrary, etherealized, the hitherto empty linear outline; it created a space for coloring, and for the overlapping and intermeshing of various scenes. The newly introduced linear frames undermined continuity, without fragmenting the body. Given that they had a different shape each time, they shifted the visual focus of the drawing and drew attention away from the figural action. If Toyen had not used them, her illustrations would have looked run-of-the-mill; with them, they acquired another space and a new dimension. In the illustrations for *Justine*, the framing device merged with the vulva and became an expression of the sex organ. Most often, however, Toyen used the frame to break up the picture plane and to offer an abstract field, as in the illustrations for *The Heptameron*. In some illustrations, Toyen directly presented a linear plot. In others, she gave free rein to her imagination. She treated various kinds of intercourse, masturbation, and the boyish lust for a woman's crotch. Nor did she shy away from popular exotic themes; in one drawing, she depicted a black woman masturbating, harking back to her older painting *Ráj černochů* (*Paradise of the Blacks*, 1925). She continued to pursue this fascination in her illustrations for *Legendy a pověsti z Melanesie* (from Bronisław Malinowski's *The Sexual Life of Savages in Northwestern Melanesia*), printed in the third volume of *The Erotic Review* from 1933.

In Toyen's figural paintings from the 1960s, among her most important late works, one can see her reflections on her own

erotic drawings from the beginning of the 1930s. In the paintings *L'un dans l'autre* (*One in the Other*, Paris, Musée National d'Art moderne, Centre Georges Pompidou, 1965), *Paravent* (*Screen*, Paris, Musée d'Art moderne de la Ville de Paris, 1966), *Eclipse* (*Eclipse*, Geneva, private collection, 1968), and *À l'instant du silence des lois* (*When the Laws Fall Silent*, Paris, private collection, 1969), she reintroduced her themes first seen in *The Erotic Review*. Although her imagery was now more sublimated and these connections were subtle, they gave a kind of unity to her work, despite subsequent stylistic transformations. More than thirty years later, this raw imagery had been absorbed to such a degree that it had lost all trace of impulsiveness, acquiring instead a sultry atmosphere, full of ambiguous suggestions, and a more mysterious, profound, sensual nuance.

In her erotic drawings, Toyen expressed an instinctual desire for the vagina and the phallus, as well as a horror of them that perhaps attracted her more as a theme. This is manifest in the six drawings for *Justine*: the bleeding vagina, the welts on the body, the cellar space with the mouse, the hand covering the eyes in fear. In these drawings, Toyen did not represent coitus, only fear of anticipated violence affecting the organs of the body. In *Justine*, she could not perhaps get any closer to the body. The vulvas and phalluses were so enlarged that they took up entire pages. The conspicuous organs that appear in the erotic editions were transformed in Toyen's painting into the hidden symbols in *Jitro* (*Dawn*, 1931, Moravian Gallery, Brno), where the vulva was represented by a crack, opening perhaps into the Earth's interior.

At the same time that Toyen was working on the illustrations for *Justine*, she completed numerous drawings for *The Heptameron*, a book for public distribution, in which, at most, she revealed breasts and idealized the naked human body. The large number of drawings did not result in a stereotypical repetition, although the motif of sweet girlish faces with wide eyes surfaced perhaps too often. The publication of *The Heptameron* was a literary event. With Toyen's illustrations, it was a much more momentous artistic undertaking than any of the earlier editions, more so than, for example, the few stories from *The Heptameron* published in 1915 in the Edice erotická (Erotic Edition), with illustrations by Vratislav Hugo Brunner.

In his essay "The Inspired Illustrator," Štyrský elaborated on the reasons why Toyen chose to illustrate *The Heptameron*: "When we read *The Heptameron*, an extravagant wealth of tales in a constant

state of metamorphosis, when we take in this incredible reservoir of human characters, and when we compare the atmosphere in this work with the rich set of drawings that Toyen created for it, we see that the illustrations for the book could not have been entrusted to more felicitous hands."[7] Štyrský recognized Toyen's unusual focus on women:

In her drawings we find one predominant fondness: a fondness for girlish beauty. Torsos of women, noble eyes full of romantic ennui, terrifying eyes rolled back at the moment of orgasm, eyes gently dimmed at the hour of death, breasts veiled by a flying cloud, stabbed by a dagger, the shadow of a crotch casually covered by lace, the gesture of a hand on a pillow, the string of a bodice undone, the lustful mouth of some vagabond monk, a graceful foot, the bare shoulders of a girl bent over a sleeping youth, the entire repertoire of fawning details that make up the romantic game.[8]

In her illustrations, Toyen demonstrated a unique ability to make do with only a few postures of the body, put in a different context each crowded time. Her understanding of illustrations was reflected in this approach: she so transformed the short list of postures that it lasted her a long while, longer than just one book. Although the stories of *The Heptameron* were set in the first half of the sixteenth century, Toyen made no references to the period in her illustrations. She emphasized the constancy of the state of sensual excitement, which was independent of time or place. For her, the naked female body was a center of alternating patterns of relationship: fidelity and betrayal, candor and deception, desire and disappointment.

Some of the illustrations for *The Heptameron* are unusually dramatic, in particular those in which Toyen's drawing is naturalistic. One thinks, for example, of the fifteenth story, where the hand of the husband, drawn in detail, appears at the young woman's window instead of the hand of the lover. For the thirty-second story, Toyen drew the skull of the dead lover, from which the unfaithful wife had to drink at dinner. Toyen further heightened the tension in her depiction of a girl bound and gagged in the thirty-first story, which tells the tale of a treacherous Franciscan who dragged "a great many women and beautiful girls" off to the monastery. This motif was one of her favorites, which she had treated earlier in the circus painting *Polykači mečů* (*Sword Swallowers*, Prague, private collection), 1924. Indeed, the taboo subject of bondage appears in her frontispieces and illustrations for poetry collections from 1933 to 1934, and Toyen exchanged the rope for barbed wire, which grips the luminous phantom in the painting *Prometheus* (Paris, private collection), 1934. A similar theme appears in *Justine* as well. Thus Toyen covered similar motifs in her books that were for "private consumption," in those that were intended for the general public, and in her paintings, moving easily among the three. Much as her earlier illustrations for *Our World* were cherished by young readers, her drawings for *The Heptameron* were similarly acclaimed by adult audiences, making her Prague's leading illustrator of the 1930s.

Emilie

Štyrský's relationship to erotic themes was distinctly manifest in the three volumes of *Edition 69*. He approached each one from a different angle. While Toyen continued with essentially graphic illustrations, Štyrský focused mainly on the xylographic collage and photomontage. He illustrated Nezval's titillating autobiographical novel, *Sexual Nocturne*, with xylographic collages, which he colored by hand in the first editions. These illustrations were inspired by Max Ernst, whose collage novels were admired by Nezval. For Halas's *Thyrsos* [CAT. 60], Štyrský provided figural drawings in red and black ink on his favorite theme of the relationship between floral motifs and the human body. The neoclassicism of these illustrations was a deliberate tribute to the conscious spirit of antiquity with which Halas had imbued his poems, and the collection was prefaced by a quote from Sophocles: "Not to be born is best, but having seen the light, the next best is to go whence one came as soon as may be."

For the last volume of the *Edition 69* series, Štyrský selected his own work *Emilie Comes to Me in a Dream*, which he accompanied with ten photomontages [CAT. 64]; for the luxury edition he included two additional images. In the flier for the publication, Štyrský offered some instructions for interpreting the material:

The sister of eroticism is the inadvertent smile, the impression of the comic or the quiver of horror. The sister of pornography, however, is always only shame, the impression of disgrace and disgust. Some of these powerfully erotic photomontage compositions will bring a smile to your lips, the rest will elicit a feeling of horror. This erotic cycle, the core of which is the supreme moment of bliss, was inspired by a story that was once related to the artist and for a long while haunted his dreams. This attempt at

iconoclasm provided the only escape from that confusion — with scissors one can separate even the most enduring pair. Male from female, sun from sky, death from the living, dream from life." [9]

Štyrský's important comment on process reveals that he saw himself as a kind of lord of creation, one who could bring anything whatsoever into being by the complementary acts of selection and elimination. With his photomontages, Štyrský wanted to evoke moments of intense pleasure and, at the same time, moments of intense anxiety. This juxtaposition reflects his lifelong fascination with life and death. More interesting than the sex organs and acts of intercourse that he foregrounded in the photomontages are the settings in which he placed them. His protagonists rise from bogs; they are part of the underwater world and the starry sky; they grow like an architectural stem from a beach by the sea. Štyrský did not hesitate to use material that was well known in his day, which he discovered in the albums of close-up photographs of plants by the German photographer Karl Blossfeldt, published in 1928.

Some of Štyrský's ideas in *Emilie Comes to Me in a Dream* are the products of a formidable imagination. Solitary male and female nudes float through the universe, to which they are connected by a kind of protoplasm; embracing figures are watched by a great many spellbinding eyes, a motif that appeared in Štyrský's work as early as 1930. In other photomontages, Štyrský developed the memento mori theme, juxtaposing erotic motifs with coffins and a skeleton. He probably had these photomontages in mind when he wrote for the flier that some of the illustrations would evoke "a feeling of horror." In one of his most celebrated images from this series, a cabaret dancer covers her face with a fan, while below her a woman's genitals are revealed. By her side, Štyrský placed a male skeleton, to which he attached an erect penis. As Matthew S. Witkovsky has established, the skeleton was probably cut out of the cover of the Polish weekly collection of detective stories, *Tajny detektyw* (*The Secret Detective*, September 13, 1931).[10] The skeleton on the cover, designed by Janusz Maria Brzeski, an important representative of the Polish avant-garde, caused a sensation when it was discovered in a cellar at the beginning of the 1930s in Poznań. Both motifs, the human skeleton and the dancer, appeared in Štyrský's book covers from the mid-1920s; this time, however, he gave them an added edge by using motifs of sex organs.

One has to interpret Štyrský's incredibly open, even harrowing, prose in *Emilie Comes to Me in a Dream* in the context of the nineteenth-century poet Karel Hynek Mácha. Interest in Mácha had been roused by Roman Jakobson's lecture "Co je poezie?" ("What Is Poetry?," 1932), delivered at the S.V.U. Mánes (Spolek výtvarných umělců Mánes [Mánes Association of Fine Artists]) in Prague and first published in *Volné směry* (*Free Directions*). In 1836, shortly before his untimely death, Mácha had published *Máj* (*May*); the work was a flop when first published, but it quickly became the most famous poem of the Czech Romantic movement, and *May* continued to inspire artists and poets throughout the next century. Another aspect of Mácha's work was revealed, however, when, many years after his death, his secret diary of erotic experiences was published. Jakobson shocked the bourgeois public when he asserted that "Mácha's diary is every bit as much a work of poetry as *May*. . . . Were Mácha alive today, he might well have set aside the lyrical poetry . . . for his own intimate use, and published the diary."[11]

The concentration on the erotic, which one sees in Czech art at the beginning of the 1930s, was, to a considerable extent, inspired and influenced by developments abroad. These influences included the publications by the Parisian Surrealists (for example, Louis Aragon, Benjamin Péret, and Man Ray) and Dalí's erotic drawings from 1931 to 1933.

NOTES

1 Bohuslav Brouk, "Onanie jakožto světový názor" ("Onanism as a World Outlook"), *Erotická revue* (*The Erotic Review*) 1 (1930–31): 80–82.

2 Ibid., 82.

3 Ibid., 83.

4 Toyen, *Jednadvacet* (*Twenty-one*), 1938. A set of twenty-one original colored drawings on handmade Van Gelder paper. One printing. Reprint: Toyen, *Jednadvacet*, ed. Karel Srp (Prague: Torst, 2002).

5 Jindřich Štyrský, "Inspirovaná ilustrátorka" ("The Inspired Illustrator," 1932), reprinted in *Jindřich Štyrský, Texty* (*Jindřich Štyrský, Texts*), ed. Lenka Bydžovská and Karel Srp (Prague: Argo), 98.

6 Ibid.

7 Ibid., 99.

8 Ibid., 99–100.

9 Jindřich Štyrský, publication flier, 1932, n.p. Publisher not identified.

10 Matthew S. Witkovsky, *Foto: Modernity in Central Europe 1918–1945* (Washington, D.C.: National Gallery of Art, 2007), 113.

11 Roman Jakobson, "What Is Poetry?," in *Selected Writings: Poetry of Grammar and Grammar of Poetry*, ed. Stephen Rudy (The Hague and Paris: Mouton, 1980), 744.

CAT. 56
Pierre Louÿs
Pybrac | 1932
Illustrations (hand-colored): Toyen | Prague: V. Lácha
7 ¾ × 5 ½ inches (19.7 × 14 cm)

PIERRE LOUYS

PYBRAC

SOUKROMÝ TISK

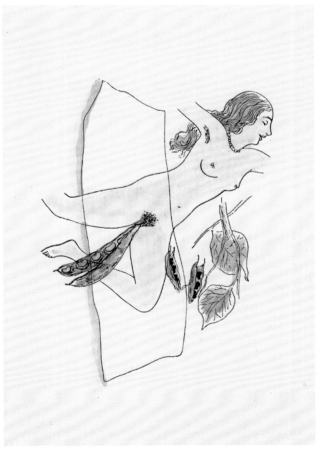

CAT. 57
Jindřich Štyrský (ed.)
Erotická revue [*The Erotic Review*], vol. 1 | 1930
Illustrations: Toyen
8 × 6 ⅛ inches (20.5 × 15.5 cm)

T.: Snící dívka

Jediný smutek Ledy

F. Halas

Ó svůdná labuti, já miluji tě tak
však odpusť mi, zeptat bych se chtěla
proč nemáš krk svůj dlouhý na spodu těla
tam kde vilnosti tvé se tyčí znak

T.: V RÁJI EXOTŮ
(Kresba z r. 1931)

81

Erotická revue

ročník druhý

redigoval J. Štyrský

Praha

květen 1932

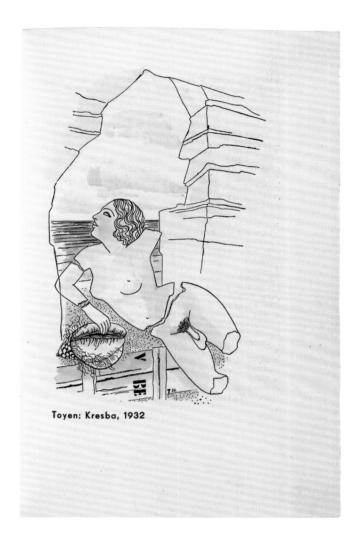

Toyen: Kresba, 1932

CAT. 58
Jindřich Štyrský (ed.)
Erotická revue [*The Erotic Review*], vol. 2 | 1932
Illustrations (hand-colored): Toyen
8 × 5 ½ inches (20.5 × 14 cm)

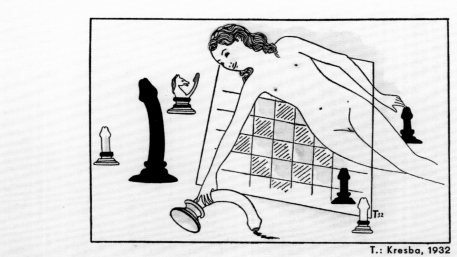

T.: Kresba, 1932

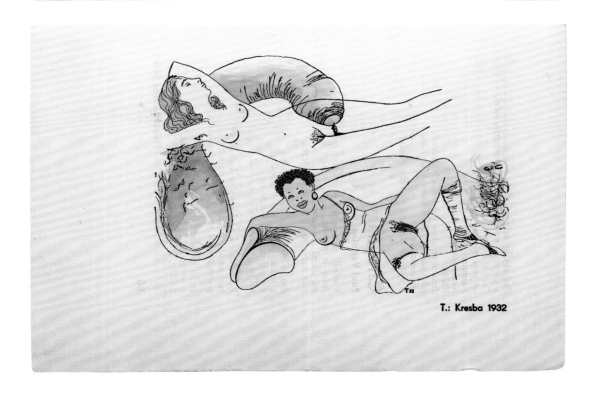

T.: Kresba 1932

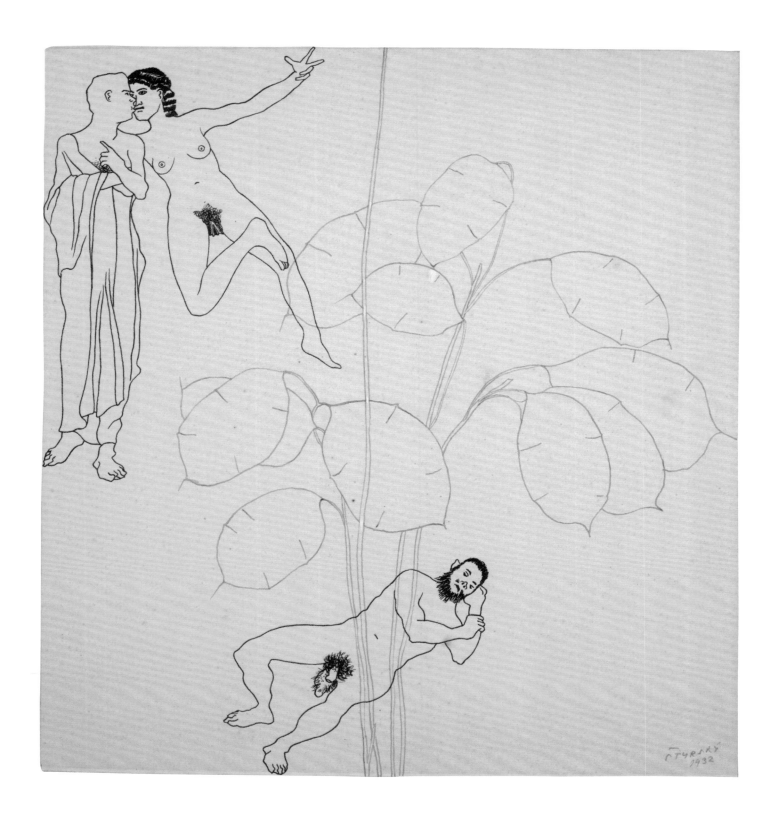

CAT. 59
Jindřich Štyrský
Illustration for Thyrsos | 1932
Ink on paper | 9 × 8 inches (22.9 × 20.3 cm)

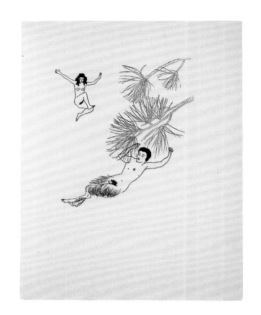

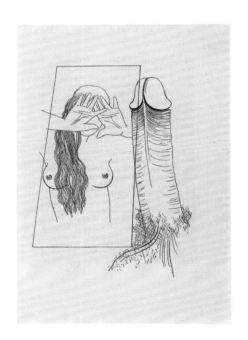

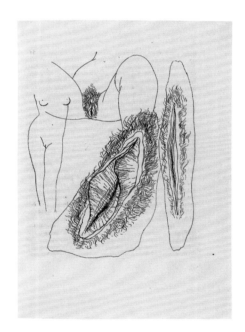

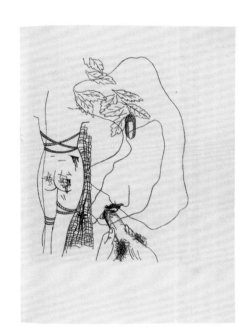

CAT. 60
František Halas
Thyrsos | 1932
Cover, illustrations, and typography: Jindřich Štyrský | Prague: J. Štyrský (Edice 69)
10 ½ × 8 ⅛ inches (26.7 × 20.6 cm)

CAT. 61
Marquis de Sade
Justina [Justine] | 1932
Illustrations: Toyen | Prague: J. Štyrský (Edice 69)
7 ⅞ × 5 ⅛ inches (20 × 13 cm)

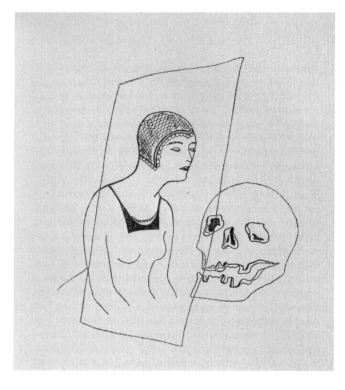

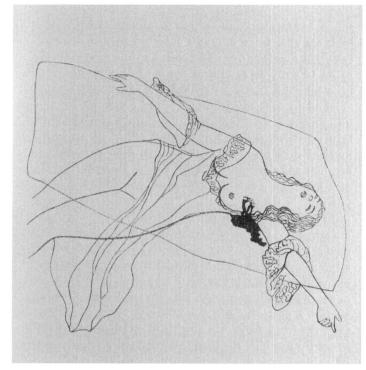

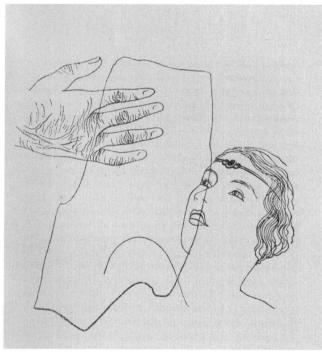

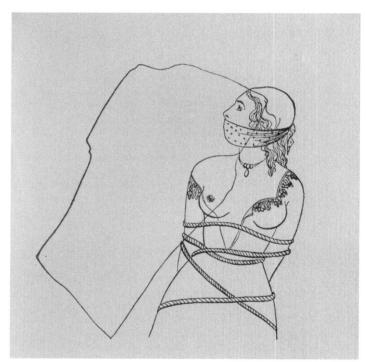

CAT. 62
Marguerite de Navarre
The Heptameron [*L'Heptaméron*] | 1932
Illustrations: Toyen | Prague: Družstevní práce
8 3/8 × 5 3/8 inches (21.3 × 13.5 cm)

Svata Kadlec

ČERNÁ
HODINKA

Soukromý tisk - Brno 1932

CAT. 63
Svata Kadlec
Černá hodinka [*Black Hour*] | 1932
Illustrations: Toyen | Brno: Soukromý tisk (private imprint)
10 × 7 ⅛ inches (25.5 × 18 cm)

CAT. 64
Jindřich Štyrský
Untitled from *Emilie přichází ke mně ve snu* [*Emilie Comes to Me in a Dream*] | 1933
Collage | 12 × 9 ½ inches (30.5 × 24.1 cm)

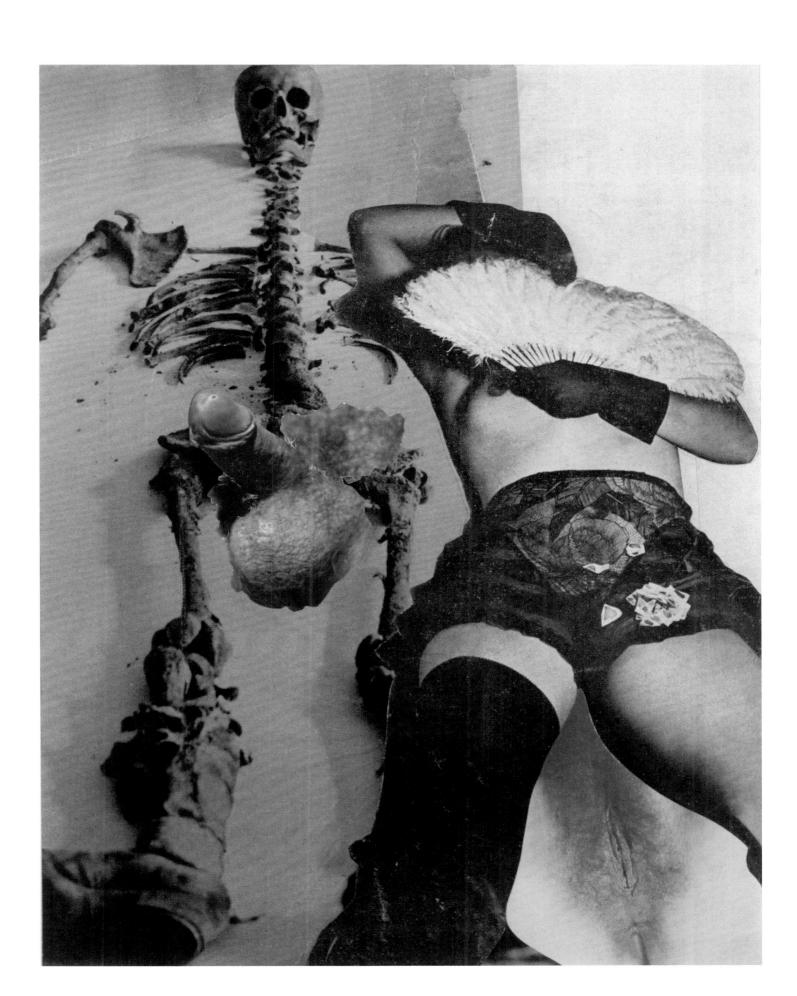

Jindřich Štyrský is the author of the text and ten photomontages *Emilie přichází ke mně ve snu* (*Emilie Comes to Me in a Dream*), which was published as the last volume in his *Edice 69* (*Edition 69*, 1933). Although quite short, its explicit treatment of taboo themes makes it one of the most important texts of Czech interwar literature. Thus far, it has been impossible to identify reliably the real sources of Štyrský's apparently autobiographical "confession." It was most likely based on his dreams, which he recorded from 1925 until just before his death in 1942. Along with Štyrský's *Erotická revue* (*The Erotic Review*), *Edition 69* was an important platform for the Czech avant-garde in their open treatment of the subject of sexuality. In its time, *Edition 69* could only be distributed by post, cash on delivery. Public sale of the series was forbidden.

Originally published as *Emilie přichází ke mně ve snu* (Prague: J. Štyrský, 1933), 3 – 7. Translated as "Emilie Comes to Me in a Dream," trans. Iris Irwin, in *YAZZYK Magazine* (Prague), no. 2 (1993); reprinted in *Emily Comes to Me in a Dream* (New York: Ubu Gallery, 1997), 3 – 5.

Jindřich Štyrský

Emilie Comes to Me in a Dream

Emilie is fading from my days, my evenings and my dreams. Even her white dress has darkened in my memory. I no longer blush as I recall the mysterious marks of teeth I glimpsed one night below her little belly. The last traces of dissimulation impeding the emotion I was ready to feel have disappeared. That troupe of girls is lost forever, smiling uncertainly and with indifference as they remember how their hearts were torn by passion and by half-treacherous humility. Even her face has been exorcised at last, the face I modeled in snow as a child, the face of a woman whose compliant cunt had consumed her utterly.

I think of Emilie as a bronze statue. Marble bodies, too, are not bothered by fleas. Her heart-shaped upper lip recalls an old world coronation; the lower lip demanding to be sucked arouses visions of harlotry. I was moving slowly beneath her, my head in the hem of her skirt. I had a close-up view of the hairs on her calves, flattened in all directions under her lace stockings, and I tried to imagine what kind of a comb would be needed to smooth them back into place. I fell in love with the fragrance of her crotch, a wash-house smell mingled with that of a nest of mice, a pine needle lying forgotten in a bed of lilies of the valley.

I began to suffer from optical illusions. When I looked at Clara her body merged into the outline of Emilie's with the tiny heel. When Emilie felt like sinning, her cunt gave off the aroma of spice in a hayrick. Clara's fragrance was herbal. My hands are wandering under her skirt, touching the top of a stocking, garter knobs, her inner thigh — hot, damp and beguiling. Emilie brings me a cup of tea wearing blue mules. I can never again be completely happy, tormented as I am by women's sighs, by their eyes rolling in the convulsions of orgasm.

Emilie never tried to penetrate the world of my poetry. She looked at my garden from over the fence, so that everyday fruit and ordinary berries seemed the awesome apples of some prehistoric paradise. I moved foolishly along the paths, like a half-wit, like a useless dog with its nose in the grass tracking down death and fleeing its own destiny. I was crazy, seeking to find again that moment when shadows fell across a paved square somewhere in the south. Leaning on the fence, Emilie sped on through life. I can see her so clearly: getting up in the morning with her long hair loose, going to the lavatory to piss, sometimes to shit, and then washing with tar soap. Her crotch made fragrant, she hurried to mingle with the living, to rid herself of the feeling that she was at a fork in the road.

Emilie's smile was a wonderful thing to watch! Her mouth seemed a dried-out hollow, but as you drew near to this upper lode of pleasure, you could hear something trembling down inside her. As she parted her lips for you, a knob of red flesh burst from between her teeth. Age fondles time lovingly. Morality is only safe at home in the arms of abandonment. Her eyes—which never closed at the height of her pleasure—would take on a gleam of heavenly delight and looked ashamed of what her lips were doing.

In the corners where I seek my lost youth, I come upon golden curls carefully laid away. Life is one long waste of time. Every day death nibbles away at what we call life and life constantly consumes our longing for trivialities. The idea of the kiss dies before ever the lips meet and every portrait pales before we can look at it. In the end, worms will eat through this woman's heart too and grin in her entrails. Who could swear then that you have ever existed? I saw you with a lovely naked girl of astonishing whiteness. She lifted her hands and the palms were black with soot. She pressed one hand between your breasts and placed the other over my eyes so that I was looking at you as through torn lace. You were naked under an unbuttoned coat. That single moment revealed your life to me in its entirety: you were a plant, swelling and budding. Two stems rising from the ground grew together and from that juncture you began to wilt. But your body was already taking shape, with a belly, two breasts and a head where two entrancing pink weals swell up. At that moment though, the lower part of your body began to wither and collapsed. And I groveled before you, grunting with love such as I had never known. I do not know whose shadow it was. I called it Emilie. We are bound together forever, irrevocably, but we are back to back.

This woman is my coffin and, as she walks, I am hidden in her image. And, so as I curse her, I damn myself and yet love her, falling asleep with a cast of her hand on my cock.

On the first of May, you'll go to the cemetery and, there in Section Ten, you'll find a woman sitting on a gravestone. She will be waiting for you to tell your fortune from the cards. You will leave her and look for explanations on the walls of boardinghouses for young ladies. But the girls' faces in the windows will turn into budding buttocks and tulip arses and will

quiver as a lorry drives past. You will be crazed with fear that they're going to fall down into the street — fear that is close to the pleasure you felt at your first boyish erection and close to the terror you felt when your sister taught you to masturbate with a *hand of alabaster*.

Who do you think can console you now? Emilie is fragmented, torn scraps of her likeness have been borne away by the wind to places beyond your knowledge, and that is why you cannot call on her to be the medium of your calming. And anyway you have long ago learned not to mourn moments of farewell.

The sky slumbers and somewhere behind the bushes a woman molded of raw flesh is waiting for you. Will you feed her on ice?

Clara always sat on the couch, wearing little and expecting to be undressed. One day she took my revolver from a drawer, took aim, and fired at a picture. The cardinal's hand went to his chest and he fell to the ground. I felt sorry for him and later on, whenever I visited brothels on the outskirts of the city and paid the whores for their skills, I was always aware that I was purchasing a moment of eternity. Any man who once tasted the salt of Cecilia's cunt would sell his rings, his friends, his morals and all the rest just to feed the insatiable monster hidden beneath her pink skirt. Oh, why do we never distinguish the first moments when women treat us as playthings from the time when we drive them to despair? I woke up one night in the early hours, at the time flowers drop their petals and birds begin to sing. Martha was lying by my side, a treasure house of all ways of making love, a hyena of Corinth, lying with her cunt spread open to the dawn. She caught the disgust in my eyes and surely wanted nothing better than to see me nauseated by the filth of her. I watched her sex swelling and pouring out of her cunt, over the bed and onto the floor, filling the room like a stream of lava. I got out of bed and fled madly from the house, not stopping until I reached the middle of the deserted town square. As I looked back, I saw Martha's sex squeezing out of the window like a monstrous tear of unnatural color. A bird flew down to peck at my seed and I threw a stone to drive it away. "You will be lucky, you will repeat yourself over and over again," a passerby spoke to me and added, "Your wife is just giving birth to a son."

Two little sparrows kept rendezvous every noon behind the pale blue corsage of Our Lady of Lourdes. I was innocent when I entered the catacombs. The row of square boxes naturally aroused my curiosity. There were a few boys hanging by their bound feet from the tops of the olive trees, flames roasting their curly young heads. In the next room, I found a bunch of lovely naked girls entwined in a single monstrous living creature like something from the Apocalypse. Their cunts were opening and closing mechanically, some empty, some swallowing their own slime. One in particular caught my eye, the lips moving as though trying to speak, or like a man whose tongue has turned to stone trying to crow like a cock. Another was a smiling rosebud that I'd recognize to this day among a hundred specimens. It was my

dead Clara's cunt, dead and buried, with nobody to wash her body with the mint-scented lotion she loved. Sadly, I brought out my cock and stuck it aimlessly into the writhing mass, uncaring and indifferent, telling myself death always brings debauchery and misfortune together.

Then I put an aquarium on my window sill. I had a golden-haired vulva in it and a magnificent specimen of a penis with a blue eye and delicate veins on its temples. As time went on, I threw everything I had ever loved into it: broken cups, hairpins, Barbara's slippers, burnt-out bulbs, shadows, cigarette butts, sardine tins, all my letters and used condoms. Many strange creatures were born in the world. I felt myself to be a Creator and I had every right to think so. When I had the aquarium sealed up, I gazed contentedly at my moldering dreams until there was no seeing through the mildew on the glass. Yet I was sure that everything I loved in the world was there inside.

I still need fodder for my eyes. They gulp down all they get, greedily and roughly. At night, asleep, they digest it. Emilie scattered her shocked scorn generously, arousing desire in all she met, provoking visions of that hairy maw.

I still remember something that happened when I was a boy. I'd just been expelled from high school and nobody would have anything to do with me. Except my sister. I would go to her secretly in the night. Lying in each other's arms, legs entwined, we slowly dreamed ourselves into the dulled state of all those who lie on the knife-edge of *shame*. One night we heard soft footsteps and my sister nudged me to hide behind the armchair. Our father came into the room, shutting the door quietly behind him, and climbed into her bed without a word. That was when, at last, I saw how one makes love.

Emilie's beauty was not meant to fade, but to rot.

5 In the Service of Surrealism

Karel Srp and Lenka Bydžovská

As collectors, Mary and Roy Cullen have been particularly interested in Surrealism as an unusually influential movement to which the core of the Czech avant-garde belonged in the 1930s. The Cullen collection includes unique, superb works of Czech Surrealism that were famous from the time they were made; it also traces the spread of the new artistic trends in book art.

Although Surrealism has had a lasting impact on Czech art, the Surrealistická skupina v ČSR (Surrealist Group in Czechoslovakia) was not established in Prague until as late as 1934, ten years after Breton's first *Le manifeste du surréalisme* (*Surrealist Manifesto*). This group was not an association of greenhorns, but middle-aged artists who were essentially Breton's contemporaries, born about 1900. They had behind them a rich avant-garde past, and had often engaged in sharp polemics with Surrealists, about whom they were well informed. The motives for their mistrust, or in some cases even radical rejection, of Surrealism, like the motives for their later acceptance of it, were connected with changes in their outlook and in those of the French Surrealist group.

At the time that French Surrealism emerged, the Czech avant-garde championed Poetism. When Czech artists eventually turned to Surrealism, they stressed that the announcement of their Poetist program in July 1924 predated Breton's October manifesto. According to their retrospective interpretation, during the 1920s the Poetist and Surrealist points of view increasingly came to resemble one another until the two trends intersected. This notion of an idyllic affinity between Poetism and Surrealism, proclaimed in the name of dialectical evolution, however, can be identified as an expedient construction, dreamed up after the fact. In many respects, this notion does not correspond to reality. The Czech avant-garde of the 1920s considered itself more politically and artistically mature than the Surrealist movement. The Czechs believed in the victory of the proletariat and in social revolution. They regarded the Soviet Union as the model for the new society of the future, and the Communist Party as the guarantor that this new society would be just. Karel Teige and Vítězslav Nezval, therefore, had serious reservations about the anarchist features of the Surrealist revolt. They did not agree that the artist should submit unconditionally to the principle of psychic automatism and exclude conscious decision-making from artwork. They criticized artistic approaches that relied on old styles. The Surrealists wanted to investigate the essence of the individual and the potential free manifestations of the human spirit. The Poetists,

by contrast, trusting in modern civilization, developed an avant-garde, hedonistic art for all of the senses.

The *Second manifeste du surréalisme* (*Second Surrealist Manifesto*), which was published on December 15, 1929, in the journal *La révolution surréaliste* (*Surrealist Revolution*), provided the key impetus for the shift in the Prague avant-garde's attitude to Surrealism. In this manifesto, Breton endorsed dialectical materialism, the classics of Marxism, and collaboration with the Communist Party of France. Nezval printed a complete translation of the manifesto in December 1930 in the second (and last) issue of his own journal, *Zvěrokruh* (*The Zodiac*). He added excerpts from Karl Marx and Friedrich Engels as epigraphs. A period full of contradictions and reversals ensued, during which the Czechs gradually came to accept Surrealism. On May 9, 1933, Nezval and the theater director Jindřich Honzl ran into Breton and the circle of Parisian Surrealists in a Paris café. On the following day, Nezval gave Breton a letter in which, in the name of the Prague avant-garde association Devětsil, he offered to collaborate with the Surrealist movement. Immediately after that, Nezval's text was printed on May 15, 1933, in the fifth issue of the journal *Le surréalisme au service de la révolution* (*Surrealism in the Service of the Revolution*).

Nezval initially claimed to represent Devětsil, which had united almost the entire Czech avant-garde in the 1920s. By the early 1930s, however, the association was no longer active. Nezval had to establish another base — the Surrealistická skupina v ČSR — if he wanted to develop Surrealism collectively. Its core consisted of a few friends who had been members of Devětsil. Originally, the group had eleven members: nine men and two women. They included the poets Nezval and Konstantin Biebl, the director Honzl, the painters Jindřich Štyrský and Toyen, the sculptor Vincenc Makovský, the author of psychoanalytical studies Bohuslav Brouk, and the composer Jaroslav Ježek.[1] By involving Ježek, Nezval, who loved music, unintentionally distinguished himself from Breton, who hated it.[2] The theoretician Teige joined his friends a little later, as soon as he had resolved a dispute of several years' duration with Štyrský.

In founding the group, Nezval showed his enthusiasm for astrology, which was for him a lifelong preoccupation. Like Breton, Nezval regarded the analogies and symbolism of astrology as essentially poetic. He established the Surrealist group in Prague on the spring equinox, March 21, 1934, at the beginning of the astronomical and astrological year. He was intrigued by the constellation of the spring horoscope, which appeared to promise success for the romantic and distinctly utopian avant-garde movement.

Breton in Prague

The Prague Surrealists pursued a wide variety of activities, organizing exhibitions and debates, and publishing their own work as well as translations of Surrealist literature. They encouraged Breton to visit Prague, and he arrived in the spring of 1935 with his wife, Jacqueline, and Paul Éluard. Nezval had had no difficulty securing invitations for Breton from various Czech cultural institutions because of an unusual surge of interest in Surrealism among Czechs at that time. Not long after the founding of the Prague Surrealist group, for example, about a thousand people attended a four-hour debate on Surrealism held on May 28, 1934. It is hardly surprising that, in this sort of atmosphere, Breton received a hero's welcome. Mark Polizzotti, in his biography of Breton, noted that Breton, who had often met with hostility and deliberate misunderstanding from French intellectuals, felt that he had received public recognition for the first time from the Czechs.[3] Breton prepared thoroughly for his public appearances. "I am obliged to give you something more than a kind of improvisation," he emphasized beforehand in a letter to Nezval, with whom he discussed the topics of the various lectures.[4] Breton wrote two new texts for Prague: the first was for the Spolek výtvarných umělců Mánes (Mánes Association of Fine Artists), which proposed to him the theme "Surrealism in Poetry and Painting."[5] The second was for the Levá fronta (Left Front), which was interested in the revolutionary activity of Surrealism. Breton titled the Mánes lecture "Situation surréaliste de l'objet — Situation de l'objet surréaliste" ("Surrealist Situation of the Object — Situation of the Surrealist Object"). He delivered it for the first time on March 29, 1935, in the Mánes hall before an audience of seven hundred. He read it again on April 4 of that year in Brno and later also in Zurich. For the Levá fronta he prepared the lecture "Position politique de l'art d'aujourd'hui" ("Political Position of Today's Art"), which he delivered on April 1, 1935. (Breton subsequently included both texts in the book *Position politique du surréalisme* [*The Political Position of Surrealism*], published in Paris in 1935.) In Prague on April 3, 1935, he also delivered his Brussels lecture from the preceding year, "Qu'est-ce que le surréalisme?" ("What Is Surrealism?"), which had already

been published. He addressed it to university students in the large lecture hall at the Humanities Faculty of Charles University.

During his lecture tour in Czechoslovakia, Breton provided an accurate and captivating general portrait of the Surrealist movement. He identified the transformations that Surrealism had undergone to date, analyzed the present situation, and reflected on where the movement was headed. He presented Surrealism's current phase as an attempt at a synthesis of Hegelian aesthetics, psychoanalysis, and Marxism. According to Breton, Surrealism was a project that, even at this critical historical moment, had not lost its avant-garde fervor. Indeed, Surrealism continued in its struggle to establish a new, different culture. In his Prague lectures, Breton considered the question of knowledge, focusing on the relationship between consciousness and the unconscious. He also addressed the political question: the liberation of the spirit, which Breton identified as the explicit goal of Surrealism, required the liberation of the individual. Surrealists, therefore, who longed to change the world, looked forward to the proletarian revolution. Breton's remarks reflected the "reasoning" phase of Surrealism in which the first, intuitive phase was intended to become an object of inquiry. At the same time, his theoretical analysis was in response to the deepening political crisis. By "objective chance," in the same year that Edmund Husserl delivered his key lectures in Prague about the "crisis of European humanity," Rudolf Carnap left his position at the Prague German University, and the Prague Structuralists published the first issue of their journal *Slovo a slovesnost* (*Word and Literature*). Thus, disparate intellectual currents intersected in Prague in 1935: Surrealism, phenomenology, logical positivism, and Structuralism. At this point in time, these currents were united by their response to the political crisis, which led to a diagnosis of the pressing state of affairs and proposals on what should be done next.[6]

As soon as it was founded, the Prague Surrealist group began to publish Czech translations of works by the French Surrealists. The first book by Breton to be published in Czech was *Les vases communicants* (*Communicating Vessels*; *Spojité nádoby*) [CAT. 71]. It was released at the end of 1934 by the Mánes association; Nezval and Honzl translated the text. The cover, designed by Toyen, referred to the work of Max Ernst — not his cover for the original French edition of the book from 1932, but rather his collage novels. They were the prototype for Toyen's xylographic collage. Her treatment of the theme of a sleeping man and his dream was based on the "Quietude" scene from the sixth chapter of Ernst's *La femme 100 têtes* (*The Hundred-Headless Woman*, 1930), in which a man with a moustache in formal dress sleeps calmly in an armchair that floats on the sea; in the background, a phallically-shaped lighthouse rises, with a stream of water gushing over it. In Toyen's collage, a sleeping man, covered by a blanket, his head on a pillow, levitates above a table. In his dream, two strange specters appear on bare branches between heaven and earth: a bird of prey that stares at the sleeper as if trying to hypnotize him, and a figure covered by a diving suit, except for its bare legs and a forearm holding a hatchet. On this occasion, Toyen chose an archaic type of diving suit, which she copied from books about alchemy and magic. Thus, she expressly severed the connection between this popular avant-garde motif and modern technology, shifting the diver into the context of the traditional sciences, which held an increasing fascination for Breton and Carl Gustav Jung, among others. Breton approved of the cover. In a letter to Nezval from December 1934, he proclaimed that it was "brilliantly inspired": "It is perfect and for a long time now nothing has pleased me so much."[7] The covers of other translations of Breton's works, published in the 1930s, also had unique designs. Josef Šíma designed the cover for *Nadja* (1935), basing it on one of *Nadja*'s drawings. In 1937 *Co je surrealismus?* (*What Is Surrealism?*) was published; it included Breton's three Prague lectures. The cover featured a striking collage by Teige. In the same year, *Vzduch vody* (*L'Air de l'eau*; *Airwater*) appeared, with illustrations and designs by the young devotees of Surrealism Bohdan Lacina and Václav Zykmund. Štyrský created collages for the translation of Éluard's *La rose publique* (*The Public Rose*; *Veřejná růže*, 1935).

Book Pictures

Among the diverse book designs by Czech artists, Teige's remarkable series of photomontages stands out. He created these for a number of Nezval's works released in the 1930s by the Prague publishing house František Borový.[8] The technique of photomontage offered him space to paraphrase and cite other artists. One can compare Teige's approach to that of Walter Benjamin, whose unfinished *Passagenwerk* (*Arcades Project*) was based on excerpts from diverse authors. Teige often appropriated the work of his colleagues abroad, giving it a "second life" and transforming its meaning. On the black cover of Nezval's *Zpáteční*

lístek (*Return Ticket*, 1933), Teige contrasted a swan, referring to Symbolism, with a locomotive, referring to machine technology [CAT. 65]. Each represented a different kind of beauty. The swan was admired by the Parnassists of the nineteenth century; the locomotive by the Poetists of the 1920s. Teige, however, took the swan from a surprising source — László Moholy-Nagy's avant-garde book *60 Fotos* (*60 Photos*, 1930), with an introduction by Franz Roh. This book provided Teige with material for other collages and books as well. For example, on the cover of Nezval's *Neviditelná Moskva* (*Invisible Moscow*, 1935), Teige developed the Surrealist dialectic of the exterior and the interior, the public and the private, as seen in the relationship between the open arch, on which the lines of an illusive perspective converge, and the crystalline polyhedron of a secret drawer, filled with a photogram by Moholy-Nagy [CAT. 66]. In 1935, Teige devoted a great deal of attention to the second edition of Nezval's *Pantomima* (*Pantomime*) [CAT. 67]. Teige had worked on the first edition of the book in 1924, along with his contemporaries from Devětsil. This time, however, the design of the key early Poetist collection was entirely in his hands. To Nezval's delight, Teige transformed it completely from a Surrealist perspective. On the cover, only a fragment of the female body remained, supplemented by absurd, objective details. The entire effect was of a convulsive, cruel aesthetic.

Teige's subsequent transition from illustration to the montages that were works of art in their own right — the "book picture" — can be traced in his collages for Nezval's Surrealist poetry collections *Žena v množném čísle* (*Woman in the Plural*, 1936) and *Praha s prsty deště* (*Prague with Fingers of Rain*, 1936), and in the second edition of Nezval's first work from 1922, *Most* (*The Bridge*, 1937) [CATS. 68 – 70]. In these collages, Teige heightened the semantic tension by embedding one picture in another, causing previously separate themes to intersect. In the strange montage for *Woman in the Plural*, Teige connected the female body with an interior space. He replaced the Functionalist diagonal with a historicizing staircase. Within the outline of a standing female nude, he cut out the silhouette of another female figure, which he filled with a reproduction of hands playing a piano. Teige rarely used this approach to collage, which the Berlin Dadaists had pioneered. Jiří Kolář later developed this method, which he called "prolage," into one of the basic techniques in his repertoire [CAT. 1].

The architectural motif on Teige's cover for *Prague with Fingers of Rain* is even more striking than that on *Invisible Moscow*. Through the Gothic arch, one sees a painting frame, inside of which are the signs of two historic Prague houses: the House at the Wheel and the House at the Crayfish.[9] House signs also appear on the frontispiece; the main motif there, however, is a large hand extending from a window and holding a violin. This image recalls a similar motif from Ernst's picture *Oedipus Rex* (1922), in which enormous fingers holding a nut protrude from a window. In *Prague with Fingers of Rain*, Teige also included a separate collage with some of his favorite motifs, which heightened the ambiguity of Nezval's poetry: one key stuck in another; fingers touching; a naked girl with a single eye in place of a head and a large ring around her body. These images are attached to the slanted facade of a classicist palace. In his collages, Teige suggested complex relationships between the motifs that he combined. Often he connected the female body, or fragments of the body, with architectural details. One sees this combination in Teige's collages for the second edition of *The Bridge*. The cover, however, differs from preceding covers: the xylograph is no more than an abstract base for the geometrical and typographical composition. Teige's contributions to Nezval's books published by Borový came to an end with the superb cover for the fourth edition of *Básně noci* (*Poems of the Night*, 1938).

For Teige, the photomontage was important because it was a printed picture that could replace the outdated, framed wall painting.[10] As he did in the mid-1920s, Teige continued to promote a different kind of picture that could be widely duplicated in print. He regarded montage as a kind of superstructure composed of diverse features that were not necessarily connected by a dialectical tension. For him, woman was the supreme poetic image. Technical complexities did not deter him from combining xylographic and photographic materials in his photomontages. Whereas the former referred to the nineteenth century, the latter were often only a few years old. Teige combined these two materials in his artistic collages and in his book covers. From the art of previous generations, he selected tried and tested material; from contemporary work, he sometimes chose reproductions that only later became important examples in the history of avant-garde art. His collages constituted a kind of "meta-commentary," reflecting back on the entire history of art.

Roots

The Cullen collection includes *Kořeny* (*Roots*, 1934), a painting by Štyrský, whose history demonstrates the close relationship between the Prague and the Parisian Surrealists [CAT. 75]. Štyrský gave this work to Breton when he visited Prague.[11] The painting subsequently appeared on loan at international Surrealist exhibitions: in 1936 in London, and in 1938 in Paris and Amsterdam. Štyrský showed the painting in public in Prague for the first time at the beginning of 1935, at the first exhibition of the Surrealistická skupina v ČSR, as part of the *Kořeny* (*Roots*) series, which included nine oil paintings.

This series was inspired by Štyrský's visual experiences during his stay in the Šumava mountains in the summer of 1934. At that time, the painter was fascinated by the strange objects that he found on his walks to the Černé (Black) Lake: bizarre tree roots, which were often mirrored in the water. Štyrský took pictures of them. The photographs, which he never reproduced or exhibited, depict tangles of creeping roots. The strange shapes influenced, sometimes closely, sometimes only loosely, Štyrský's hybrid beings. Štyrský isolated peculiar details from the photographs and enlarged them in his paintings to portray suggestive, distinctly tangible forms, which cast black shadows in dramatic lighting. Land and water (and sometimes sky) meet in the shallow space of the background. Sometimes they are clearly distinct from one another; elsewhere they merge. The relationships among them change in the various paintings; the perspective from which the viewer regards the ambiguous roots also changes. Each of the objects is individual, distinct from the others.

In terms of form and content, the *Roots* series draws on other sources of inspiration as well, such as selected themes from Štyrský's dreams. All his life, Štyrský was interested in the subject of the dream object, which Breton had treated in his early work "L'introduction au discours sur le peu de réalité" ("Introduction to the Discourse on the Paucity of Reality," 1927). Štyrský's drawing *Mandragora* (*Mandrake*, 1930) prefigures *Roots*, as do the drawings that refer to concurrent dreams about an eviscerated snake, in particular *Had bez konce* (*Endless Snake*, 1931), which combines phallic and vaginal motifs. A similar object with a gash also appears in one of the paintings from the *Roots* cycle (today in the Západočeská galerie v Plzni [West Bohemian Gallery in Plzeň]), as well as in the painting *Hermafrodit* (*Hermaphrodite*, 1934). Štyrský's study of tree roots in the Šumava region tapped

into deeper levels of his inner world and led to the expression of hidden traumas.

Štyrský's *Roots* fascinated Nezval:

If they are painted in such a way that one can imagine that they might be replaced by real roots, positioned in a lighting that might be replaced here by the red light of dusk, there by moonlight; if one is tempted to replace them with an object, and if they are there-fore substitute objects and thus a kind of hallucination object, then their entire content is in the illusion, which they suggest, in the illusion, which almost always has a highly provocative erotic meaning. While these roots are not always lovers embracing, as is the case with one of them, they are at least ravenous shears, a carnivorous creature of sexual meaning; to sum up, they are hybrid beings.[12]

According to Nezval, they arose in the same way that strange figures and scenes automatically emerge before us out of the patterns on marble café tables, wallpaper, and the moving leaves of trees. Nezval noted that the Prague Surrealists interpreted Štyrský's *Roots* variously:

When thinking of André Breton's words about convulsive beauty, which would be magique circonstancielle, *"magic-circumstantial," nothing came to mind more strongly than the image of a root, placed against the sky and expressing the fleeting drama of an incomparably complex embrace on a raised, forlorn spot. The painting was examined in my presence by several friends whose interpretations differed only in terms of the estimated number of embracing figures. Thus, the hallucinatory object had an obvious romantic meaning. I do not know what I liked best: the movable spider of that mound of kisses or the vision of the ravenous shears or the carnivorous being that looked about as innocent as creatures spied in an isolated spot at the moment of orgasm. It is certain, however, that none of the interpretations selected by the eye of the observer would be the same the next day on viewing the painting again.*[13]

Nezval's reference to Breton conceals a specific connection. In the fifth issue of the journal *Minotaure*, from May 1934, Breton's text "La beauté sera convulsive" ("Beauty Will Be Convulsive"), which ended with a call for "magic-circumstantial" beauty, was illustrated by Brassaï's photograph of a luxuriant tangle of roots

growing from an old potato. This photograph was titled *Magique-circonstancielle* (*Magic-circumstantial*), and it touched on a theme close to Štyrský's *Roots*, as did the illustrations for Max Ernst's poetic text "Les mystères de la forêt" ("The Mysteries of the Forest"), printed in the same issue. These consisted of three photographic close-ups of twisted trunks, suggesting various erotic associations, as well as the 1835 Forestière (Forest) font composed of the bizarre shapes of cut trees, branches, and roots. Štyrský's imagination moved on the same territory as did that of Ernst and Brassaï; his approach, however, based on his perceptions, dreams, and experiences as a painter, was unique.

Štyrský's *Roots* had an impact on poetry, including his own poem "Nejsou tu třešně, ptáci a sítě" ("There Are No Cherries, Birds or Nets Here").[14] Nezval wrote a short poetic commentary on *Roots* for the catalogue of the first Surrealist exhibition, as he did for all of the pictures that Štyrský and Toyen exhibited: "Roots — and yet we will always be uneasy when we sleep with our heads close to the ground."[15] He published a poem on the same theme in the May 1935 issue of *Volné směry* (*Free Directions*).[16] This poem was printed below a reproduction of one of the paintings from the *Roots* cycle (today in the Národní galerie v Praze [National Gallery in Prague]) on a two-page spread with Toyen's painting *Hlas lesa* (*The Voice of the Forest*), likewise with a poem by Nezval. One of the paintings from the *Roots* cycle also appeared in Nezval's article about Štyrský and Toyen in the Surrealist double issue *Cahiers d'art*, published in the autumn of 1935.[17] Four reproductions of *Roots* (including the painting — which Nezval described as "ravenous shears" — from Breton's collection, now in the Cullen collection) appeared in the sole issue of the journal *Surrealismus* (*Surrealism*), edited by Nezval, in Prague in 1936 [CAT. 72].

Photographing Surreality

In the first exhibition of the Prague Surrealist group, Štyrský showed not only paintings but also extensive series of photographs (*Žabí muž* [*Frogman*], *Muž s klapkami na očích* [*Man with Blinkers*]) and collages (*Stěhovací kabinet* [*The Portable Cabinet*]).[18] According to Štyrský, he began to photograph in the early 1920s, yet not until 1934, when he embraced Surrealism, did he fully appreciate the potential that photography held for the Surrealist perception of the world.[19] In the text "Surrealistická fotografie" ("Surrealist Photography"), published in *České slovo*

(*The Czech Word*) on January 30, 1935, as a commentary on the photographic section of the Surrealist exhibition, Štyrský explained his current approach: "The only thing that interests me, indeed, fanatically attracts me in photography today is the search for the surreality hidden in real objects."[20] A photograph, the original contact print of which is today in the Cullen collection, illustrates the article [CAT. 76]. Štyrský worked with a Rolleiflex (6 x 6 cm) camera and archived his contact prints, adhering them to paper, for the most part in original groups according to the time and place of origin. He composed cycles by rearranging various photographs in random order. He entrusted Jaroslav Fabinger, from the Czech Club of Amateur Photographers in Prague, with the task of making the enlargements for the exhibition.

Štyrský concentrated exclusively on a direct style of photography that did not involve manipulations. He did not make use of experimental techniques. His photographs have a static quality that is further emphasized by the absence of living people, who have been replaced by various motifs: curious figures and body parts from fairground posters and advertisements; statues and reliefs, often discarded and disintegrating; plaster dwarves, figurines and tailor's dummies; arranged doll-like figures; masks; and prosthetic devices and diverse anatomical aids displayed in shop windows. Štyrský's main thematic circles included: popular forms of entertainment, represented by all items from fairs, shooting galleries, and even graffiti; the world of consumer goods, which acquired absurd forms in distinctive arrangements inside display windows; and motifs from cemeteries and burial establishments, which dominated the cycle *Pařížské odpoledne* (*Parisian Afternoon*, 1935).

From the beginning, Štyrský's photographs suggested a connection with Eugène Atget, whom the Czech avant-garde artists admired, as did the Parisian Surrealists. In addition to the obvious similarities, however, there were marked differences between the artists. Atget's characteristic perspective preserved the connection between the objects photographed and their milieu; he catalogued them as documents of the era. Štyrský, by contrast, wrenched fragments out of their original settings. In focusing attention on close-up details, he gave them a monumental dimension. He stripped the objects of their original functions and revealed their ambiguities. Štyrský transformed them into personal fetishes, into phantoms — "the extremely material and yet elusive occupants of a dream."[21]

Most of Štyrský's Surrealist photographs date from 1934 and 1935. Štyrský continued to exhibit his work from this period in the late 1930s at photography exhibitions organized by the Mánes association.[22] In 1941 the photographs inspired the young poet Jindřich Heisler, who had joined the Prague Surrealist group right before the war, to collaborate with Štyrský on a book titled *Na jehlách těchto dní* (*On the Needles of These Days*). This book includes thirty of Štyrský's photographs from the cycles *Man with Blinkers* and *Frogman*. Heisler wrote the accompanying poetic sequence, which was a free, irrational interpretation of the selected photographs. Heisler stuck bandages on the pages of the book, which he prepared for the banned Edice surrealismu (Surrealist Edition). The book was published officially in a design by Teige (with twenty-nine photographs) in 1945 immediately after the war by the Prague publishing house of František Borový.

Artificial Beings

From 1934 through 1935, Štyrský pursued with a passion not only photography but also collage, a form that had long attracted him. This new surge of interest in collage led to the creation of the extensive, loose cycle *Stěhovací kabinet* (*The Portable Cabinet*). At the Surrealist exhibition where it was first displayed, *The Portable Cabinet* included sixty-six collages, two of which are now in the Cullen collection [CATS. 73 and 74]. According to Nezval, Štyrský worked systematically on the collages from the autumn of 1934 to January 1935. In the book *Řetěz štěstí* (*Chain of Fortune*), Nezval notes that about December 13, 1934, Štyrský told him: "In the past few days I've constructed a number of artificial figures, as I've wanted to do for some time: a figure with a spear of asparagus for a body, to which is attached one of those old-fashioned shoes for women that we spoke of not long ago; a female figure with a body consisting of an old-fashioned ottoman and a head from an ad for increasing bust size; and several other poetic figures that I find equally exciting."[23] Štyrský focused on the creation of "new beings," which he often mentioned in his texts from the 1930s. He gave life to creatures that had never existed before. He overturned values, bringing objects to life and objectifying the human body. Symbols of sexuality and death fascinated Štyrský. His female, male, and child figures were fundamentally unrealistic, yet at the same time they were far from Giuseppe Arcimboldo's type of grotesquerie, in which images of vegetables, fruits, and

flowers are combined to form portraits. They represented the tension between the exterior and the interior, and disintegrated into isolated fragments: eyes, mouth, breasts, legs, and arms, as well as the skeleton and internal organs. Štyrský was intrigued by the process of ruin, often symbolized by a rash or boils. He made new combinations of objects that fired his imagination: an axe, for example, or a bathtub, a chimney, a cigar, shoes, or food, in particular fruit, vegetables, and raw meat. These appeared in one collage after another. Štyrský introduced the same motif in various semantic contexts, thereby increasing its resonance and ambiguity. He reevaluated the original meaning of objects, which were often consumer goods from everyday life. Štyrský found the most direct route from the given to the possible, paying particular attention to psychoanalytical interpretations. He found the most diverse symbols in the phenomenal world for the male and female sex. Many of his collages have a clear sexual symbolism. He situated his artificial beings either in an empty background, in order to underline the essence of their unexpected structure, or in reproductions of interiors or landscapes. In the latter case, the overall impact was intensified by the atmosphere of this setting, which suggested a certain mood, certain memories, or ideas that the artist subverted through his intervention.

Štyrský drew on a number of different source materials simultaneously. In addition to the xylographs that Ernst had popularized, Štyrský quickly appropriated other components (kitsch color prints, anatomical atlases, price lists, icons, and advertisements), which he used to express his criticism of religion, and of bourgeois and consumer society. He thereby fundamentally expanded new areas of sensibility, which had no prototype in older art, and enriched the techniques of the Parisian Surrealists with his innovations. Štyrský and Ernst often used similar materials and motifs. Unlike Ernst's Surrealist collage novels, however, Štyrský's collages in *The Portable Cabinet* cycle were not set in a narrative sequence, nor were they illustrations. Rather, each could stand on its own as a picture.

With *The Portable Cabinet*, Štyrský found himself on the threshold of a different type of artwork based on a kind of "cross-fertilization": he elevated what was ordinary and overlooked, while downplaying what was conventionally considered important. He overturned the relationship between the elevated and the low, the sacred and the profane. More so than any other work by Štyrský, *The Portable Cabinet* brims with sarcasm and ridicule, black humor

and paradox. The negative dialectic could not have been more compelling, and it generated a semantic reconstruction.

For the Prague Surrealist group, *The Portable Cabinet* collages functioned as a kind of manifesto for a new artistic outlook. They figured prominently in the group's three main publications: on the cover of the catalogue for the first exhibition (1935); on the title page of the first issue of *Mezinárodní bulletin surrealismu / Bulletin international du surréalisme* (*International Surrealist Bulletin*), on which the Prague and Parisian Surrealist groups collaborated in the spring of 1935; and on the cover of the *Surrealismus* (*Surrealism*, 1936) review [CAT. 72]. In 1938 he gave the latter to the avant-garde playwright and director E. F. Burian, who at that time was attracted to Surrealism and involved in organizing exhibitions. The original color print that Štyrský used in the collage depicts an anecdotal scene enacted in a nineteenth-century, bourgeois interior: a ballerina embraces one man, while another man wearing a monocle observes the pair numbly from an open door. Below the picture, a caption is printed in five languages: "One's good fortune, the other's misfortune." Štyrský thoroughly caricatured the awkward romantic scene: he covered the embraced man with an image of a skeleton and all sorts of internal organs; on the woman's skirt, he stuck a shape resembling a crack, which a child, covered in a rash, holds onto as if it were the site of his birth. In the collage, Štyrský vividly exposed the falsehood in human relationships. By covering the original figures with cuttings from anatomical atlases, he penetrated below the surface and revealed the true motives behind their behavior.

Štyrský's passion for collage inspired caricature. In 1936 and 1937, Antonín Pelc created a number of caricatures in which Štyrský typically appeared as the owner of a "shop selling real objects" [CAT. 77]. In this manner, Štyrský was associated with the Surrealistic objects, the bizarre configurations of fragments from reality, found in his collages as well as in his 1936 painting *Trauma zrození* (*The Trauma of Birth*). For these caricatures, Pelc employed both collages and pen-and-ink drawings, and worked with Surrealist principles: he established new connections between objects and actions, determined solely by an internal meaning.[24]

After he completed *The Portable Cabinet*, Štyrský continued to make collages, although no longer at such a prodigious rate, and to develop and transform his conception of collage. In June 1936, the Prague Surrealist group published the anthology *Ani labuť ani Lůna* (*Neither Swan nor Moon*) to mark the hundredth anniversary of the death of the Czech Romantic poet Karel Hynek Mácha [CAT. 78]. The Surrealists regarded Mácha as their predecessor, and their anthology constituted a protest against the official Mácha celebrations. Štyrský and Toyen each produced four xylographic collages for the anthology; in each of these collages, they connected their own favorite themes with a direct reference to a specific work by Mácha, further underlined by a quotation that served as the title. Two of Štyrský's collages for the Mácha anthology are about the "trauma of birth," the theme that he treated in the monumental painting of the same title. (With this work, he returned to painting after a serious illness.) In the collages, he radically reevaluated nineteenth-century French and German landscape lithography with his colorful anatomical depictions. He created an inventive backdrop for the scene inspired by the line "O sword! O my image!" from Mácha's *Kat* (*The Executioner*), using a dark, pleated cloak instead of a landscape. The cloak appeared in a lithographic portrait by Karl Gussow, which Štyrský turned on its side. He then covered the face in the portrait with an image of two men holding swords. Thus, a mysterious, oppressive space emerged from a specific figural representation.

In her collages for the Mácha anthology, Toyen situated empty items of clothing and underwear in Romantic natural settings; the garments refer to the human body and at the same time emphasize its absence. In the collage titled *Ani labuť ani Lůna* (*Neither Swan nor Moon*), she developed Mácha's metaphor: the kerosene lamp that stands on a rock replaces the gleaming full moon, and the corset that drifts over the lake replaces the snow-white swan. In this period, the corset motif so intrigued Toyen that she returned to it repeatedly, treating it from various perspectives. On the cover of Bohuslav Brouk's study *Manželství — sanatorium pro méněcenné* (*Marriage — A Sanatorium for Menials*, 1938), Toyen used the motif sarcastically, whereas no satire was suggested in the major painting *Opuštěné doupě* (*Abandoned Burrow*, 1937). The themes in Toyen's Mácha collages are those that most appealed to her imagination: eroticism, death, desire, and abandonment. In many respects, they had a distinct impact on her work up to the 1960s: the kerosene lamp appears on her cover for Breton's book *La lampe dans l'horloge* (*The Lamp in the Clock*, 1948). Empty garments were a permanent feature in her pictures from the 1950s on. In Toyen's Mácha collage titled ". . . *ztracený lidstva ráj*" (". . . *man's lost paradise*"), the animal world is represented by a claw attached to the frame of a painting of an idyllic, floral still

life, which hangs in a rocky landscape at night. In the same period, the claw motif appears in an even more vicious form in the crucial painting *Poselství lesa* (*The Message of the Forest*, 1936), which is one of the key pieces in the Cullens' Surrealist collection [CAT. 80].

World of Phantoms

In *The Message of the Forest*, Toyen developed an idea that had informed three of her paintings from 1934, all titled *Hlas lesa* (*The Voice of the Forest*). She showed them at the first exhibition of the Prague Surrealist group. One of them she gave to Paul Éluard early on. This painting subsequently appeared regularly in the late 1930s at major international Surrealist exhibitions. After Éluard's death, the painting ended up in the collection of the Musée d'art et d'histoire in Saint-Denis. The two other versions of *The Voice of the Forest* remained in Czech collections: the larger painting, which belonged to Nezval, is today in the Moravská galerie v Brně (Moravian Gallery in Brno); the smaller painting is in the Národní galerie v Praze (National Gallery in Prague). All versions of *The Voice of the Forest* depict an elusive, threatening specter offset against an Informel style of background suggesting tree bark. In the search for new sources of inspiration, Toyen made good use of her Artificialist period. At that time, using such daring techniques as the relief layering, roughening, gouging, pouring, and spraying of paint, she managed to evoke both visual and tactile perceptions. According to Nezval, the main shift from Artificialism to the first phase of Toyen's Surrealism consisted in the attempt to incarnate a feeling in a peculiar, unidentifiable object: "Toyen's phantom fledglings embodied the twilight that Toyen had tried so many times to evoke in her earlier paintings."[25] They are imaginary, nocturnal birds of prey with soft, fluffy feathers, but without eyes, beak, claws, or any other kind of specific descriptive detail. The actual shape of the body is hidden under ruffled feathers, into which viewers can imagine plunging their hands. The physical qualities of the feathers suggest erotic associations of the sort that Meret Oppenheim drew on when she created her famous fur teacup and saucer, *Le déjeuner en fourrure* (*Breakfast in Fur*, 1936). In the various versions of *The Voice of the Forest*, dark, interior spaces yawn inside the gaps; the bird-phantoms seem to form around these gaps and collapse back into them again.

Nezval was enthusiastic about this group of three paintings: "The impact of these owls, attached as if by a choking kiss to the shadowy, ever unstable network of trees, was a mystery to me until I saw that their empty heads, tilted back and separated from their bodies, were symbols veiled in horror, about the origin of which there could be no doubt. These creations, to which Breton's *explosante-fixe*, 'fixed-explosive,' so aptly applied, epitomized for me the concrete meaning of Breton's phrase about convulsive beauty."[26] In the catalogue for the first exhibition of the Surrealist group, Nezval provided a poetic commentary on the paintings: "The voice of the forest — the gale of frayed trees blew all the lacerated cushions down onto a single heap." He wrote the poem "Hlas lesa" ("The Voice of the Forest") about the painting that Toyen gave him. It begins: "A vacuum more terrible than a gunshot wound."[27] In the same period, Nezval's fascination with this subject also found expression in the libretto, with lighter fairy-tale and folksy elements, that he wrote for the radio opera *Hlas lesa* (*The Voice of the Forest*). Bohuslav Martinů composed the work in the spring of 1935. In the same year, on October 6, Czechoslovak radio broadcast the opera for the first time. The works that Toyen had given him had an impact on Nezval's imagination when he wrote poems about his own decalcomania in 1937. At that time, he dreamt up the Owl Man as well as other hybrid creatures; Nezval gave verbal form to this being in the poem of the same name included in the "Decalcomania" section of his collection *Absolutní hrobař* (*The Absolute Gravedigger*).

In modern art, the themes of the forest and night are closely linked with Romanticism, which the Surrealists consistently admired. One can see this connection, in the Czech setting, in the Surrealist Mácha anthology. The theme of the forest has been associated with the female principle; it represents wild, unconstrained plant life, and symbolizes the unconscious. Ernst had a lifelong fascination with the mystery of the forest, which inspired a number of his paintings, and with the technique of frottage. His interest in the forest was connected to an early childhood experience and to his admiration for the German Romantics, in particular Novalis, Ludwig Achim von Arnim, and Franz Brentano. Ernst featured this theme in his text "Les mystères de la forêt" ("The Mysteries of the Forest"), published in the fifth issue of *Minotaure* in May 1934. A year later, in the seventh issue in June 1935, the journal returned to the theme of nocturnal nature, in the literal and figurative sense, as an important source for the Surrealist imagination. It printed a long text by Jacques Delamain about owls ("Oiseaux de nuit. Chouettes et hiboux" ["Night birds: Owls"]), accompanied by numerous photographs. Of course, the

owl motif had appeared in earlier Surrealist iconography. Éluard's collection, for example, included not only Toyen's *The Voice of the Forest* but also a pastel drawing that Valentine Hugo had made during one of the Surrealist games of 1932. Breton had written the sentence "*La verité tomberait du ciel sous la forme d'un harfang*" ("Truth would fall from the sky in the form of a snowy owl"), and immediately he and Éluard challenged Hugo to illustrate it on the spot.[28]

According to Teige, Breton's lecture about the Surrealist object, delivered in Prague in the spring of 1935, may have influenced Toyen's and Štyrský's development "from the intuitive stage of Surrealism to a new phase, which one might call the phase of objective surreality."[29] Their new approach was first manifest in two large paintings from 1936: Štyrský's *The Trauma of Birth* and Toyen's *The Message of the Forest*. Both paintings were shown at the intergenerational *Výstava československé avantgardy* (*The Czechoslovak Avant-Garde Exhibition*), which opened in Prague in the spring of 1937. Teige interpreted them as "mental objects," as "paintings in which the world of the free imagination acquires the same convincing, self-evident, and objective density as the world of everyday reality. In these paintings, the imagination searches for a world that would correspond to it in the realm of phenomenal reality."[30] The hulking owl-phantom reappears in altered form in *The Message of the Forest*. The basic outline of the bird is based on the version of *The Voice of the Forest* that Toyen gave to Éluard; this time, however, the bird has no black body cavity. In contrast to the earlier painting, this one has a realistic, aggressive detail: the phantom digs a claw into a girl's head. (A human hand, one of the objects depicted in Štyrský's *The Trauma of Birth*, has similar claws. They are derived from the xylographic claws that Toyen incorporated into one of her collages for the Mácha anthology.) The second leg of the bird of prey in *The Message of the Forest* ends — characteristically — in a hollow stump. The owl's head and the girl's head are the same size and are located on the same axis. One head is veiled in feathers; the other is uncovered, but equally inscrutable. The pale female face is striking on account of its languid, calm expression, like that of a sleepwalker. It is as if the phantom dominates the girl's thoughts and emotions.[31]

Once again, Nezval provided an interpretation of the painting: "In *The Message of the Forest*, Toyen reveals . . . a concrete, irrational situation, expressing an objective coincidence, which consists in the chance encounter of a woman's head with a phantom of the woods. In doing so, she shows us that what has hitherto been considered incompatible — a subjective painting style and an objective idea that functions as a symbol — is uniquely disposed to create, through its misalliance, a concrete, irrational figment of the imagination *par excellence*, which is to say the specter."[32] One can draw an imaginary line from *The Message of the Forest* to the painting *Nebezpečná hodina* (*Dangerous Hour*, 1942), in which a bird of prey merges with a man to form a hybrid being, a majestic eagle with blood-red lips instead of an eye, and human hands press against sharp fragments of glass. The wounding claws that appeared in *The Message of the Forest* have been transformed here into vulnerable hands, yet the disturbing contrast between cruelty and pleasure remains, as does the expression of deceptive calm, which provokes an intense feeling of anxiety in the viewer. According to Breton, Toyen's "purely spectral period," which had begun with *The Voice of the Forest*, culminated in *Dangerous Hour*.[33] In other respects as well, *The Message of the Forest* constituted an important turning point. It raised a crucial theme in Toyen's work, to which she continued to return until the end of her life: the power of nature, represented by beasts and birds of prey, over the human world and its laws. One can see similarities between *The Message of the Forest*, *Paravent* (*Screen*, 1966), *À l'instant du silence des lois* (*When the Laws Fall Silent*, 1969), and *Les affinités électives* (*Elective Affinities*, 1970).

The impact of Surrealism on Czech art of the 1930s was by no means restricted to the Prague Surrealist group. It attracted many young and middle-aged artists. The most distinctive among them, František Janoušek, is represented in the Cullen collection [CAT. 84]. From the mid-1930s on, his work was marked by a tragic outlook, expressed in dramatic, eccentric painting techniques, a contrasting, dark range of color, and dynamic, threatening new formations. Janoušek depicted chaos, destructive processes, mutilation, decay, and the disintegration of the natural order. A powerful, inner energy permeates his works, articulating a profound horror at the imminent catastrophe, devastation, and ruin of European culture.

Janoušek's response to Parisian Surrealism was original. He was interested in metamorphoses and the merging that occurred among human, plant, and animal forms in the development of a new natural mythology. His works have elements in common with those of Joan Miró, Max Ernst, and Salvador Dalí. Some of Janoušek's

vigorous, dramatic visions resemble those of André Masson from the end of the 1930s, or those of Kurt Seligmann. Janoušek, however, could have known of their current work only from reproductions in *Minotaure*. Rather than a direct influence, these artists more likely shared an inner affinity with Janoušek, which yielded similar results.[34] Janoušek's phantom objects and mythical hybrid beings are corroded within; at the same time, outwardly they grow morbidly, perniciously. The paintings give material form to an alarming yet artistically fascinating vision of the destructive proliferation of colorful fibers from which an apocalyptic world of phantoms is born.

NOTES

1 The three other young writers, whom Nezval brought to the group — Imre Forbath, Josef Kunstadt, and Libuše Jíchová (Katy King) — did not play an active part in its activities.

2 In the interwar period, the Czech Surrealists did not establish close ties with the Brussels Surrealist group, in which music played an important role.

3 Mark Polizzotti, *Revolution of the Mind: The Life of André Breton* (London: Bloomsbury, 1995), 414.

4 Letter from André Breton to Vítězslav Nezval from January 18, 1935, in Vítězslav Nezval, *Depeše z konce tisíciletí (Dispatches from the End of the Millenium)*, ed. Marie Krulichová, Milena Vinařová, and Lubomír Tomek (Prague: Československý spisovatel, 1981), 74.

5 Most of the members of the Surrealist group were also members of the Czech modernist Mánes association. The first exhibition of the Surrealistická skupina v ČSR opened in the Mánes building on January 15, 1935.

6 See Miroslav Petříček, "Setkání surrealismu s fenomenologií v magické Praze" (The Encounter between Surrealism and Phenomenology in Magical Prague"), in Lenka Bydžovská and Karel Srp, eds., *Český surrealismus 1929–1953 (Czech Surrealism 1929–1953)* (Prague: Argo – Galerie hlavního města Prahy, 1996), 106–11.

7 Nezval, *Depeše z konce tisíciletí (Dispatches from the End of the Millenium)*, 71.

8 See Karel Srp, *Karel Teige a typografie. Asymetrická harmonie (Karel Teige and Typography: An Asymmetrical Harmony)* (Prague: Arbor vitae, 2009), 154–87.

9 The interest in Prague house signs, sparked by Breton's and Éluard's visit to Prague, was still manifest in a set of paintings by Toyen from the early 1950s.

10 Karel Teige, "Fototypografie" ("Phototypography"), *Typografia (Typography)* 40, no. 8 (1933): 178.

11 At that time, Toyen gave Breton her painting *Prometheus*, and Éluard *The Voice of the Forest*. Štyrský gave Éluard the paintings *Sodom a Gomorha (Sodom and Gomorrah)* and *Člověk krmený ledem* (*Man Fed on Ice*). In addition, Štyrský gave collages and Toyen watercolors to their French friends.

12 Vítězslav Nezval, "První výstava surrealismu v Praze (1935)" ("The First Surrealist Exhibition in Prague, [1935]"), in *Dílo (Oeuvre)*, vol. 25, ed. Milan Blahynka (Prague: Československý spisovatel, 1974), 163.

13 Vítězslav Nezval, "Úvodní slovo" ("Introduction"), in Vítězslav Nezval and Karel Teige, *Štyrský a Toyen (Štyrský and Toyen)* (Prague: Fr. Borový, 1938), 13.

14 Jindřich Štyrský, *Poesie (Poetry)* (Prague: B. Stýblo, 1946), 13.

15 Vítězslav Nezval, "Názvy obrazů Štyrského" ("The Titles of Štyrský's Paintings"), in Nezval and Teige, *Štyrský a Toyen (Štyrský and Toyen)*, 110.

16 Vítězslav Nezval, "Kořeny" ("Roots") in Nezval and Teige, *Štyrský a Toyen (Štyrský and Toyen)*, 108. See the English translation in this catalogue, p. 179.

17 Vítězslav Nezval, "Štyrský – Toyen," *Cahiers d'art (Art Notebooks)* 10, nos. 5–6 (1935): 135.

18 Štyrský exhibited twenty-two paintings, seventy-four photographs, and sixty-six collages.

19 The earliest photographs that Štyrský published are of the ruin of Lacoste Castle, which he visited in the summer of 1932. See the monographs on Štyrský's photography: Annette Moussou [Anna Fárová], *Jindřich Štyrský. Fotografické dílo 1934–1935 (Jindřich Štyrský: Photographic Work 1934–1935)* (Prague: Jazzová sekce, 1982); and Karel Srp, *Jindřich Štyrský* (Prague: Torst, 2001), in Czech and English, bibliography on p. 166).

20 Jindřich Štyrský, *Jindřich Štyrský, Texty (Jindřich Štyrský, Texts)*, eds. Lenka Bydžovská and Karel Srp (Prague: Argo, 2007), 131.

21 Vítězslav Nezval, "Neviditelná Moskva" ("Invisible Moscow," 1935), in *Dílo (Oeuvre)*, vol. 31 (Prague: Československý spisovatel, 1958), 31.

22 Štyrský showed five photographs at the *Mezinárodní výstava fotografie*

(International Photography Exhibition, March 6–April 13, 1935), which featured the international avant-garde headed by Man Ray. Lubomír Linhart organized the exhibition. Štyrský showed the cycles Parisian Afternoon and Frogman (altogether forty-seven photos) at the Fotografie (Photography) exhibition, February 22–April 3, 1938, which included the work of six members of the Mánes photography division. Jaromír Funke opened the exhibition and Linhart wrote the text for the catalogue.

23 Vítězslav Nezval, Řetěz štěstí (Chain of Fortune, 1936), in Dílo (Oeuvre), vol. 32, ed. Milan Blahynka (Prague: Československý spisovatel, 1980), 188.

24 Miroslav Lamač, Antonín Pelc (Prague: NČSVU, 1963), 8. See also: Ondřej Chrobák and Tomáš Winter, eds., V okovech smíchu. Karikatura a české umění 1900–1950 (In Chains of Laughter: Caricature and Czech Art 1900–1950) (Prague: Galerie hlavního města Prahy, 2006), 67–71.

25 Vítězslav Nezval, "Surrealismus Štyrského a Toyen. Proslov na vernisáži obrazů Štyrského a Toyen v lednu 1938 v Praze" ("The Surrealism of Štyrský and Toyen: A speech delivered at the opening of an exhibition of paintings by Štyrský and Toyen in January 1938 in Prague"), in Dílo (Oeuvre). vol. 25, ed. Milan Blahynka (Prague: Českolovenský spisovatel, 1974), 375.

26 Nezval, "Úvodní slovo" ("Introduction"), in Nezal and Teige, Štyrský a Toyen (Štyrský and Toyen), 14.

27 It was printed, along with the poem "Kořeny" ("Roots") and reproductions of the two paintings, in Volné směry (Free Directions) 31, nos. 8–9 (1935): 202.

28 José Pierre, L'Universe surréaliste (The Surrealist Universe) (Paris: Somogy, 1983), 185; Sylvie Gonzales, ed., Paul, Max et les autres: Paul Éluard et les surrealists (Paul, Max, and the Others: Paul Éluard and the Surrealists) (Saint-Denis: Éditions de l'Albaron, 1993), 127, 147.

29 Karel Teige, "Doslov" ("Epilogue"), in Nezval and Teige, Štyrský a Toyen (Štyrský and Toyen), 195.

30 Ibid.

31 In 1938, Toyen created a gentler, "children's" version of this theme in the introductory drawing for Nezval's translation of the book Nekoga (Long Ago, Dávno), by the Bulgarian writer Dora Gabe.

32 Nezval, "Úvodní slovo" ("Introduction"), in Nezal and Teige, Štyrský a Toyen (Štyrský and Toyen), 17. In connection with the "chance encounter of a woman's head with a phantom of the woods," one should mention a passage from Alfred Brehm's Tierleben (Life of Animals), a copy of which Štyrský owned: "There is no doubt that even the common owl engages in wild hunts, and whoever has experienced such a thing, like Schlacht, will swear that he was hunted by a terrifying predator. Schlacht gives this account: 'On one occasion, the sudden appearance of an owl gave me a terrible fright. It was in the evening in January and I was standing quietly with my gun on the watch for game. All of a sudden, I felt soft wings waft over me like some kind of ghostly apparition. But at that instant a large bird flew down onto my hat, which was pulled down over my face, and settled there. It was a large common owl, which chose a human head for a post from which it might look around for prey.'" Brehmův život zvířat. Ptáci. Dravci II (Brehm's Life of Animals: Birds, Birds of Prey II) (Prague: Gutenberg, 1930), 117–18.

33 André Breton, "Introduction à l'oeuvre de Toyen" ("Introduction to Toyen's Work"), in André Breton, Jindřich Heisler, and Benjamin Péret, Toyen (Paris: Éditions Sokolova, 1953), 15–17.

34 Jindřich Chalupecký, František Janoušek (Prague: Odeon, 1991), 242.

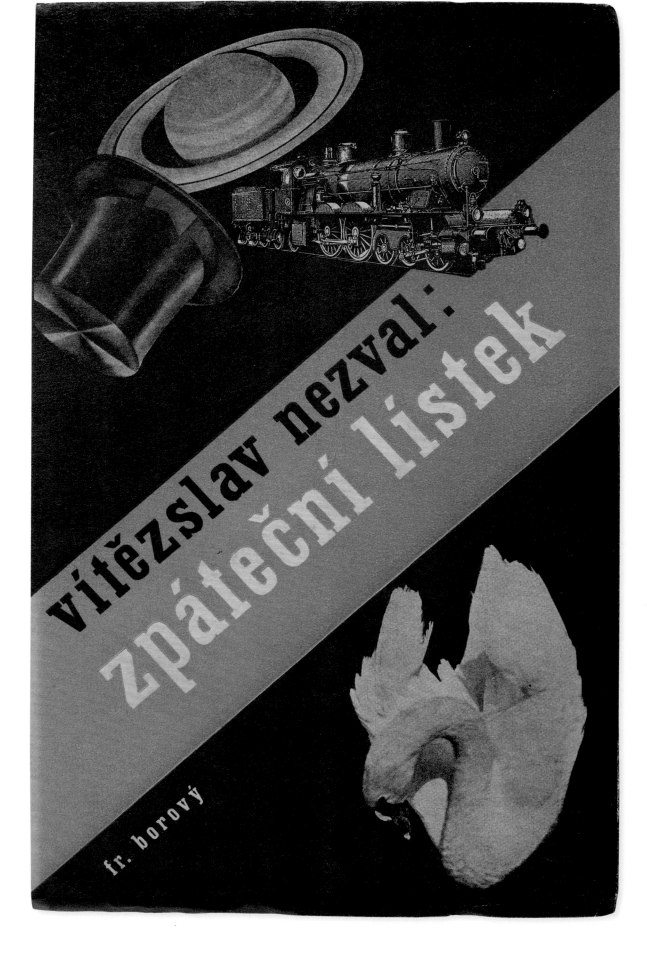

vítězslav nezval:
zpáteční lístek

fr. borový

CAT. 65
Vítězslav Nezval
Zpáteční lístek [Return Ticket] | 1933
Cover and typography: Karel Teige | Prague: František Borový
8 ³⁄₈ × 5 ³⁄₈ inches (21.3 × 13.5 cm)

CAT. 66
Vítězslav Nezval
Neviditelná Moskva [Invisible Moscow] | 1935
Cover and typography: Karel Teige | Prague: František Borový
8 ¹⁄₂ × 5 ³⁄₈ inches (21.5 × 13.8 cm)

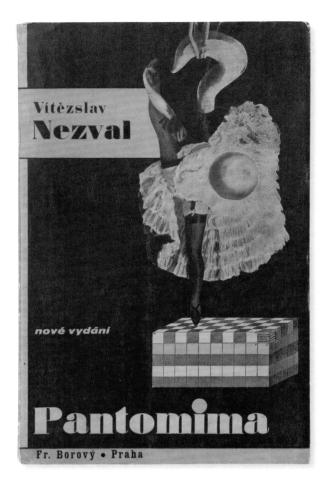

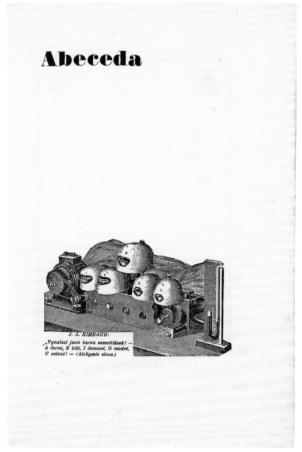

CAT. 67
Vitězslav Nezval
Pantomima [*Pantomime*] | 1935
Cover, illustrations, and typography: Karel Teige | Prague: František Borový
8 ½ × 5 ⅜ inches (21.5 × 13.5 cm)

Rodina harlekýnů

Depeše na kolečkách

Papoušek na motocyklu

Týden v barvách

Malíři Štyrskému

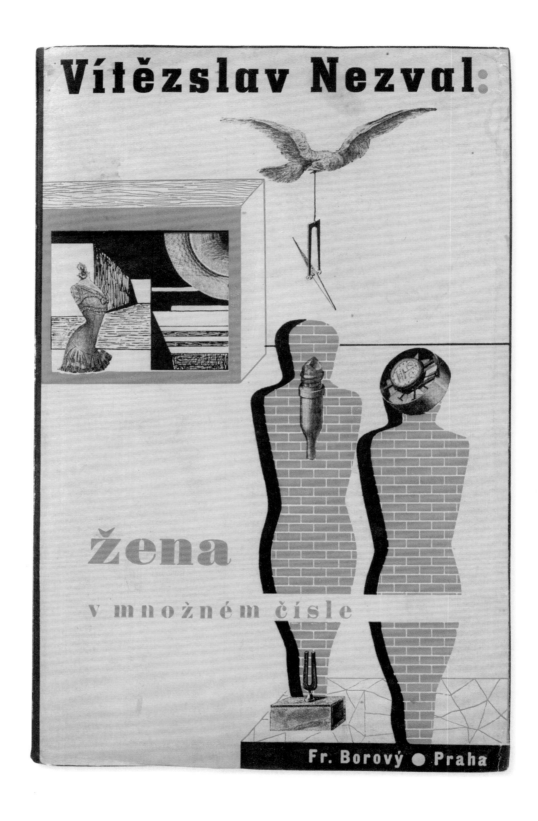

CAT. 68
Vítězslav Nezval
Žena v množném čísle [*Woman in the Plural*] | 1936
Cover, illustrations, and typography: Karel Teige | Prague: František Borový
8 ½ × 5 ⅜ inches (21.5 × 13.8 cm)

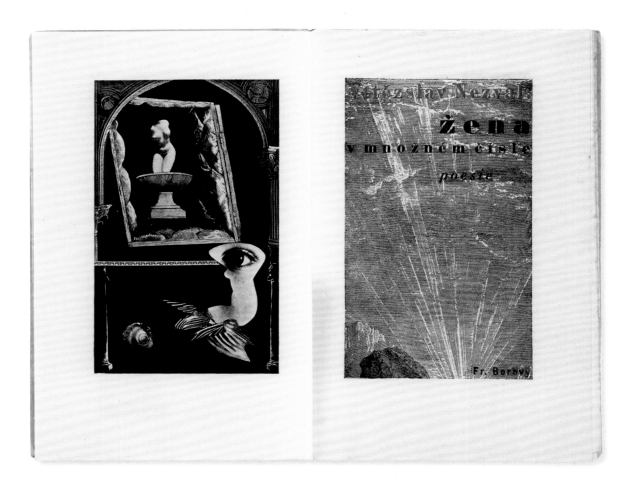

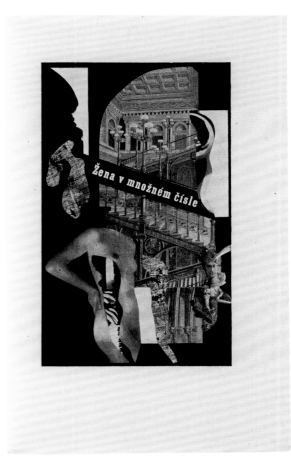

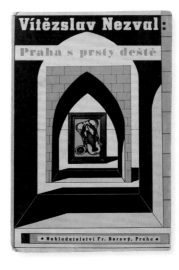

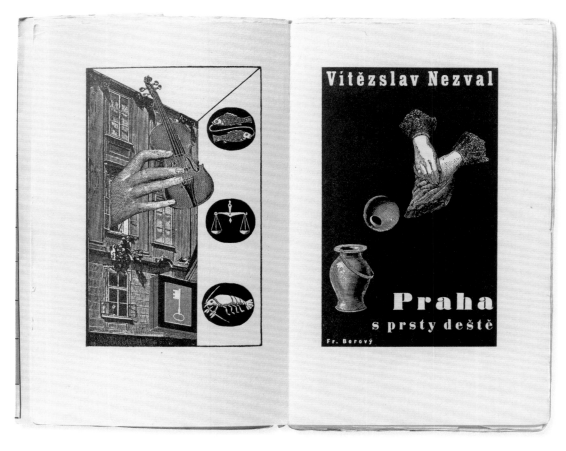

CAT. 69
Vítězslav Nezval
Praha s prsty deště [*Prague with Fingers of Rain*] | 1936
Cover, illustrations, and typography: Karel Teige | Prague: František Borový
8 ½ × 5 ⅜ inches (21.5 × 13.5 cm)

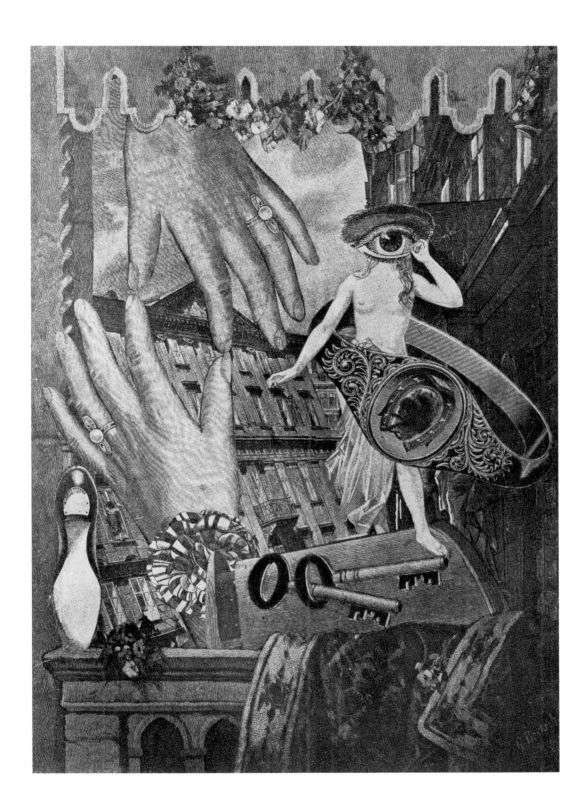

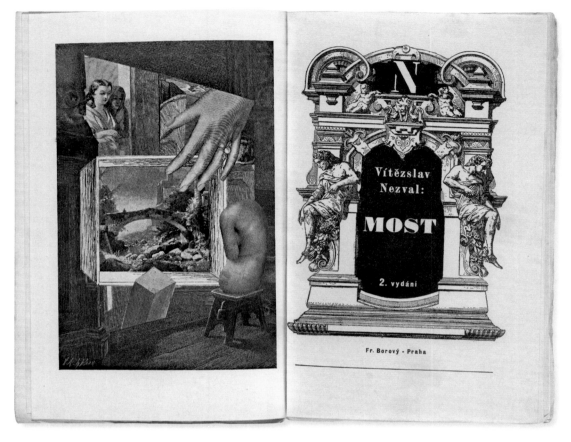

CAT. 70
Vítězslav Nezval
Most [*The Bridge*] | 1937
Cover, illustrations, and typography: Karel Teige | Prague: František Borový
8 ½ × 5 ⅜ inches (21.5 × 13.8 cm)

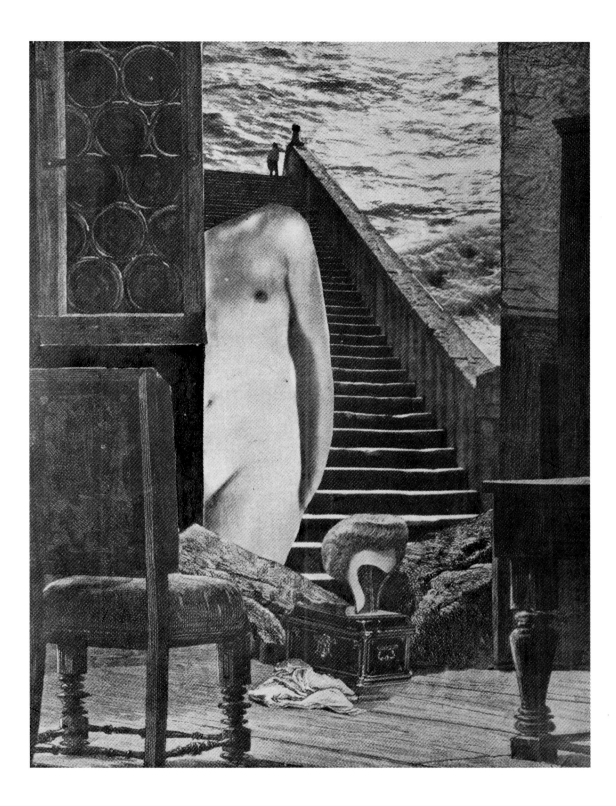

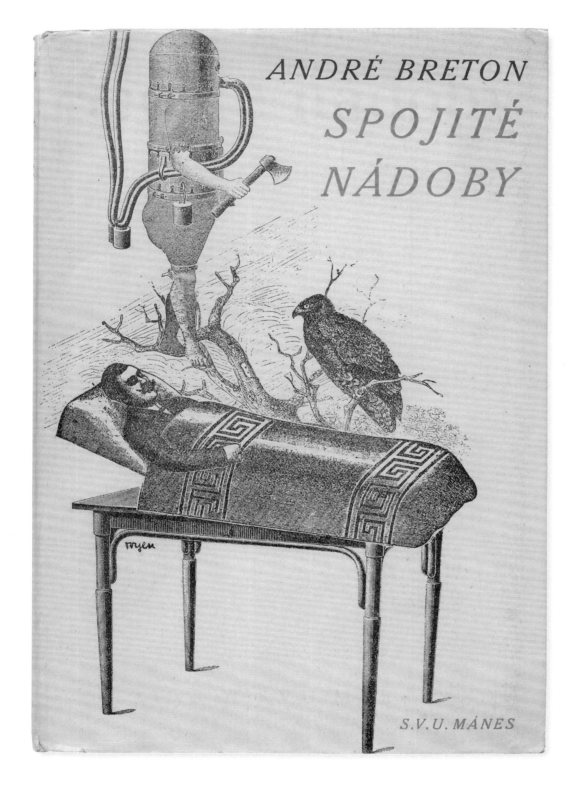

CAT. 71
André Breton
Spojité nádoby [*Les vases communicants; Communicating Vessels*] | 1934
Cover: Toyen | Prague: S.V.U. Mánes
7 7/8 × 5 3/8 inches (20 × 13.5 cm)

CAT. 72
Vítězslav Nezval (ed.)
Surrealismus [*Surrealism*] | 1936
Prague: Edice surrealismu
7 7/8 × 5 3/8 inches (20 × 13.5 cm)

CAT. 73
Jindřich Štyrský
Untitled from *Stěhovací kabinet* [*The Portable Cabinet*] | 1934
Collage | 16 ⅜ × 13 inches (41.5 × 33 cm)

CAT. 74
Jindřich Štyrský
Untitled from *Stěhovaci kabinet* [*The Portable Cabinet*] | 1934
Collage | 15 ¼ × 10 ⅛ inches (38.7 × 25.7 cm)

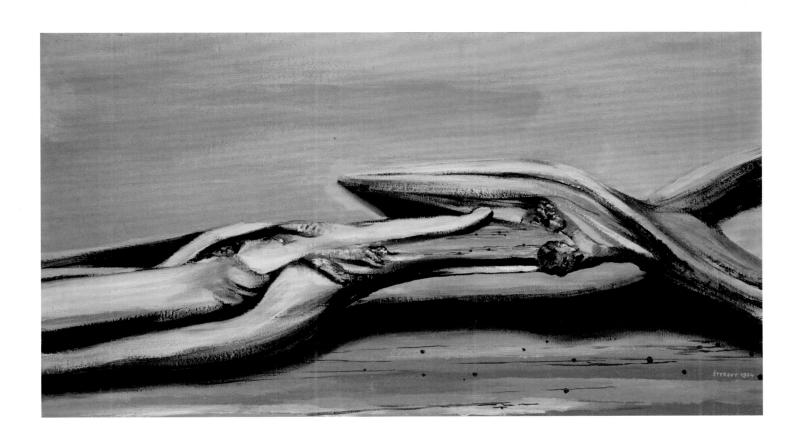

CAT. 75
Jindřich Štyrský
Kořeny [*Roots*] | 1934
Oil on canvas | 12 ½ × 19 ¼ inches (31.8 × 48.8 cm)

CAT. 76
Jindřich Štyrský
Untitled | 1934
Silver gelatin contact print | 2 ³⁄₈ × 2 ³⁄₈ inches (6 × 6 cm)

CAT. 77
Antonín Pelc
Jindřich Štyrský | 1937
Ink and collage on paper | 22 ⁷⁄₈ × 17 ³⁄₄ inches (58.1 × 45.1 cm)

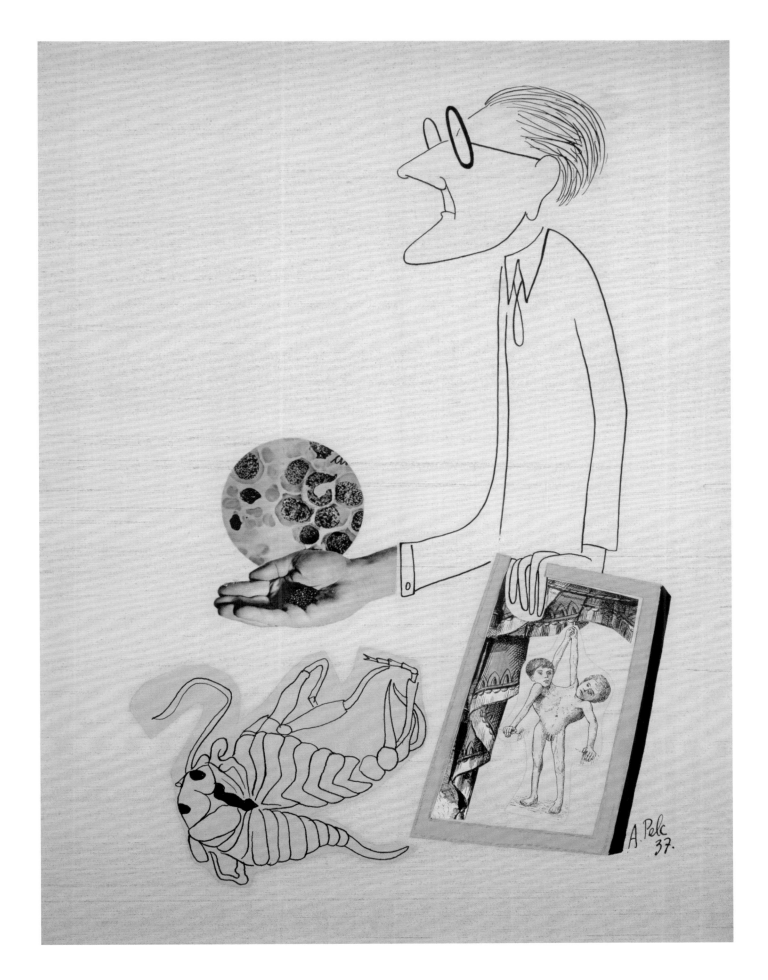

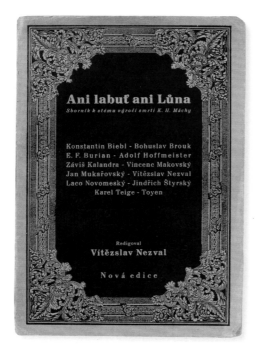

Jindřich Štyrský: »...a v běhu rozličné jim činiti otázky.«
K. H. Mácha: Pouť Krkonošská

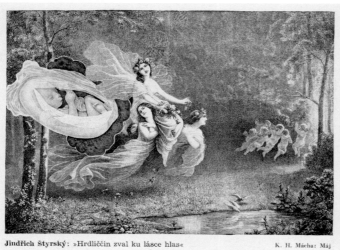

Jindřich Štyrský: »Hrdličin zval ku lásce hlas«
K. H. Mácha: Máj

Jindřich Štyrský: »Meči! obraze můj!«
K. H. Mácha: Kat

Jindřich Štyrský: »...a hodina porodu jeho buď poslední životu mému, jestliže křivě přisahala jsem tobě!!!«
K. H. Mácha: Přísaha

CAT. 78
Vítězslav Nezval (ed.)
Ani labuť ani Lůna [*Neither Swan nor Moon*] | 1936
Illustrations: Jindřich Štyrský (p.172) and Toyen (p.173) | Prague: Otto Jirsák
8 ⅜ × 5 ¾ inches (21.3 × 14.8 cm)

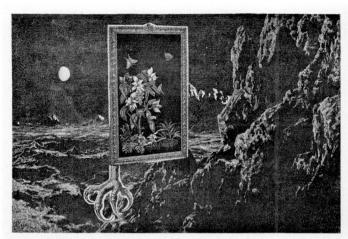

Toyen: »...ztracený lidstva ráj« K. H. Mácha: Máj

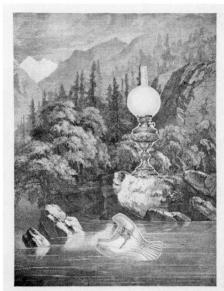

Toyen: »Ani labuť, ani Lůna« K. H. Mácha

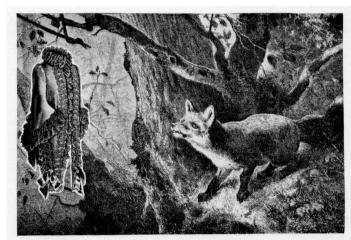

Toyen: »Dalekáť cesta má — Marné volání!« K. H. Mácha: Cikáni

Toyen: »Dobrou noc. Vzal kalendář.«
 K. H. Mácha: Deník na cestě do Italie. (1834)

CAT. 79
Jaroslav Durych
Na horách [In the Mountains] | 1933
Cover: Toyen | Prague: Melantrich
7 ⁷⁄₈ × 5 ¼ inches (20 × 13.3 cm)

CAT. 80
Toyen
Poselství lesa [The Message of the Forest] | 1936
Oil on canvas | 63 × 51 inches (160 × 129 cm)

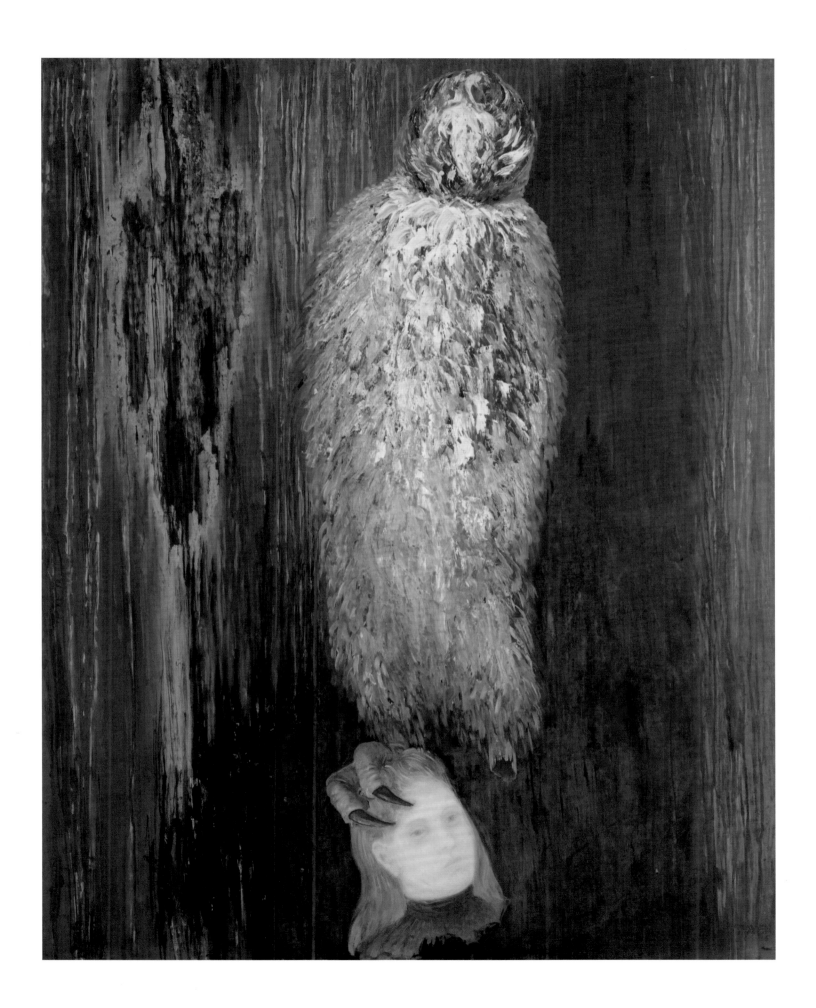

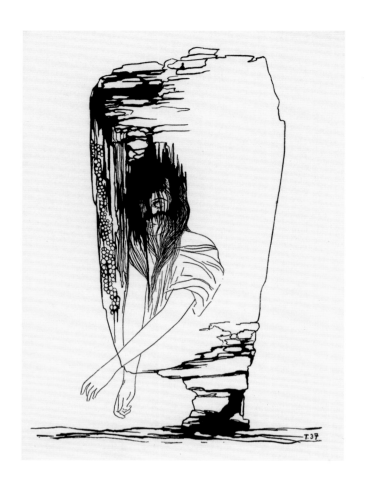

CAT. 81

Vítězslav Nezval

Antilyrique [*Antilyric*] | 1936

Frontispiece: Toyen | Paris: Guy Lévis-Mano

10 × 7 ⅝ inches (25.5 × 19.5 cm)

CAT. 82

Emanuel z Lešehradu

Básníkův rok [*The Year of the Poet*] | 1940

Frontispiece: Toyen | Prague: author's edition

6 ⅛ × 4 ⅜ inches (15.5 × 11 cm)

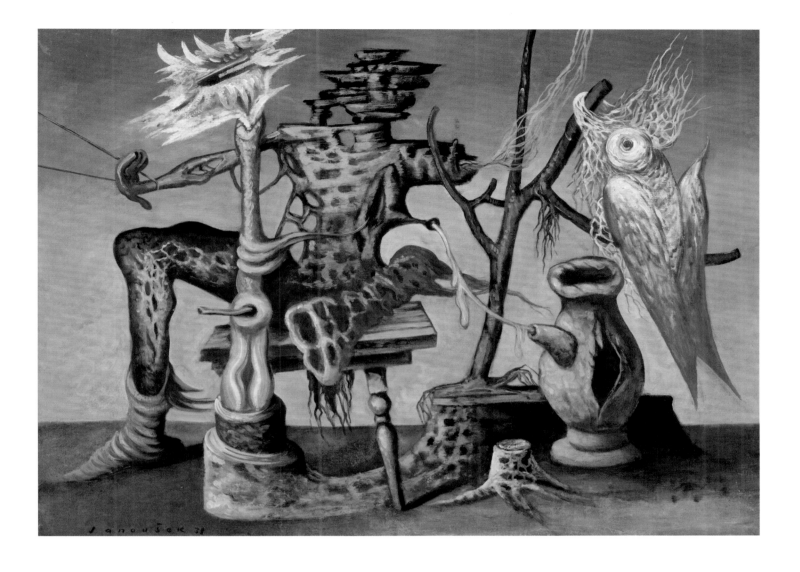

CAT. 83
František Janoušek
Obraz [*Painting*] | 1938
Oil on canvas | 25 × 34 inches (63.5 × 86.4 cm)

Toyen's painting *Hlas lesa* (*The Voice of the Forest*) and Jindřich Štyrský's *Kořeny* (*Roots*) [CAT. 75] inspired two poems by Vítězslav Nezval, which were printed in the journal *Volné směry* (*Free Directions*) in 1935, published by the Spolek výtvarných umělců Mánes (Mánes Association of Fine Artists). In the early 1930s, both painters had joined this association, which offered them opportunities to show their art regularly at the members' exhibitions. Mánes organized the exhibition *Poesie 1932* (*Poetry 1932*, 1932) and the first exhibition of the Skupina surrealistů v ČSR (Surrealist Group in Czechoslovakia, 1935). The poems represent the culmination of Nezval's relationship, as a poet, to the art of Štyrský and Toyen, a relationship that dated from their Artificialist period when Nezval invented titles for and wrote short poems about their paintings. All of Nezval's poetic responses to Štyrský's and Toyen's work were collected in the 1938 monograph on the painters by Nezval and Karel Teige published by František Borový.

Translated by Kathleen Hayes. Originally published as "Hlas lesa" ("The Voice of the Forest"), *Volné směry* (*Free Directions*) 31, nos. 8–9 (1935): 202.

Vítězslav Nezval

The Voice of the Forest

To Toyen

A vacuum more terrible than a gunshot wound
Ball lightning that scorched a well in the forest
And in the brief flare of sparks from burning feathers
A witch from Macbeth's cave emerges
Neither smoke nor feathers
Feathers and smoke
Or those old gigantic trees scarred by the teeth of primeval people
In the smoking heaths of winged cyclones
A voice whistling in the draft of the open vistas of the forest with no door
That terrifies the deer
Stars like wisps of plucked feathers
In this lofty vault
Reeking of worm-eaten wood
The voices of the forest that astonish the wind
Night or love
Neither night nor love
Love and night

Translated by Kathleen Hayes. Originally published as "Kořeny" ("Roots"), *Volné směry* (*Free Directions*) 31, nos. 8–9 (1935): 203.

Vítězslav Nezval

Roots

To Jindřich Štyrský

If the walker returns
He will no longer find the sunny noon
Or the evening
If the walker looks back
He will see death
We went on
Eyes and roots and the wildest beasts
Nearby the black hat of night lies overturned
A card with the qualities of a mirror
I see nature of a thousand years ago when the bark of trees did not yet proclaim a lover's hardness
Velvet snakes in lairs from which primeval horsetail coal
yawned at us
Or the glow of a mantle with faerie eyes
You saw in the loveless abandoned forest
The marriage of roots branches and rotten grasses
Dells after nightfall empty of people
More shadowy than a theatre of masks than orgiastic
processions of women than the flame of a lamp
Evening turns the forest leaves for you
In the windless beauty always magic circumstantial

The first exhibition of the Skupina surrealistů v ČSR (Surrealist Group in Czechoslovakia) opened in early 1935 at the exhibition hall of the Mánes Association of Fine Artists in Prague. The catalogue for the exhibition, with a collage by Jindřich Štyrský on the cover, documented the journey, of several years' duration, that led Karel Teige, Vítězslav Nezval, Štyrský, and Toyen from Poetism and Artificialism to Surrealism, with ever closer contacts with André Breton and other members of the Paris Surrealist group.

Translated by Kathleen Hayes. Originally published as "Surrealismus není uměleckou školou" ("Surrealism Is Not a School of Art"), in *První výstava Skupiny surrealistů v ČSR* (*The First Exhibition of the Surrealist Group in Czechoslovakia*) (Prague: S.V.U. Mánes, 1935), 3–5.

Karel Teige

Surrealism Is Not a School of Art

A sign stating that SURREALISM IS NOT A SCHOOL OF ART should be put up in front of the door of the first exhibition of the Group of Czechoslovak Surrealists, over the entrance to the exhibition hall where the paintings, sculptures, photographs, and montages by *Toyen*, *Jindřich Štyrský*, and *Vincenc Makovský* are installed.

This statement, this emphatic reminder, has to be explained. Almost all modern artistic "isms" have aspired to be something broader and more all-encompassing than a mere artistic method. Not only Poetism, but Impressionism too saw itself as an atmosphere of life rather than an artistic trend. Expressionism was considered to be an ideology; Constructivism had a tendency to become a methodology for all artwork in the field of material culture. In the trend to overstep the narrow boundaries of "mere art" one can see a need to smash the framework of the existing artistic fields and genres and to break out of the vicious circle of art for art's sake.

Surrealism breaks through the framework of the categories and specialized spheres of intellectual activity to a far greater extent than did the abovementioned isms. The products of Surrealism cannot be neatly labeled as either art or science. Does Breton's work *Les vases communicants* [*Communicating Vessels*] not have an entirely new structure, which synthesizes poetic, scientific, and philosophical components? Is Crevel's book *Les pieds dans le plat* [*Putting My Foot in It*] not a combination of a novelistic lampoon, social reportage, and political commentary?

One cannot permit Surrealism and its activities to be interpreted as just another new aspect of avant-garde art. One cannot permit Surrealism to be restricted to the sphere of art, the boundaries of which, for that matter, have been expanded almost infinitely, even

completely erased, by avant-garde poets and painters in recent decades. Surrealism is not simply a school of art: it is *a certain human stance, which engages the whole individual*" (Guy Mangeot). Art—the creation and renewal of painting, poetry, and theater—is not the goal of the Surrealists but rather an instrument, one of the ways that can lead to the liberation of the human spirit and of human life in general, on condition that it identify with the direction of the revolutionary movement of history.

Just as one cannot condone the crippling and curtailing of Surrealism entailed by reducing it to an artistic movement, likewise one cannot agree with the expansion of Surrealism outside its own terrain, the heralding of Surrealism as a new philosophy, a new ideology. Far from it, Surrealism is not simply an "artistic revolution"; nor is the "Surrealist revolution," a special revolutionary and social doctrine. Surrealism is neither a specific creative method nor a specific philosophy. The philosophy, the ideology of Surrealism is dialectical materialism, which Surrealists endorse wholeheartedly, and which they do not intend to revise or supplement with any kind of foreign theory. And when Surrealists say the word REVOLUTION, they understand it in exactly the same way as do the proponents of the social movement that is based on the ideology of dialectical materialism. In all sectors, Surrealism bases its activities on the philosophy that emphasizes *the primacy of matter over thought*, and teaches that *it is within our powers to understand the world completely and to change it*; that is, on the philosophy of dialectical materialism. Surrealism's proper terrain and sphere of interest is man, *the authentic individual with a mind and a body*, and in particular the sphere of his thought, and the dialectic of the relationships between expression and reality. With its distinctive methods of research, its microscopes, probes, and acid tests, Surrealism tries to analyze objectively, to dissect and to identify thought as it is in reality, and to understand the complexity of the relationships between existence and thought. Of course, Surrealism cannot be reduced to certain scientific spheres, for example, the sphere of psychology, even if some of its working and experimental methods are sometimes closer to science than to what is usually understood by the term "art." For that matter, consistent materialists cannot condone the summary separation of art from science by an impenetrable Chinese wall. On more than one occasion, modern psychologists have admitted that art has often provided them with more valuable information and material than scientific studies.

At the risk of a certain degree of inaccuracy, which is inherent to any scheme, one can divide Surrealist activity into three areas: *poetic*, *experimental*, and *critical* activity. *Poetic* activity is the component of Surrealism that is closest, to put it generally, to what is usually called art. *Experimental* activity, on the border between art and science, is rather closer to science. *Critical* activity leads to theoretical and practical work that is socially revolutionary. These three aspects of Surrealist activity cannot be separated from one another; they are interconnected. The poetic creations of Surrealism, whether in painting, sculpture, theater,

photography, or cinematography, cannot be separated from revolutionary political activity, from experimentation, or from theoretical scholarship. Not only that: the poetic creations of Surrealism also include experimental and revolutionary critical components.

If one studies Surrealist artwork—that is to say, Surrealist poetry in painting, sculpture, graphic art, and photography—if one looks at the works in this exhibition, one sees clearly that the products of the artists represented here—the poetry in painting and sculpture—have not only poetic and lyrical qualities but also experimental and revolutionary critical aspects. The specific field of Surrealist artistic experimentation—that is to say, the composition of "Surrealist objects" (a field that is fundamentally different from sculpture)—is not represented at this exhibition. The viewer, however, is here assailed to a greater extent by Surrealist revolutionary criticism—by the cycles of montages, engravings, photographs, and color prints, which have a frenzied fever about them. The familiar political cartoonists, satirists, and caricaturists, who present a distorted mirror of the world, restrict their social criticism of certain institutions and of the phenomena of the class system almost entirely to rational hypotheses. They attack only the surface of these institutions and these facts, and go no further than humanitarian, often sentimental protest. Only George Grosz and John Heartfield, thanks to their Dadaist origins, sometimes managed to go deeper. In contrast to the tendentious graphic art, Jindřich Štyrský's Surrealist montages are profoundly subversive because, devoid of social sentiment, they are able to touch upon human instincts in a purely materialistic manner, without the mediation of intellectual reportage. Undoubtedly, they provoke the disgust and hatred of sentimentalists. In obscene and repulsive combinations, they wreak havoc on the sacred sentiments that are spun around the institutions of family and marriage, those canonized forms of prostitution, those mechanisms for murdering revolt and love, mechanisms for the production of intellectual poverty. The sacraments of bourgeois and priestly morality are here discredited and made to seem suspicious by a method that is much more revolutionary than revolutionary caricature because they are discredited and ruined by all of the means available to the unrestricted Surrealist imagination.

For that matter, even the paintings, sculptures, and photographs at this exhibition have something frenzied about them. Yes, this Surrealist revolution persists in the period of terror. The intense instinctual glow of materialistic corporeal desire colors the canvases on display and models the sculptures. Painting, which has gone to the extreme opposite of abstract Cubist geometry, has been accused of lacking artistic balance, of being literary and illustrative. And yet these works resist any kind of descriptive interpretation; they are poetic pictures, created by the dialectical high-frequency currents between man and the world, which elude critical evaluation that is based on the existing academic and idealistic aesthetics. Here one is very far from formalistic and mechanistic abstractions and very close to animal and human nature; far from idealization, allegory, or any kind of literature, and close to the incandescent core of the instinctive universal soul and the vibrations of human desire, revolt, and love.

In 1933 and 1934, Nezval worked systematically on the establishment of the Skupina surrealistů v ČSR (Surrealist Group in Czechoslovakia), preparing a pamphlet about it for the occasion of the founding of the group (March 21, 1934). The group's first exhibition, showing work by Štyrský, Toyen, and the sculptor Vincenc Makovský, was held from January 15 to February 17, 1935.

Teige and Nezval, who had closely collaborated on the theoretical formulation of Poetism, regarded Surrealism as a continuation of that trend on a new epistemological level, enriched by the ideas of Karl Marx and Sigmund Freud. As far as Teige was concerned, it constituted the most viable counterpart to date of Modernism and post-Cubism. Nezval invented original designations for the broad range of Surrealist objects.

Translated by Kathleen Hayes. Originally published as "Systematické zkoumání skutečnosti rekonstrukcí objektu, halucinace a iluse" ("Systematic Investigation of Reality through the Reconstruction of the Object, Hallucination, and Illusion"), in *První výstava Skupiny surrealistů v ČSR* (*The First Exhibition of the Surrealist Group in Czechoslovakia*) (Prague: S.V.U. Mánes, 1935), 5 – 9.

Vítězslav Nezval

Systematic Investigation of Reality through the Reconstruction of the Object, Hallucination, and Illusion

One cannot explain the theory of Surrealist painting without explaining the theory of objects.

I am thinking in particular of André Breton's old discovery of the so-called *oneiric object*, the dreamt object, which for him was a book with velvet pages, an exact replica of a book he had dreamt of.

As Breton expressly says of the Surrealist object: "*It is certainly the case of a poetic object, which is or is not valuable on the level of poetic images, and no other.*"[1]

This statement concerns a certain *phantom object* of Breton's, which he made himself and which he analyzes with incredible precision in *Les vases communicants* [*Communicating Vessels*]. In my opinion, however, it captures the function of *Surrealist objects* in general.

To sum up Breton's interpretation of the *phantom object* in my own words: the *phantom object* is an artificial creation, which, in collaboration with the censorship of consciousness, expresses sublimated fear of libidinous origin.

In addition to the indeterminate *Surrealist objects*, of which we have said that they are poetic objects applied in one way or another in the sphere of poetic pictures, in addition to the *oneiric objects* modeled on dreams, and the *phantom objects* embodying sublimated libidinous horror in an imaginative manner, there are also the *animated objects with an erotic meaning* designed by Salvador Dalí. Or as Breton put it, "*objects destined to arouse, by indirect means, a particular sexual emotion.*" Of some of the objects of this type, in so far as

1

In the paragraphs that follow, Nezval quotes from Breton's *Les vases communicants* (*Communicating Vessels*, 1932). He does not identify these passages with quotation marks, but rather uses italics, which are also used elsewhere in the essay for emphasis. For the quotations from Breton's work, I have relied on the English translation by Mary Ann Caws and Geoffrey T. Harris, published in 1990 by the University of Nebraska Press. I have used quotation marks to identify these citations. *Trans.*

they deliberately incorporate a predetermined latent content in a manifest content, Breton says that on account of their too particular conception, on account of that incorporation of a predetermined latent content in a manifest content, the tendency to dramatize and to magnify is weakened in them, the same tendency, which, in the opposite case, censorship uses with such success. They will undoubtedly, according to Breton, "*always lack the astonishingly suggestive power that certain almost everyday objects are able to acquire by chance*." Citing an example of such an everyday object with symbolic and emotional meaning, Breton mentions that instrument of schoolroom physics known as the electroscope. As I intend to return to everyday objects with emotional meaning later, I will point out here that, in contrast to artificially constructed *animated objects with symbolic meaning*, I will refer to these everyday practical objects, which are able to evoke excitement, as virtual objects. Dalí's objects include the *scatological object*. For that matter, I cannot help but mention here the very astute distinction that Dalí makes between phantoms and specters. As I would like to continue to observe this distinction of Dalí's in my terminology, I will at least touch on the most characteristic qualities, which Dalí attributes to phantoms as opposed to specters. The phantom is distinguished by the representation of content, and the specter by the disintegration, the destruction of illusory content. Phantoms are distinguished by their permanent essence or corpulence, specters by their flat and insubstantial inconstancy. The phantom has thrilling contours, the specter visceral. For Dalí, for example, cotton and plaster are phantoms — that is, contours revealing content. Asbestos and silk are specters — that is, *rays* cutting contours to pieces. Or, if I am to give two of Dalí's most synthetic examples, the phantom is a sponge and the specter a brush.

Well then, Surrealist objects of all types are an attempt at a spatial, concrete remaking of objective reality into subjectively objective surreality. This can be accomplished by direct active interference in the sense of a more or less conscious and artificial incorporation of the subjective latent content of the object in question into its objective content. This is the case with *oneiric objects*, *phantom objects*, *animated symbolic objects*, *scatological objects*, and *specter objects*. Or it can be accomplished by the indirect passive interference of sensibility, which, without any visible or artificial remaking of the object under observation, identifies and detaches the object's latent subjective meaning, as is the case with *virtual objects*.

It seems to me — and a great many of the pictures and creations in this exhibition confirm — that the reconstruction of reality as surreality does not occur exclusively through the reconstruction of the object, that is, exclusively objectively, but rather, considered dialectically, also through the reconstruction of impressions. Therefore, before I comment on the present exhibition, I must say a word about the role of illusion and hallucination, which, both in everyday life and in poetic creations such as Surrealist pictures, play a great part in the transformation

of objective reality into subjectively objective surreality. Nowhere is the role of illusion in the creation of surreality more strikingly manifest than in Štyrský's cycle of paintings titled *Kořeny* [*Roots*]. If they are painted in such a way that one can imagine that they might be replaced by real roots, positioned in a lighting that might be replaced here by the red light of dusk, there by moonlight; if one is tempted to replace them with an object, and if they are therefore substitute objects and thus a kind of *hallucination object*, then their entire content is in the illusion, which they suggest and which almost always has a highly provocative erotic meaning. While these *Roots* are not always lovers embracing, as is the case with one of them, they are at least ravenous shears, a carnivorous creature of sexual meaning; to sum up, they are *hybrid beings*. In spite of their peculiarity, one is fully justified in including them among the *ghosts*, as Breton describes Dalí's *El gran masturbador* [*The Great Masturbator*], Picasso's *Le joueur de clarinette* [*The Clarinet Player*], de Chirico's *Il vaticinatore* [*The Prophet*], Duchamp's *La mariée* [*The Bride*], Ernst's *La femme 100 têtes* [*The Hundred-Headless Woman*], and Giacometti's strange moving figure, as Breton puts it. Štyrský's *hallucinatory illusion objects*, as I propose to call them, can be subjected, like the abovementioned *ghosts* and like Breton's *Silence-envelope*, to an analysis similar to that which Breton gave of his *phantom object*.

These *hallucinatory illusion objects* were born of the same tendency as the things born on marble tables in cafés, which those who are fond of random drawing on marble tables interpret in their own way and usually in terms of the automatic process. They are born of the same tendency that leads children to see figures and scenes that are not always innocent in wall ornaments and in the moving leaves of trees.

I explain similarly the very striking *hallucinatory phantom object*, the ghostly fledgling that emerges from a hallucinatory trunk in one of Toyen's pictures, and her *phantom illusions* of faces emerging from the sketchy suggestions of tree bark, and her *hallucinatory specter objects* of flesh-colored clothes. I would, however, interpret differently her picture, which I have called a *mirage* on account of its very distant and intangible connection with the impulse that gave rise to it, which it does not recall in any way.

The need to cover, at least in general theoretical terms, all of the new types of surreal creations that Czech Surrealists have introduced to Surrealism compels me to try to define Štyrský's *hallucinatory monster objects*. I refer to them as monsters, on account of their peculiar delight in horror and ugliness, in order to distinguish them from phantoms and specters. These monsters are endowed with the same sort of excess of delightful horror as dolls made of excrement, which are the first toys of very small children, who, joyfully clutching them in their hands, hurry to terrify adults with them, just as white nocturnal creatures, gripping a phantom envelope by the ear, hurry to terrify these same children when they have grown up a little.

I never regarded the development that Štyrský's and Toyen's art underwent, their preceding works — as I have had occasion to state at the openings of their earlier exhibitions — as the products of "abstract painting." That development bequeathed an extremely original tradition to both of these Surrealists, both in terms of the conception of the painting and in terms of the technical handling of the most difficult tasks in painting. Thus, their first expressly Surrealist works, which one finds at this exhibition, enrich Surrealism immediately on two counts, with their extremely original poetic inspiration, and with their special technical solutions, which are in no way indebted to the discoveries of Ernst, Tanguy, Dalí, or any other Surrealist.

Now it is time for me to return to *virtual objects* and to explain, with their aid, the collages and photographs to which so much space has been devoted at this exhibition.

In spite of my old efforts to create artificial figures in poetry, as attested by my book of a few years ago — I am thinking of the cycle "Mluvící panna" ["The Talking Doll"] from *Zpáteční lístek* [*Return Ticket*] — I was very surprised when I saw the first pieces of *Stěhovací kabinet* [*The Portable Cabinet*], as we called this cycle. I was surprised when I saw that artificial figure, which Štyrský constructed out of asparagus and a woman's old shoe, or the figure composed of a divan and a head taken from an advertisement for a preparation for increasing a woman's bust size. I was surprised when I saw the fifty or so prints with a similar poetic meaning, which Štyrský made as if in a dream and which confirmed for me that it was possible to unite two visual elements, no matter how different, just as it was possible to unite two poetic images, no matter how different. I cannot help quoting Breton here, who says on a similar subject: "*We shall be forced to admit, in fact, that everything creates and that the least object, to which no particular symbolic role is assigned, is able to represent anything. The mind is wonderfully prompt at grasping the most tenuous relation that can exist between two objects taken at random, and poets know that they can always, without fear of being mistaken, say of one thing that it is like the other; the only hierarchy that can be established among poets cannot even rest on anything other than the degree of freedom they have demonstrated on this point.*"

This quote, with which I bring to an end the theoretical part of my essay, allows me to express, with unqualified joy, my enthusiasm for the work exhibited by my friends and to confirm for them that the absolute freedom, which they demonstrated in their canvases, photographs, collages, and sculptures, is unmistakably Surrealist freedom in the most beautiful sense, dialectical freedom understood as the recognition of necessity.

Now, after my attempt to interpret the works, which are entirely the products of the intuition of the artists who made them, let me permit my intuition to salute the worlds of my friends so close to me, with whom my imagination has always felt absolutely at home.

Štyrský, tireless inventor of caresses and cruelties, which do not reject even the most daring sources of inspiration. Surrounded, like des Esseintes, by curios, behind the exotic allure

of which always lies the absolute truth of reality; courageous and suspicious of other people's truth; cynical and wistful; always and ever more mysteriously revealing his inexhaustible desire for intoxication. . . .

Toyen, serious, never presuming to joke; serving up reality in the most latent style, and therefore trusting so profoundly in the discretion of the traps in which, for her, the entire alchemical truth of reality is to be found. Toyen, working without a safety belt over the steep rooftop of her profound somnambulism; dreamy without postures; always sensing the curse that hangs over intoxication; deeply illusory. . . .

Makovský, under whose hand the most intricate, emotional, and inspirational situations are simplified without losing any of their subtlety; always terse, rendering reality in true abbreviations; a synthesist of intuition, entering, like Štyrský and Toyen, only those places that have not been touched by muddy feet.

I am happy that the artistic fate of Surrealism in Czechoslovakia is in the hands of these three profoundly complementary imaginations, and that it has today opened up the most miraculous prospects for the future.

6 Lunatic Years

Karel Srp and Lenka Bydžovská

In March 1938, the Prague Surrealist group faced a serious crisis when its founder, the poet Vitězslav Nezval, tried to disband it. He wholeheartedly endorsed the political line of the Communist Party of Czechoslovakia at that time, including its approval of the staged Moscow trials. Most of the other members of the Surrealist group vehemently opposed Nezval's views and decided to pursue their activities from that point on without him. Karel Teige was one of the first leftist intellectuals to point out, in May 1938 in his booklet *Surrealismus proti proudu* (*Surrealism against the Current*), that fascist Germany and the Stalinist Soviet Union used similar methods to suppress free culture. Surrealism, which encouraged uncompromising, independent thought and action, would always be anathema to any kind of totalitarian regime. The political situation in Europe soon reached a crisis point. In September 1938, Czechoslovakia was betrayed when its former allies France and England, along with Germany and Italy, signed the Munich Pact, which permitted the Nazis to annex Czechoslovakia's borderlands. On March 15, 1939, the German Army occupied Prague. The Protectorate of Bohemia and Moravia was established. Slovakia seceded to become a separate state with fascist leanings. These events, of ominous importance for Czech society, naturally also had a direct impact on culture and art. Some of the artists who had been active in the antifascist movement in the 1930s made perilous journeys into exile, most often to the United States. Many others suffered and died in prisons and concentration camps on account of their antifascist views or Jewish origins.

Nazi ideology condemned Surrealism, along with other avantgarde trends, as "degenerate art" that had to be eradicated. From 1939 on, the Czech Surrealists were forbidden to publish or exhibit their work publicly.[1] The Prague Surrealist group went underground. Its core consisted of Teige, Jindřich Štyrský, Toyen, and a new member, the poet Jindřich Heisler, who was a generation younger. In 1941 Heisler decided not to respond to the summons requiring "non-Aryans" to register. On several occasions, he narrowly escaped arrest and death. For most of the war, he hid in Toyen's apartment, and by giving him shelter, she risked her own life. The Surrealist group, which had no news of the predicament of Surrealism abroad, continued its underground activities until Štyrský's death in March 1942.[2] In the years that followed, Teige, Toyen, and Heisler continued to collaborate. Teige, meanwhile, supported the new devotees of Surrealism who longed for a "liberated intellectual existence" in the oppressive atmosphere of

the Protectorate.[3] Despite the risks associated with it, Surrealism continued to attract a younger generation of artists. Some of them had dabbled in Surrealism before the war. Others had become acquainted with it just before the introduction of censorship, at high school or — before Czech universities were closed in November 1939 — at Jan Mukařovský's seminar at Charles University in Prague. These writers and visual artists established their own Surrealist groups in various Prague districts (Žižkov, Michle, Libeň, and Spořilov), and in other Czech towns and cities (Rakovník, Brno, Louny, and Zlín). They organized private debates and circulated typed copies of books and anthologies among a select circle of their friends. In spite of the repression and the need for secrecy, Surrealism found expression in many unusually vibrant forms in the occupied Czech lands.[4]

Toyen's Wartime Work

The theme of war was strikingly manifest in Toyen's paintings and series of drawings. The first of these was *Les spectres du désert* (*Specters of the Desert*), twelve drawings from 1936 – 37 that clearly reveal the profound impact of the state of anxiety and fear on her work. In 1939 these drawings were published in a book, accompanied by poems by Heisler [CAT. 84]. To deceive the censor, the book appeared only in French translation as *Les spectres du désert*; the publisher credited in the colophon was the Parisian firm Albert Skira, thanks to the mediation of Benjamin Péret. In fact, Heisler published three hundred numbered copies of the book at his own expense in Prague as a volume in the Edice surrealismu (Surrealist Edition).[5] In *Specters of the Desert*, strange creatures or fragments from the animal realm transform from animate to inanimate forms; they become rigid, crack, and fall apart. Toyen interpreted form as a skin stretched taut between a depleted interior and the space surrounding it. Heisler precisely captured the ambiguity of the drawings in his layered poetic imagery. His work merged with Toyen's in an act of profound empathy and imagination. Whereas some of the poems only loosely reflect the drawings, others evoke images that are closely related to them. The book encourages the comparison of these artists' different experiences. Like Toyen, Heisler understood time as a current that destroyed illusion, as covert movement that becomes apparent only in its destructive impact.

During the occupation, Toyen worked on other series of drawings that elaborated on the themes introduced in *Specters of the Desert*. These series included: *Střelnice* (*The Shooting Gallery*,

1939 – 40), *Den a noc* (*Day and Night*, 1940 – 45), *Zvířata spí* (*The Animals Are Asleep*, 1941 – 45), and *Schovej se, válko!* (*War, Hide Yourself!*, 1944). Soon after the liberation of the country, Toyen displayed all of these drawings, along with paintings, at an exhibition of her wartime work in Prague in November through December of 1945. The first to interpret these works were Teige, in a study printed in the catalogue, and Mukařovský, in a speech at the opening of the exhibition. In 1946 Toyen published books of these series through the Prague publishing house František Borový; *The Shooting Gallery* appeared in February and *War, Hide Yourself!* in November.

The Shooting Gallery features twelve drawings by Toyen, with an introductory poem by Heisler and a preface by Teige [CAT. 85].[6] Teige also designed the typography and the cover with the motif of the target. According to Teige, *The Shooting Gallery* refers to childhood memories as well as to the drama of war. In her drawings, Toyen combined images of the war-torn world with images of the deteriorating and bullet-ridden props of a fair. She assembled strange still lifes of junk, ruined toys, absurd classroom tools, birds' torn bodies, stuffed animal heads, and cracked eggs. She depicted the lost paradise of childhood not as idyllic but rather as loaded with sexual content and cruelty. The protagonist of this series is a young girl who appears in two of the drawings. She resembles the ghostly figures in Toyen's major paintings *Sen* (*Dream*) and *Spící* (*Sleeping*), from 1937. In the first drawing, the girl, a jump rope in her hands, stands helplessly in a landscape with dead roosters. Her head is turned toward the viewer, but her face is missing. In the oval where her face should be, the viewer sees the line of the horizon. The erosion of the girl's body is manifest in her decaying arm. In another drawing, the figure — now a schoolgirl — stands with her back to the viewer in a wasteland scattered with feathers and dead birds. Her body resembles a crumbling statue. The world in *The Shooting Gallery* is both transparent and ponderous. In another drawing, the isolated face of a prematurely aged child, with mouth wide open and eyes squeezed shut, assumes the form of the cracked, petrified fairground. The surrounding landscape can be seen through the figure's mouth. Tears drop from the closed eyes and, as they fall to the ground, are transformed into the balls of a game. The motif of balls and cages that appears in the drawing suggests the meaning of the empty space. In other drawings, nuts, pen caps, abandoned nests, funeral wreaths, fence posts with barbed wire, and mechanical toys function in the same manner. Mukařovský pointed out that Toyen's repetition of certain motifs in the foreground and

background, a technique that one sees in *The Shooting Gallery* as well as in the later paintings *Polní strašák* (*Scarecrow*, 1945) and *Předjaří 1945* (*Early Spring 1945*, 1945), was a powerful semantic tool. Teige and Mukařovský saw direct connections between various motifs in the drawings and specific events. For example, according to Teige, the funeral wreaths scattered around a lone chair in one of the drawings of *The Shooting Gallery* refer to the fall of Paris. Both Teige and Mukařovský, however, stressed that the emotional tension in Toyen's work was timeless and would affect viewers even in changed historical circumstances. Striking motifs, which deceived the censorship of consciousness, found their way into the drawings. Teige wrote: "There undoubtedly is latent content, hidden behind the theme of war — the fictive indulgence of aggressive and destructive instincts, and of the dark death wish (horror both repels and fascinates). There is latent content as well behind the theme of the lost childhood paradise — the imaginary fulfillment of polymorphous infantile longing."[7]

The title of the series of nine drawings *War, Hide Yourself!*, from 1944, refers to a line from Lautréamont's *Poésies* (*Poems*) [CAT. 86]. After its publication in 1946 in Prague, it was subsequently published in Paris in May of the following year as *Cache-toi, guerre!* Both editions included Heisler's introductory poem of the same title. *Specters of the Desert* was populated by fossilized, weather-worn animals and parts of animals. In *War, Hide Yourself!*, by contrast, only the fantastical skeletons of animals remain in the barren, open space. These skeletons, however, sometimes behave like living creatures. They fly through the air, merge with objects to form bizarre configurations, and fall into ruin. Moths flutter around a rib cage instead of a kerosene lamp. Skeletal hands hang in a birdcage. A vast school of fish floats an inch above the ground. Clouds and smoke from explosions fill the sky. Ever inventing new creatures for her imaginary bestiary, Toyen depicted a world in which nature had broken free from its original order and purpose. She portrayed absurd scenes with an insistent, realistic precision, creating a "horribly vivid dream."[8] Drawing attention to the antiwar message in Toyen's extraordinary work from the occupation period, Teige compared it to Francisco Goya's series *The Disasters of War*. Mukařovský also pointed out that, in those years of complete isolation, Toyen engaged in "a true dialogue with the era."[9] Yet unlike many of her contemporaries, she did not resort to direct references to describe the experiences of suffering and hope, nor did she employ classical mythology or biblical scenes. She dealt with the

wartime events in her own fashion, as if she were taking snapshots of a battlefield or hinterland seen through a Surrealist lens. By inventing a distinctive artistic language, Toyen avoided explicitness and imitation. Although Mukařovský noticed specific connections between her work and the war, he was convinced that Toyen was not creating allegories but rather symbols, through which the next generation would probably discover new content: "Who knows what they will suggest. Who knows what question they will answer, but answer they will. And only symbols can do that."[10]

The Cullen collection includes the books that feature her wartime series, which introduced Toyen's art to a wider public, as well as contemporaneous examples of her collaboration with various Czech publishers, which provided her with an important source of income. Toyen's book art covered a broad spectrum, ranging from unique and daring designs to those that were merely routine. (Her most radical work was the experimental book of "implemented poems" *Z kasemat spánku* [*From the Casemates of Sleep*], which she made with Heisler at the beginning of the war. It was published illegally in a private print run of only seventeen copies for the Surrealist Edition.) The randomness of the various commissions that Toyen undertook reflects the tastes of the era and its changing visual outlook. In some cases, one can detect unintentional points of contact between Toyen's high and low artworks and their influence upon one another. In some book covers, Toyen openly experimented with popular forms in order to determine if she could use these unusual sources of inspiration in her noncommissioned artwork. In her book art, she also indulged her lifelong love of film, incorporating images from motion pictures in her photomontage covers.

Toyen's book commissions from the 1940s fall into two categories. On the one hand, she continued to produce drawings of the delicate, dreamy, melancholy faces of languid women, thereby catering to the sentimental tastes of the period. Among the most interesting examples are her illustrations for the sheet music *Písně milostné* (*Love Songs*), produced in 1943 by the Brno composer Vilém Petrželka, who set verses of the eleventh-century Persian poet Baba Tahir Oryan to music [CATS. 87 – 90]. On the other hand, Toyen created covers with photomontages highlighting action. In a few of these instances, Toyen returned to the iconography and motifs of the early 1920s, such as the theme of man swallowed by the machine. On the cover of Svatopluk's novel *Gordonův trust žaluje* (*The Gordon Trust Sues*), from 1940, she inserted the

figure of a running worker between the giant cogs of a machine [CAT. 106]. Though she usually signed her commercial covers with only the initial T. or left them unsigned, this composition bears her full pseudonym.[11] Toyen often used photomontage for the covers of detective novels, on which she worked continuously from 1938 until 1947 for several important detective series. After making more than twenty photomontage covers of this type, she was something of an expert, and could capture the key moment of a story in a few striking images. Typical motifs included the faces of terrified victims and the menacing shadows of lurking murderers.[12] In many of her commissions, Toyen employed standard techniques that had been developed from the beginning of the 1930s by Jindřich Štyrský in his photomontage covers for Bohumil Janda's publishing house Sfinx. In these, a shadow cast by a hidden figure often dramatized a scene. Toyen, however, also introduced variations to these standard approaches. The 1947 cover for Renée Gaudin's *La mort se lève à 22 heures* (*Death Rises at 10 p.m.*, in Czech *Smrt přichází o 22. hodině*) is a typical example of Toyen's covers for detective novels [CAT. 107]. The green tint unites the two planes on the cover. In the first plane, a woman who is being strangled turns her face to the viewers, drawing them into the action as inadvertent witnesses. Aside from the hands on her throat, the murderer is not shown. In the second plane, two policemen ride on bicycles with their backs turned to the crime scene. In this composition, as in most of Toyen's wartime and postwar book designs for various publishers and series, one sees her tendency to focus on the role of the isolated individual. However much her covers differed in external details, they tended to share this unifying theme.

Deformations

Whereas Toyen, in the 1940s, used collages only in her book covers and not in her noncommissioned work, Karel Teige felt an important personal need to create artistic collages.[13] From the mid-1930s to 1951, he produced almost four hundred of them. Today, no exhibition or publication on Surrealism in Czechoslovakia would be complete without them, yet Teige himself regarded them primarily as a personal matter intended for his circle of friends. In them, he gave freer rein to his imagination than in his theoretical texts. His collages combined reproductions of old and modern art, architectural images, famous works by modern photographers, and banal snapshots. Teige used some of these images merely as building material, without regard for their primary context and role.

Other pieces inspired him to enter into dialogue with the original artists and offer fresh interpretations of their work. Above all, Teige was fascinated by the nude female body and its component parts. His collages often included a headless torso, sometimes with breasts, eyes, lips, or other objects in place of the head. He assembled mutants from fragments of bodies. Teige saw a similarity between his own work, with its violent deformation of the erotic female body, and that of Hans Bellmer. Teige's belief that art was eroticism transposed informed his collages, as one can see in his piece in the Cullen collection [CAT. 92]. Here, Teige transformed a woman's stockinged legs, raised at the sky among fighter planes, into a phallic symbol.

From Poetry to Visual Art: Heisler

The Cullen collection also includes outstanding examples of wartime visual art by the poet Jindřich Heisler. He had always been intrigued by the "miraculous tension between word and image" that arose through "the spontaneous irrationality of interpretation, both of the written text and of the visual perception."[14] From the end of the 1930s on, he collaborated closely with Toyen and Štyrský on books, which they published privately in the Surrealist Edition. Only a small circle of readers were aware of Heisler's work, given that he debuted on the literary scene in 1939, under the oppressive conditions of the Protectorate. About 1942 he grew dissatisfied with the expressive devices of the poem. He was undoubtedly familiar with Sigmund Freud's theory that the interpretation of dreams put into words primal and purely visual experiences to which the dreamer had only indirect access. Heisler came to the conclusion that visual art, with no apparent narrative or past or future tense, was more concrete than the written word, and could express the figments of his imagination with greater immediacy. He quickly switched from working mainly with texts to working with images. Not only did his medium change, but his style did as well, as is evident from his first pieces from 1943. Whereas his poetry had been obscure, relying on subliminal suggestion, his visual art was vivid, concise, and unusually striking, introducing new forms and content into the Surrealist repertoire. Heisler quickly settled on a style of his own, which combined collage, objects, and photography [CATS. 93–97]. He incorporated ordinary objects and figures into his art, shedding new light on them as he cast them in unusual stylistic and semantic positions. His visual art often involved direct representations of metaphor, for example, bow ties flying up to a

tree. (The Czech word *motýlek* can mean both butterfly and bow tie.) In addition, Heisler arranged ephemeral objects solely for the purpose of documenting them in photographs. In doing so, he continued loosely in the same vein as the painter František Vobecký, who, from 1935 to 1937, created and photographed evanescent dream assemblages and collages. Vobecký invented erotic stories, peopled by the fictional heroines Psyche, Aurora, Marietta, and Ophelia. The Cullen collection includes his 1936 work *Chvíle zázraků* (*The Moment of Miracles*) [CAT. 91].[15]

Heisler's ingenuity was manifest in his invention of a Surrealist technique, which he called "photo-graphique." The poet Georges Goldfayn, a member of André Breton's postwar group who befriended Heisler, described the approach thus: "We know how the enlargers that photographers use work. Heisler did not consider it necessary to enlarge an image through the combined action of light and lens. On the dull glass where the negative was usually placed, he replaced it with gelatin, glycerin, cotton wool, soap bubbles, and twigs. He wanted to use light to investigate the viscous world that was attached by umbilical cord to the earth-procreator."[16] Heisler teased out fantastical, amorphous, protoplasmic shapes from the dark surface. Sometimes he colored them. He had visions of primal, disembodied beings: flying birds, a horse's head, stalking beasts, a man dragging a net, figures that were sometimes struggling and sometimes making pledges to one another. These beings were prefigured in poems from the collection *Neznámé cíle* (*Unknown Destinations*), published a few years earlier; the poems often refer to translucent, glittering light-bodies with complex interiors.[17] Heisler continued to approach his work as a poet who found a new method of expression in visual art. He presented his photo-graphiques from 1944 in the series *Ze stejného těsta* (*From the Same Mold*). The Cullen collection includes a work from this series, as well as Toyen and Heisler's joint New Year's greetings card for 1945 [CAT. 98]. The image on the card unites the imaginative vision of both artists: the schoolgirl from *The Shooting Gallery* observes the horizon, with its ghostly scene taken from one of Heisler's gelatin silver prints.

Drama of War and Reality

In addition to the Surrealists, other associations of young artists were active in the Czech lands during the occupation. The most important of these was Skupina 42 (Group 42), in which visual artists, poets, and theorists joined ranks; it was active from 1942 to 1948. The Cullen collection includes a set of smaller works by a number of the group's members: František Hudeček, František Gross, Jan Smetana, and Bohumír Matal.[18] Unlike the Surrealists, the members of Skupina 42 were able to exhibit and publish despite the censorship that was in force in the Protectorate.[19] Their ability to do so was all the more surprising given that key individuals in the group had artistic roots in Surrealism: in the mid-1930s, the painters Hudeček and Gross, along with the sculptor Ladislav Zívr, developed various experimental techniques that enhanced the existing Surrealist range of methods. At that time, they were already collaborating with the theorist Jindřich Chalupecký. In his 1940 essay "Svět, v němž žijeme" ("The World We Live In"), Chalupecký formulated the basis of the new aesthetic that they had pursued since the turn of the 1930s: "the meaning and aim of art are none other than the daily, grim, and glorious drama of man and reality: the drama of mystery confronting miracle."[20] In their work, the Skupina 42 artists concentrated on the myth of the city, technology, and civilization. On the one hand, they expressed the alienation that oppressed the individual lost in an anonymous society. On the other hand, they recognized the unity of modern man and the throbbing organism of the metropolis. They perceived the ambiguity of ordinary things, which could be beautiful but also sinister; first and foremost, they saw a direct connection between these things and human existence. In the early 1940s, Hudeček, an inventive and versatile artist, often projected his fundamental experience of existence into the melancholy theme of "the night walker," which evoked meditative and ecstatic moments of wandering the dark, empty streets of Prague on starry nights [CATS. 102 and 104]. Hudeček modified the theme in a rich register of imaginative variations: the night walker was sometimes represented as a three-dimensional organic form, a crystalline figure, or an abstract geometrical sign. Hudeček's work blended reality, dream, and geometrical order into a unique whole. In the same period, Gross pursued an interest in urban landscapes and interiors, but also in the concept of the human-machine and the city-machine; these depictions culminated in irrational, linear constructions and diverse new forms [CAT. 103]. Smetana, who was ten years younger, portrayed urban subjects in an aerial, perspectival space and with atmospheric light [CAT. 101].[21] He concentrated on the city's outskirts, industrial quarters, desolate buildings, courtyards, factories, and junkyards. His sensual, subtle paintings feature subdued color harmonies, often light grays and browns, with a vast sky stretching over a low horizon. The youngest

member of Skupina 42, the Brno painter Matal, who joined the group after the war, also cultivated a distinctive style that reflected the group's fascination with urban civilization [CAT. 100].22 In his firmly constructed shapes, he emphasized the structure of the city, a technique that he also applied in his geometrical figures.

Surrealism in Discussion

Immediately after the liberation of Czechoslovakia, Surrealist activities boiled up from the conspiratorial underground to the surface. The long period of enforced "fasting" was followed by three years of frenzied work in the public eye. Artists published works they had made during the occupation; they engaged in debates in the new cultural journals and organized lectures and discussion sessions; and they held numerous exhibitions and renewed contacts with their colleagues abroad. Amid this flurry of activity, artists in Prague, like those in Paris and Brussels, became acquainted with contemporary Surrealism and its orientation in the changed circumstances. Among the most active participants in these events were the young artists who introduced themselves to the public after the war as the Prague-Brno Skupina Ra (Ra Group).23 This group's roots lay in the 1930s, when the painters Bohdan Lacina and Václav Zykmund became friends while studying in Prague. They both admired Surrealism, in particular the work of Salvador Dalí. In 1937 Zykmund founded the Ra Edition of books in the town of Rakovník, west of Prague. The first volume that he published was a translation of Breton's poetry collection *L'Air de l'eau* (*Airwater*, in Czech *Vzduch vody*), with a cover by Bohdan Lacina. Zykmund made the frontispiece and drypoints. Zykmund's friend Josef Podrabský, a painter and collage artist, designed the cover for another volume in the Ra Edition from 1939. Podrabský continued to work on his Surrealist art in seclusion, without giving up his day job. The Cullen collection includes a single painting by him from 1945; his work has not yet been studied in detail [CAT. 99]. The collection also contains a single painting by Zykmund [CAT. 105]. Unlike Podrabský, Zykmund was an active member of the group and worked on many artistic projects, often in collaboration with several artists.24 He was extravagantly inventive, working as a painter, photographer, poet, theorist, and organizer of events. His art united poetry and drawing. He was one of the predecessors of action art and happenings. His painting was also experimental, ranging from veristic Surrealism to semi-abstraction and abstraction. In this respect, he resembled another member

of Skupina Ra, Josef Istler. Koreček and Istler tended toward abstraction in their use of experimental photographic techniques such as "fokalk."25 Although Skupina Ra recognized its origins in Surrealism, it had certain reservations, which it formulated in a 1947 manifesto: "Instead of automatism . . . we emphasize the striving for form and composition, which are, however, distant from dull engineering; painters favor elements that are purely visual and painterly, rejecting any literary quality; poets are not distracted by associations from the verbal material."26 They distrusted works made "according to psychoanalytical formulas," which involved the use of predetermined symbols and allegories. Prewar Surrealism was, according to them, analytical and destructive, whereas the new avant-garde art was synthetic and constructive.

Skupina Ra's international orientation reflected its distinctive views. In 1947 the group joined the short-lived movement of the Revolutionary Surrealists. It was founded in opposition to André Breton by the young poets Christian Dotremont in Brussels and Noël Arnaud in Paris, both of whom had been active in the illegal Surrealist group La Main à Plume (The Hand That Writes) during the war. At the same time, a Danish experimental group led by Asger Jorn joined the ranks of the Revolutionary Surrealists. All of them naively believed that it was possible to collaborate closely with the Communist parties and yet maintain complete artistic freedom. They therefore criticized the *Rupture inaugurale* (*Inaugural Rupture*) manifesto, in which Breton's group distanced itself for good from the Communist Party of France in June 1947. Breton's interest in the occult also alienated them. The Revolutionary Surrealist movement gradually disintegrated in 1948. Its collapse, however, gave rise to the Danish-Belgian-Dutch group CoBrA. In 1949 Czech artists still had contact with their colleagues abroad. However, the radically changed political situation in Czechoslovakia thwarted their interest in collaboration.

Teige, Toyen, and Heisler, by contrast, supported Breton's postwar concept of Surrealism. Toyen and Heisler took part in the Parisian exhibition *Le surréalisme en 1947* (*Surrealism in 1947*), organized by Breton, Marcel Duchamp, and Frederick Kiesler. The exhibition included a hall of altars to the "new myth," for which Toyen and Heisler each contributed a piece. In addition, Heisler also arranged for a selection of paintings and drawings from this exhibition to travel to Prague; the show, *Mezinárodní surrealismus* (*International Surrealism*), opened in November 1947 in the Topič Salon. It did not attempt to copy Breton's complex installation, but rather concentrated exclusively on recent Surrealist works. In

a study published in the catalogue, Teige focused on the "polar opposition within Surrealism, when at one extreme the inner model is rewritten as subjectless sign, a kind of shorthand or diagram, automatically registering internal pressure, while at the other extreme there are paintings of an inner world, visions of dream and imagination stabilized by a realistic depiction."[27] Teige focused on the concept of magical realism, which Breton had also explored. According to Teige, magical realism had a broad scope; indeed, it encompassed Surrealism and opened up a new field, which included the occasional ritual events staged in Brno by Zykmund and his friends, and in Prague by Emila and Mikuláš Medek. Magical realism did not seek to discover surreality in the everyday world, but rather to create an entirely new reality. Its aim was "the magical mastery and magical transformation of actual existence."[28] The need for a spiritual transformation of the world, according to Teige, was increasingly apparent: "Metaphor, expanding the range of its contrast, becomes metamorphosis; the poem is an incantation."[29] In "Druhá archa" ("The Second Ark"), the text that he wrote for the Prague catalogue, Breton reminded readers that art was only one of the means on the path that led to the liberation of the individual. He named the enemies who were trying once again to dominate art. Breton warned of underestimating the danger inherent in the relationship between art and the ruling ideological systems: "Let us not forget that in the prewar years even regimes with different ideological goals waged a campaign against free art using similar means."[30] He voiced an urgent fear for the future of art: "When art accepts or promulgates any military-political command it commits a betrayal. The sole obligation of the poet and the artist is to oppose his unchanging NO to all disciplinary decrees."[31]

Breton's warning soon had a special urgency for Czechoslovakia: after the Communist coup in February 1948, those artists who wanted to create freely had no choice but to withdraw once again to the underground. The new regime did not tolerate even a hint of the avant-garde in art or in thought. Teige, branded a Trotskyite, fell victim to a crude Stalinist campaign. Once again, he was excluded from public life and forced to give up editing and publishing.[32] At this time, he turned instead to the complex task of writing the *Fenomenologie moderního umění* (*Phenomenology of Modern Art*), although he had no hope of publishing it. He continued to offer encouragement to young artists who had not submitted to the dictates of power.

Gradually, a new, open, and tolerant group formed around him. It included members of the former Skupina Ra, like Josef Istler, Václav Tikal, and Jan Kotík, as well as other artists of the younger generation who had also dabbled in Surrealism, like Mikuláš Medek and Libor Fára. Writers, such as the poet and theorist Vratislav Effenberger and the poet Karel Hynek, played an important role in this circle of friends. From January to October, 1951, they collaborated on monthly, samizdat issues of an anthology of works in progress. Each issue, only a single copy of which was produced, was named after a sign of the zodiac. Teige's untimely death in October 1951 put an end to this undertaking. All of those who had been involved, however, remained aware of the need to create independently.[33]

In addition to Teige, another figure from the interwar avant-garde who influenced the younger generation in the early postwar years was Josef Šíma, who had settled permanently in France. Šíma suffered a profound personal crisis during the Second World War, which he saw as the failure of basic values of European humanism. In 1939 he stopped working for ten years, with the exception of a few pieces in which he expressed his despair, such as the 1945 drawing *La pouvoir de la bêtise* (*Stupidity Rules; Vláda pitomosti*). A version of this drawing from 1951 is in the Cullen collection [CAT. 108].[34] During the war, Šíma was active in the resistance and volunteered to help the Czechoslovak government in exile. From the end of the war until the late 1940s, he advised the Czechoslovak embassy in Paris on cultural matters. Among the numerous Czechoslovak-French events that he helped to organize, the exhibition of young Czechoslovak painters at the La Boëtie Gallery, titled *Art Tchécoslovaque 1938 – 1946* (*Czechoslovak Art 1938 – 1946*), stands out. Many of the artists who showed there had a chance to visit Paris and become personally acquainted with the local art scene. They did not yet suspect that this was only a brief respite between two periods of international isolation. In 1950 Šíma took up painting once again, but his work was cut off from his homeland. Not until the 1960s did Czech viewers have an opportunity to see Šíma's artwork from that time.

NOTES

1 Karel Teige, "Osud umělecké avant-gardy v obou světových válkách" ("The Fate of the Artistic Avant-garde in Both World Wars," 1946), in *Osvobozování života a poezie. Studie ze čtyřicátých let* (*The Emancipation of Life and Poetry: Studies from the 1940s*), ed. Jiří Brabec and Vratislav Effenberger (Prague: Aurora and Československý spisovatel, 1994), 99–125.

2 Jindřich Heisler probably joined the Surrealist group in the spring of 1938. The composer Jaroslav Ježek was one of the key figures at the Liberated Theater, which had a distinctly antifascist repertoire in the 1930s. In January 1939, he immigrated, along with Jiří Voskovec and Jan Werich, to the United States, where he died in early 1942. Bohuslav Brouk's enthusiasm for Surrealism cooled during the war. The theater director Jindřich Honzl turned away from the group for good in 1946. The poet Konstantin Biebl also gradually distanced himself from Surrealism.

3 Zdeněk Lorenc, "Na oknech jsou kapky" ("There Are Raindrops on the Windows"), in *Skupina Ra* (*The Ra Group*), ed. František Šmejkal (Prague: Galerie hlavního města Prahy, 1988), 61. See also: František Šmejkal, "Surréalisme en Tchécoslovaquie" ("Surrealism in Czechoslovakia"), in *La planète affolée. Surréalisme, dispersion et influences 1938–1947* (*The Crazed Planet: Surrealism, Dispersal and Influence 1938–1947*), ed. Germaine Viatte (Paris: Flammarion, 1986), 237–43.

4 Some of the young Surrealists joined the resistance, with all of the consequences that that entailed. The poet Robert Altschul, from the Prague Spořilov group, was arrested and died on a death march. The painter Václav Chad, from the Zlín circle, was shot while attempting to flee.

5 The Czech poet Jindřich Hořejší translated Heisler's poems into French. The second edition of *Les spectres du désert* was published in Paris in 1953 by the Arcanes publishing house, in a translation by Benjamin Péret and Heisler. In 1974 a shortened edition was published that included the French text and an English translation by Stephen Schwartz: *Specters of the Desert: Poem* (Chicago: Black Swan Press, 1974).

6 In Paris in 1973, Radovan Ivšić prepared a new bibliophile edition of the series, *Tir* (*The Shooting Gallery*), in collaboration with Toyen [CAT. 114]. Ivšić wrote a poem for the publication. See the next chapter.

7 Karel Teige, "Střelnice" ("The Shooting Gallery"), in Toyen, *Střelnice* (Prague: František Borový, 1946), 5. See the English translation in this catalogue.

8 Karel Teige, "Obrazy a kresby Toyen" ("Toyen's Paintings and Drawings"), in *Toyen* (Prague: Topičův salon, 1945), unpaginated.

9 Jan Mukařovský, "Toyen za války" ("Toyen during the War," 1946), in *Studie z estetiky* (*Studies in Aesthetics*) (Prague: Odeon, 1966), 313.

10 Ibid.

11 Jindřich Toman addresses the question of whether Toyen laid claim to her work for publishing houses, which on principle concealed the identity of their designers, by using the initial T., or whether, on the contrary, she thereby distinguished her commercial commissions from her independent artwork, which she signed with her full pseudonym. See Jindřich Toman, *Foto/montáž tiskem – Photo/Montage in Print* (Prague: Kant, 2009), 178–79.

12 See also Jindřich Toman, "The Dream Factory Had a Horror Division: Štyrský's and Toyen's Psycho-Covers from the 1930s," *Umění* (*Art*) 48, no. 3 (2000): 170–80.

13 For publications in English on Teige's collages, see Vojtěch Lahoda, Karel Srp, and Rumjana Dačeva, *Karel Teige: Surrealist Collages 1935–1951* (Prague: Středoevropská galerie a nakladatelství, 1994); Karel Srp, *Karel Teige* (Prague: Torst, 2001).

14 Jindřich Heisler, "O ilustraci, která není ilustrací" ("About Illustration That Is Not Illustration," probably 1946), in *Z kasemat spánku* (*From the Casemates of Sleep*), ed. František Šmejkal, Karel Srp, and Jindřich Toman (Prague: Torst, 1999), 309.

15 František Šmejkal, *František Vobecký* (Brno: Dům umění města Brna, 1982); Antonín Dufek, "Surrealistická fotografie" ("Surrealist Photography"), in Vladimír Birgus, *Česká fotografická avant-garda 1918–1948* (*Czech Avant-garde Photography 1918–1948*) (Prague: Kant, 1999), 221.

16 Georges Goldfayn, "Jindřich Heisler," *Phases*, no. 8 (January 1963): 60–64. See also: Edouard Jaguer, *Surrealistische Photographie: Zwischen Traum und Wirklichkeit* (*Surrealist Photography: Between Dream and Reality*) (Cologne: DuMont, 1974), 125–27.

17 The 1939 collection was first published posthumously in 1977.

18 The following were members of Skupina 42: the painters František Gross, František Hudeček, Jan Kotík, Kamil Lhoták, Jan Smetana, Karel Souček, and Bohumír Matal, who joined after the war; the sculptor Ladislav Zívr; the photographer Miroslav Hák; the poets Ivan Blatný, Jiřina Hauková, Josef Kainar, Jiří Kolář (who exhibited his first collages in 1937), and after the war also Jan Hanč; the theorists Jindřich Chalupecký and Jiří Kotalík. See *Skupina 42*, ed. Eva Petrová (Prague: Akropolis and Galerie hlavního města Prahy, 1998); Zdeněk Pešat and Eva Petrová, *Skupina 42: Antologie* (*Skupina 42: An Anthology*) (Prague: Atlantis, 2000).

19 The first exhibition of Skupina 42 was held in the spring of 1943 in the small East Bohemian town of Nová Paka, from which three members of the group hailed. It was closed early, however, at the behest of the authorities. One of the local organizers, who was active in the resistance, had just been arrested by the Gestapo for sheltering parachutists flown in by the Allies. See Tomáš Hylmar, "První výstava Skupiny 42 pohledem Ladislava Zívra" ("The First Exhibition of Skupina 42 Through the Eyes of Ladislav Zívr"), *Umění* (*Art*) 58 (2010): 326–35.

20 Jindřich Chalupecký, "Svět, v němž žijeme" ("The World We Live In"), *Program D* 40, no. 8 (February 8, 1940): 88–89. See the translation in this catalogue.

21 Jan Smetana was one of the students arrested by the Gestapo on November 17, 1939, after the brutal suppression of demonstrations against the Nazi occupation. He was released from the Sachsenhausen concentration camp on April 20, 1940.

22 Soon after completing his studies at the School of Applied Arts and Crafts in Brno, Bohumír Matal was sent to the German forced labor camp Lohbrück, where he was interned from 1942 to 1945.

23 See František Šmejkal, ed., *Skupina Ra* (Prague: Galerie hlavního města Prahy, 1988). In addition to Zykmund, the members of Skupina Ra included: the painters Josef Istler, Václav Tikal, and Bohdan Lacina; the photographers Miloš Koreček and Vilém Reichmann; and the poets Ludvík Kundera and Zdeněk Lorenc. After Teige introduced the Prague and Brno artists to one another, they worked together during the occupation.

24 See Jiří Valoch, ed., *Václav Zykmund* (Brno: Dům umění města Brna, 1999).

25 See Éric de Chassey and Sylvie Ramond, eds., *1945–1949: Repartir à zero* (*1945–1949: To Start from Scratch*) (Paris: Éditions Hazan, 2008).

26 "Skupina (Ra)," in *Skupina Ra*, ed. František Šmejkal (Prague: Galerie hlavního města Prahy, 1988), 126.

27 Karel Teige, "Mezinárodní surrealismus" ("International Surrealism"), in *Mezinárodní surrealismus* (*International Surrealism*) (Prague: Topičův salon, 1947), unpaginated.

28 Ibid.

29 Ibid.

30 André Breton, "Druhá archa" ("The Second Ark"), in *Mezinárodní surrealismus* (*International Surrealism*), unpaginated.

31 Ibid.

32 His friend Záviš Kalandra was, with Milada Horáková, accused of treason and espionage and condemned to death in the first Czechoslovak monster-trial.

33 The girlfriends and wives of the artists also attended the meeting with Teige: the photographer Emila Tlásalová (later Medková); Anetta Šafránková (later Fárová), who would go on to write histories of photography; Gerda Istlerová; and Anna Marie Effenbergerová.

34 See František Šmejkal, *Josef Šíma* (Prague: Odeon, 1988), 232–40.

CAT. 84
Toyen and Jindřich Heisler
Les spectres du désert [*Specters of the Desert*] | 1939
Cycle of twelve photogravures based on drawings by Toyen from 1936–37, accompanied by poems by Jindřich Heisler
Prague: anonymous; credited as Paris: Éditions Albert Skira
11 ³⁄₈ × 9 ¼ inches (28.8 × 23.3 cm)

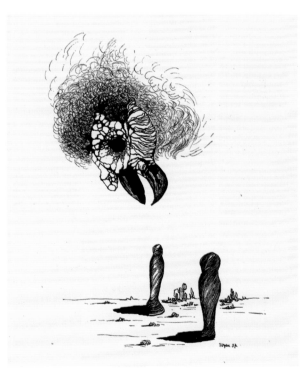

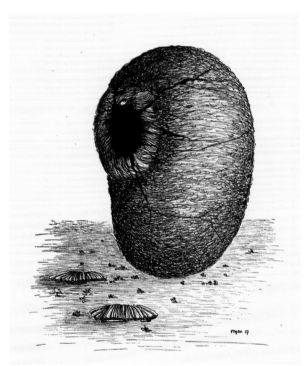

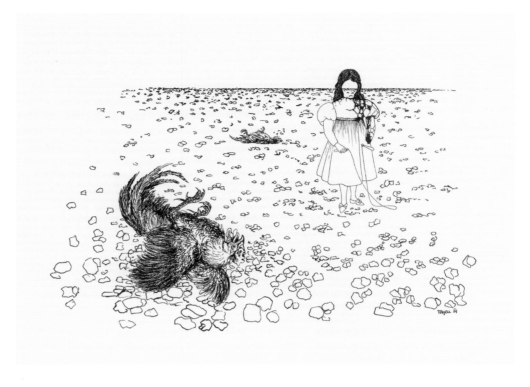

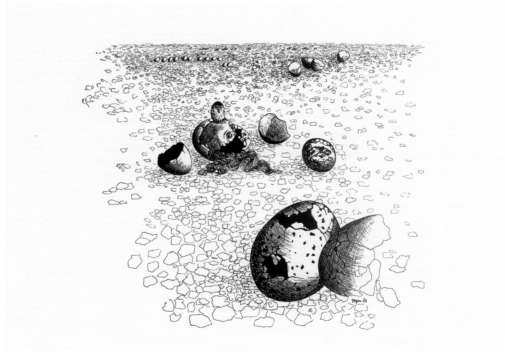

CAT. 85
Toyen
Střelnice [*Tir; The Shooting Gallery*]
Cycle of twelve photogravures based on drawings from 1939–40; reprinted 1973
Paris: Éditions Maintenant
13 ³/₈ × 17 ⁷/₈ inches (34 × 45.5 cm)

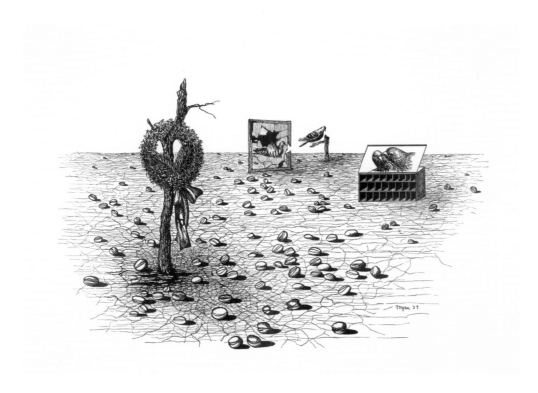

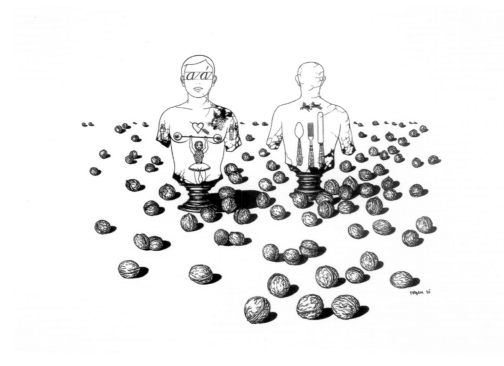

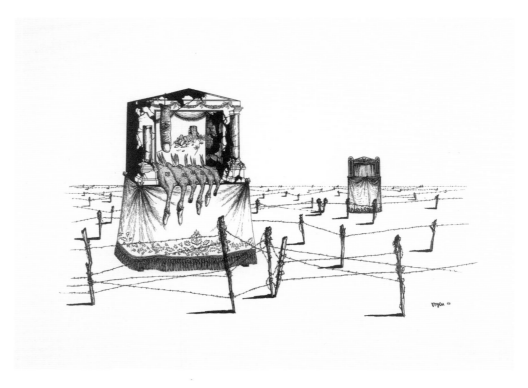

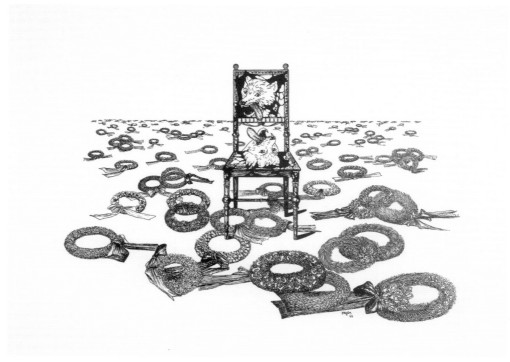

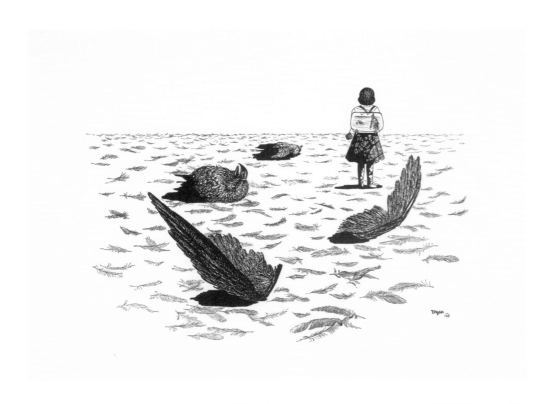

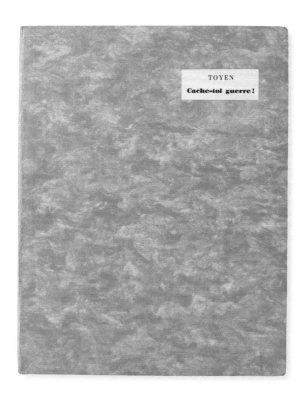

CAT. 86
Toyen
Cache-toi, guerre! [*Schovej se, válko!; War, Hide Yourself!*] | 1947
Cycle of nine photogravures based on drawings from 1944 | Paris: artist's imprint
16 7/8 × 12 5/8 inches (43 × 32 cm)

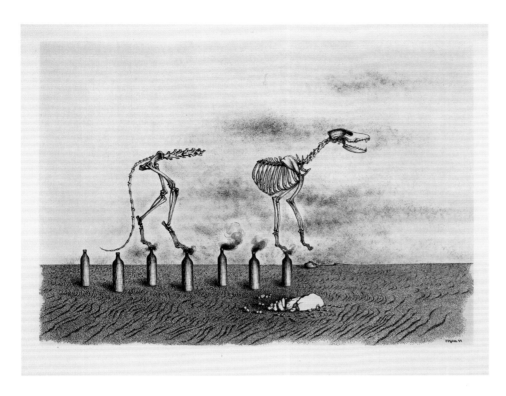

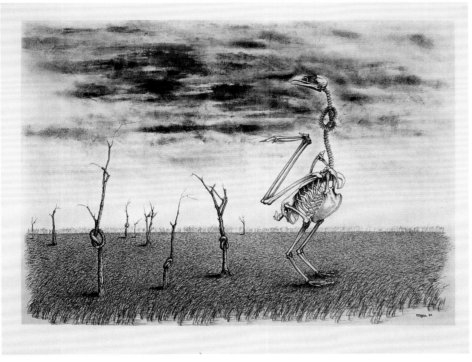

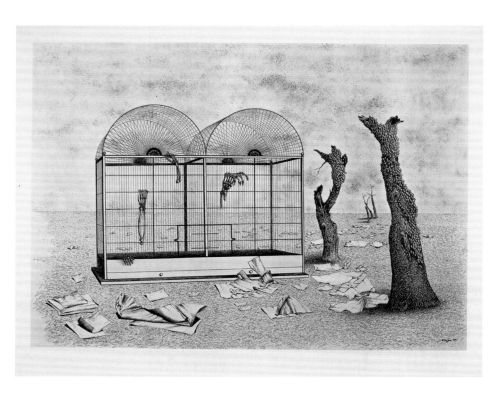

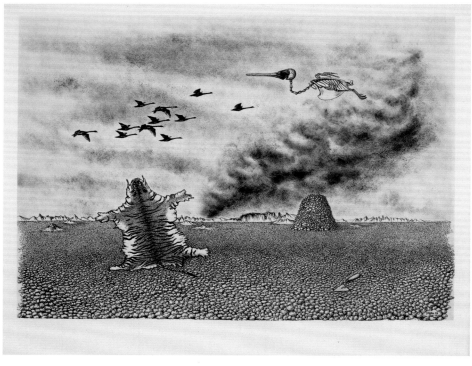

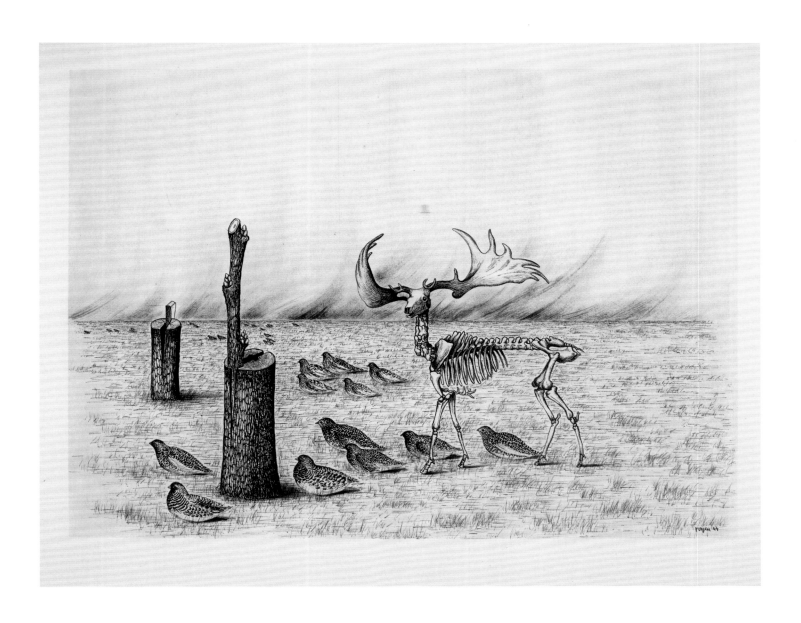

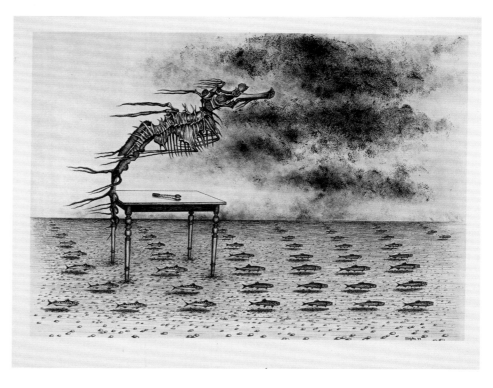

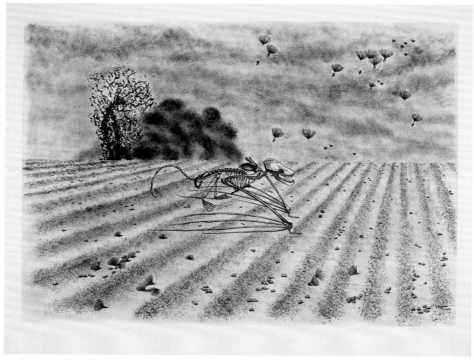

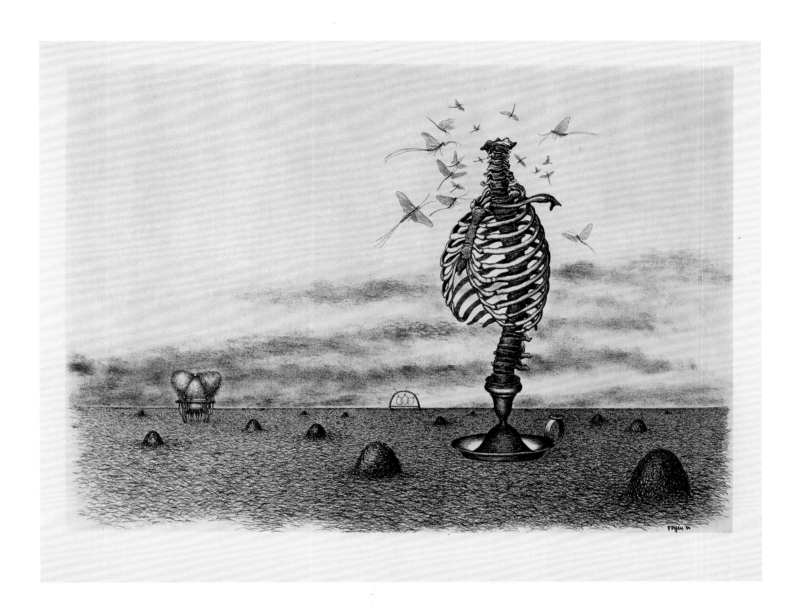

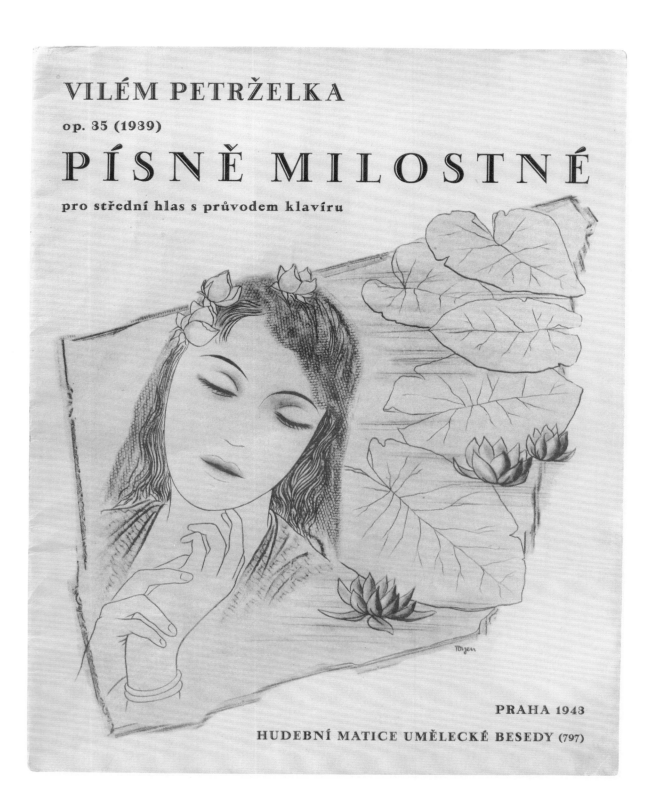

VILÉM PETRŽELKA

op. 35 (1939)

PÍSNĚ MILOSTNÉ

pro střední hlas s průvodem klavíru

PRAHA 1943

HUDEBNÍ MATICE UMĚLECKÉ BESEDY (797)

CAT. 87
Vilém Petrželka
Písně milostné [*Love Songs*] | 1943
Cover and illustrations: Toyen | Prague: Hudební matice Umělecké besedy
10 ⅝ × 13 ½ inches (27 × 34.3 cm)

CAT. 88
Toyen
Untitled | Illustration for *Pisně milostné* [*Love Songs*] | c. 1943
Graphite and frottage on paper | 9 ¼ × 8 inches (23.5 × 20.5 cm)

CAT. 89
Toyen
Untitled | Illustration for *Pisně milostné* [*Love Songs*] | c. 1943
Graphite and frottage on paper | 10 ¼ × 9 inches (26 × 22.9 cm)

CAT. 90
Toyen
Untitled | Illustration for *Pisně milostné* [*Love Songs*] | c. 1943
Graphite and frottage on paper | 10 × 9 inches (25.4 × 22.9 cm)

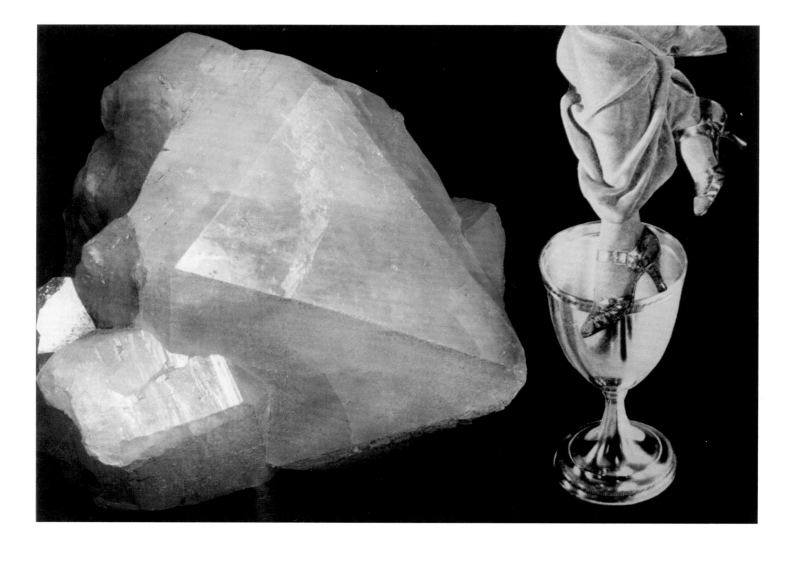

CAT. 91
František Vobecký
Chvíle zázraků [*The Moment of Miracles*] | 1936
Gelatin silver print, photomontage | 10 ⅝ × 14 ⅞ inches (27 × 37.8 cm)

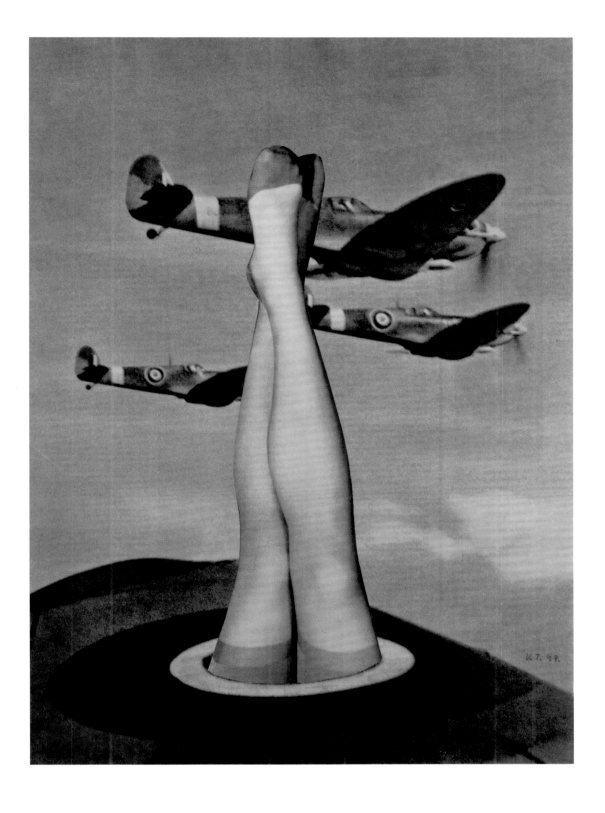

CAT. 92
Karel Teige
Untitled | 1947
Collage | 15 × 11 ¼ inches (38.1 × 28.6 cm)

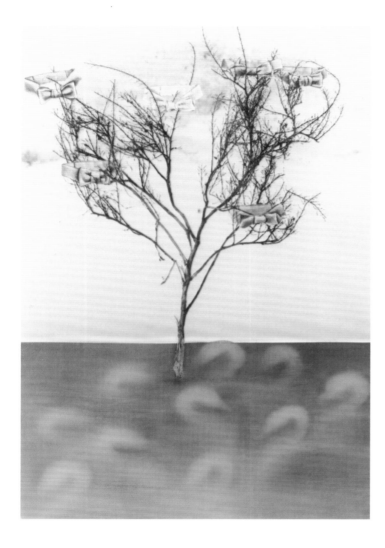

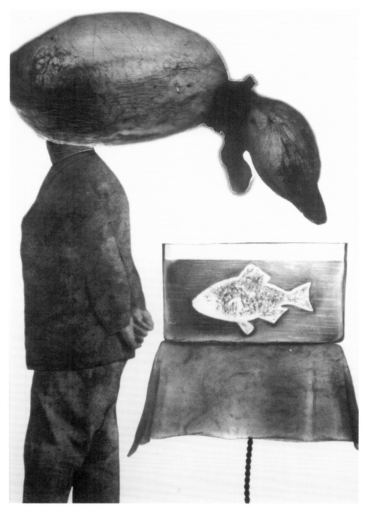

CAT. 93
Jindřich Heisler
Untitled | 1943
Gelatin silver print, photomontage | 10 ⅞ × 9 ½ inches (27.6 × 24.1 cm)

CAT. 94
Jindřich Heisler
Untitled | 1943
Gelatin silver print, photomontage | 10 ⅞ × 7 ½ inches (27.6 × 19.1 cm)

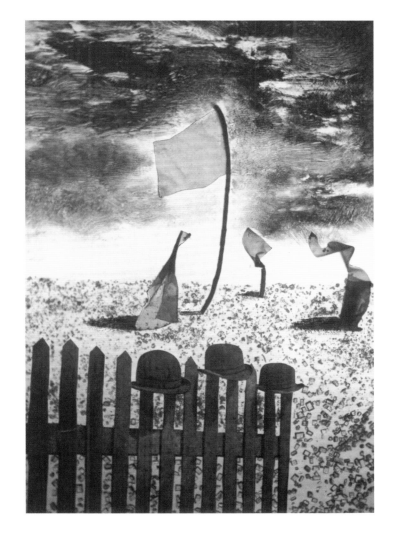

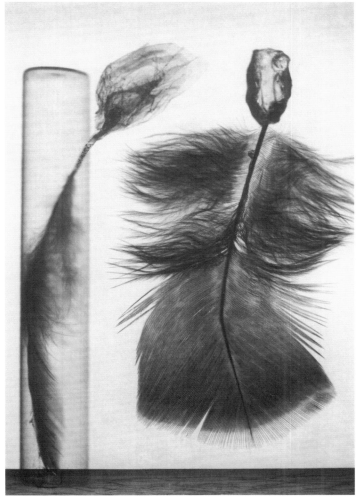

CAT. 95
Jindřich Heisler
Untitled | 1943
Gelatin silver print, photomontage | 10 ⅞ × 7 ½ inches (27.6 × 19.1 cm)

CAT. 96
Jindřich Heisler
Untitled | 1943
Gelatin silver print, photomontage | 10 ⅞ × 7 ½ inches (27.6 × 19.1 cm)

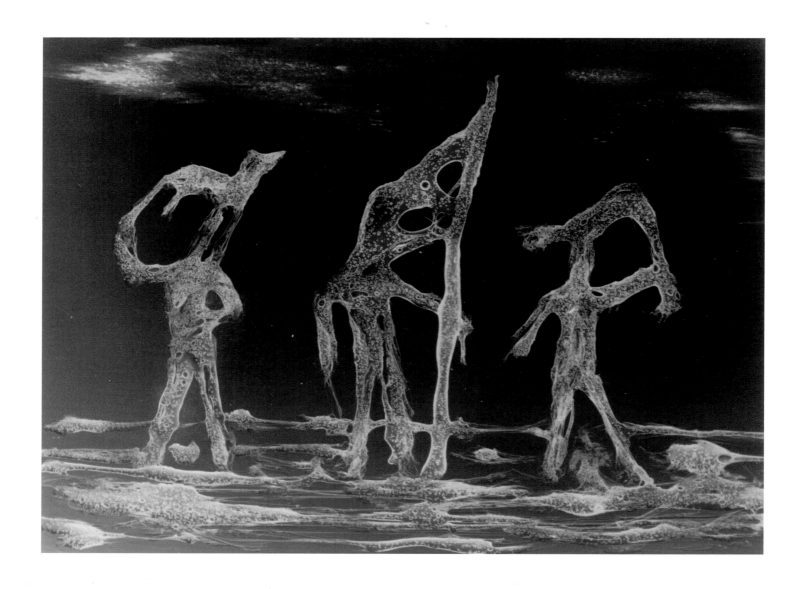

CAT. 97
Jindřich Heisler
Untitled | 1943
Gelatin silver print, photo-graphique | 6 ⅞ × 9 ¼ inches (17.5 × 23.5 cm)

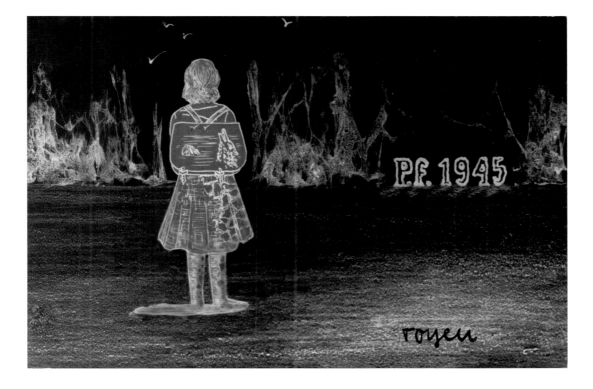

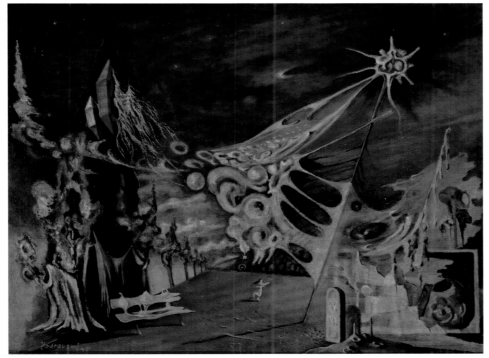

CAT. 98
Jindřich Heisler and Toyen
Pf. 1945 | 1945 | New Year's Eve greetings
Hand-colored gelatin silver print, photo-graphique on cardboard
5 ³⁄₈ × 6 ¹⁄₂ inches (13.7 × 16.5 cm)

CAT. 99
Josef Podrabský
Oslava [*Celebration*] | 1945
Oil on canvas | 22 ¹⁄₂ × 29 ¹⁄₈ inches (57 × 74 cm)

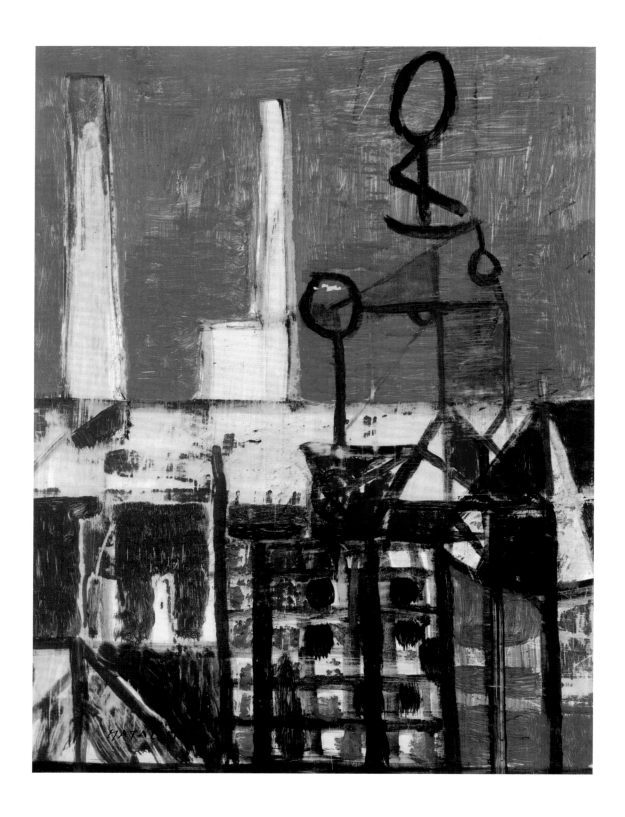

CAT. 100
Bohumir Matal
Untitled | 1946
Oil on board | 15 ¼ × 11 ½ inches (38.7 × 29.3 cm)

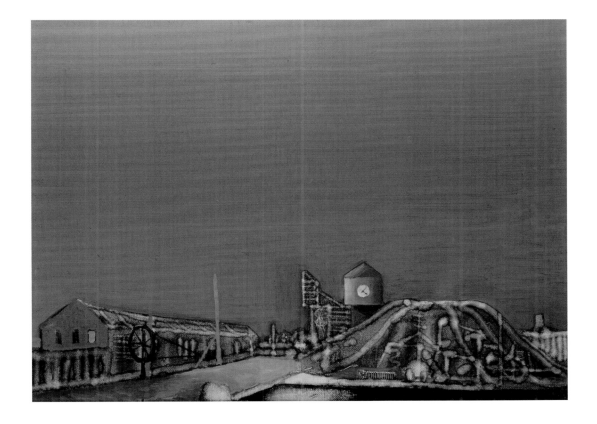

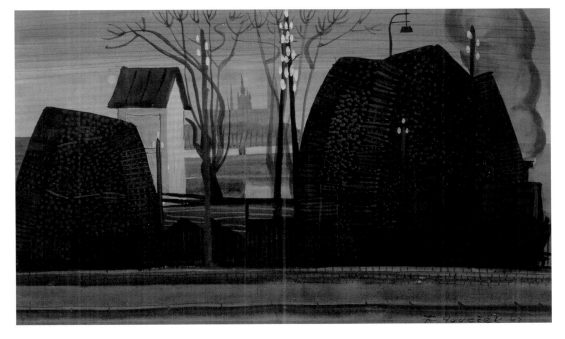

CAT. 101
Jan Smetana
Untitled | c. 1945
Oil on board | 8 ¼ × 11 inches (21 × 27.9 cm)

CAT. 102
František Hudeček
Pohled na Prahu [*View of Prague*] | 1942
Watercolor on paper | 8 ¾ × 14 inches (22.2 × 35.6 cm)

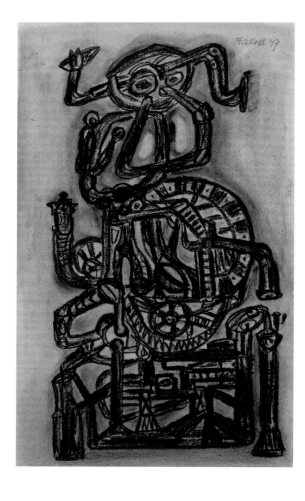

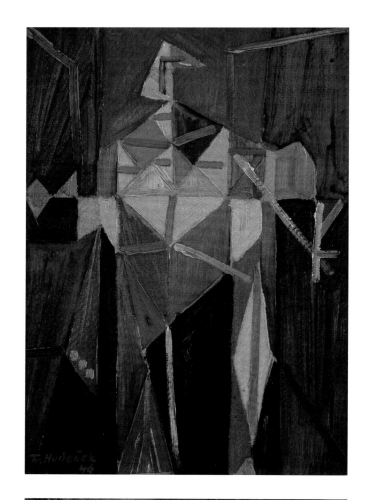

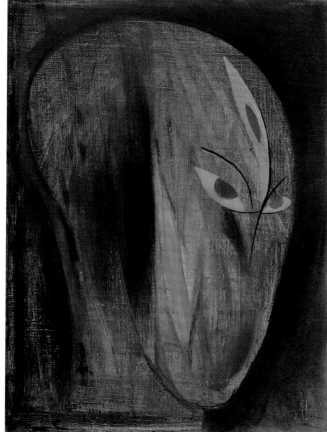

CAT. 103
František Gross
Untitled | 1943
Gouache on paper | 15 × 19 ¼ inches (38.5 × 23.5 cm)

CAT. 104
František Hudeček
Untitled | 1946
Oil on wood | 11 × 7 ¾ inches (27.9 × 19.7 cm)

CAT. 105
Václav Zykmund
Šedá hlava [Gray Head] | 1946
Oil on canvas | 16 ⅜ × 12 inches (41.5 × 30.5 cm)

CAT. 106
T. Svatopluk (Svatopluk Turek)
Gordonův trust žaluje
[*The Gordon Trust Sues*] | 1940
Cover: Toyen | Brno: K. Smolka
8 ½ × 6 inches (21.5 × 15.3 cm)

CAT. 107
Renée Gaudin
Smrt přichází o 22. hodině
[*La mort se lève à 22 heures; Death Rises at 10 p.m.*] | 1947
Cover: Toyen | Prague: J. Šedivý
4 ⅞ × 7 ⅝ inches (12.3 × 19.3 cm)

CAT. 108
Josef Šíma
Vláda pitomosti [*La pouvoir de la bêtise; Stupidity Rules*] | 1951
Graphite on paper | 17 1/8 × 11 5/8 inches (43.5 × 29.5 cm)

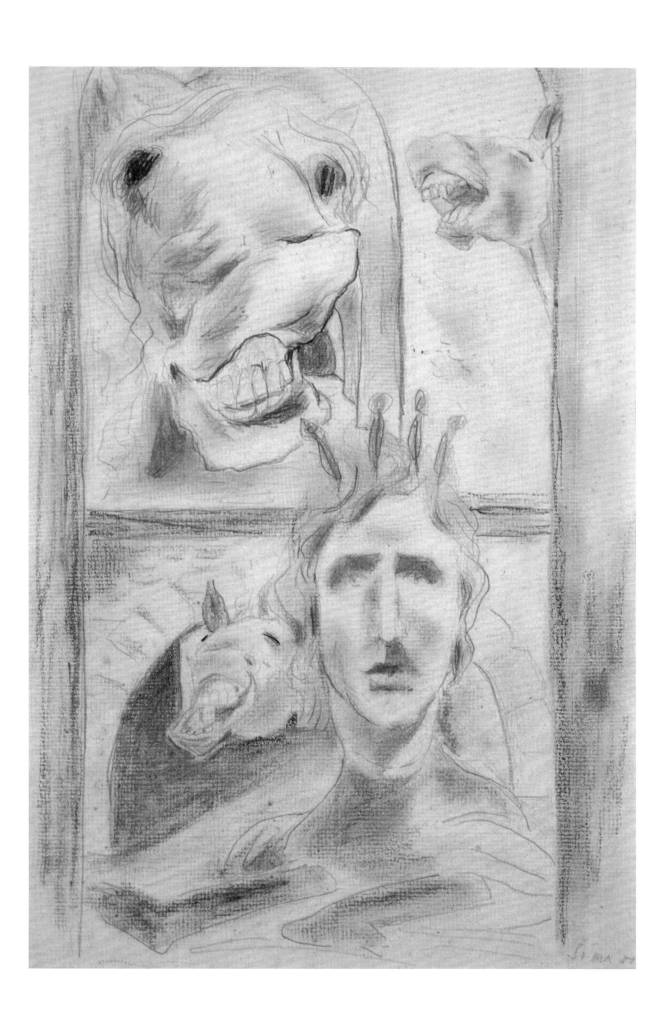

The young poet Jindřich Heisler brought fresh ideas to the Skupina surrealistů v ČSR (Surrealist Group in Czechoslovakia) when he joined it in the late 1930s, in particular shedding new light on the relationship between poem and image. The book *Les spectres du désert* (*Specters of the Desert*, 1939) was Heisler and Toyen's first collaborative project. For political reasons, it was first published in Prague in French in a limited print run of three hundred numbered copies, with the name of the Parisian publishing house of Albert Skira in the colophon. The collection was not published separately in Czech. Heisler and Toyen's joint undertakings brought to a new height the collaboration of two artists working in different media, poetry and painting, an experiment that Devětsil had promoted from its earliest manifestations in 1922.

Specters of the Desert: Poem, Surrealist Research and Development Monograph Series, no. 8, trans. Stephen Schwartz (Chicago: Black Swan Press, 1974). Originally published in the book *Les spectres du désert* (1939), where it accompanied Toyen's cycle of twelve drawings, and reprinted in *Aniž by nastal viditelný pohyb* (*Though Not the Slightest Move Was Made*) (Toronto: Sixty-Eight Publishers, 1977), 7–20.

Jindřich Heisler

Specters of the Desert

When the eyes are too tired
of having ceaselessly leaped from orbit to orbit
the mounds resume the game
by changing places
But still the newly swollen knolls
and the fuses whose head comes to a point
surround the sad landscape
that calls solitude

Flies
made blue-green by the exhalation of a dung-heap
have wanted to sleep on cheeks so fine
that they have fallen dead
Carried toward shore the ponds
of troublesome memories transform them
into scarecrows in the fields of forgotten dreams

Trembling nostrils
detached from the feet in the form of an open book by forgetfulness
rustle among the humid blades of grass
They are double
in a single pair of scissors small or big
for the currents of air of the streets and the beaches

for the currents of air that cut off their thighs
and feed on these scraps

There are flamboyant couples
like a diesel engine
like a pair of reins
like vestiges of the grammatical duel
but only a pair of knives
sustains at its height
between blades and handles
the just distance of the kiss

Like a poplar resembling the empress Maria Theresa
while pushing the landau before her
She invents the head of a deep sea diver
at the end of a ladder rising toward her
uniquely

Look at me this chimney sweep
told her before they began
what happiness what happiness
and all the buttons closing the fly in question have jumped

Neither the ku klux klan
so sad outside and within
nor the ku klux klan of stone that throws its shadow
no ku klux klan in the end
even while undressed
and above all while undressed
catches itself in the door

Sometimes behind a handbag
sometimes between the M and the L of my lips
another time in the ravine pierced by the sun
if not in the blackest of forests
where one never ceases to lift the pylons of broadcasting stations
which loosen the nets of uneasy planets

The static whole set like terror
draped in tapestries
and carried by chronological dates

This whole throws its shadow by necessity
for even in the tightest embrace
no double window is opened
perhaps to be replaced

In the display windows the necklaces rest in their velvet manes
a chambermaid dashes into the street
All the tides are loaded with gunpowder
and the billiard-cue frightened by the green cloth
prefers to spit the blue chalk from its tip
on the newspapers of Central Europe

Stretched out in the folded red of fever
stacked on top of each other like cardboard
they answer serenely by their why
and expect the locomotive to whistle
to signal that a tunnel approaches

Installed in cafes and all along the railway
hatred awaits the coming transatlantic
without suspecting how much it will delight the little fishes
and the rose-colored sand will only be printed with four new heads

In his art criticism from the early 1930s, Jindřich Chalupecký took a stand against Devětsil's original avant-garde program. He represented a younger generation that had grown up in different social and cultural conditions under the shadow of the Great Depression. The essay "Svět, v němž žijeme" ("The World We Live In") was published at the beginning of February 1940 in *Program D 40*, a journal edited by the poet Vladimír Holan. It is regarded as the informal manifesto of the rising generation, which, a few years later, would coalesce into Skupina 42 (Group 42). The group's members included the painters František Hudeček and František Gross, the sculptor Ladislav Zívr, and the photographer Miroslav Hák. The Skupina 42 artists had shared roots in Surrealism. During the Second World War, however, their work came to focus more on everyday objects and their immediate surroundings, which bore the scars of conflict.

Translated by Kathleen Hayes. Originally published as "Svět, v němž žijeme" ("The World We Live In"), *Program D 40*, no. 4 (February 8, 1940): 88–89.

Jindřich Chalupecký

The World We Live In

The most striking feature of modern art is the disintegration of the canonical types of theme: in painting, one sees the gradual disappearance of figural composition, the landscape, the portrait, and the still life; in poetry, the same is happening to the epic, the meditative, and the sentimental poem. Of course, the disappearance of themes has not happened all at one stroke. First, the most demanding themes receded; the rest faded away by degrees until they were no more than a mere pretext, and then they vanished altogether, albeit with a tendency to reappear occasionally. Thus, figural composition recurs in Surrealist painting and meditative poetry in philosophical or semi-philosophical poems, for the most part invoking the model of Valéry and Rilke.

This phenomenon of recurrence leads one to conclude that it was clearly an error to explain the disintegration and suppression of themes as a path to subjectless art. There was a good deal of talk back then about "subjectless painting." As for poetry that did away with themes, it was supposed to be a kind of arabesque of words and ideas, if it was too timid to reject even this "content" and go as far as an artificial language, sounds with no verbal meaning.

This trend was soon over. The interpretation that tried to demonstrate that the evolution of art was moving toward the rejection of themes was clearly wrong. It is true that themes had obviously vanished from Picasso's Cubism and from Reverdy's poems in favor of pure structure in painting and words. Yet this liberation of art was not supposed to reduce it to a fantastical fairy tale of the senses, no matter how magical.

At the same time, another trend interpreted modern art in a completely different way. This was based on Rimbaud, Lautréamont, Jarry, and de Chirico, and assumed its most consistent form in the theory and practice of the Parisian Surrealist group. It undertook an important reevaluation of theme. The rigid, vanishing literary and artistic *types* were succeeded by a single, universally valid type: the theme of art was the individual, his life, and in particular his inner life. Art was defined as the product of the subconscious, in the sense of Freudian psychoanalysis.

But the automatic texts, the literary simulations of madness, the paranoid interpretations of the visible world, and the records of dreams yielded no more than a few articles, one booklet, and a couple of paintings. The work of Breton, Éluard, Dalí, and Ernst went further, and in a different direction, unable to restrict itself to the narrow and monotonous potential of authentic manifestations of the subconscious.

If the meaning of modern art, however, is not to be found in the elimination of themes or in the expansion of themes to include the entire inner life of the individual, where should one look for it? Setting aside the theories that modern art has produced, making effective use of them one moment only to cast them away the next, let us try to define some of the features of modern art.

The destruction of types and the disappearance of themes were accompanied by an unusual flourishing of metaphor. More daring than ever, metaphor now became the main, indeed the sole, content of the poem, whereas previously it had been mere "decoration." According to the textbook definition, "a juxtaposition arises when two things that have a common feature are compared," and "metaphor transfers the name of one object to another so that their common trait stands out vividly." Given that modern art extols metaphor as the dominant form of the poetic vision of the world, given that it transforms a "formal" device into the "content" of the poem, it is easy to identify the essential difference between the prosaic and the poetic, the rational and the irrational conception of the universe.

According to the rational conception, the universe is a network of diverse individual phenomena and states; thus, a discontinuous system. The irrational conception, by contrast, stresses the similarities between, the de-individualization of, the components of the universe. It conceives of the universe as a whole that is continuous and coherent in all respects.

Pursuing these interpretations of existence — one seeking diversity, and the other unity — through to their conclusions, one sees that rational thought culminates in the differentiated description provided by language. It transforms the universe into a dictionary of signs of individual things, a set of components. The irrational consciousness, by contrast, ultimately unites the universe in a single indivisible mass.

In the course of these reflections, one also arrives at an explanation of the two characteristics of the modern poem.

First—the content of the poem is its form, and this also means that the form of the poem is its content. Form and content merge; they turn out to be one and the same thing. Hence the *lack of themes* in modern poetry; its theme is not something external to the poem (for example, an emotion, a reflection); its theme is nothing less than poetic knowledge of the universe.

Second—this poetic knowledge of the universe ends fatefully *beyond the poem*. If, as has been noted, language was created in order to categorize the universe into separate things, then the poet has to destroy this function of language. He tries to use it in a completely different way. He violates it, destroys it, in order to indicate the path that has to be taken in order to break holes in the prison of the rational construction of the universe. He aims at an intuition of Wholeness, of the single comprehensive totality of existence; he aims at the opposite of categorization; he aims at that which is by definition inexpressible. It is no coincidence that so many modern poems end in a pause, an exclamation, a tightening of the throat, silence; these are the only means of giving resonance to *this* particular artwork.

One should note that the same is true of modern painting. It too seeks the destruction of the rational universe. Picasso's paintings shatter the object and reevaluate it in a form that is increasingly ambiguous. The individual thing vanishes, replaced by painterly form, which suggests a world that *is no longer composed of things*.

Should the aim and meaning of art be exhausted then by this crushing pause, this unearthly sob, this superhuman and inhuman *above* and *beyond*?

Behold modern man, abandoned by the new science that relegates reality to a far-distant, unimaginable transreality. Abandoned by religion, now fatefully outdated—not in its function, but in its form. Man, transformed into a lifeless cog in the social machine, which has stubbornly run amok like a crazy *perpetuum mobile*. Man, reduced to two dates, the date of birth and the date of death, between which there is nothing but the occasional foolishness when his head simply *can't help but* spin. Foolishness that he quickly sets right, thanks to his rationality, which is that of a useful component, carrying out its work as diligently and as pointlessly as the entire machine. And now, on top of that, he is abandoned by art, which goes somewhere beyond and outside of man, uprooting him from life in an unearthly and otherworldly instant. Man, who hasn't even lived yet, who needs to be brought back to life. How closely this art, which is perhaps supreme but also certainly terminal, resembles that brilliant flare up of dying cultures. How close it is to late Rome, the Rome of oriental cults and Neo-Platonists. The end? Is it the end? Should Europe really endure the fate of the distant lost steppes of Asia? The fate of those cultures, which, after so much suffering and striving, petered out long ago on a

note too high for human hearing, yet persisted in a terrible, blissful, and deadening limbo on the margins of heaven, living their long centuries with eyes fixed on a superhuman distance? Should it, with a mysterious kind of irony, reduce the personal life of the individual once and for all to a monotonous rite, dully repeated without change from generation to generation? Will man forget about man, forget this amazing occurrence, this trembling flame, alive, alive, alive in the midst of the infinity of the motionless duration of existence, alien to the age-old law of rigid matter and the monstrous absolute? Will he forget about it, the miracle of his inscrutable desire, awareness, and self-confidence? Will he dispense with his mystery brutally and sordidly, in favor of an endless sleep from which even dreams have been extirpated? Will he humiliate himself, sinking to the divine heights of existence, where consciousness and unconsciousness, existence and nonexistence, action and inertia, are no longer distinct? What confusion! Is perfection perfect?

Or will he dare, in the end, to accept himself, to remain a tragic hero persisting between the twin poles of God and nothingness, and rejecting both? Will he remain a senseless and desperate experiment, an attempt to become conscious of himself, though incomprehensible, to desire, without ever being able to understand the motive or the meaning of his desire, and to experience, only to be surrendered again and again to primordial confusion? What is man, if he is not the one who becomes aware of himself but never understands?

To live, to live. Man wants to live, in spite of everything, in spite of the ease of lifelessness, in spite of the fact that everything is so arranged as to distract attention from life. And Europe, old, pained, and unhappy Europe, does not give up. It trembles with the writhing masses that beg, despair, and decide, without knowing why, but from some unshakeable certainty, that they must have the courage to do something other than *this*.

To live. To return man to mystery, confusion, life. To begin again. Art, you trifling and clumsy paintings, you little poems twittering your words in the midst of such vast events, would you be able—?

If you are not helpers, you are at least witnesses. Now and then, you find the courage that human endeavor will need: the courage to be and yet not understand, for that is life. I think of the paintings of Italian cities and French bathing pools, as de Chirico saw them, the eternally unfinished machine of Duchamp's *Mariée*, the hymn of Joyce's *Ulysses*, and the aching pages of Jouve's books, the rugged and fresh sensitivity of the verse and prose of American poets, of the Parisian peasant Aragon, Fargue's intoxicating texts, Dalí's severity, some of Bonnard's alarming canvases, Breton's wily transcripts, Atget's photographs and those of his skilled followers, scenes from old films, the brick walls and gas meter in Chaplin's *The Kid* —you may think it is foolish to compile such a list, and yet: here, on all sides, something resounds that I would call *the mythology of modern man or the world we live in*.

While living his life, man is naturally led to judge the things around him according to how much they help or hinder his attempt to provide for himself without too much effort or risk. Hence the encroachment on reality, removing things that are unpleasant, obstructive, and making things that are pleasant, convenient: in a word, civilization. Life is simplified, facilitated. It is reduced to the fewest possible reactions, which become standardized. Rationalization leads to automation. Man no longer needs to be on guard for reality. His reactivity to his surroundings becomes pointless.

This trend has its counterpart. In this second trend, man also perceives reality as something that, being external to him, is primarily hostile to him. It is something foreign, unknown, existing in itself; it limits and thus negates him. As it constitutes his negation, however, it forces him at the same time to become aware of himself: it is from this function that reality gives rise to the artistic act. Art always begins with an unexpected encounter with reality, which is not integrated into a rational system, having wrenched itself free; reality thereby lays bare the sensibility of the spirit and mobilizes its forces, which try to overpower reality. The theme of art is always the unknown, the loss of orientation, the attempt at something new. At the same time, art compels man to become aware of himself. It does not matter what the starting point is: as soon as he becomes conscious of the division of existence into I and the other, man and the universe, both stand out in their true grandeur.

Thus, things are more than the limitation and negation of the subject; they are a condition and constitutive component of consciousness. If one now bears in mind, however, that consciousness is a *function of life*, the form of this relationship between man and the world becomes clear: he unfolds things in his time and makes them participate in that senseless and incessant activity of a being that, for some unknown reason, was commanded not only *to be and to persist*, but also to come into being again and again at every instant at its own risk and on its own strength. Resisting the vast calm of the oceans of eternity, which beckons on all sides to blissful repose, and defending the incomprehensible futility of life against the certainty of death, it was commanded to transform its life, which is constantly under threat, into an unquenchable *thirst for life. In this longing to live, in this hunger for existence, it was commanded to wrench things free* from the dead, rational design, to assure itself that it is alive and to transform things into the guides and symbols of its desperate hope, to transform them into the *myth of its life*.

Things. *These* things. Not the anaesthetized, standardized products of abstract memory, but things that are living, unique, indubitable on account of their recalcitrant strangeness, their irreducible reality, which is capable of confirming itself and establishing the reality of the life of the subject. Thus, not things that are artistic, polished, and modified so as to be beautiful, pleasant, delightful, but rather things that are rough, cruel, mysterious, insistently making their presence felt through their impervious consistency, and rigidly chafing against the

smarting skin of the living organism, that "air, rocks, coal, and iron ore" for which Rimbaud's famous poem hungers.[1]

How many times has the model for art been sought in the dream; and yet, human timidity has exchanged the dream for dreaming, for a pleasing arrangement of simple, secure, appealing, contrived artifacts, not daring to learn from the power of the dream, which *situates* those very things that we are constantly encountering and does not bother about the rational or aesthetic qualities that we intended to allocate or deny them. And how many times has there been talk of realism in art, while all the while art was made from surrogate realities rather than from reality itself; that is, it was made from things that were as tried and tested and as far removed as possible from modern man, for example, the allegories of the seasons, the exoticism of rural life, and even nudes, bouquets, and still lifes, arranged solely for artistic purposes.

The feeble, cautious painter or poet of today seeks the most unobjectionable reality for his art, a reality that is as remote as possible from his experience of life, and he pursues it to places far removed from himself. By contrast, formerly in his art man always touched upon the reality that was close to him, whether that was the wild beast that he hunted, the silk dresses of the women he loved, or the landscape in which he lived. In fact, the reality of the modern painter and poet is the city: its people, pavement, lampposts, shop signs, buildings, staircases, and apartments. And he denies this reality because he is afraid of it, because that is the world in which he lives. Modern man is afraid of that world because, in it, he would have to think of himself — and he is afraid of himself.

If art is to recover its lost meaning in the life of the individual, it has to return to the things among which and with which man lives. But it should not return to a theme that exists *before* the artwork and *external* to it. If art rejected the repertoire of the old, dead themes, which had become fixed as artistic *types*, it cannot mechanically replace this repertoire with a new theme — cannot simply restore the old types and *once again defuse* reality by including it among the traditional themes as a mere variation on them. There is no alternative but to create it, because reality is not at the beginning of an artwork, to be adapted and transformed by it; rather, it is at the end of the artwork. Art discovers reality, creates it, reveals it; art reveals the world we live in and those of us who live there. Because not only the theme, but the meaning and aim of art are none other than the daily, grim, and glorious drama of man and reality: the drama of mystery confronting miracle.

If modern art is not up to this, it is useless.

1

He quotes from Arthur Rimbaud's *Une saison en enfer* (*A Season in Hell*, 1873): "Je déjeune toujours d'air, / De roc, de charbons, de fer." *Trans*.

Jindřich Heisler's poem "Schovej se, válko!" ("War, Hide Yourself!") dates from 1944, when Toyen created a set of nine drawings with the same title. The publishing house of František Borový issued the poem and drawings after the end of the Second World War in 1946. A year later, the book was published in Paris in French. The title refers to a line from *Poésies* (*Poems*), "Cache-toi, guerre!" by Isidore Ducasse, comte de Lautréamont, one of the poets most admired by the Prague Surrealists.

Translated by Kathleen Hayes. Originally published as "Schovej se, válko!" (1944) ("War, Hide Yourself!"), in Toyen, *Schovej se, válko!* (*War, Hide Yourself!*) (Prague: Fr. Borový, 1946), 3.

Jindřich Heisler

War, Hide Yourself!

Cache-toi, guerre!
Lautréamont

The first step sent the leaves whirling
the second landed between stone and lizard
and the third crumbled like a clod of earth on the body of a
sprawling sow
which sucked a metal rooster
a toy whistle with joined legs

Thus the season of fatigue arrives
brimming with a natural perfect swindle

Other steps are pressed in dust
and dust clutches the ends of light
Tongue seeks tongue
and a moldy poppy falls in the dark of a climbing street
which ends like a lemon
in the maw of a grinning pig

Two fish meet in a mouth
where baby teeth grind against other teeth
and fight like ice picks

Young parched throats suddenly sputter with saliva
thickened blood

The blood of healthy teeth
chattering with pain and pleasure
soaks white tufts of wool that
like final thoughts
roam over the ceiling

Pain ignites the gaping jaws
and their bloated warts
visit other warts

It is not about enmity or love

Red skies
accompanied by frozen wandering paper
are followed by desolate voids
in which old forsaken things appear
and they start up
biting each other
and if possible
try to grow into each another
to achieve the goal
of suiting everything

And while deer antlers interlock
like an echo returning four times

a blush crawls out of the world of commerce
on four little wooden legs
with a miner's lamp through which it breathes
It does not listen behind the door
nor clock in like the night watchman
but creeps after begging children
and if it manages to forget its obligations
it is not the time now
for flying stones to look each other in the eye
it is not the time now
to turn the light on or off

It is not about enmity or love,
Kisses make dents for little lakes of blood
and blood flows in narrow streams
gouging out suitable nooks for kisses
A few intensely awkward memories
ingrained like petrified parrots
cheerfully hop about in that tangled thicket
and heavy haymaking teams of horses
approach
to drive through half-opened heads
whose sleep is like the prolonged threading of a needle

Teige's study of Toyen's wartime work served as the introduction to a set of twelve drawings by Toyen from 1939 – 40, published under the title *Střelnice (The Shooting Gallery)* by František Borový in February 1946. The book also included Jindřich Heisler's poem "S důvěrou" ("In Good Faith"), from the manuscript collection *Daleko za frontou (Far from the Front*, 1940 – 41), written shortly after Toyen made her drawings. Heisler's collection was not published until 1977. Teige perceptively analyzed the fundamental transformation in Toyen's art during the Second World War.

Translated by Kathleen Hayes. Originally published as "Střelnice" ("The Shooting Gallery"), in Toyen, *Střelnice (The Shooting Gallery)* (Prague: Fr. Borový, 1946), 3 – 6.

The Shooting Gallery

Karel Teige

The question of what a drawing, a painting, or a statue means is based on the assumption that being and consciousness, reality and idea, object and subject are identical. This assumption lies behind the requirement that a picture represent reality, and that all of reality be represented in the picture in such a way that the depiction accords with the account that sense perceptions give us of the external world. The relationship between being and consciousness, perception and idea, object and sign, is not one of mechanical correspondence or analogy, in which a real fact directly determines the trace that it leaves in the mind; nature was duplicated in the reflection in the mirror, and the perceived object, like a negative plate, left a positive imprint in the perceiving subject.

Man consults a surface of water or a shadow in order to assure himself of his existence and his fate. He consults paintings, drawings, poems, those mirrors in which the world and life are reflected. For the viewer who wants to encounter his double in the mirror, and who verifies his vision of the world in pictures, the shadow plays of Goya's *Disparates (Sueños)* [*The Follies (Dreams)*], Tiepolo's *Capricci* and *Scherzi* [*Caprices* and *Jokes*], G. B. Bracelli's *Bizzarrie* [*Bizarre Figures*], and Dürer's *Melencolia* [*Melancholy*] are a mirror, offering a confusing and mysterious testimony. The abstruse and fantastical visions of Bosch, Bruegel, and Grünewald were subsequently interpreted in the light of mystical texts, legends, apocrypha, and prophecies. Arcimboldo's *Vertumnus*, Giambellino's small *restello* polyptych in the Venice Academy, and Titian's *Amor Sacro Amor Profano* [*Sacred and Profane Love*] can be explained as

allegories. Although such interpretations are woefully incomplete and raise too many questions, they provide at least a partial rational answer to those who seek to understand what these dark pictures, loaded with symbols and hidden meanings, represent. To this day, the mystery of works like Dürer's *Melencolia* and Goya's *Disparates* defies interpretation. After all of the comparative critiques, the iconographic analyses, and ideological speculations, scholars have to admit that these scurrilous and bizarre prints of indeterminate content, which appear to have no rational motivation and defy the established allegorical semiotics, can be interpreted in ambiguous, often contradictory ways. They have to admit that the significance of these mysterious prints remains shrouded, that they are riddles to which one cannot attribute a specific meaning or story. In the case of Goya's *Caprichos* [*Caprices*], the artist's commentary on his work is more an obstacle than an aid to interpretation. Its well-meaning banality does not shed a sliver of light on the demonic night from which these phantasms erupted, thereby indicating that the verbal commentary was conceived with the intent to mislead the viewer and to mask the terrifying power of these delirious scenes. Likewise, the pictures by Ernst, Tanguy, Paalen, Štyrský, and Toyen guard their mystery and preserve their magnetic power untouched. The man who hopes to be reassured about himself and the universe by looking in the mirror is terrified when he does not recognize his own face there, and sees instead an unfamiliar world in which he has no place.

Given that the key to the Egyptian script was rediscovered when Champollion deciphered the hieroglyphic and Demotic passages on the Rosetta Stone with the aid of the Greek text, it will perhaps be possible, when interpreting works that resist the instruments of art scholarship, to accept help from other disciplines. In particular, the psychoanalytic study of magical thought and the semantics of dreams may be of assistance where other types of cultural-historical research have proven to be of little use.

The clairvoyant sees an invisible world in the crystal ball. In the Surrealist mirror of Toyen's new drawings and paintings, one sees a stage where strange and even everyday things are transformed into specters. *Střelnice* [*The Shooting Gallery*] is a cycle of twelve drawings that evoke some of the motifs and elements of the preceding *Přízraky pouště* [*Specters of the Desert*] (1936–37) and influence the later series *Schovej se, válko!* [*War, Hide Yourself!*] (1944). The labyrinthine mirror of *The Shooting Gallery* multiplies the meanings of the objects reflected in it. One could describe the character and the developmental trend that take shape in these cycles of prints as progress toward an increasingly more objective and concise concretization of an inner model. The subjectless compositions and, to a certain extent, the colorful games of Artificialism from 1926 to 1930 were a mirror without an image. Now a reflection appears in the mirror once again, and a drawing or a painting is a mirror of fantastical

objects. A picture is no longer a picture. It is no longer a composition of abstract lines and forms. Rather, it is, once again, a depiction and a reflection. The realistic picture was a mirror that reflected the things set before it. In Toyen's magical mirror of paintings and drawings, one sees a bizarre ghostly world, objects that are unrecognizable to the senses, and real things that are inexplicably juxtaposed. The surface of the Surrealist mirror is not angled in such a way as to capture the spectacle of the external world. The things that are reflected there are situated on the other side, on the banks of desire, not in front of the mirror but behind it: adventures in wonderland. The realistic depiction of a world, which the positivist realist regards as unreal and nonexistent, is a paradox of Realism, a kind of Realism turned inside out.

The realistic painting strove to depict an external model, a feat that the camera achieved with an ease that painting techniques could not rival. By contrast, Surrealist painting, which depicts an inner model and replaces visual perception with an internal image, an idea, was defined as "handmade color photography of concrete irrationality and of the imaginative world in general" (Dali). This definition juxtaposes, in a terse and simplified manner, the picture of the external model and the picture of the internal model. It suggests that both cases involve a picture, which, in its fidelity, is like a photograph, a cast, or a mirror reflection. But the definition overlooks the fact that the mirror that captures the inner model is different from that which reflects the external world. The former is a symbolic and magic mirror of metamorphoses.

In the prints of the album *The Shooting Gallery*, one sees objects, figures, and heads scattered randomly over a flat earth, which merges with an empty sky; in other words, the most neutral scenery imaginable. These objects are uprooted, cracked, battered, broken, and destroyed. They are shipwrecked and yet salvaged, more wreckage than reality, washed up by the tide of events on a sandy beach. Yet they are, thanks to the artist's virtually miniaturist technique of precise drawing, which gives them the plausibility and tangibility of material facts, undeniably existent and real objects. *Specters of the Desert* are realistic pictures of figures and things, which, although products of the imagination, are not unlike real things. Among these bizarre chrysalides, eerie birds, and animal heads, one also finds things that are familiar from experience, not only the broken statues of a lion and scattered puppets, but also a very real and threatening claw. The forms that resemble objects from real life are weakened in their reality, depicted as cracked and disintegrating fragments, statues rather than living bodies. In *The Shooting Gallery*, there are several motifs that are similar to those in *Specters* and other contemporaneous drawings. The drawings and paintings that preceded *The Shooting Gallery* were, for the most part, reflections of chimerical, unfamiliar things, which the imagination had shaped from forms borrowed from the empirical world. *The Shooting Gallery* and more recent pictures reflect extraordinary scenes and bizarre encounters, which

the imagination concocted by confronting objects that were, in general, as real and familiar as Lautréamont's umbrella and sewing machine on the operating table. The drawing and painting techniques, which gave concrete and material form to a poetic idea in a fanciful object, were essentially realistic, although they were distinguished by a distinctive, highly sophisticated style. When the poetic image, however, acquires such a degree of concreteness that the imagination no longer creates peculiar objects to which realistic drawing lends the appearance of real things, when, on the contrary, the imagination ushers in utterly real and ordinary figures and objects, displaced in space and time, when it juxtaposes incongruous and completely unrelated things in a bizarre setting, then individual style vanishes in the technique of depiction, and an austere impersonal craftsmanship predominates, recalling illustrational engravings and pictures from textbooks.

In Lautréamont's "beautiful encounter," the sewing machine and the umbrella on the operating table enact the passionate embrace of a woman and a man in bed, an act of love against a background of death. When the most ordinary things are removed from their standard functional context by dream, imagination, and longing, their hidden meaning, usually suppressed by their practical function, comes alive. The things that meet in the scenes of *The Shooting Gallery* are symbols of latent tension, although the meticulously realistic technique never allows them to cease being what they are in reality. In everyday life, our treatment of ordinary and even unusual things is mostly, although not exclusively or unequivocally, motivated by rational considerations. The irrational libidinous evaluation of objects plays an entirely secondary role. Similarly, the things in pictures and poems that are removed from practical relationships and become symbols of unconscious ideas and events are not lost. They do not merge with the meaning that they symbolize. Rather, they remain themselves.

If an artwork is defined as a unique set and system of signs, which is itself, as a whole, a coherent sign, one cannot overlook the difference between the signifying character and semantic construction of those works that aim to imitate realistically an external or internal model, and those works that, in their formal structure, depart from the naturalistic message and description. In pictures that are abstract rather than naturalistic, the lines and colors of certain geometric shapes can represent this or that specific thing, depending on the context in the picture. An oval can be a face. The vertical triangle in the middle of the oval can be a nose. Outside of the oval, it can be a tree, the pinnacle of a tower, a cliff, the sail of a boat, in short, anything whatsoever depending on the semantic context. By contrast, as Jan Mukařovský demonstrated in his semantic analysis of pictures by Toyen and Štyrský — "On the Noetics and Poetics of Surrealism in Painting"[1] — in pictures executed in a realistic

1

"K noetice a poetice surrealismu v malířství," *Slovenské směry* [*Slovak Trends*] 5, nos. 6 — 8, 1938).

style, the focus is not on the sign but on the designated thing. The latter becomes a symbol, representing other things, and obscurely expressing other related hidden meanings and ideas.

The group of things that one sees on the surface of *The Shooting Gallery* is a parable of entirely different events. The style of drawing is precise and impersonal, so realistic that it creates the illusion of direct imitation. It keeps artistic flourishes in check so that they do not distract from the object portrayed, which is at the forefront of the painter's and the viewer's interest. It persuades one that the shapes on the surface of the picture are not the ciphers, allusions, or signs of things, but rather the direct imprint of things. Indeed, it persuades one that these shapes are the very things themselves, things that have lost none of their materiality or their sensual properties, that have not ceased to be themselves, and yet that are, at the same time, symbols of something else. It is in the nature of the symbol, as Hegel and Freud understood it, to be polysemous, or at least ambiguous. A symbol is a visible, existing thing, which should not, however, be understood simply as something existing on its own, but in a more general and figurative sense as a sign. It represents other things and ideas, which it resembles, be it ever so distantly, in some of its properties. The symbolized idea extends beyond its external existence; it projects from the object in which it is manifest; it is not entirely enclosed by the object, nor does it vanish within it. The symbolizing thing also includes in itself other qualities, in addition to those that highlight the symbolized meaning. The mystery of symbolic works, which resist conceptual, rational interpretation, the impossibility of giving a precise and complete answer to the question of what such paintings represent and mean, lies in the fact that the symbol cannot be absolutely identified with its meaning, the fact that the symbolic picture always represents something more than the symbolized content, while at the same time it remains a direct, nonfigurative designation of a thing. After all, one cannot be sure whether or not certain components and motifs in pictures should be understood as symbols. Every object portrayed can both refer to itself and symbolize some other idea or thing. Behind every depicted object, there are secondary meanings and ideas, often blurred and contradictory. The more naturalistic the depiction of the object is, the richer, more diverse, and numerous are the clusters of ideas, which hide behind the thing depicted and merge with its properties. A condensed, almost ideogrammatic sketch transforms a thing into a sign; in this case, only those sensual qualities of the thing that convey the intended meaning are preserved. A detailed, realistic depiction preserves all of the sensual aspects of the object, be it empirical or fictional; these aspects can evoke countless diverse ideas, memories, emotional images, and unconscious stirrings. Toyen strives for a drawing style that is as detailed and naturalistic as possible in order to evoke this rich play of unconscious ideas and intense lyrical emotion. Thus, in the new drawings and paintings, chimerical objects give way little by little

to things drawn from life; their familiar shapes and qualities, it seems, can send out ripples of related ideas and memories in a way that is even more vivid. Often, chimerical objects are confronted with real things, replete with symbolic meaning, in a single picture: these encounters create the most numerous and polysemous reverberations.

The Shooting Gallery is both an amusement at a fair — the drawings are full of such shabby props riddled with bullet holes — and an image of the world ravaged by the drumfire of battles. The image of puppet theaters encircled by barbed-wire fences gives an ambiguous meaning to the title that embraces all twelve prints. Given the ambiguity of the collection's title, each drawing and each thing depicted is situated on a border between its own essence and the secondary figurative meanings concealed in the background. The drawings of *The Shooting Gallery* are based essentially on a twofold contradictory scheme: the world of childhood is confronted with the world of war. All of the things depicted belong to the repertoire of childhood memories and games. Only a single motif — the posts with barbed wire — recalls the years of terror and massacre. But this motif is so drastic and powerful that it imposes an ambiguous meaning on the entire album. For the viewer, the childhood memories and ruined toys scattered in the drawings are plunged into the shadow of the horrors of war, although these are not directly expressed anywhere in the artwork.

 The houses made from children's building blocks, knocked down in the grass, the ruins of bombarded cities, and the children killed while playing; the mangled bodies of birds lying on the ground like airplanes shot down; the broken dolls; the schoolgirl headed somewhere beyond the horizon of the picture; the funeral wreaths scattered on the ground around a rickety chair, when Paris fell; the puppet theater with the lifeless, severed finger suspended over the stage where plucked fowls hang, neck down, throats cut, as in a market stall; the price tags suggest that, even in the abattoirs of history, one can do business and make money; the curtain is still down on the other theater, and one does not know what drama is unfolding there. . . . All of these things, dilapidated and half rotten, are pregnant with many wide-ranging meanings. The toys of a children's paradise form the scenery for the current historical tragedy, and they become terrifying objects: the age of childishness, humanity's lost paradise, stranded in the wild fury of time. The game of shooting targets at a fair is transformed into the bloody horror of the worldwide catastrophe.

 The present catastrophe was unleashed in the wings of a stage that was the delight of childhood. Of the two thematic and semantic schemes — the scheme of childhood and the scheme of war — only the motifs of the former appear explicitly. The events of the implicit scheme of war, however, are so manifest that the viewer, directed by the motif of barbed wire, the ambiguous title, and the date, almost automatically interprets this strange still life,

composed of junk and toys, as an illustration of the chronicle of the Second World War, a sort of *Los desastres de la guerra* [*The Disasters of War*] for our times. Goya's work, however, is monothematic; it is a news report, a chronicle of wartime events, rounded off with a few allegorical compositions. Although it does not appear explicitly, the scheme of war in *The Shooting Gallery* is not one of hidden meanings. The artist undoubtedly intended the motifs of childhood memories to develop the war theme implicitly and yet all too clearly. This second scheme of war motifs is deliberately laid out as the background; although empty and vague, it reflects all the more vividly the motifs that are projected onto its surface. From the beginning, the children's toys were intended to represent images of war. Although the war theme is not directly depicted, it is set up as the dominant thematic line. Only a detailed psychological analysis could reveal the profound latent content, the incandescent lyrical core. There undoubtedly is latent content, hidden behind the theme of war — the fictive indulgence of aggressive and destructive instincts, and of the dark death wish (horror both repels and fascinates). There is latent content as well behind the theme of the lost childhood paradise — the imaginary fulfillment of polymorphous infantile longing. In one print, caps of pens are planted before a backdrop of flat weatherworn stones. The latter have numbers on them — the numbers are not without significance — in the form of a multiplication equation. Also drawn on the stones are the heads of two girls, depicted in inverted positions as if on a deck of cards, one with her eyes bound, and the other with a scarf over her mouth; the open jaws of an animal with its tongue sticking out; a dog's head and two sheep kissing . . . This drawing so tricked the censorship of consciousness that it managed to express its latent content in barely veiled symbols. (The image of a girl's head with bound eyes, an open mouth, and her tongue sticking out appears in a drawing illustrating Heisler's book *Jen poštolky* [*Only Kestrels*].[2] There must have been compelling reasons to repeat the motif here, broken up and in altered form.)

Neither a detailed semantic interpretation nor an extensive psychological analysis — which, for that matter, is always incomplete and, without the hard facts of biographical details, unreliable — can elucidate all of the components, all of the depths of an artwork. They cannot provide a complete transcription of all of its concepts or capture the nature of its brilliance. The latent content of a dream, which, after a detailed analysis, can be summarized in a few sentences, is no more than a dry account of the riveting outlandish drama so often played out in dreams. The emotional power of an artwork is in the disturbing mystery of inner tension between the various semantic spheres, which strike a spark when juxtaposed. It is in the charges of lyrical electricity between the poles of thing and symbol, life and dream. The multivalent cryptogram of the picture and the poem can never be completely deciphered.

2

The full title of this work is *Jen poštolky chčí klidně desatero* (Only Kestrels Calmly Piss on the Ten Commandments). *Ed.*

The Shooting Gallery provides an authentic testimony of the fiery years of horror, robbery, and bloodshed that date its prints, just as Goya's account, in *Los desastres*, testifies to the drama he witnessed—*He visto*. It is not a news report on the Second World War, an illustrated chronicle of terrorism, a transcription of murderous events, or political propaganda. Its message is undoubtedly that of an *antiwar and antifascist protest*, all the more shocking in that this is never directly expressed in the overt theme, which is not openly polemical. It is an accusation, which, although not expressed, is drastically manifest in the painful confrontation of delightful childhood memories with the cruel, barbaric, and infernal present. In the drawings, this present appears only in the single motif of barbed-wire fences, and in the violation and destruction of the toys and other objects. They have thereby lost the charm of childhood and are transformed into gruesome wreckage, testifying to a cataclysm, just as uprooted trees testify to the fury of the gale that has blown over the land. Critics of Surrealism have accused it of turning away from real events and social conflicts and seeking an illusory refuge in an ivory tower. They have accused it of ignoring the call of the times, of failing to participate in the revolutionary struggle for the new world. Yet in this album, Surrealism has created a work that is so damning as to banish such prejudices and false incriminations for good. *The Shooting Gallery* is proof that the romantic ivory tower has been abandoned and torn down, that the poetic idea is not like a rootless orchid, that it does not grow up in a greenhouse or faint away in the traumas of the present. Like Goya's *Los desastres* and Picasso's *Guernica*, *The Shooting Gallery* refutes the nonsense that is spouted again and again to the effect that a mature picture of revolutionary events requires the perspective of distance. These drawings do not revert to the methods of descriptive, tendentious Realism. They are not a one-off pamphlet of ideological propaganda. Rather than a rejection, they are a verification of the premises that Surrealism identified and accepted as the basic precondition of poetry: free choice of theme, irrespective of external circumstances and demands, and the right to complete freedom of imagination. The drawings in *The Shooting Gallery* do not accommodate the dictates of the present by basing their themes on historical events. They do not have any a priori subjects, but rather create themes in the process of crystallizing and concretizing imaginative ideas. They do not portray, illustrate, or allegorize rational slogans, but rather sketch out fanciful inner images. They do not place themselves at the service of pacifist, antimilitarist, and anti-imperialist propaganda. Their magically mesmerizing revolutionary power derives from the latent content. The war theme, which, although not explicit, provides the tone and framework of the drawings, is not a mere echo of the events of the period. Rather, it is a product of the self-generating autonomous development that led Toyen from *Specters of the Desert* to *The Shooting Gallery* and to the cycles *Den a noc* [*Day and Night*] and *War, Hide Yourself!*, and from the pictures *Samotář* [*Loner*], *Obzor* [*Horizon*], and *Finis Terrae* to *Nebezpečná hodina* [*Dangerous Hour*], *Polní*

strašák [*Scarecrow*], *Zelený stůl* [*Green Table*], and *Předjaří 1945* [*Early Spring 1945*]. The choice of themes and their semantic ambience here is not simply the result of the persistent agonizing pressure of horrifying experiences. Rather, it is perhaps primarily an internal matter of poetic structure and motion. *The Shooting Gallery* is not simply a response to the events and problems of the present. Rather, it is an answer to the developmental issues raised by *Specters of the Desert*, those portents of despair and mad lives. The two different keyboards on which *The Shooting Gallery* plays — childhood reminiscence and contemporary drama — correspond to the duality of desire, which trembles in the depths of man, where collective hope draws its desperate and victorious energy from personal hopelessness: the desire to escape from a hellish world and the will to change this inhuman life and world.

The Shooting Gallery condemns not only its era, but also the disgraces that its era proclaimed as art. Bouquets in a jar and intimate still lifes, picturesque idylls and sweet landscapes, religious scenes and tasteful decoration — these products of the infinite imbecility of the official artists are a reactionary hoax, which attempts to hide, behind a mask of smiles and compassion, the pitfalls and chasms of a world that has fallen prey to demonic horror. It is a reactionary hoax if art conceals the misery of life and the blood of the abattoirs and execution grounds with a floral veil of consolation and charm. History, with its crises and convulsions, is not the only or even the main source of inspiration for poets and painters, who have a right to keep some distance in their work from the chaos of the present. And yet those games of color and line that are fit to decorate the parlors of tycoons and pirates, the pictures that are untouched by the shadow of apocalyptic times, are nothing but sophisticated cosmetics, the goods of a hairdresser or a haberdasher. Poetic value, born of freedom of the spirit and aiming at higher and higher freedom, cannot be separated from the powers that strive for the liberation of man.

Prague, autumn 1945

The Well in the Tower

Karel Srp and Lenka Bydžovská

While living in exile in Paris, Toyen continued not only to paint but also to work on drawings, graphic art, collages, and objects. These works constitute a remarkable epilogue to the Czech avant-garde artwork in the collection of Roy and Mary Cullen.[1] In the spring of 1947, Toyen and Jindřich Heisler left Czechoslovakia to settle permanently in France because they were wary of the direction that political developments in the country were taking—developments that would culminate in the Communist coup of February 1948. Life in Paris was difficult, given that they were poor and had no contact with home, but they immediately became active members of André Breton's group. After Heisler's untimely death in 1953, Toyen was the only remaining figure of the Prague prewar Surrealist group to continue to work in that style, which she did, in collaboration with her Parisian friends, until her death in 1980.

Even in this foreign-language environment, the relationship between image and word, which had been an aspect of Toyen's artwork since her early Devětsil period, remained important to her. At her solo Parisian exhibitions, she stressed the connection between visual art and poetry more systematically than ever before. Breton, Benjamin Péret, and E. L. T. Mesens all wrote poetic texts for her imaginative catalogues, as did younger members of the group who had concentrated around Breton after the war. One of these, the poet Georges Goldfayn, chose the titles for Toyen's pictures in the 1950s, just as Vítězslav Nezval had done in Prague in the period between World War I and II. Toyen often contributed to new Surrealist journals and anthologies, sometimes providing drypoints for deluxe copies.

Exile in Paris also involved sacrifices: Toyen had to break from all those who had remained in Czechoslovakia. The Czech press in exile paid little attention to her work, with one striking exception. In March 1953, the Parisian exile publishing house Éditions Sokolova, founded by Meda Sokolová, published a monograph on Toyen. (Sokolová was later known by her married name, Mládková.) In terms of the quality of printing and design, the book was superior to other exile book productions of the time. It was published in a bilingual edition, with an English translation supplementing the French. A limited number of copies included original graphic art. The monograph was the brainchild of Toyen's friends from the Surrealist group: Breton and Péret wrote the texts, and the architect Guy Doumayrou designed the cover.

As far as her own book art was concerned, Toyen first concentrated on publishing her older cycles of drawings, which had

already been released in Prague. In 1947 she published the wartime cycle *Cache-toi, guerre!* (*War, Hide Yourself!*), and in 1953 *Les spectres du désert* (*Specters of the Desert*). Toyen also intended to publish her first French cycle of drawings, *Ni ailes ni pierres: ailes et pierres* (*Neither Wings nor Stones: Wings and Stones*) from 1948 to 1949. According to the advertising flier, the seventeen hand-colored drypoints were to be issued as the second volume of the art series produced at the publishing house of the journal *Neuf*. The plan came to nothing, but the cycle later inspired paintings and drawings in which Toyen focused on certain isolated motifs. When comparing this cycle with Toyen's wartime works, the changes in style and content are immediately apparent. The horizon has vanished, and there is no coherent space or unifying vanishing point. In the void of the white surface, a new world has emerged from diverse fragments of reality and fantasy, with startling linguistic connections and plant, animal, and human combinations. Toyen arbitrarily enlarged or shrank selected motifs; these motifs did not conform to a single scale, nor did they respect the law of gravity; sometimes they mirrored one another and multiplied. One can identify some details precisely, but others are less defined. The cycle is like a lyrical stream in which personal experiences and ideas merge with snatches of perceptions. This work inspired her to create portraits of Breton and Péret, both of which later appeared in books. In one version of Breton's portrait on canvas, in the Cullen collection, his profile is set in the center of three overlapping triangles and surrounded by symbols of the four elements [CAT. 109]. Toyen deliberately followed an iconographic plan, which she used to represent the ideas that inspired Breton at that time, in particular his growing interest in alchemy and esotericism. In 1952 this portrait appeared as the frontispiece in Victor Crastre's publication *André Breton*.

Toyen designed the cover and the frontispiece for Breton's *La lampe dans l'horloge* (*The Lamp in the Clock*, 1948), and for Péret's book *Le gigot. Sa vie, son oeuvre* (*The Leg of Mutton: Its Life and Works*, 1957). In addition to producing works for these founding figures of Parisian Surrealism, she also illustrated the first poetry collection by the young Surrealist poet Charles Flamand, titled *À un oiseau de houille perché sur la plus haute branche du feu* (*For a Coal Bird Perched on the Highest Blazing Branch*, 1957). Her interest in book art took a new and unexpected direction after the mid-1960s under the influence of the Surrealist poet and dramatist Radovan Ivšić.

Passion for Books

A native of Zagreb, Croatia, Ivšić settled in Paris in 1954 and joined Breton's group. Toyen met him at this time. They had a natural mutual understanding because both had fled countries in which proletarian dictatorships had assumed power after the Second World War. Unlike their French contemporaries, they had no illusions about Communist regimes. Toyen and Ivšić did not work together, however, until the late 1960s. By then, Ivšić already had experience in publishing his own work and took a special interest in the artistic presentation of his texts. His book *Mavena*, for example, was illustrated by Joan Miró. Ivšić and Toyen worked well together: "My close collaboration with Toyen in the publishing world began in spring of 1966 when she quite suddenly brought me a set of twelve magnificent India-ink drawings for which she asked me to write a text, emphasizing, 'These are the debris of dreams.' I was not at all expecting that she would ask me to be, if I can put it this way, their illustrator, and least of all to design and publish them as a case-bound book."[2]

All twelve drawings in the cycle *Débris de rêves* (*The Debris of Dreams*) date from 1966. They depict both romantic and menacing forms of encounter. Fingers gently touch a breast (as they caressed a phallus in Toyen's prewar erotic drawings) or play in a head of hair. A bird of prey winds possessively around a woman's legs; another bird with a diamond eye catches a loop of hair on its beak; yet another pecks the rubbery flesh of human tongues; a claw slits a human throat. Anthropomorphous and animal motifs merge: an identical pair of leopard heads replaces the features of a girl's face; the heads look like butterfly wings, or a mask. Elsewhere, a bird's head emerges from the outline of a man's body. The skin of a woman's body is decorated with floral tattoos; in this way, Toyen recalled Štyrský's dream, from many years earlier, of babies tattooed with pornographic pictures. Most of the motifs from *The Debris of Dreams* also appear in paintings: *Coulée dans le lointain* (*Distant Stream*, 1962) depicts an elongated, supine body, with drawings of white birds and plants on its skin; in *Paravent* (*Screen*, 1966), the skins and heads of beasts of prey cover a woman's torso; in *Éclipse* (*Eclipse*, 1968), colorful fish glow against the dark shadows of male and female figures.

In *The Debris of Dreams*, Toyen returned to an approach that she had employed in *Specters of the Desert*: she asked a writer, in this case Ivšić, to create poems to accompany her already completed cycle of drawings. Ivšić's texts for this book constitute

a work of art in their own right; thus, the book has two titles — *Le puits dans la tour. Débris de rêves (The Well in the Tower. The Debris of Dreams)* [CAT. 110]. The first refers to Ivšić's poetry, and the second to Toyen's drawings. The preparation of the book for publication took an entire year. Ivšić carefully supervised this process. He relied on well-known printers, Marthe Fequet and Pierre Baudier, who had collaborated with Pablo Picasso, Georges Braque, and Miró. Two versions of the book were printed: a standard version with reproductions of drawings and a luxury edition with twelve drypoints. Toyen colored some of the first copies of the luxury edition by hand. The book was published under the imprint Éditions surréalistes, to which the Surrealists had recourse from 1926 on whenever they needed to publish their work at their own expense or for subscribers. Before the book was released, excerpts from it appeared in April 1967 in the first issue of the journal *L'Archibras*.

For *The Debris of Dreams*, Toyen created a case reminiscent of an erotic game-object. It was inspired by a popular children's game, in which, by tilting the surface, a marble is rolled into indentations. Pinkish-red, geometrical abstract shapes on a black foundation decorate the top of the purple case for *The Debris of Dreams*. They could represent either a face or a woman's body. Games with marbles and balls appear frequently in Toyen's wartime work: in *Střelnice (The Shooting Gallery*, 1939 – 40); in both versions of the painting *Na zámku La Coste (At Lacoste Castle*, 1943, 1946); and in the painting *U zeleného stolu (At the Green Table*, 1945). They even appear in *L'Origine de la vérité (The Origin of Truth*, 1952). According to Goldfayn, a nighttime dream inspired this painting, although Toyen was usually much more interested in daydreams: "I can confirm that she was having difficulty completing the painting *The Origin of Truth*, which she permitted me to see unfinished. One day she told me that she had found the solution in a dream and then the little marble appeared there above the dark hollow."[3] The prewar work of the poet Georges Hugnet inspired Toyen's new approach to book covers. For Hugnet, the binding of a book was a Surrealist object in itself; his creative bindings were featured in the journal *Minotaur* in the winter of 1937. Péret, in the accompanying commentary, described them as phantom constructions built around books; they had no obvious meaning and had to be interpreted from a personal, poetical point of view.

Toyen also worked on a book by the young French poet and theoretician Annie Le Brun, who joined the Surrealist group in 1963. In February 1967, Le Brun finished a manuscript titled *Sur-le-champ (Right Now)*, which so impressed Ivšić and Toyen that they decided to publish it under the imprint Éditions surréalistes, with collages by Toyen [CAT. 111]. At this time, Toyen had started to work on collages once again, after a break of many years, and she discovered in them previously unsuspected possibilities of expression. She used reproductions from contemporary magazines, including advertisements. She did not simply juxtapose two different realities. Rather, she captured the subversive potential of visual analogy, which liberates beings and things from the meaning or function in which they are usually imprisoned. In six collages for *Right Now*, she treated the themes of pleasure and cruelty from a subtly ironic perspective: an enlarged bat bites the thigh of a walking woman wearing tight-fitting shorts; a pair of grinning mouths is inserted into an advertisement for underwear — a reference to the menacing motif of the *vagina dentata*. Two drypoints, which treat similar themes in a different medium, constitute a counterpart to the caustic collages. A third drypoint, depicting a column of eyes, touches on another subject: in a kind of alchemical transformation, the iris and pupil of an eye change successively into the head of an animal, the head of a bird, a crystal, a target, and the phases of the moon.

Ivšić wrote of the origin of the book *Right Now*:

I believe I am one of the few who can attest to what extent Toyen felt an actual physical need to produce a book, thus lending, through form, material, colour and volume, a solidity to the fragility of thought that ventured so far from herself into poetry. When working with her, one had the impression that she was investing all her energy into accomplishing this concretisation, in which her subtle sense for materials came into play, primarily thanks to her predilection for paper, its texture, its grain, its colour . . . not to mention her interest in all new materials. How many hours we spent deliberating on the colour of the printing ink that would best match that of the paper we wished to choose! And, with the same passion, how we strove to find the exact shade that the impression of her design printed on the silk of the case should take! It was thus that we decided, by mutual agreement, to make Sur-le-champ *a book with a black cover and case but printed on pink blotting paper. One can imagine the technical problems that this posed.*[4]

Toyen adorned the monochromatic black case of *Right Now* with the symbol representing the female sex, the same symbol that Hugnet, in a more striking form, had used on the binding of

Breton's *L'Amour fou* (*Mad Love*, 1937). In Le Brun, Toyen had discovered, after a long period of collaboration with men, a woman writer whose temperament was close to her own. In the 1930s in Czechoslovakia, Toyen had illustrated books written by women, though at the time, she had been motivated by the need to earn a living, rather than by shared artistic convictions. This situation changed when she became acquainted with Le Brun, who was an insightful and provocative thinker and one of the most inspiring Surrealists of the 1960s generation. Toyen agreed with Le Brun's criticism of neofeminism as an attempt at ideological control over the personal freedom of the individual. Toyen's lifelong philosophy was in harmony with Le Brun's criticism of collective morality, her refusal to accept any kind of role forced on her by society, and her defense of an unconditional individuality. They were both interested in "erotic humor" ("l'humour érotique"), which Le Brun described as a new category discovered by Toyen.[5] They made a joint contribution to the journal *L'Archibras* (1968), with Toyen providing collages for her friend's text, "Dispersion préliminaire en vue de la confection d'une Eve future entrelacée par Toyen" ("Preliminary Breakdown for the Making of the Next Eve, as Toyen Spins Her"). They made a collaborative compilation of "dream creatures" (*Carte d'identité* [*Identity Card*]), satirizing film magazines, though it was not published. Toyen continued to illustrate Le Brun's books into the 1970s.

From the mid-1960s on, Toyen mainly used material from contemporary magazines in her collages, but she did, on occasion, also take a fresh look at well-established techniques. In 1968, at the request of the Surrealist Jehan Mayoux, she created six collages and one drypoint for the book edition of Ivšić's 1943 play *Le roi Gordogane* (*King Gordogan*) [CAT. 112]. She decided on xylographic collages in the form of fortune-telling cards, returning to a technique that she had used in the 1930s in Prague. Her work recalled Heisler's *Abeceda* (*Alphabet*), from the beginning of the 1950s, in which each letter suggested a different story. In 1976 she created more pieces for *King Gordogan*, but these were theater masks based on a totally different conception of collage.

An emphasis on unusual materials, combined with daring color design, characterized Toyen's approach to the book *La forêt sacrilège et autres textes* (*The Sacrilegious Forest and Other Texts*) [CAT. 113]. This book was released in 1970 as the last of three volumes of posthumously published poems by the Surrealist Jean-Pierre Duprey. As a talented young poet, Duprey had attracted the attention of Breton at the end of the 1940s, and later, in the 1950s, he had concentrated on sculpture. Toyen printed the six drypoints for *The Sacrilegious Forest* on green silk. The case that she designed for this book was made of white polystyrene. The hollowed-out shape of an animal's body appears on the top and bottom of the case. On one side, the animal holds a green stone in its mouth; on the other, a red stone. The work is reminiscent of Toyen's painting *L'un dans l'autre* (*One in the Other*, 1965), in which she inserted a real green stone in a painted necklace. She covered the white box with green Plexiglas, giving visual form to an idea that had informed the title of one of her paintings from 1951: *Je m'aperçois que ma page blanche est devenue verte* (*I see that my white page has changed to green*).

When the activities of the Surrealist group came to an end after Breton's death, Toyen regularly took part in collective Surrealist events organized by her circle of friends in the 1970s. This group included Le Brun, Ivšić, Goldfayn, Gérard Legrand, Pierre Peuchmard, and others. In 1972, they founded Éditions Maintenant, which released a series of remarkable small books known as the "Collection S." The name indicated that, for the publishers, Surrealism ("S") was still relevant. In 1973 Toyen prepared a set of twelve collages, *Vis-à-vis*, for this series; it was printed on green paper and supplemented by one drypoint. Éditions Maintenant published a number of works that were challenging to produce, including Le Brun's book *Tout près, les nomades* (*Close by, the Nomads*, 1972), for which Toyen created a circular drypoint depicting a bat and a case with the outline of a dove. It also printed a new luxury edition of *Tir* (*The Shooting Gallery*, 1973) [CAT. 114]. This time Ivšić, instead of Heisler, wrote the accompanying poem; Ivšić also prepared the book for publication. Toyen added two drypoints to the set of drawings [CATS. 115 and 116]. The composition of these pieces was based on the target shape, which Karel Teige had included on the cover of the Prague publication. In the drypoints, Toyen used the target as a backdrop for one of her major themes: the union—sometimes blissful, sometimes violent—of human and bestial features. In one of the prints, a schematic round face, with its tongue sticking out, appears as a minor motif. Toyen had previously employed the same motif in her painting *Eclipse* (1968); stylistically, it recalls Toyen's typogram. *The Shooting Gallery* was enclosed in a turquoise case with a symbolic figure on the lid. In June 1973, Ivšić presented it at an exhibition, which he had organized, of Toyen's book art at the

Parisian gallery-bookstore Les Mains Libres. The Art et technique du livre committee awarded *The Shooting Gallery* the prize for the most beautiful book of the year.

Toyen's last book project was for Le Brun's poetry collection *Annulaire de lune* (*Moon Ring-Finger*), published in 1977 [CAT. 117]. Toyen produced six drawings in red ink; these were designed with a view to how they would look next to the page of text, which was printed in green ink. In these distinctly vertical composite bodies, one sees once again the transformations that occur when various motifs intersect: the female body and its parts, underwear and clothes, fingers, fruit, birds, and beasts of prey. In each instance, a new organic whole emerges that cannot be broken down again into individual components. A fusion occurs, inspired by an erotic vision that excited Toyen to the very end.

In her Parisian period, Toyen's relationship to the book was highly refined. In contrast to her prewar production, she no longer designed books for a living but rather concentrated exclusively on authors and works that were personally connected to her, in particular the poetry collections of her friends from the Surrealist group. She gave up mass-produced books and focused on bibliophile editions. Her approach to the book was increasingly individual. In addition, her relationship to the exterior and interior of the book changed. Whereas, in the 1930s, Toyen had focused mainly on the cover in order to attract the interest of potential readers, in the 1960s, she gave her full attention to the interior of the book. She remained hidden within the book, in her own intimate space, which only a single reader could peruse at one time. The graphics and collages that she created for these pages were often works of art in their own right, rather than mere illustrations. As Toyen withdrew increasingly from the world, the cover of the books she designed gained in bulk. In the end, she transformed the cover into a separate case, in which the book lay like a relic. The case protected her from the world; it was a "frame" that separated the private from the public. Ultimately, Toyen resided in the book like the mind in the body.

NOTES

1 On Toyen's life and work, see Karel Srp, "Bibliography," trans. Karolina Vočadlo, in *Toyen* (Prague: Argo and City Gallery Prague, 2000), 382–88; and more recently, Karla Tonine Huebner, *Eroticism, Identity, and Cultural Context: Toyen and the Prague Avant-garde* (dissertation), University of Pittsburgh, 2008.

2 Adapted from Radovan Ivšić, "Book against the Wind and Waves," trans. Lisa Houghton, in Srp, *Toyen*, 344–47, see 345.

3 Georges Goldfayn, "Úlovky bdělých snů" ("Recovered from Waking Dreams"), *Ateliér* 13, no. 9 (2000): 8.

4 Ivšić, "Book against the Wind and Waves," in Srp, *Toyen*, 346.

5 Annie Le Brun, "À l'instant du silence des lois" ("When the Laws Fall Silent"), in *Štyrský, Toyen, Heisler* (Paris: Musée national d'art moderne, Centre Georges Pompidou, 1982), 57–65, see 58.

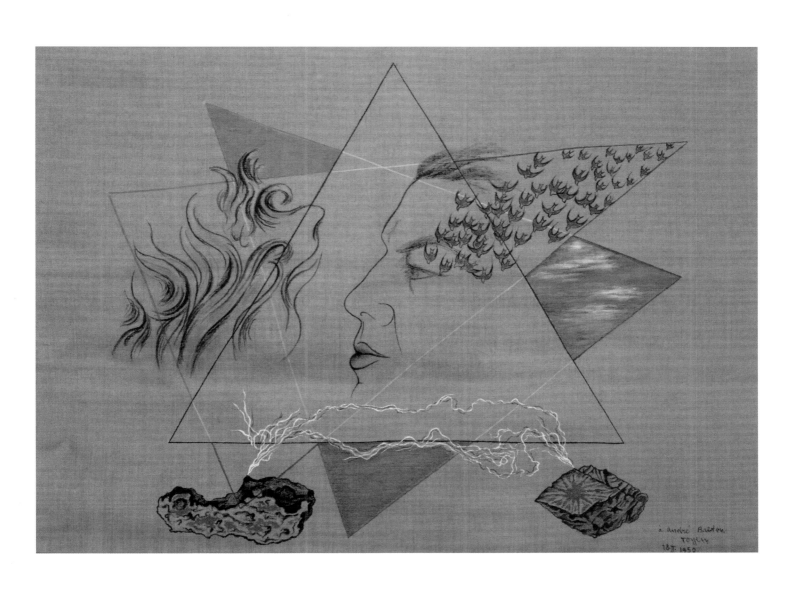

CAT. 109
Toyen
Portrait d'André Breton [*Portrait of André Breton*] | 1950
Crayon, charcoal, oil, and glitter on linen | Inscribed: à André Breton | Signed: Toyen 18 II 1950
19 ½ × 26 ½ inches (46 × 64 cm)

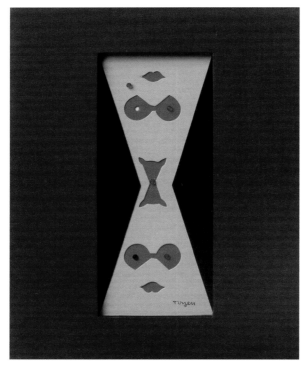

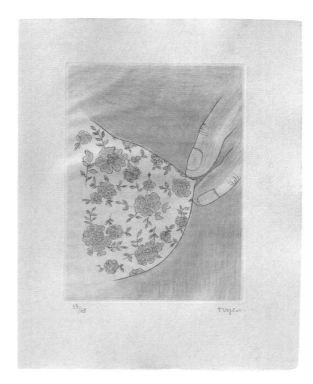

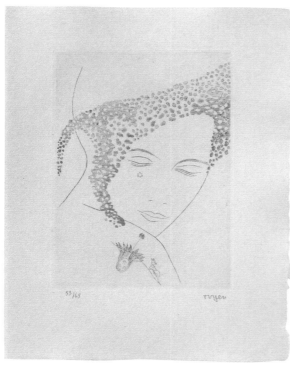

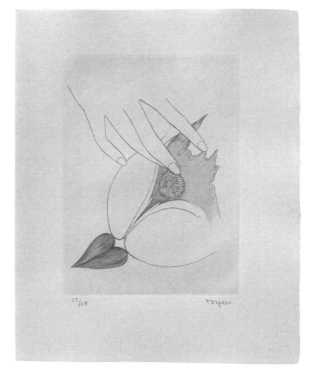

CAT. 110
Radovan Ivšić and Toyen
Le puits dans la tour. Débris de rêves [*The Well in the Tower. The Debris of Dreams*] | 1967
Folio case and cycle of twelve drypoints: Toyen | Paris: Éditions surréalistes
13 ¾ × 11 inches (35 × 28 cm)

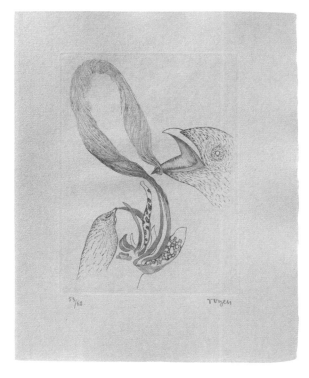

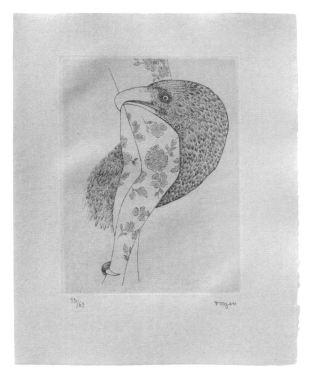

53/69 Toyen 53/69 Toyen

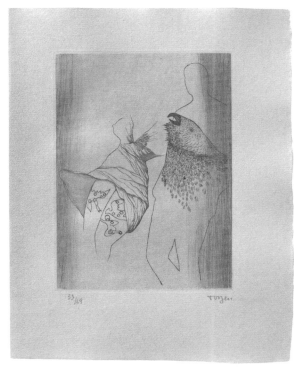

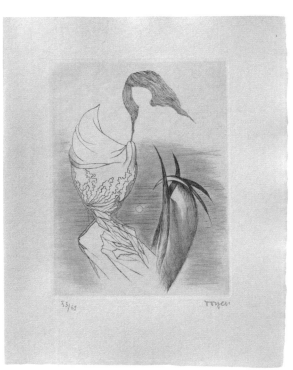

53/69 Toyen 53/69 Toyen

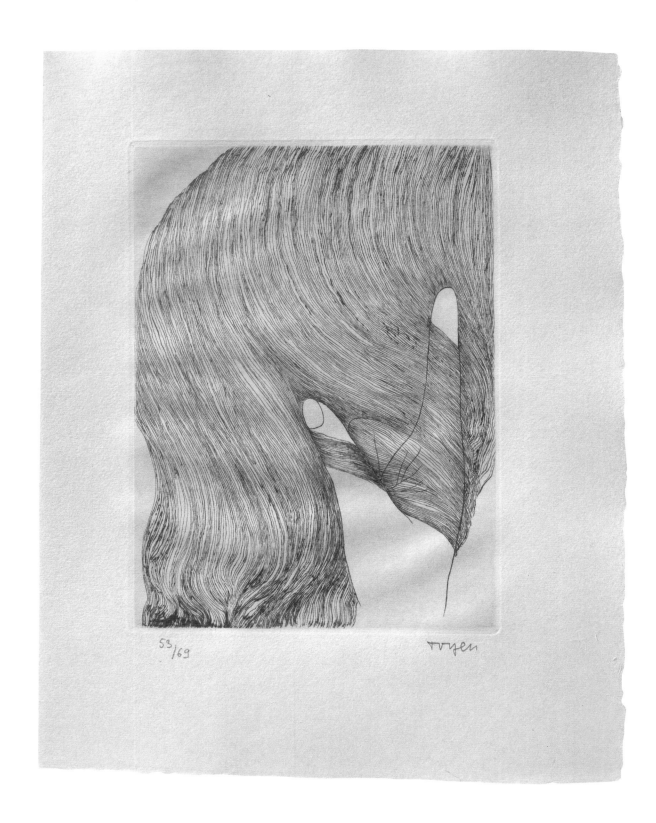

53/69 royen

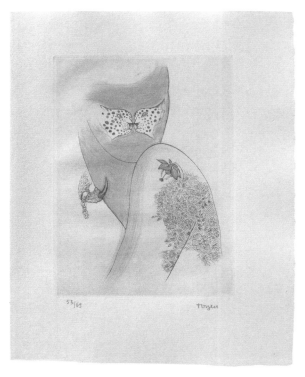

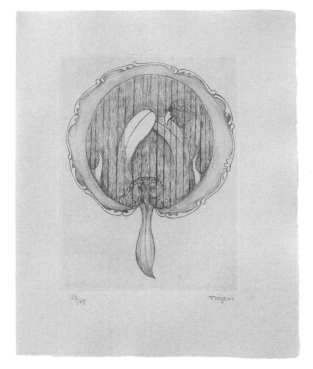

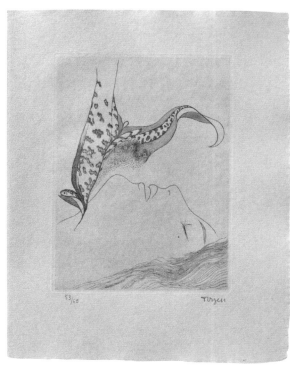

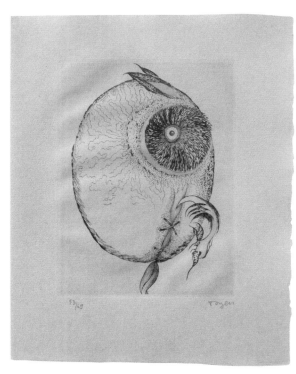

CAT. 111
Annie Le Brun
Sur-le-champ [*Right Now*] | 1967
Folio case, drypoints, and photogravures: Toyen | Paris: Éditions surréalistes
12 ³⁄₈ × 9 ³⁄₄ inches (31.5 × 24.8 cm)

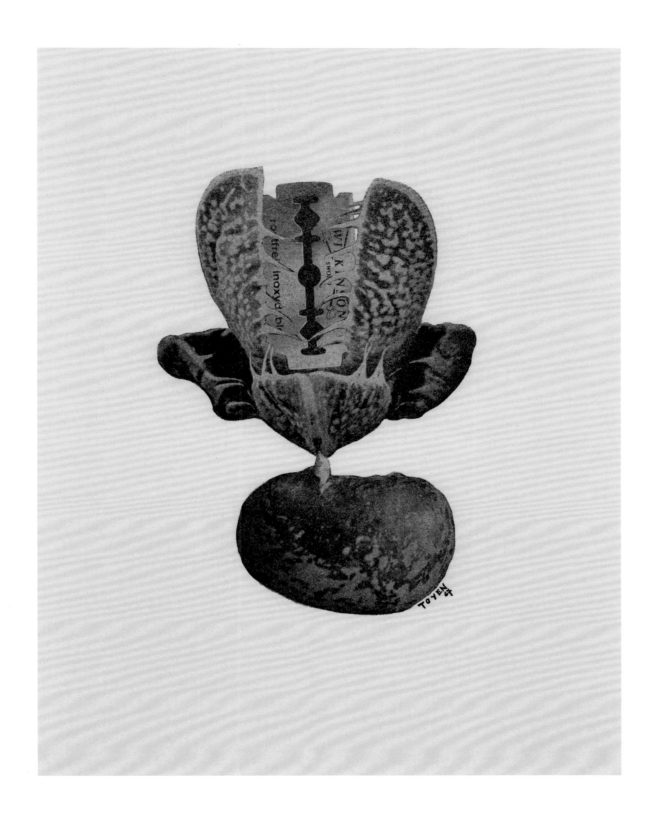

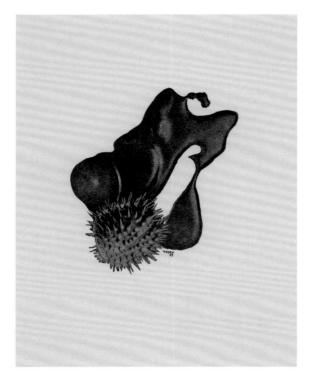

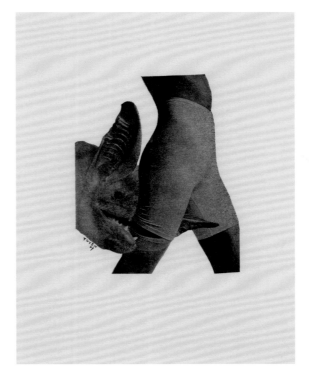

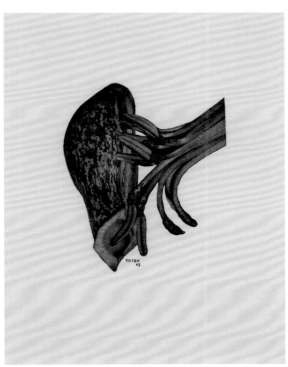

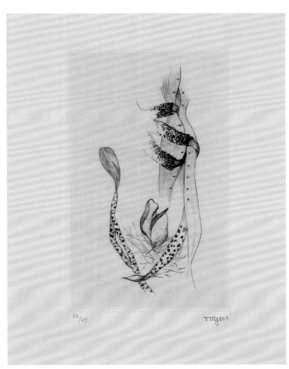

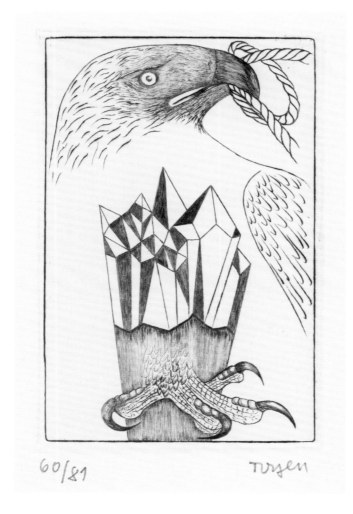

60/81 Toyen

CAT. 112
Radovan Ivšić
Le roi Gordogane [*King Gordogan*] | 1968
Drypoint and photogravures: Toyen | Paris: Éditions surréalistes
10 ³⁄₈ × 6 ³⁄₄ inches (26.3 × 17 cm)

La
forêt
sacrilège
et
autres
textes

LE
SOLEIL
NOIR

CAT. 113
Jean-Pierre Duprey
La forêt sacrilège et autres textes
[*The Sacrilegious Forest and Other Texts*] | 1970
Folio case and drypoints on silk mounted on paper: Toyen | Paris: Le Soleil noir
9 5/8 × 7 3/4 inches (24.5 × 19.8 cm)

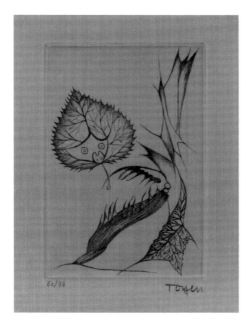
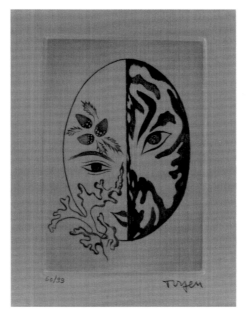
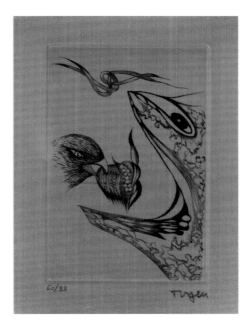

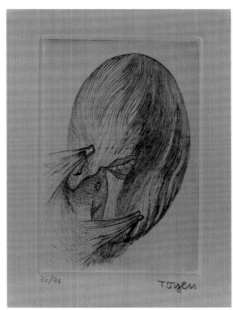
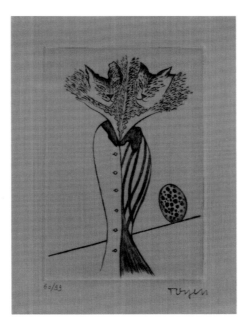
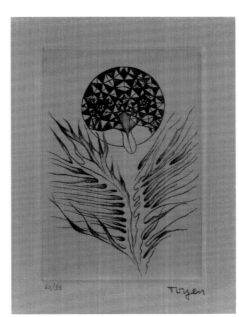

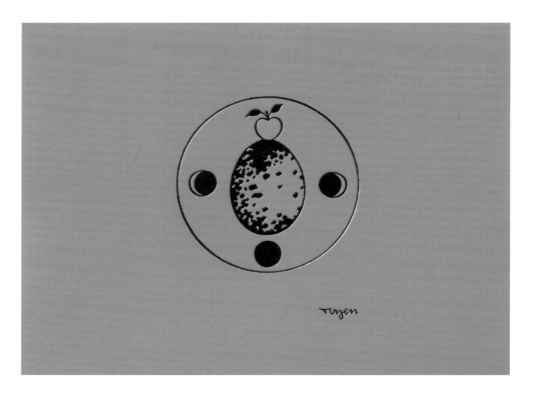

CAT. 114
Toyen
Tir [*The Shooting Gallery*] | 1973
Folio case, title page, reprint of *Strělnice* [*The Shooting Gallery*], and two drypoints: Toyen
Paris: Éditions Maintenant
12 ⁵/₈ × 17 ¼ inches (32 × 43.8 cm)

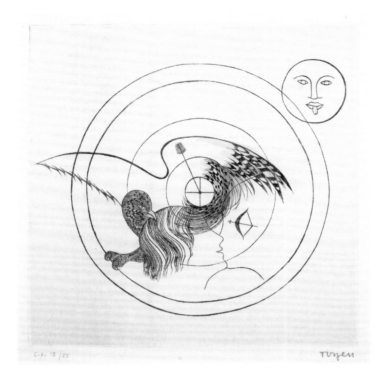

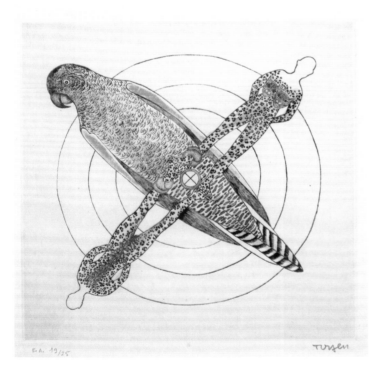

CAT. 115
Toyen
Tir [*The Shooting Gallery*] | 1973
Hand-colored drypoint
11 ½ × 11 ½ inches (29.2 × 29.2 cm)
Gift of Radovan Ivšić and Annie Le Brun to Mary Cullen

CAT. 116
Toyen
Tir [*The Shooting Gallery*] | 1973
Hand-colored drypoint
11 ½ × 11 ½ inches (29.2 × 29.2 cm)

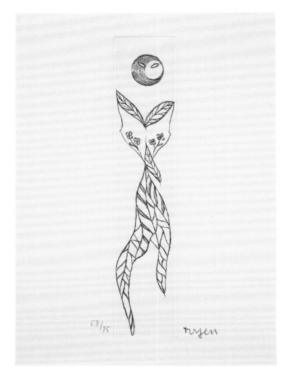

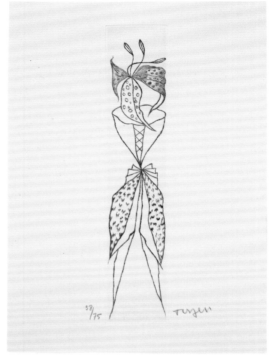

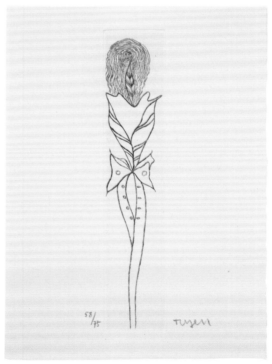

CAT. 117
Annie Le Brun
Annulaire de lune [*Moon Ring-Finger*] | 1977
Drypoints: Toyen | Paris: Éditions Maintenant
10 ½ × 7 ½ inches (26.8 × 19 cm)

The Zagreb poet and dramatist Radovan Ivšić, who settled in Paris in 1954, was an astute critic of Toyen's work, which he treated thoughtfully in a 1974 monograph. In the late 1960s and early 1970s, he encouraged Toyen to return to book illustrations — most often drypoints and collages. Ivšić also prepared a new edition of *Střelnice* (*Tir*; *The Shooting Gallery*, 1973), in the bibliophile series Éditions Maintenant. One of his poems accompanied the work, which included the original twelve etchings as well as two new drypoints by Toyen. In 1973 this second edition won Ivšić the prize for most beautiful book of the year from the committee Art et technique du livre. Toyen's collaboration with Ivšić was among the last in a succession of long-term projects that she undertook with poets.

Translated by Helga Aurisch. Originally published as "Les grandes ténèbres du Tir," in Toyen, *Tir* [*The Shooting Gallery*] (Paris: Éditions Maintenant, 1973).

The Large Shadows of the Shooting Gallery

without tympanums **without drums**

Radovan Ivšić

The blind gusts of wind against the murky grindstone of the forests

An ancient footprint in the swell of hard roots

The cries of the shellfish under the pitch-black night

It is in the storm that the tawny owl sheds its feathers

8 Czech Modern Glass and the Roy and Mary Cullen Collection

Jan Mergl

In the first three decades of the twentieth century, Czech glass underwent a rich and rapid transformation from Art Nouveau to Functionalism. During this period, the Czech refineries demonstrated that they could still produce high-quality decorative art, which has a tradition in Bohemia stretching back to the Middle Ages.

The Roy and Mary Cullen collection provides an overview of Czech glass from 1900 to the end of the 1930s. This diverse collection includes more than three hundred superb pieces, mostly of ornamental glass, and documents the stylistic development of Czech glass during this critical period. At the same time, the Cullen collection also reflects the role that various glassmakers, educational institutions, and personalities played in the changing approach to formal design and decoration.

Czech glass made significant contributions in the eighteenth-century Baroque and in the early nineteenth-century Biedermeier eras, and made its mark once again about 1900, at the height of the French Art Nouveau. In the first decade of the twentieth century, however, Czech glass was heavily influenced by Vienna, which even in the waning years of the Habsburg Empire remained both a seat of political power and artistic ferment. Czech glass firms kept close ties with Viennese glass dealers. They also were in contact with the main representatives of the Wiener Secession (Vienna Secession), headed by Josef Hoffmann. The Wiener Secession's decorative style, with its love of geometrical patterns, was adapted by Czech glassmakers and found its full expression after the First World War.

Among the first to implement the principles of the Wiener Secession, and subsequently also those of the Wiener Werkstätte (Vienna Workshop), were the glassworks firms Meyr's Neffe in Adolfov near Vimperk and Johann Lötz Witwe in Klášterský Mlýn (Klostermühle), both founded in the nineteenth century in the Šumava region in southwest Bohemia. The Vimperk glassworks, which focused mainly on the production of more utilitarian glass to be used for serving beverages, produced, among other things, goblets designed by the Viennese artists Otto Prutscher and Hoffmann, who consistently made use of geometrical features in the shape and decoration of their work. In contrast to Vimperk, the Klášterský Mlýn glassworks emphasized decorative glass, and filled Viennese orders for this type of glass as early as 1899. Designs for this firm by Viennese artists, in particular Hoffmann, and Koloman Moser and his students, exploited the possibilities of furnace-shaped and

decorated colored glass with an iridescent surface. After 1906, close collaboration with the architect Leopold Bauer had an even greater impact on the factory's products, evident in several series of vases of austere shape and color, including a two-handled vase in the Roy and Mary Cullen collection [CAT. 118].

After 1910, the Klášterský Mlýn glassworks made a significant shift toward the principles of the Art Deco style. At that time, the company, once again in contact with Viennese artists, made special display collections for decorative-art exhibitions at the Österreichisches Museum für Kunst und Industrie (Austrian Museum of Art and Industry, today the Museum für angewandte Kunst [Museum of Applied Arts]) in Vienna. The firm also produced exhibition collections for the famous and artistically innovative exhibition of the Deutscher Werkbund (German Work Federation) in Cologne in 1914. Most of these unique exhibition pieces featured decorative designs achieved through a cold-working etching technique, which Adolf Beckert had introduced during his 1909 – 11 tenure at Klášterský Mlýn. Etching was particularly well suited to the geometrically stylized Viennese motifs. The sharp definition of the etched surfaces allowed for the precise reproduction of the rigorous order of lines and the rhythmical, geometrical figures that were typical of the designs of Hoffmann, Carl Witzmann, Milla Weltmann, and Hans Bolek. The distinctive colors — white, black, deep red, and blue — used for these pieces further enhanced the effect of the decoration.

Michael Powolny, another important member of the Wiener Werkstätte and of the Deutscher Werkbund, exploited to even greater effect the color contrast of richly colored opal glass in his series of glass pieces made with hot-working techniques. The vases and bowls, which he designed with vertical threads placed at measured intervals, drew on the experiences of the glassmakers at Klášterský Mlýn and on the tradition of perfectly controlled work with molten glass. Powolny's small but artistically innovative exhibition collection for the 1914 Deutscher Werkbund exhibition at Cologne soon inspired many new forms produced by the Lötz glassworks, such as the vase with blue threads on a white background in the collection of Roy and Mary Cullen [CAT. 120]. Along with these new forms, the Lötz glassworks also produced Powolny's decoration in a number of color variations.

The Emergence of Decorativism

About 1920, the growing interest in the distinctive color of opal glass, which suited the increasingly popular trend of Art Deco that was spreading from France, had led to its extensive serial production. In anticipation of the 1925 Exposition des Arts Décoratifs et Industriels Modernes in Paris (from which the term "Art Deco" was later derived), the Klášterský Mlýn factory's production of opal-glass pieces reached its peak. Its production concentrated on decorative items such as vases, bowls, and jardinières, as well as dressing-table sets, drink sets, and other table accessories. The most frequently employed colors were various shades of red, orange, and dark yellow and lemon yellow; light blue, pea green, and turquoise green were also common. The glasses featured attached elements — such as pointed or curved handles, globular stems, decorative ridges, disks, rings, and threads emphasizing edges — made from a contrasting dark, usually black, glass. Often the colorful surface formed a background for a painting of small motifs, sometimes geometrically styled floral elements, or abstract zigzags, lightning bolts, curves, and spirals. Lötz glassworks was the leading innovator in this decorative style in terms of creativity and the quality of the pieces produced. In addition, many other glassworks focused on production of this type. One of the most important of these was the Wilhelm Kralik Sohn glassworks in Lenora in the southern Šumava region. By the end of the 1920s, this company would take over the initiative from the Lötz factory and expand production of furnace-shaped glass to include new, expressively modeled vases and jardinières with bright color compositions of spots, trailed threads, veined bands, and inlaid disks [CAT. 124]. Other well-known producers of colorful opal glass included glassworks in northern Bohemia, in particular the Harrachov glassworks in Nový Svět in the Krkonoše region, Josef Riedel in Polubné, and Antonín Rückl & Sons in Skalice u České Lípy. In the Teplice region, the firm of Ernst Steinwald & Co., Teplice-Šanov, also manufactured this type of glass. It is, however, very difficult to distinguish the serial productions of these glassworks because the pieces tended to be unsigned and very similar. In addition, precise identification is virtually impossible given that other, more obscure glassworks made similar products, catering to popular demand for this glass.

In responding to the new principles of the international Art Deco style, the Czech glass industry had nevertheless tried to find its own new expression — one that could represent the Czechoslovak Republic, the state that had emerged after the dissolution of the Austro-Hungarian monarchy in 1918. The resulting style, known as Decorativism, met with tremendous success in the

exhibition of Czechoslovak arts and crafts displayed at the 1925 Exposition des Arts Décoratifs et Industriels Modernes in Paris. There, the Czechoslovak exhibition — and Czech glass in particular — won several of the main prizes, confirming the importance of Decorativism and spreading its renown.

The beginning of the 1930s saw a reaction against the colorful, material aspect of opal glass and a revival of interest in transparent glass made with hot-working techniques. The resulting vases and bowls, with their elegant, thin walls and softly modeled shapes, relied on traditional methods of fabrication and pointed to the influence of contemporary Venetian production. The elaborate undulation of the contours, the alternating thickness of the walls, and the curves of the handles of these pieces fully exploit the visual qualities and potential of glass [CAT. 125].

Developments in Northern Bohemia

Decorativism excited interest in northern Bohemia, and cold-refining techniques, such as painting and etching, and cutting and engraving, proved fundamental to the development of the principles of Decorativism in Czech glassmaking. In this respect, the glass manufacturers, cutting shops, painting shops, and other enterprises in northern Bohemia, in the region of Bor, Kamenický Šenov, and Česká Kamenice, played a major role, as had traditionally been the case.

The school in Kamenický Šenov, the first glassmaking school in the world, was founded in 1856. The school in Bor was founded a little later and began training glassmakers in 1870. Instruction at both schools included artistic and practical training in all types of refining techniques and took into consideration contemporary changes in style. Soon after 1910, the schools emerged as centers of production that helped to define the artistic direction of glass in the spirit of the ascendant Decorativism. At that time, Heinrich Strehblow headed the school in Bor, while Adolf Beckert assumed his post as head of Kamenický Šenov in 1911. Under the direction of such experienced and artistically inclined teachers, the schools' studios produced works that the local glassworks then emulated. Thanks to this interaction between the schools and the local glassmaking firms, the new, progressive designs of the teachers and their students often had a decisive impact on production. In addition, the attempt by the schools and the glassworks to employ contemporary stylistic features in as many ways as possible sometimes led to innovations in the use of ordinary decorative techniques and approaches.

Accompanying the development of the decorative style in the work of the northern Bohemian glassworks was a penchant for geometrically stylized ornament. Cutting was a technique that, because of its precision, offered interesting possibilities for the creation of rhythmically ordered decorative compositions. After 1910, the glassmaking school in Bor developed several approaches, the common denominator of which was the cutting of one or two layers of color covering the casing of the vessel. One frequently used scheme was a regular, dense network of cut lenses, making use of a reducing effect [CAT. 127]. More elaborate compositions employed wedge-shaped indentations or cut olives arranged into motifs resembling the structure of a plant. The use of specially shaped grinding wheels was reintroduced to make indentations in a flat pattern. A similar type of decoration, also developed at the Bor school, involved cutting vertical grooves into the casing of vases, goblets, and flacons with an undulating outline. The products of the firm Carl Meltzer & Co., in Skalice u České Lípy, championed this method of decoration. The most attractive novelty from the school's studios, which likewise attracted prompt attention from the glassworks, was the glass "cut with a decorative border." The cutting of two distinct layers of differently colored opal glass generated this unusual decorative effect. Many versions of this decoration were executed by the Johann Oertel & Co. glassworks, in Bor, which collaborated closely with the school there. A number of other combinations were produced at the cutting shop of Carl Schappel, another well-known firm in Bor.

Painting, however, was the true domain of the northern Bohemian glassmaking schools and factories. A clear transformation occurred in this field as well after 1910. Corresponding artistic methods had to be found to meet the demands of Decorativism and thus to expand the expressive possibilities of painting. Considerable attention was therefore focused on color and its application in the details and on the surface of glass. Red and yellow stains were frequently used singly and in combination with cutting and engraving [CAT. 128]. The black stain, referred to as "noble black" on account of its chic glossy surface, was reinvented by the Bor school in 1914 and mainly used subsequently by the Carl Hosch firm. The technique of painting with reductive colors, another interest of the time, was used most successfully in the schematized plant patterns seen on the vases produced by the painting shop of another eminent firm in Bor, Beyermann & Co. One of the most interesting innovations to emerge from the Bor school was the

painting technique known as *millefiori*, characterized by small geometrical motifs composed of tiny drops of colored enamel [CAT. 129]. Another special decorative technique, "precious enamel" (*Edelschmelz*), used a similar approach: painting with transparent colors on a shiny gilded background.

A broad range of techniques further elaborated the artistic language of the Bor school, culminating shortly after 1920 in the pure abstract forms of the Art Deco style. Until the 1930s, the arsenal of decorative features used by most of the Bor firms — such as Carl Goldberg, Alois Rasche, Gebrüder Rachmann, and Karl Palda — included distinctly defined surfaces and figures, expressive, sharply pointed or star-shaped forms painted in basic colors, oblique bands, and densely grouped lines.

A different innovative technique emerged from the painting workshops in Kamenický Šenov after 1912 — the technique of decorating with subtle black-gold drawing. Initially, the color combination and the stylization of some of the features, as seen particularly in the work of Karl Massanetz, who pioneered this type of decoration, suggested that they might have been inspired by the contemporary work of artists from the Wiener Werkstätte, especially Dagobert Peche. Gradually, however, the drawing developed into a distinctive style.

As the head of the glassmaking school in Kamenický Šenov, Adolf Beckert played a fundamental role in the development of the principles of Decorativism. He had made his first radical contributions to Czech glass during his tenure at Klášterský Mlýn and was an original and versatile artist, one of the foremost designers of his generation. His distinctive interpretation of Decorativism had a clear impact on the work of his students, as well as on the products of the local factories. For example, the influence of Beckert's inventive designs, based on miniature drawings of ornamental and figural motifs, appears in the production of the firms Conrath & Liebsch [CAT. 130] and Gebrüder Lorenz. About 1915 Beckert collaborated closely with the Friedrich Pietsch painting shop, which offered various versions of his decorative glass with black-gold drawing and yellow-stained surfaces [CAT. 131]. Beckert's artistic endeavors, however, were not restricted to painting; he utilized other techniques such as cut features and engraved outlines. He also had a fundamental impact on the development of colorful abstract compositions of etched decoration.

Under Beckert's artistic and organizational leadership, the school in Kamenický Šenov became a first-rate institution, which influenced northern Bohemian glassmaking in the 1920s. Successes at numerous exhibitions at home and abroad also enhanced the school's renown. The school's display at the 1925 Exposition des Arts Décoratifs et Industriels Modernes in Paris earned the Grand Prix, and Beckert received a gold medal for his designs. At the close of the 1920s, the work of other teachers drew on Beckert's artistic legacy, and later, about 1935, the designs of Alfred Dorn, Paul Eiselt, and Oswald Lippert would echo his late Art Deco style.

From the time it was founded in 1920, the glassmaking school in Železný Brod also helped to maintain and improve the fine quality of Czech glass. Like the other two schools, the one in Železný Brod mainly focused on supporting the burgeoning local glassmaking industry. The artistic direction of the school was heavily influenced by its principal, Alois Metelák. His work, most of it in cut glass, evolved from Decorativism to Functionalism, a style that prioritized utility over ornament. Metelák's simply articulated yet formally and visually striking vases influenced the cut glass of the Železný Brod firms, such as the ponderous vases of smoky-gray glass represented in the Roy and Mary Cullen collection, as well as the more colorful vases fabricated at the cutting shop founded in 1930 by Rudolf Hloušek, a recent graduate of the school [CAT. 146].

The period between the two world wars was artistically fruitful for several other glassworks, first and foremost that of Ludwig Moser & Sons in Dvory near Karlovy Vary. Leo Moser was responsible for the image of its products. His artistic talent was recognized in 1916 when he was appointed its artistic director. His search for a new, distinctive face for Moser glass led to the development of colored glass products and culminated, at the beginning of the 1920s, in Neoclassical vases, bowls, and goblets modeled with a faceted cut [CAT. 142]. The color range consisted of a few basic types of glass, such as purple Amethyst (the name given to it by the firm), green Emerald, cobalt-blue Sapphire, and yellow-green, uranium-colored Radion. The use of another Moser specialty, known as *oroplastique*, intensified the retrospective look of the vessels by making possible the addition of friezes with classical figural motifs of the battle between the Amazons and the Greeks. This decoration was engraved and subsequently gilded and given a patina. Leo Moser consistently focused on collaboration with designers and artists. As a result, Decorativism was more firmly entrenched there than it had been before 1920, as evidenced in the success of the firm's glassware at the 1925 Paris

Exposition. Moser established ties with the architect Rudolf Wels, who looked to the world of exotic animals as the source of motifs for his oroplastique decoration, as well as with the Vysoká škola uměleckoprůmyslová v Praze (School of Applied Arts in Prague). At the end of the decade, his collaboration with the German graphic artist Heinrich Hussmann led to exploring new potential uses for etching and cutting. In the 1930s, the Moser glassworks showed a distinct preference for the Functionalist style in its decorative glass and in its glass used for serving beverages, which had traditionally accounted for a sizeable portion of its production.

Outside of northern Bohemia, other eminent Czech glass-making firms absorbed and propagated the stylistic and technical innovations of the times. In Moravia, the Solomon Reich & Co. glassworks in Krásno nad Bečvou produced large vases in an austere, semiovoid shape, as seen in the example in the Cullen collection [CAT. 147]. Their decoration consists of stained and sandblasted compositions of simplified, stylized flowers, female heads in profile, and nudes. These wares constituted only a small, but more commercially appealing, proportion of the production of the large firm, which manufactured a variety of everyday consumer glassware and luminaires. Although these vases lack serious artistic ambition, they are interesting nonetheless from the perspective of the development of Decorativism in Czech glass and how it eventually came to be diluted. The vases stand at the end of the imaginary line of Decorativism.

Political developments after the Second World War significantly restricted or even obstructed the pursuit of promising trends — for example, the new understanding of the potential of engraving in glass, and the formal design of tableware in the spirit of Functionalism. The nationalization of the glass industry, the rise of Communist rule, and the concomitant requirement that glass production address the needs of the socialist individual all spelled an end to experimentation. Not until the end of the 1950s were individual artists working with glass able to bring about a revival in the field.

CAT. 118
Manufactured by Johann Lötz Witwe, Klášterský Mlýn (Klostermühle), Bohemia
Vase | 1908 | Glass
13 ³⁄₈ × 4 ¾ inches (34 × 12.1 cm)

CAT. 119
Manufactured by Johann Lötz Witwe, Klášterský Mlýn (Klostermühle), Bohemia
Design: Hans Bolek, Vienna
Dish | 1916 | Mold-blown glass with enamel
4 7/8 × 4 1/2 inches (12.4 × 11.4 cm)

CAT. 120
Manufactured by Johann Lötz Witwe, Klášterský Mlýn (Klostermühle), Bohemia
Vase | 1914 | Glass
5 × ¼ inches (12.7 × 13.5 cm)

CAT. 121
Manufactured by Johann Lötz Witwe, Klášterský Mlýn (Klostermühle), Bohemia
Vase | c. 1936 | Mold-blown glass
8 × 6 ⅛ inches (20.3 × 15.5 cm)

CAT. 122
Manufactured by Johann Lötz Witwe, Klášterský Mlýn (Klostermühle), Bohemia
Vase | c. 1930 | Glass
10 ¼ × 8 ¼ inches (26.1 × 21 cm)

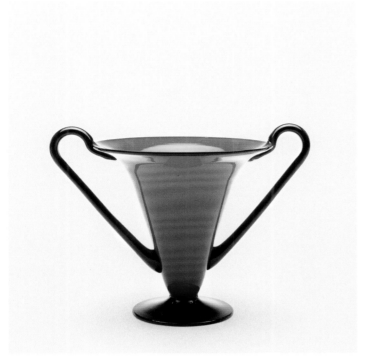

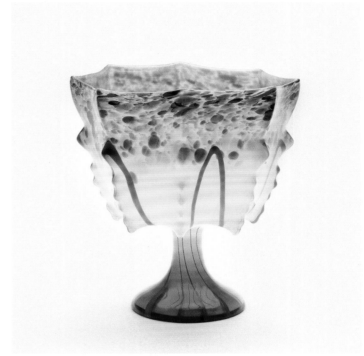

CAT. 123
Manufactured by Antonín Rückl & Sons, Skalice u České Lípy, Bohemia
Vase | c. 1925 | Glass
6 × 7 ⅞ inches (15.2 × 20 cm)

CAT. 124
Manufactured by Wilhelm Kralik Sohn, Lenora (Eleonorenhain), Bohemia
Bowl | c. 1930s | Mold-blown glass
9 ¾ × 9 inches (24.8 × 22.9 cm)

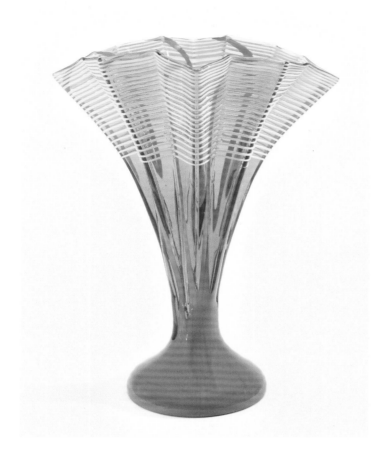

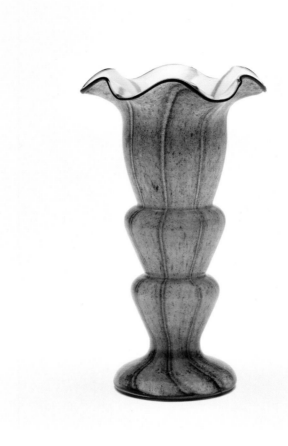

CAT. 125
Manufactured by Ernst Steinwald & Co.,
Teplice-Šanov (Teplitz-Schönau), Bohemia
Vase | c. 1930 | Glass
11 ½ × 8 ⅞ inches (29.2 × 22.5 cm)

CAT. 126
Manufactured by Franz Welz, Hrob (Klostergrab), Bohemia
Vase | c. 1930 | Glass
8 ⅛ × 4 ½ inches (20.6 × 11.5 cm)

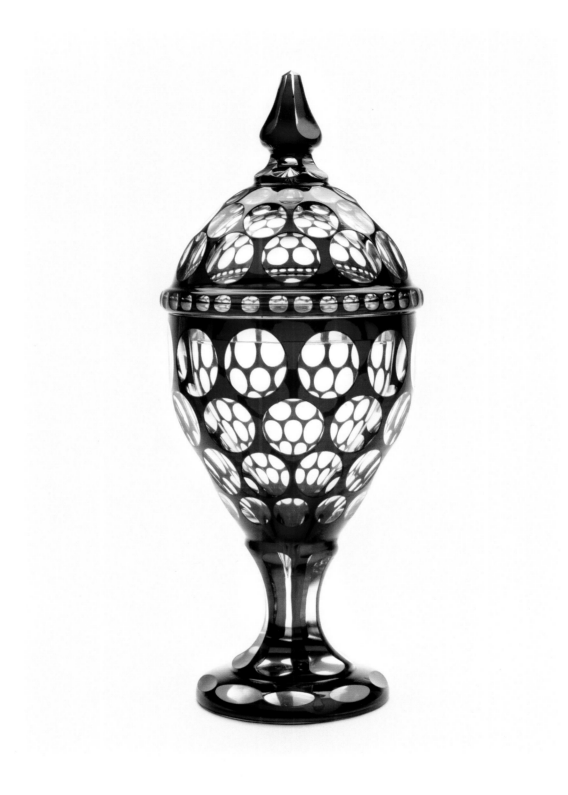

CAT. 127
Manufactured in Nový Bor (Bor/Haida), Bohemia
Vase | c. 1915 | Glass
13 ⅜ × 5 ⅜ inches (34 × 13.7 cm)

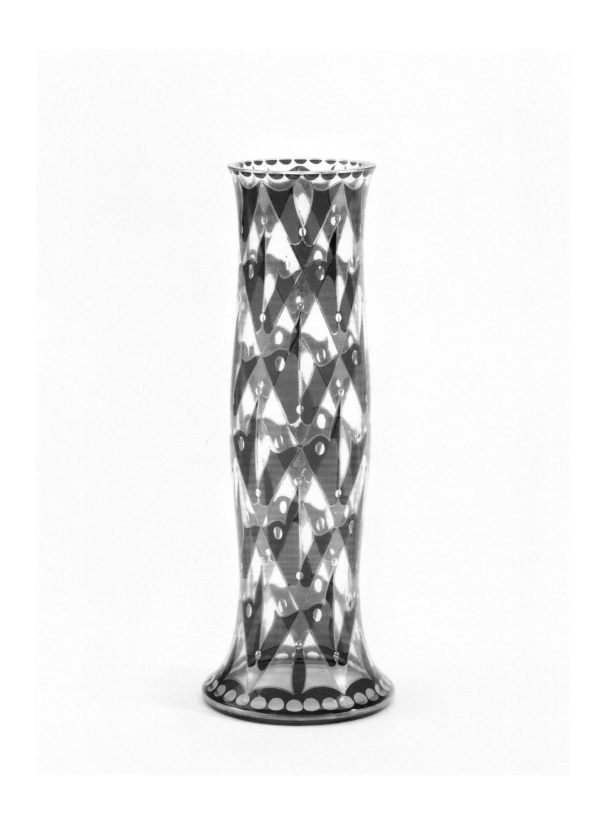

CAT. 128
Manufactured by the Glass School, Nový Bor (Bor/Haida), Bohemia
Vase | c. 1914 | Glass
11 ⅛ × 3 ⅞ inches (28.3 × 10 cm)

CAT. 129
Manufactured by the Glass School, Nový Bor (Bor/Haida), Bohemia
Vase | c. 1912 | Glass
8 × 4¾ inches (20.3 × 11.9 cm)

CAT. 130
Manufactured by Conrath & Liebsch, Nový Bor (Bor/Haida), Bohemia
Jar | 1914 | Clear glass with lid, black, yellow, and gold pattern and trim
5 ⅝ × 3 ½ inches (14.3 × 8.9 cm)

CAT. 131
Probably manufactured by Friedrich Pietsch, Kamenický Šenov, Bohemia
Design: Adolf Beckert
Jar | 1920–22 | Glass | 7 × 3 ⅝ inches (17.8 × 9.2 cm)

CAT. 132
Probably manufactured by the Glass School, Nový Bor (Bor/Haida), Bohemia
Vase | c. 1915–20 | Glass
7 ⅞ × 6 ¾ inches (20 × 17.1 cm)

CAT. 133
Probably manufactured by the Glass School, Kamenický Šenov, Bohemia
Vase | 1920–25 | Glass
11 ⁷⁄₈ × 6 inches (30.2 × 15.2 cm)

CAT. 134
Manufactured by the Glass School, Kamenický Šenov, Bohemia
Vase | 1925 | Glass
6 ¾ × 6 ½ inches (17.1 × 16.5 cm)

CAT. 135
Manufactured by Johann Oertel & Co., Nový Bor (Bor/Haida), Bohemia
Vase | 1924 | Glass
6 ¾ × 6 ¼ inches (17.1 × 15.9 cm)

CAT. 136
Probably manufactured by the Glass School, Kamenický Šenov, Bohemia
Vase | c. 1930s | Glass
6 ¼ × 4 ⅛ inches (15.7 × 10.3 cm)

CAT. 137
Probably manufactured by the Glass School, Kamenický Šenov, Bohemia
Vase | 1930 | Glass
6 ⅝ × 4 ½ inches (16.8 × 11.4 cm)

CAT. 138
Manufactured by the Glass School, Kamenický Šenov, Bohemia
Design: possibly Alfred Dorn
Vase | c. 1935 | Glass
7 ¾ × 5 ¾ inches (19.8 × 14.6 cm)

CAT. 139
Manufactured by the Glass School, Kamenický Šenov, Bohemia
Design: possibly Oswald Lippert
Vase | 1935 | Glass
5 ⅝ × 3 ⅞ inches (14.3 × 10 cm)

CAT. 140
Manufactured by Beyermann & Co., Nový Bor (Bor/Haida), Bohemia
Goblet | c. 1920 | Glass
6 ⅝ × 4 ¼ inches (16.8 × 10.6 cm)

CAT. 141
Manufactured by Carl Goldberg, Nový Bor (Bor/Haida), Bohemia
Vase | 1930–35 | Glass
8 ¼ × 5 ¼ inches (21.1 × 13.1 cm)

CAT. 142
Manufactured by Ludwig Moser & Sons, Karlovy Vary (Karlsbad), Bohemia
Design: Leo Moser
Vase | 1925 | Glass with gold metal
12 ¼ × 6 ⅞ inches (31 × 17.6 cm)

CAT. 143
Manufactured by Rachmann Bros., Nový Bor (Bor/Haida), Bohemia
Vase | c. 1930 | Glass
4 ³⁄₈ × 5 ¼ inches (11.1 × 13.4 cm)

CAT. 144
Manufactured by Johann Oertel & Co., Nový Bor (Bor/Haida), Bohemia
Vase | 1924 | Mold-blown glass
7 ⁵⁄₈ × 4 ⁵⁄₈ inches (19.4 × 11.7 cm)

CAT. 145
Possibly manufactured by Karl Palda, Nový Bor (Bor/Haida), Bohemia
Vase | c. 1930 | Glass
11 ⁷⁄₈ × 5 ³⁄₈ inches (30.2 × 13.7 cm)

CAT. 146
Manufactured by Rudolf Hloušek, Železný Brod, Bohemia
Vase | After 1935 | Glass
9 ½ × 6 ⅜ inches (24.1 × 16.2 cm)

CAT. 147
Manufactured by Solomon Reich & Co., Krásno nad Bečvou, Moravia
Vase | c. 1935 | Glass
10 × 7 inches (25.4 × 17.8 cm)

Supplemental Information

CAT. 118
Manufactured by Johann Lötz Witwe, Klášterský Mlýn (Klostermühle), Bohemia
Vase | 1908
The glasswork's manufacturing documentation identifies the piece as product number 5668 from 1908. It was produced in four different sizes.[1] The collection of the Glasmuseum (Glass Museum) in Passau, Germany, includes a version with red applications. The austere cylindrical shape of the vase and the simple decoration of coiled thread and attached beads in a single color suggest that it was inspired by the designs of the Viennese architect Leopold Bauer for the glass display at the Milan International Exhibition in 1906.[2]

CAT. 119
Manufactured by Johann Lötz Witwe, Klášterský Mlýn (Klostermühle), Bohemia
Design: Hans Bolek, Vienna
Dish | 1916
The Viennese architect Hans Bolek, a student of Josef Hoffmann, designed his first glass pieces for the Österreichischer Werkbund (Austrian Work Federation) in 1913. The glassworks in Klášterský Mlýn produced single copies of them for the Werkbund exhibition in Cologne in 1914. One of the main features of these designs by Bolek was the decoration consisting of stylized plant motifs.[3] The simplified forms of leaves and flowers subsequently appeared on large, commercially successful series of etched and painted glass, which the firm manufactured until the early 1920s.[4] These series included the container with lid from 1916, listed as product number 811. The basic version is made from white and black opal glass.[5] There are, however, other color combinations, for example yellow-black.[6] A later smaller container was made in other colors such as blue-black, green-black, and red-black.[7]

CAT. 120
Manufactured by Johann Lötz Witwe, Klášterský Mlýn (Klostermühle), Bohemia
Vase | 1914
The group of five vases designed by Michael Powolny for the 1914 Werkbund exhibition in Cologne inspired numerous versions of this type of glass.[8]

The austere decoration of vertical threads exploits the sharp color contrast between white and blue glass. This was the original color combination, which the glassworks referred to as "Ausführung 127, opal mit blauen Streifen" (Version 127, opal with blue stripes). As early as 1914, the glassworks had promptly added to its repertoire other vases and bowls with Powolny's decoration. These pieces, in established as well as in brand-new shapes, were made from richly tinted opal glass in a wide range of color combinations.[9]

CAT. 121
Manufactured by Johann Lötz Witwe, Klášterský Mlýn (Klostermühle), Bohemia
Vase | c. 1936
The shape of the piece reflects the Functionalist trend in the Czechoslovak glass industry after 1930.[10] The dappled iridescent Papillon decoration was one of the most common types of ornament used at the Lötz glassworks when the high Secession style dominated production. It first appeared in 1898 as one of the possible uses of the special Silbergelb glass. In the 1930s it returned to production. The mutable dappled structure was most striking as an ornamental pattern on vases with simple forms.

CAT. 122
Manufactured by Johann Lötz Witwe, Klášterský Mlýn (Klostermühle), Bohemia
Vase | c. 1930
This vase is the product of experiments in hot-working techniques about 1930. The formal proportions and the delicate handles modeled by pincers suggest that it was inspired by contemporary Venetian glass.

CAT. 123
Manufactured by Antonín Rückl & Sons, Skalice u České Lípy, Bohemia
Vase | c. 1925
This piece has been attributed to the Rückl glassworks because it resembles glass in the firm's catalogue from about 1925. The collection of the Kunstgewerbemuseum (Museum of Decorative Arts) in Berlin includes a similarly shaped vase made of turquoise-green glass.

CAT. 124
Manufactured by Wilhelm Kralik Sohn, Lenora (Eleonorenhain), Bohemia
Bowl | c. 1930s
With the modeling of the body of this bowl the Kralik glassworks in Eleonorenhain made an original contribution to the idiom of furnace-shaped glass in the interwar period. One can see in the sharp pointed edges a parallel to the abstract patterns of flat decoration characteristic of the Art Deco style. The colorfulness of the decoration is also in the spirit of 1920s Art Deco. The same sculptural features and ornamental pattern were applied in numerous other serially manufactured models about 1930.[11]

CAT. 125

Manufactured by Ernst Steinwald & Co., Teplice-Šanov (Teplitz-Schönau), Bohemia

Vase | c. 1930

A drawing of a similar vase appeared in a 1930 advertisement for the Steinwald glassworks.[12] It is a standard example of the furnace-shaped and decorated glass, which the firm promoted as "artistic glass." Another model was similarly decorated.[13]

CAT. 126

Manufactured by Franz Welz, Hrob (Klostergrab), Bohemia

Vase | c. 1930

It is often difficult or almost impossible to identify the manufacturer of a piece of glass, given that many similar types of glass were produced by various firms. In this case, the vase has been identified as a product of the Welz glassworks on the basis of a vase with the same color scheme, made with the same technique and marked with the Welz label in the collection of the Glasmuseum in Passau. With its traditional focus on hot-working techniques of shaping and decorating glass, the Welz glassworks developed a wide range of decorative glass, from colorful creations with coated and trailed decorative elements to iridescent glass.[14]

CAT. 127

Manufactured in Nový Bor (Bor/Haida), Bohemia

Vase | c. 1915

The decoration, consisting of a regular dense network of cut lenses, was one of the most common types of patterns cut in glass with layered colors. The Glass School in Nový Bor designed numerous vases with this type of ornament, which were manufactured by the Johann Oertel & Co. glassworks. Other firms in Nový Bor, such as Julius Mühlhaus and Carl Schappel, produced slightly different versions.[15]

CAT. 128

Manufactured by the Glass School, Nový Bor (Bor/Haida), Bohemia

Vase | c. 1914

Practical training at the Glass School in Nový Bor included the design and production of similar flat decoration based on rhythmical patterns of plant, animal, and abstract motifs.[16]

CAT. 129

Manufactured by the Glass School, Nový Bor (Bor/Haida), Bohemia

Vase | c. 1912

After 1910, ornament painted in colorful enamels and framed by black lines was one of the basic decorative patterns executed by the painting shops at the Glass School in Nový Bor. At that time, the school devoted considerable attention to the development of new painting techniques. The colorful ornament, consisting of tiny drops and spots, was a variation on the painting technique known as millefiori.

CAT. 130

Manufactured by Conrath & Liebsch, Nový Bor (Bor/Haida), Bohemia

Jar | 1914

A similar vase was included in the collection of the Conrath & Liebsch glassworks at the Österreichische Kunstglas Ausstellung (Exhibition of Austrian Artistic Glass) at the Kunstgewerbemuseum (Museum of Decorative Arts) in Berlin in 1914.[17]

CAT. 131

Probably manufactured by Friedrich Pietsch, Kamenický Šenov, Bohemia
Design: Adolf Beckert

Jar | 1920–22

One sees an almost identical ornamental composition, designed by Adolf Beckert, on a container manufactured by the Friedrich Pietsch glassworks.[18] Other firms painted similar decoration, as seen, for example, on the Conrath & Liebsch container at the Österreichische Kunstglas Ausstellung (Exhibition of Austrian Artistic Glass) at the Kunstgewerbemuseum (Museum of Decorative Arts) in Berlin in 1914.[19]

CAT. 132

Probably manufactured by the Glass School, Nový Bor (Bor/Haida), Bohemia

Vase | c. 1915–20

Similar symmetrical decorations, subtly drawn and painted in transparent colors, are typical of the school designs from the period after 1914. One can trace the development of the decoration in a number of variations produced by Johann Oertel & Co. up to the beginning of the 1920s.

CAT. 133

Probably manufactured by the Glass School, Kamenický Šenov, Bohemia

Vase | 1920–25

In the 1920s, an overlay in ruby glass, or a similarly striking painting with a red stain, often appeared in combination with cut and etched decoration.

CAT. 134

Manufactured by the Glass School, Kamenický Šenov, Bohemia

Vase | 1925

One of the typical products of Johann Oertel & Co. in Nový Bor was an etched, engraved ornament, in one or more colors, with characteristic subtle shading. About 1925, however, this kind of decoration also appeared in elaborate designs by Adolf Beckert at Kamenický Šenov.

CAT. 135

Manufactured by Johann Oertel & Co., Nový Bor (Bor/Haida), Bohemia

Vase | 1924

The vase is from a series of etched glass pieces prepared for the 1925 Exposition Internationale des Arts Décoratifs et Industriels Modernes (International Exposition of Modern Industrial and Decorative Arts) in Paris.[20] An uncommon version of the decoration is described in the manufacturer's price list as: "Deep etched coloured glass, lavender, gold tinted background." It was also produced in a green and blue version, and with several variations of etched ornament employing stylized plant motifs.[21]

CAT. 136

Probably manufactured by the Glass School, Kamenický Šenov, Bohemia

Vase | c. 1930s

The ornament, with its gentle organic curves, reflects the imaginative painting of the period; it constitutes a formal response to the subject-less structures of Poetism and Artificialism, pioneered in Bohemia by the avant-garde Devětsil artistic association.

CAT. 138

Manufactured by the Glass School, Kamenický Šenov, Bohemia
Design: possibly Alfred Dorn

Vase | c. 1935

After 1930, a type of flat ornament with plant motifs predominated in the school projects at Kamenický Šenov. The director of the school, Alfred Dorn, had a considerable influence on the designs.

CAT. 139

Manufactured by the Glass School, Kamenický Šenov, Bohemia.
Design: possibly Oswald Lippert

Vase | 1935

About 1937, Professor Oswald Lippert's studio produced vases with analogous motifs drawing on sport and modern civilization.[22]

CAT. 140

Manufactured by Beyermann & Co., Nový Bor (Bor/Haida), Bohemia

Goblet | c. 1920

The Beyermann & Co. glassworks in Nový Bor developed this characteristic type of luster painting about 1915. It was mostly used with stylized plant ornaments.[23] The abstract decoration of lines on the goblet was specially designed for this particular shape.

CAT. 141

Manufactured by Carl Goldberg, Nový Bor (Bor/Haida), Bohemia

Vase | 1930–35

An almost identical type of decoration has been documented on glass marked with the label of the firm. Carl Goldberg was one of the busiest glassworks in Nový Bor. Its glass from the 1930s exemplifies the serial production of the era, ornamented with standard stylistic features. Mary and Roy Cullen's collection contains numerous examples of this type of glass.

CAT. 142

Manufactured by Ludwig Moser & Sons, Karlovy Vary (Karlsbad), Bohemia.
Design: Leo Moser

Vase | 1925

The Moser line, dominated by cut, colored glass, won an eminent position among Czechoslovak glassworks. From 1915 to 1925, Leo Moser was responsible for most of the new designs of vases with facet cuts. Cutting was often combined with the specialty of the glassworks: an etched and gilded ornament with a patina known as oroplastique, employed from 1911 on. The most common version, known as *Fipop*, consisted of a figural frieze depicting the battle of the Amazons and the Greeks.[24]

CAT. 143

Manufactured by Rachmann Bros., Nový Bor (Bor/Haida), Bohemia

Vase | c. 1930

The shape of this piece and the decoration indicate the growing influence of the Functionalist trend. A covered container with the same decoration, by the Nový Bor firm of Gebrüder Rachmann, is at the Regionální muzeum (Regional Museum) in Teplice.[25]

CAT. 144

Manufactured by Johann Oertel & Co., Nový Bor (Bor/Haida), Bohemia

Vase | 1924

This vase is from the series of cut vases and bowls for the 1925 Exposition Internationale des Arts Décoratifs et Industriels Modernes (International Exposition of Modern Industrial and Decorative Arts) in Paris.[26] The influence of the Art Deco style is manifest in the shape and proportions of the design.

CAT. 145

Possibly manufactured by Karl Palda, Nový Bor (Bor/Haida), Bohemia

Vase | c. 1930

The combination of cutting and painting with a black stain was particularly popular about 1930. It appears in pieces on offer from several glassworks in Nový Bor. The Karl Palda firm was the most famous producer of this type of glass in Nový Bor.

CAT. 146

Manufactured by Rudolf Hloušek, Železný Brod, Bohemia

Vase | After 1935

This solid-glass cut vase, by the Hloušek glassworks, exemplifies the standard production in Želený Brod in the mid-1930s. The blue-glass version is less common. A version was also made from smoke-colored glass.[27]

CAT. 147

Manufactured by Solomon Reich & Co., Krásno nad Bečvou, Moravia

Vase | c. 1935

This is a serially manufactured vase, produced with several versions of a flat, etched, Art Deco ornament, most often with the motif of a girl's head and flowers.[28]

NOTES

1 See Helmut Ricke and Ernst Ploil, eds., *Lötz. Böhmisches Glas 1880–1940* (Munich: Prestel, 1989), 472.

2 See ibid., cat. no. 286; and the *Studio Year Book* (n.p.: 1907), 218–20.

3 See Jan Mergl, Ernst Ploil, and Helmut Ricke, *Lötz: Bohemian Glass 1880–1940* (Ostfildern-Ruit and New York: Hatje Cantz, 2003), 230–33, cat. nos. 212–14.

4 See, for reference, Georg Höltl, ed., *Das Böhmische Glas 1700–1950*, vol. 4 (Passau: Passauer Glasmuseum, 1995), illus. no. IV.203–6.

5 See also the copy in the collection of the Muzeum Šumavy (Šumava Museum) in Kašperské Hory (Bergreichenstein), in Ricke and Ploil, *Lötz. Böhmisches Glas 1880–1940*, cat. no. 347.

6 See Torsten Bröhan, *Glaskunst der Moderne. Von Josef Hoffmann bis Wilhelm Wagenfeld* (Munich: Klinkhardt & Biermann, 1992), 85.

7 See Höltl, *Das Böhmische Glas 1700–1950*, vol. 4, illus. no. IV.211.

8 See the photo of the exhibition display case in *Deutsche Kunst und Dekoration*, vol. 34 (n.p.: 1914), 378; and the period documentation and vases in Mergl, Ploil, and Ricke, *Lötz: Bohemian Glass 1880–1940*, 231, 250–51.

9 See, for reference, Ricke and Ploil, *Lötz. Böhmisches Glas 1880–1940*, vol. 1, 286; vol. 2, 578, illus. 1; and Mergl, Ploil, and Ricke, *Lötz: Bohemian Glass 1880–1940*, 262.

10 Other examples of vase shapes in this series can be seen in: Ricke and Ploil, *Lötz. Böhmisches Glas 1880–1940*, 312–15, illus. no. 395, 397, 398; Höltl, *Das Böhmische Glas 1700–1950*, vol. 6, 21, illus. nos. VI.10, VI.11; Mergl, Ploil, and Ricke, *Lötz: Bohemian Glass 1880–1940*, 281, illus. nos. 247, 248.

11 For a vase with the same shape but different color, see Höltl, *Das Böhmische Glas 1700–1950*, vol. 6, 43, illus. no. VI.44; slightly different vases and bowls can be seen in Truitt, *Collectible Bohemian Glass*, 60, illus. nos. 4, 5; 51, illus. no. 3.

12 See Rudolf Lodgmann and Erwin Stein, *Die sudetendeutsche Selbstverwaltungskörper*, vol. 4, *Teplitz-Schönau* (Berlin: n.p., 1930), 296.

13 See Robert Truitt and Deborah Truitt, *Collectible Bohemian Glass*, vol. 2, *1915–1945* (Kensington, MD: B&D Glass, 1998), 52, illus. no. 6; for variations in other colors, see ibid., 50, illus. nos. 5, 6.

14 On the new types of Welz glass, see "Farbige und irisierende Gläser," *Die Schaulade* 7 (1931): 212.

15 See Waltraud Neuwirth, *Glas 1905–1925. Vom Jugendstil zum Art Deco*, vol. 1 (Wein, Selbstverlag Dr. Waltraud Neuwirth, 1985), illus. nos. 200, 244, 288, 311, 320, 324, and 336.

16 See, for example, the covered vase with the squirrel motif, in Höltl, *Das Böhmische Glas 1700–1950*, vol. 4, illus. no. IV.453; and the vase with stylized birds made by the Gebrüder Lorenz glassworks, in Gustav E. Pazaurek, *Kunstgläser der Gegenwart* (Leipzig: Klinkhardt & Biermann, 1925), 128, illus. no. 114.

17 See *Deutsche Kunst und Dekoration* (1916), illus. p. 274.

18 In Höltl, *Das Böhmische Glas 1700–1950*, vol. 4, illus. no. IV.438.

19 See *Deutsche Kunst und Dekoration* (1916), illus. p. 274.

20 Adolf Beckert, "Österreichisches und böhmisches Glas auf der Internat. Kunstgewerbeausstellung Paris, II. Die böhmische Glasfabriken," *Die Schaulade* 2 (1926): 87.

21 See Heinrich Strehblow, "Das Glaskunststädtchen Haida," *Die Schaulade* (1925): 347. For other vases of this type, see Höltl, *Das*

Böhmische Glas 1700–1950, vol. 4, illus. no. IV.92; Truitt, *Collectible Bohemian Glass*, vol. 2, *1915–1945*, 31, illus. no. 6; and Eva Ranšová, *Sklo 1880–1930. Nový Bor a okolí* (Prague: Obecní dům, 2002), 41, illus. no. 5.

22 See, for references, *Tchéco Verre* 4 (1937): 718.

23 See Höltl, *Das Böhmische Glas 1700–1950*, vol. 4, illus. nos. IV.460–63.

24 Other examples in Jan Mergl and Lenka Pánková, *Moser 1857–1997* (Karlovy Vary: Moser, 1997), cat. nos. 77–82.

25 See Jana Horneková, ed., *Art Deco Bohemia 1918–1938* (Milan: Electa, 1996), cat. nos. III–79. For a liqueur set with a similar decoration, see Höltl, *Das Böhmische Glas 1700–1950*, vol. 4, illus. no. IV.111.

26 See the photo of other cut pieces in Beckert, "Österreichisches und böhmisches Glas auf der Internat," 87.

27 See Horneková, ed., *Art Deco Bohemia 1918–1938*, 132.

28 See Höltl, *Das Böhmische Glas 1700–1950*, vol. 6, illus. no. VI.67; and Horneková, ed., *Art Deco Bohemia 1918–1938*, 132.

Checklist of the Exhibition

Note to reader: Whenever possible, the original Czech titles have been preserved, with English translations following. In cases where the Czech titles are translated from other languages, the original language appears as well.

The New Alphabet

Jaroslav Seifert and Karel Teige (eds.)
Revoluční sborník Devětsil
[*Devětsil Revolutionary Anthology*]
1922
Cover and typography: Karel Teige and Jaroslav Seifert
Prague: Večernice (V. Vortel)
9 ½ × 6 ½ inches (24 × 16.5 cm)
CAT. 12

Karel Teige
Město u řeky
[*City by a River*]
1918
Watercolor on paper
9 ¾ × 12 ¾ inches (25.2 × 32.5 cm)
CAT. 13

Josef Šíma
Studie pro Vlak a skladiště v Brně
[*Study for Train and Depot in Brno*]
c. 1920
Graphite on paper
8 ⅞ × 6 ½ inches (22.5 × 16.5 cm)
CAT. 14

Jaroslav Seifert
Na vlnách TSF
[*On the Waves of TSF*]
1925
Cover and typography: Karel Teige
Prague: Václav Petr
9 × 6 ⅞ inches (22.8 × 17.5 cm)
CAT. 15

Vítězslav Nezval
Abeceda
[*Alphabet*]
1926
Cover and typography: Karel Teige
Choreography: Milča Mayerová
Photography: Karel Paspa
Prague: J. Otto
12 ¼ × 9 ½ inches (31 × 24 cm)
CAT. 16

Hugo Boettinger
Studie aktu Milči Mayerové
[*Nude Study of Milča Mayerová*]
1925
Graphite on paper
14 ¾ × 10 ¾ inches (37.5 × 27.3 cm)
Gift of Eva Matějková-Willenbrinková, 1998
CAT. 17

Hugo Boettinger
Studie aktu Milči Mayerové
[*Nude Study of Milča Mayerová*]
1929
Graphite on paper
16 ¾ × 11 ¾ inches (42.6 × 29.9 cm)
Gift of Eva Matějková-Willenbrinková, 1998
CAT. 18

Vladimír Lidin
Mořský průvan
[*Sea Breeze*]
1925
Cover: Karel Teige
Prague: Aventinum
8 ¼ × 5 ¼ inches (21.5 × 13.3 cm)
CAT. 19

Guillaume Apollinaire
Sedící žena
[*La femme assise;
The Seated Woman*]
1925
Cover: Karel Teige and Otakar Mrkvička
Prague: Odeon
7 ⅝ × 5 ½ inches (19.5 × 14 cm)
CAT. 20

Vítězslav Nezval
Falešný mariáš
[*Cheating at Whist*]
1925
Cover: Jindřich Štyrský and Toyen
Prague: Odeon
7 ¾ × 5 ½ inches (19.5 × 14 cm)
CAT. 21

Karel Schulz
Dáma u vodotrysku
[*Lady at the Fountain*]
1926
Cover: Jindřich Štyrský and Toyen
Prague: Ladislav Kuncíř
7 × 4 ³/₈ inches (17.8 × 11 cm)
CAT. 22

Jindřich Štyrský, Toyen, and
Vincenc Nečas
Paříž [*Paris*]
1927
Cover: Jindřich Štyrský
Prague: Odeon
7 ¹/₈ × 4 ¹/₂ inches (18 × 11.5 cm)
CAT. 23

Vítězslav Nezval
Karneval: Romaneto [*Carnival: A Novel*]
1926
Cover: J. Don
Prague: Odeon
7 ³/₄ × 5 ¹/₂ inches (19.5 × 14 cm)
CAT. 24

André Maurois
Básník a svět [*The Poet and the World*]
1926
Title page: Karel Teige
Prague: Odeon
7 ⁵/₈ × 5 ³/₈ inches (19.25 × 13.8 cm)

Karel Teige (ed.)
*ReD: Revue Svazu moderní
kultury Devětsil*
[*ReD: Review of the Union for
Modern Culture, Devětsil*]
Volume 1, nos. 1–10, 1927–28
Volume 2, nos. 1–10, 1928–29
Volume 3, nos. 1–10, 1929–30
Covers and typography: Karel Teige
Prague: Odeon
7 × 9 inches (17.8 × 22.9 cm)
CAT. 25

Konstantin Biebl
S lodí, jež dováží čaj a kávu
[*On the Ship Bringing Tea and Coffee*]
1928
Covers, illustrations, and typography:
Karel Teige
Prague: Odeon
7 ⁷/₈ × 5 ³/₄ inches (20 × 14.5 cm)
CAT. 26

Konstantin Biebl
Zlom [*Break*]
1928
Covers, illustrations, and typography:
Karel Teige
Prague: Odeon
7 ⁵/₈ × 5 ¹/₂ inches (19.5 × 14 cm)
CAT. 27

Stanislav Kostka Neumann
Bragožda
1928
Cover: Karel Teige
Prague: Odeon
7 ³/₄ × 5 ¹/₂ inches (19.8 × 14 cm)
CAT. 28

Vladislav Vančura
Pekař Jan Marhoul
[*The Baker Jan Marhoul*]
1929
Cover: Karel Teige
Prague: Odeon
7 ³/₄ × 5 ¹/₂ inches (19.8 × 14 cm)
CAT. 29

Ladislav Dymeš
Ze světa do světa
[*From One World to Another*]
1929
Cover: Karel Teige
Prague: R. Rejman
7 ⁷/₈ × 4 ⁷/₈ inches (20 × 12.5 cm)
CAT. 30

Thornton Wilder
Most svatého Ludvíka krále
[*The Bridge of San Luis Rey*]
1930
Cover: Toyen
Prague: Melantrich
7 ⁷/₈ × 5 ³/₈ inches (20 × 13.5 cm)

František Halas
Kohout plaší smrt
[*The Cock Scares Death*]
1930
Cover: Vít Obrtel
Frontispiece: Jindřich Štyrský
Illustration: Toyen
Prague: R. Škeřík
8 ¹/₂ × 5 ³/₈ inches (21.5 × 13.5 cm)
CAT. 31

Karel Teige (ed.)
*MSA 1: Mezinárodní soudobá
architektura*
[*MSA 1: International Contemporary
Architecture*]
1929
Cover: Karel Teige
Prague: Odeon
9 ¹/₄ × 7 ¹/₄ inches (23.5 × 18.5 cm)
CAT. 32

Karel Teige
*MSA 2: Moderní architektura
v Československu* [*MSA 2: Modern
Architecture in Czechoslovakia*]
1930
Cover: Karel Teige and Fritz Heine
Prague: Odeon
9 ¹/₄ × 7 ¹/₄ inches (23.5 × 18.5 cm)
CAT. 33

Josef Havlíček and Karel Honzík
MSA 3: Stavby a plány
[*MSA 3: Buildings and Projects*]
1931
Cover and typography: Karel Teige
Prague: Odeon
9 ¹/₄ × 7 ¹/₄ inches (23.5 × 18.5 cm)
CAT. 34

F. X. Šalda (ed.)
Almanach Kmene [*Kmen Almanac*]
1930–31
Cover: Karel Teige
Photography: Josef Sudek
Prague: Kmen
7 ⁵/₈ × 5 inches (19.5 × 12.5 cm)
CAT. 35

Josef Hora (ed.)
Almanach Kmene [*Kmen Almanac*]
1931–32
Prague: Kmen
7 ⁵/₈ × 5 inches (19.5 × 12.5 cm)
CAT. 36

Mirrors without Images
Adolf Hoffmeister
Tristan Tzara bloumá po Paříži
[*Tristan Tzara Saunters around Paris*]
1931
Ink on paper
15 ¹/₂ × 11 ¹/₂ inches (39.4 × 29.2 cm)
CAT. 37

Josef Šíma and Philippe Soupault (eds.)
Paříž [*Paris*]
1927
Cycle of eighteen drypoints
(hand-colored): Josef Šíma
Prague: Aventinum
15 ¹/₄ × 12 ¹/₂ inches (28.7 × 31.8 cm)
CAT. 38

Vítězslav Nezval
Židovský hřbitov [*The Jewish Cemetery*]
1928
Illustrations: Jindřich Štyrský
Typography: Karel Teige
Prague: Odeon
11 ³/₄ × 9 ³/₄ inches (30 × 24.8 cm)
CAT. 39

Isidore Ducasse, comte de Lautréamont
Maldoror
[*Les chants de Maldoror; The Songs
of Maldoror*]
1929
Illustrations: Jindřich Štyrský
Typography: Karel Teige
Prague: Odeon
7 ¹/₂ × 5 inches (19 × 12.8 cm)
CAT. 40

Konstantin Biebl
Plancius
1931
Frontispiece (hand-colored):
Jindřich Štyrský
Prague: Sfinx (B. Janda)
7 ⅞ × 5 ⅝ inches (20 × 14.2 cm)
CAT. 41

František Halas
Tvář
[*The Face*]
1932
Frontispiece: Jindřich Štyrský
Prague: Družstevní práce
7 ½ × 4 ⅞ inches (19 × 12.3 cm)
CAT. 42

W. H. [William Henry] Hudson
Purpurová země
[*The Purple Land*]
1930
Illustrations: Toyen
Prague: R. Škeřík (Edice Symposion)
7 ¾ × 5 ⅜ inches (19.5 × 13.5 cm)

Vítězslav Nezval
Sylvestrovská noc
[*New Year's Eve*]
1930
Illustrations: Toyen
Prague: Sfinx (B. Janda)
7 ¾ × 5 ⅛ inches (19.5 × 13 cm)

Karel Konrád
Dvojí stín
[*Double Shadow*]
1930
Illustrations: Toyen
Prague: Edice Megalith
6 ½ × 5 inches (16.5 × 12.5 cm)

Charles Vildrac
Růžový ostrov
[*L'Ile rose; Rose Island*]
1930
Cover and illustrations: Toyen
Prague: Odeon
8 ¼ × 6 inches (21 × 15 cm)
CAT. 43

Stanislav Kostka Neumann
Žal [*Grief*]
1931
Frontispiece and illustrations
(hand-colored): Toyen
Typography: Karel Teige
Prague: E. Janská
9 ⅝ × 6 ½ inches (24.3 × 16.5 cm)
CAT. 44

Molière [Jean-Baptiste Poquelin]
Příležitost dělá lékaře
[*Le médecin volant; The Flying Doctor*]
1932
Frontispiece: Toyen
Typography: Karel Dyrynk
Prague: V. Lácha (Edice Trimalchion)
8 ⅞ × 6 inches (23.5 × 15 cm)

Josef Kajetán Tyl
Rozervanec [*The Misfit*]
1932
Frontispiece: Toyen
Typography: Karel Teige
Prague: E. Janská
7 ¾ × 5 ⅛ inches (19.5 × 13 cm)
CAT. 45

Guillaume Apollinaire
Alkoholy [*Alcools; Alcohols*]
1933
Frontispiece: Toyen
Typography: Jindřich Štyrský
Prague: A. Jirout – K. Teytz
5 ¼ × 7 ⅞ inches (13.5 × 20 cm)
CAT. 46

František Halas
Hořec [*Gentian*]
1933
Illustrations: Toyen
Typography: Jindřich Štyrský
Prague: E. Janská
9 ⅜ × 6 ⅜ inches (24 × 16 cm)
CAT. 47

Toyen
Jaro [*Spring*]
1933
Set of ten lithographic postcards with
cover
Typography: Ladislav Sutnar
Prague: Družstevní práce
4 ⅛ × 6 ⅞ inches (10.5 × 14.7 cm)

Toyen
Study for the cover of Marcel
Aymé's *La jument verte*
[*Zelená kobyla; The Green Mare*]
1934
Ink and watercolor on cardboard
4 ½ × 4 ½ inches (11.5 × 11.5 cm)
CAT. 48

Marie Majerová
Mučenky — Čtyři povídky o ženách
[*Passion Flowers — Four Stories
about Women*]
1934
Illustrations (hand-colored): Toyen
Prague: Čin
7 ¼ × 4 ⅞ inches (18.5 × 12.5 cm)
CAT. 49

Zdenka Marčanová
Náš svět
[*Our World*]
1934
Cover and illustrations: Toyen
Typography: Ladislav Sutnar
Prague: Družstevní práce
9 × 12 ¼ inches (23 × 31 cm)
CAT. 50

Alois Wachsman
Untitled
1931
Graphite on paper
5 ¼ × 8 ¼ inches (13.3 × 21 cm)
CAT. 51

Alois Wachsman
Prospero (stage design)
1937
Watercolor on paper
11 ½ × 16 ⅝ inches (29.2 × 43 cm)
CAT. 52

Jindřich Štyrský
Untitled
1933
Graphite on paper
11 ½ × 8 ⅞ inches (31.5 × 23.5 cm)
CAT. 53

Toyen
Untitled
1933
Watercolor on paper
17 ¾ × 12 ½ inches (45.1 × 31.8 cm)
CAT. 54

Toyen
Untitled
1933
Ink and watercolor on paper
19 × 13 inches (48.3 × 33 cm)
CAT. 55

Under Covers
Pierre Louÿs
Pybrac
1932
Illustrations (hand-colored): Toyen
Prague: V. Lácha
7 ¾ × 5 ½ inches (19.7 × 14 cm)
CAT. 56

Jindřich Štyrský (ed.)
Erotická revue
[*The Erotic Review*], vol. 1
1930
Illustrations: Toyen
8 × 6 ⅛ inches (20.5 × 15.5 cm)
CAT. 57

Jindřich Štyrský (ed.)
Erotická revue
[*The Erotic Review*], vol. 2
1932
Illustrations (hand-colored): Toyen
8 × 5 ½ inches (20.5 × 14 cm)
CAT. 58

Jindřich Štyrský
Illustration for Thyrsos
1932
Ink on paper
9 × 8 inches (22.9 × 20.3 cm)
CAT. 59

František Halas
Thyrsos
1932
Cover, illustrations, and typography:
Jindřich Štyrský
Prague: J. Štyrský (Edice 69)
10 ½ × 8 ⅛ inches (26.7 × 20.6 cm)
CAT. 60

Marquis de Sade
Justina [*Justine*]
1932
Illustrations: Toyen
Prague: J. Štyrský (Edice 69)
7 7/8 × 5 1/8 inches (20 × 13 cm)
CAT. 61

Marguerite de Navarre
The Heptameron [*L'Heptaméron*]
1932
Illustrations: Toyen
Prague: Družstevní práce
8 3/8 × 5 3/8 inches (21.3 × 13.5 cm)
CAT. 62

Svata Kadlec
Černá hodinka [*Black Hour*]
1932
Illustrations: Toyen
Brno: Soukromý tisk (private imprint)
10 × 7 1/8 inches (25.5 × 18 cm)
CAT. 63

Aubrey Beardsley
Venuše a Tannhäuser
[*Venus and Tannhäuser*]
1930
Illustrations: Toyen
Prague: Arnošt Vaněček
11 × 7 3/4 inches (27.8 × 19.5 cm)

Johann Wolfgang von Goethe
Deník [*Diary*]
1932
Illustrations: Toyen
Prague: F. V. Müller
10 1/4× 6 3/4 inches (26 × 17.3 cm)

Jindřich Štyrský
Untitled from *Emilie přichází*
ke mně ve snu
[*Emilie Comes to Me in a Dream*]
1933
Collage
12 × 9 1/2 inches (30.5 × 24.1 cm)
CAT. 64

In the Service of Surrealism
Vítězslav Nezval
Zpáteční lístek [*Return Ticket*]
1933
Cover and typography: Karel Teige
Prague: František Borový
8 3/8 × 5 3/8 inches (21.3 × 13.5 cm)
CAT. 65

Vítězslav Nezval
Neviditelná Moskva [*Invisible Moscow*]
1935
Cover and typography: Karel Teige
Prague: František Borový
8 1/2 × 5 3/8 inches (21.5 × 13.8 cm)
CAT. 66

Vítězslav Nezval
Pantomima [*Pantomime*]
1935
Cover, illustrations, and typography:
Karel Teige
Prague: František Borový
8 1/2 × 5 3/8 inches (21.5 × 13.5 cm)
CAT. 67

Vítězslav Nezval
Žena v množném čísle
[*Woman in the Plural*]
1936
Cover, illustrations, and typography:
Karel Teige
Prague: František Borový
8 1/2 × 5 3/8 inches (21.5 × 13.8 cm)
CAT. 68

Vítězslav Nezval
Praha s prsty deště
[*Prague with Fingers of Rain*]
1936
Cover, illustrations, and typography:
Karel Teige
Prague: František Borový
8 1/2 × 5 3/8 inches (21.5 × 13.5 cm)
CAT. 69

Vítězslav Nezval
Most [*The Bridge*]
1937
Cover, illustrations, and typography:
Karel Teige
Prague: František Borový
8 1/2 × 5 3/8 inches (21.5 × 13.8 cm)
CAT. 70

André Breton
Spojité nádoby
[*Les vases communicants;*
Communicating Vessels]
1934
Cover: Toyen
Prague: S.V.U. Mánes
7 7/8 × 5 3/8 inches (20 × 13.5 cm)
CAT. 71

Vítězslav Nezval (ed.)
Surrealismus [*Surrealism*]
1936
Prague: Edice surrealismu
7 7/8 × 5 3/8 inches (20 × 13.5 cm)
CAT. 72

Jindřich Štyrský
Untitled from *Stěhovací kabinet*
[*The Portable Cabinet*]
1934
Collage
16 3/8 × 13 inches (41.5 × 33 cm)
CAT. 73

Jindřich Štyrský
Untitled from *Stěhovací kabinet*
[*The Portable Cabinet*]
1934
Collage
15 1/4 × 10 1/8 inches (38.7 × 25.7 cm)
CAT. 74

Jindřich Štyrský
Kořeny
[*Roots*]
1934
Oil on canvas
12 1/2 × 19 1/4 inches (31.8 × 48.8 cm)
CAT. 75

Jindřich Štyrský
Untitled
1934
Silver gelatin contact print
2 3/8 × 2 3/8 inches (6 × 6 cm)
CAT. 76

Jindřich Heisler
Na jehlách těchto dní
[*On the Needles of These Days*]
1945
Illustrations: Jindřich Štyrský
Prague: František Borový
8 1/4 × 6 inches (21 × 15 cm)

Antonín Pelc
Jindřich Štyrský
1937
Ink and collage on paper
22 7/8 × 17 3/4 inches (58.1 × 45.1 cm)
CAT. 77

Vítězslav Nezval (ed.)
Ani labuť ani Lůna
[*Neither Swan nor Moon*]
1936
Illustrations: Jindřich Štyrský and Toyen
Prague: Otto Jirsák
8 3/8 × 5 3/4 inches (21.3 × 14.8 cm)
CAT. 78

Jaroslav Durych
Na horách [*In the Mountains*]
1933
Cover: Toyen
Prague: Melantrich
7 7/8 × 5 1/4 inches
(20 × 13.3 cm)
CAT. 79

Toyen
Poselství lesa
[*The Message of the Forest*]
1936
Oil on canvas
63 × 51 inches (160 × 129 cm)
CAT. 80

Jules Laforgue
Legendární morality
[*Moralités légendaires; Moral Tales*]
1934
Illustrations: Toyen
Prague: R. Škeřík
7 3/4 × 5 1/2 inches (19.5 × 13.3 cm)

Guillaume Apollinaire
Básně
[*Poems*]
1935
Illustrations: Toyen
Prague: Ústřední dělnické
knihkupectví a nakladatelství
8 ½ × 5 ¾ inches (21.8 × 14.5 cm)

Vítězslav Nezval
Antilyrique
[*Antilyric*]
1936
Frontispiece: Toyen
Paris: Guy Lévis-Mano
10 × 7 ⅝ inches (25.5 × 19.5 cm)
CAT. 81

Emanuel z Lešehradu
Básníkův rok
[*The Year of the Poet*]
1940
Frontispiece: Toyen
Prague: author's edition
6 ⅛ × 4 ⅜ inches (15.5 × 11 cm)
CAT. 82

Vítězslav Nezval and Karel Teige
Štyrský a Toyen [Štyrský and Toyen]
1938
Prague: František Borový
11 ⅞ × 8 ½ inches (30 × 21.3 cm)

Bohuslav Brouk
Stoupa života [The Pulp Mill of Life]
1939
Prague
Cover, title page, and typography:
Toyen
6 ⅞ × 4 ⅜ inches (17.5 × 11.3 cm)

František Janoušek
Obraz [Painting]
1938
Oil on canvas
25 × 34 inches (63.5 × 86.4 cm)
CAT. 83

Lunatic Years
Toyen and Jindřich Heisler
Les spectres du désert
[*Specters of the Desert*]
1939
Cycle of twelve photogravures
based on drawings by Toyen
from 1936–37, accompanied by
poems by Jindřich Heisler
Prague: anonymous; credited as
Paris: Éditions Albert Skira
11 ⅜ × 9 ¼ inches (28.8 × 23.3 cm)
CAT. 84

Toyen
Střelnice [*Tir; The Shooting Gallery*]
Cycle of twelve photogravures based
on drawings from 1939–40; reprinted
1973
Paris: Éditions Maintenant
13 ⅜ × 17 ⅞ inches (34 × 45.5 cm)
CAT. 85

Toyen
Cache-toi, guerre!
[*Schovej se, válko!; War,*
Hide Yourself!]
1947
Cycle of nine photogravures based
on drawings from 1944
Paris: artist's imprint
16 ⅞ × 12 ⅝ inches (43 × 32 cm)
CAT. 86

Vilém Petrželka
Písně milostné
[*Love Songs*]
1943
Cover and illustrations: Toyen
Prague: Hudební matice
Umělecké besedy
10 ⅝ × 13 ½ inches (27 × 34.3 cm)
CAT. 87

Toyen
Untitled
Illustration for *Písně milostné*
[*Love Songs*]
c. 1943
Graphite and frottage on paper
9 ¼ × 8 inches (23.5 × 20.5 cm)
CAT. 88

Toyen
Untitled
Illustration for *Písně milostné*
[*Love Songs*]
c. 1943
Graphite and frottage on paper
10 ¼ × 9 inches (26 × 22.9 cm)
CAT. 89

Toyen
Untitled
Illustration for *Písně milostné*
[*Love Songs*]
c. 1943
Graphite and frottage on paper
10 × 9 inches (25.4 × 22.9 cm)
CAT. 90

František Vobecký
Chvíle zázraků
[*The Moment of Miracles*]
1936
Gelatin silver print, photomontage
10 ⅝ × 14 ⅞ inches (27 × 37.8 cm)
CAT. 91

Karel Teige
Untitled
1947
Collage
15 × 11 ¼ inches (38.1 × 28.6 cm)
CAT. 92

Jindřich Heisler
Untitled
1943
Gelatin silver print, photomontage
10 ⅞ × 9 ½ inches (27.6 × 24.1 cm)
CAT. 93

Jindřich Heisler
Untitled
1943
Gelatin silver print, photomontage
10 ⅞ × 7 ½ inches (27.6 × 19.1 cm)
CAT. 94

Jindřich Heisler
Untitled
1943
Gelatin silver print, photomontage
10 ⅞ × 7 ½ inches (27.6 × 19.1 cm)
CAT. 95

Jindřich Heisler
Untitled
1943
Gelatin silver print, photomontage
10 ⅞ × 7 ½ inches (27.6 × 19.1 cm)
CAT. 96

Jindřich Heisler
Untitled
1943
Gelatin silver print, photo-graphique
6 ⅞ × 9 ¼ inches (17.5 × 23.5 cm)
CAT. 97

Jindřich Heisler and Toyen
Pf. 1945
1945
New Year's Eve greetings
Hand-colored gelatin silver print,
photo-graphique on cardboard
5 ⅜ × 6 ½ inches (13.7 × 16.5 cm)
CAT. 98

Josef Podrabský
Oslava
[*Celebration*]
1945
Oil on canvas
22 ½ × 29 ⅛ inches (57 × 74 cm)
CAT. 99

Bohumír Matal
Untitled
1946
Oil on board
15 ¼ × 11 ½ inches (38.7 × 29.3 cm)
CAT. 100

Jan Smetana
Untitled
c. 1945
Oil on board
8 ¼ × 11 inches (21 × 27.9 cm)
CAT. 101

František Hudeček
Pohled na Prahu
[*View of Prague*]
1942
Watercolor on paper
8 ¾ × 14 inches (22.2 × 35.6 cm)
CAT. 102

František Gross
Untitled
1943
Gouache on paper
15 × 19 ¼ inches (38.5 × 23.5 cm)
CAT. 103

František Hudeček
Untitled
1946
Oil on wood
11 × 7 ¾ inches (27.9 × 19.7 cm)
CAT. 104

Václav Zykmund
Šedá hlava [*Gray Head*]
1946
Oil on canvas
16 ⅜ × 12 inches (41.5 × 30.5 cm)
CAT. 105

T. Svatopluk (Svatopluk Turek)
Gordonův trust žaluje
[*The Gordon Trust Sues*]
1940
Cover: Toyen
Brno: K. Smolka
8 ½ × 6 inches (21.5 × 15.3 cm)
CAT. 106

Renée Gaudin
Smrt přicházi o 22. hodině
[*La mort se lève à 22 heures; Death Rises at 10 p.m.*]
1947
Cover: Toyen
Prague: J. Šedivý
4 ⅞ × 7 ⅝ inches (12.3 × 19.3 cm)
CAT. 107

Vlastimil Louda
Lidice
1946
Illustrations: Toyen
Prague: Ministerstvo vnitra (Ministry of the Interior)
11 ¾ × 8 ½ inches (29.8 × 21.5 cm)
CAT. 108

Josef Šíma
Vláda pitomosti
[*La pouvoir de la bêtise; Stupidity Rules*]
1951
Graphite on paper
17 ⅛ × 11 ⅝ inches (43.5 × 29.5 cm)
CAT. 108

The Well in the Tower
Toyen
Portrait d'André Breton
[*Portrait of André Breton*]
1950
Crayon, charcoal, oil, and glitter on linen
Inscribed: à André Breton
Signed: Toyen 18 II 1950
19 ½ × 26 ½ inches (46 × 64 cm)
CAT. 109

Radovan Ivšić and Toyen
Le puits dans la tour. Débris de rêves
[*The Well in the Tower. The Debris of Dreams*]
1967
Folio case and cycle of twelve drypoints: Toyen
Paris: Éditions surréalistes
13 ¾ × 11 inches (35 × 28 cm)
CAT. 110

Annie Le Brun
Sur-le-champ
[*Right Now*]
1967
Folio case, drypoints, and photogravures: Toyen
Paris: Éditions surréalistes
12 ⅜ × 9 ¾ inches (31.5 × 24.8 cm)
CAT. 111

Radovan Ivšić
Le roi Gordogane
[*King Gordogan*]
1968
Drypoint and photogravures: Toyen
Paris: Éditions surréalistes
10 ⅜ × 6 ¾ inches (26.3 × 17 cm)
CAT. 112

Jean-Pierre Duprey
La forêt sacrilège et autres textes
[*The Sacrilegious Forest and Other Texts*]
1970
Folio case and drypoints on silk mounted on paper: Toyen
Paris: Le Soleil noir
9 ⅝ × 7 ¾ inches (24.5 × 19.8 cm)
CAT. 113

Annie Le Brun
Tout près, les nomades
[*Close By, the Nomads*]
1972
Folio case and drypoint: Toyen
Paris: Éditions Maintenant
10 ¼ × 7 ⅜ inches (26 × 18.8 cm)

Toyen
Tir [*The Shooting Gallery*]
1973
Folio case, title page, reprint of *Strělnice* [*The Shooting Gallery*], and two drypoints: Toyen
Paris: Éditions Maintenant
12 ⅝ × 17 ¼ inches (32 × 23.8 cm)
CAT. 114

Toyen
Tir [*The Shooting Gallery*]
1973
Hand-colored drypoint
Gift of Radovan Ivšić and Annie Le Brun to Mary Cullen
11 ½ × 11 ½ inches (29.2 × 29.2 cm)
CAT. 115

Toyen
Tir [*The Shooting Gallery*]
1973
Hand-colored drypoint
11 ½ × 11 ½ inches (29.2 × 29.2 cm)
CAT. 116

Annie Le Brun
Annulaire de lune [*Moon Ring-Finger*]
1977
Drypoints: Toyen
Paris: Éditions Maintenant
10 ½ × 7 ½ inches (26.8 × 19 cm)
CAT. 117

Annie Le Brun
Vagit-Prop
1985
Illustrations: Toyen
Paris: Har/Po
8 ¼ × 5 ½ inches (21 × 14 cm)

Czech Modern Glass
Manufactured by Johann Lötz Witwe, Klášterský Mlýn (Klostermühle), Bohemia
Vase
1908
Glass
13 ⅜ × 4 ¾ inches (34 × 12.1 cm)
CAT. 118

Manufactured by Johann Lötz Witwe, Klášterský Mlýn (Klostermühle), Bohemia
Design: Hans Bolek, Vienna
Dish
1916
Mold-blown glass with enamel
4 ⅞ × 4 ½ inches (12.4 × 11.4 cm)
CAT. 119

Manufactured by Johann Lötz Witwe, Klášterský Mlýn (Klostermühle), Bohemia
Vase
1914
Glass
5 × 5 ¼ inches (12.7 × 13.5 cm)
CAT. 120

Manufactured by Johann Lötz Witwe,
Klášterský Mlýn (Klostermühle),
Bohemia
Vase
c. 1936
Mold-blown glass
8 × 6 ⅛ inches (20.3 × 15.5 cm)
CAT. 121

Manufactured by Johann Lötz Witwe,
Klášterský Mlýn (Klostermühle),
Bohemia
Vase
c. 1930
Glass
10 ¼ × 8 ¼ inches (26.1 × 21 cm)
CAT. 122

Manufactured by Antonín Rückl &
Sons, Skalice u České Lípy, Bohemia
Vase
c. 1925
Glass
6 × 7 ⅞ inches (15.2 × 20 cm)
CAT. 123

Manufactured by Wilhelm Kralik
Sohn, Lenora (Eleonorenhain),
Bohemia
Bowl
c. 1930S
Mold-blown glass
9 ¾ × 9 inches (24.8 × 22.9 cm)
CAT. 124

Manufactured by Ernst Steinwald &
Co., Teplice-Šanov (Teplitz-Schönau),
Bohemia
Vase
c. 1930
Glass
11 ½ × 8 ⅞ inches (29.2 × 22.5 cm)
CAT. 125

Manufactured by Franz Welz, Hrob
(Klostergrab), Bohemia
Vase
c. 1930
Glass
8 ⅛ × 4 ½ inches (20.6 × 11.5 cm)
CAT. 126

Manufactured in Nový Bor (Bor/
Haida), Bohemia
Vase
c. 1915
Glass
13 ⅜ × 5 ⅜ inches (34 × 13.7 cm)
CAT. 127

Manufactured by the Glass School,
Nový Bor (Bor/Haida), Bohemia
Vase
c. 1914
Glass
11 ⅛ × 3 ⅞ inches (28.3 × 10 cm)
CAT. 128

Manufactured by the Glass School,
Nový Bor (Bor/Haida), Bohemia
Vase
c. 1912
Glass
8 × 4 ¾ inches (20.3 × 11.9 cm)
CAT. 129

Manufactured by Conrath &
Liebsch, Nový Bor (Bor/Haida),
Bohemia
Jar
1914
Clear glass with lid, black, yellow,
and gold pattern and trim
5 ⅝ × 3 ½ inches (14.3 × 8.9 cm)
CAT. 130

Probably manufactured by Friedrich
Pietsch, Kamenický Šenov, Bohemia
Design: Adolf Beckert
Jar
1920 – 22
Glass
7 × 3 ⅝ inches (17.8 × 9.2 cm)
CAT. 131

Probably manufactured by the
Glass School, Nový Bor (Bor/Haida),
Bohemia
Vase
c. 1915 – 20
Glass
7 ⅞ × 6 ¾ inches (20 × 17.1 cm)
CAT. 132

Probably manufactured by the
Glass School, Kamenický Šenov,
Bohemia
Vase
1920 – 25
Glass
11 ⅞ × 6 inches (30.2 × 15.2 cm)
CAT. 133

Manufactured by the
Glass School, Kamenický Šenov,
Bohemia
Vase
1925
Glass
6 ¾ × 6 ½ inches (17.1 × 16.5 cm)
CAT. 134

Manufactured by Johann Oertel &
Co., Nový Bor (Bor/Haida), Bohemia
Vase
1924
Glass
6 ¾ × 6 ¼ inches (17.1 × 15.9 cm)
CAT. 135

Probably manufactured by the Glass
School, Kamenický Šenov, Bohemia
Vase
c. 1930S
Glass
6 ¼ × 4 ⅛ inches (15.7 × 10.3 cm)
CAT. 136

Probably manufactured by the Glass
School, Kamenický Šenov, Bohemia
Vase
1930
Glass
6 ⅝ × 4 ½ inches (16.8 × 11.4 cm)
CAT. 137

Manufactured by the Glass School,
Kamenický Šenov, Bohemia
Design: possibly Alfred Dorn
Vase
c. 1935
Glass
7 ¾ × 5 ¾ inches (19.8 × 14.6 cm)
CAT. 138

Manufactured by the Glass School,
Kamenický Šenov, Bohemia
Design: possibly Oswald Lippert
Vase
1935
Glass
5 ⅝ × 3 ⅞ inches (14.3 × 10 cm)
CAT. 139

Manufactured by Beyermann & Co.,
Nový Bor (Bor/Haida), Bohemia
Goblet
c. 1920
Glass
6 ⅝ × 4 ¼ inches (16.8 × 10.6 cm)
CAT. 140

Manufactured by Carl Goldberg, Nový
Bor (Bor/Haida), Bohemia
Vase
1930 – 35
Glass
8 ¼ × 5 ¼ inches (21.1 × 13.1 cm)
CAT. 141

Manufactured by Ludwig Moser
& Sons, Karlovy Vary (Karlsbad),
Bohemia
Design: Leo Moser
Vase
1925
Glass with gold metal
12 ¼ × 6 ⅞ inches (31 × 17.6 cm)
CAT. 142

Manufactured by Rachmann Bros.,
Nový Bor (Bor/Haida), Bohemia
Vase
c. 1930
Glass
4 ³/₈ × 5 ¼ inches (11.1 × 13.4 cm)
CAT. 143

Manufactured by Johann
Oertel & Co., Nový Bor (Bor/Haida),
Bohemia
Vase
1924
Mold-blown glass
7 ⁵/₈ × 4 ⁵/₈ inches (19.4 × 11.7 cm)
CAT. 144

Possibly manufactured by Karl
Palda, Nový Bor (Bor/Haida),
Bohemia
Vase
c. 1930
Glass
11 ⁷/₈ × 5 ³/₈ inches (30.2 × 13.7 cm)
CAT. 145

Manufactured by
Rudolf Hloušek, Železný Brod,
Bohemia
Vase
After 1935
Glass
9 ½ × 6 ³/₈ inches (24.1 × 16.2 cm)
CAT. 146

Manufactured by Solomon Reich &
Co., Krásno nad Bečvou, Moravia
Vase
c. 1935
Glass
10 × 7 inches (25.4 × 17.8 cm)
CAT. 147

Artists' Biographies

Konstantin Biebl
poet and author

BORN FEBRUARY 26, 1898, SLAVĚTÍN, BOHEMIA
DIED NOVEMBER 12, 1951, PRAGUE

Konstantin Biebl was a leading representative of Poetism. He joined Devětsil in 1926, and Karel Teige designed most of his anthologies, including: *S lodí, jež dováží čaj a kávu* (*On the Ship Bringing Tea and Coffee*), 1927; the second edition of *Zlom* (*Break*), 1928; and *Nebe, peklo, ráj* (*Heaven, Hell, Paradise*), 1930. Biebl's Poetist period culminated in *Nový Ikaros* (*The New Icarus*, 1929), inspired by the work of Guillaume Apollinaire; the book design was by František Muzika. In 1934 Biebl was one of the founders of the Skupina surrealistů v ČSR (Surrealist Group in Czechoslovakia). His enthusiasm for Surrealism was reflected in his collection *Zrcadlo noci* (*The Mirror of the Night*), 1939, designed by Vojtěch Tittelbach. In 1951, no longer able to face Communist repression, Biebl committed suicide.

Selected Reference:
Pelc, Jaromír. "Doslov" ("Afterword"). In Konstantin Biebl, *Modré stíny pod zlatými stromy* (*Blue Shadows under Gold Trees*). Prague: Československý spisovatel, 1988, 235–302.

Hugo Boettinger
painter, graphic artist, and caricaturist (pseudonym Dr. Desiderius)

BORN APRIL 30, 1880, PLZEŇ
DIED DECEMBER 9, 1934, PRAGUE

Hugo Boettinger studied at the School of Applied Arts in Prague, 1895–98, and at the Academy of Fine Arts in Prague, 1899–1902. In 1912 he was dazzled by the performance of the Russian actress and dancer Olga Gzovska in Prague, and he began to study the representation of movement in painting and drawing. His interest in dance later influenced the artistic career of his niece, the dancer Milča Mayerová.

Selected Reference:
Friedl, Antonín. *Hugo Boettinger*. Prague: Melantrich–S.V.U. Mánes, 1940.

František Gross
painter and graphic artist

BORN APRIL 19, 1909, NOVÁ PAKA, BOHEMIA
DIED JULY 27, 1985, PRAGUE

František Gross studied at the Czech University of Technology, 1927–28, and at the School of Applied Arts in Prague, 1928–31. He was a member of the Umělecká beseda (Artists' Club), 1941–52, and was one of the founders of Skupina 42 (Group 42), 1942–48. From the

mid-1930s on, under the influence of Surrealism, he experimented with various techniques, including frottage, collage, decalcomania, and rebus pictures, which, in 1937, culminated in a series of picture-objects. In particular, he was attracted by motifs of absurd machines and depersonalized civilization.

Selected References:
Kotalík, Jiří. *František Gross*. Prague: Nakladatelství československých výtvarných umělců, 1963.

Petrová, Eva. *František Gross*. Prague: Vltavín, 2004.

František Halas
poet, translator, and author of essays on literature, art, culture, and politics

BORN OCTOBER 3, 1901, BRNO
DIED OCTOBER 27, 1949, PRAGUE

František Halas was a founder of the Brno section of Devětsil in 1923, coeditor of the first volume of the Devětsil magazine *Pásmo (Zone)*, 1924–25, and the anthology *Fronta (Front)*, 1927. He was influenced by Proletarian poetry and Poetism. His collections include the Poetist *Sépie (Cuttlefish)*, 1927, and *Kohout plaší smrt (The Cock Scares Death)*, 1930, which reflected experiences of the First World War. Jindřich Štyrský designed his anthologies *Tvář (The Face)*, 1931, and *Hořec (Gentian)*, 1933.

Selected Reference:
Kundera, Ludvík. *František Halas*. Brno: Atlantis, 1999.

Jindřich Heisler
poet, photographer, and filmmaker

BORN SEPTEMBER 1, 1914, CHRAST, BOHEMIA
DIED JANUARY 4, 1953, PARIS

Jindřich Heisler was among the youngest members of the Skupina surrealistů v ČSR (Surrealist Group in Czechoslovakia), which he joined in 1938. He formed important friendships with Toyen and Jindřich Štyrský in the second half of the 1930s, and, during the Nazi occupation of Czechoslovakia, he ignored the decree that as "non-Aryans," Jews had to be registered; ultimately, he was forced to hide in Toyen's apartment from 1941 until the end of the war. Despite conditions of incredible adversity, Heisler continued to publish clandestinely in Prague. Among his anthologies were: *Jen poštolky chčí klidně na desatero (Only Kestrels Calmly Piss on the Ten Commandments)*, with Toyen's illustrations and a collage cover by Štyrský, 1939; *Les spectres du désert (The Specters of the Desert)*, with poems by Heisler and drawings by Toyen, 1939 (although as a ruse the publisher was listed as "A. Skira, Paris"); *Na jehlách těchto dní (On the Needles of These Days)*, with poems by Heisler and photographs by Štyrský, 1941. Heisler and Toyen together produced the collection of "implemented poems" titled *Z kasemat spánku (From the Casemates of Sleep)*, 1940. In 1947, he moved to Paris with Toyen, where he joined the Paris Surrealist Group. He helped to organize *Surréalisme en 1947* in Paris, which also traveled in a condensed version to Prague. From January 1948 to July 1949, he edited the *NÉON* review, with Jean-Louis Bédouin, Victor Brauner, and Jacques Hérold. Among his last projects were three *Knihy-objekty-básně (Books-Objects-Poems)*, 1950–51, dedicated to André Breton, Toyen, and Benjamin Péret.

Selected References:
Heisler, Jindřich. *Z kasemat spánku [From the Casemates of Sleep]*, ed. František Šmejkal, Karel Srp, and Jindřich Toman. Prague: Torst, 1999.

Le Brun, Annie. *Jindřich Heisler: A Crystal in the Night, Surrealist Photographs Made Clandestinely in Nazi-Occupied Prague*. New York: Ubu Gallery, 1998.

Šmejkal, František, Radovan Ivšić, Annie Le Brun, et al. *Štyrský, Toyen, Heisler*. Paris: Musée National d'Art Moderne, 1982.

Adolf Hoffmeister
painter, illustrator, caricaturist, author, and lawyer

BORN AUGUST 18, 1902, PRAGUE
DIED JULY 24, 1973, ŘÍČKY, BOHEMIA

Originally a devotee of Dadaism, Adolf Hoffmeister was one of the founders of Devětsil in 1920. After experimenting with the Cubist style, he became an advocate of Proletarian art. He was influenced by the naive poetic style of Henri Rousseau. He wrote many travel books, which he also illustrated, including: *Obratník kozoroha (The Tropic of Capricorn)*, 1926; *Hors d'oeuvre*, 1927; and *Kalendář (The Calendar)*, 1930. From the beginning of the 1930s, he promoted Surrealism, taking part in the exhibition *Poesie 1932 (Poetry 1932)* in Prague. In 1934, he published Czech and French versions of the album *Podoby (Portraits)*, with thirty-six drawings and collages representing important figures of contemporary politics, literature, and art, including representatives of French Surrealism. In the same year, he organized in Prague the antifascist *Mezinárodní výstava karikatur a humoru (International Exhibition of Caricature and Humor)*. In 1939, he was compelled to immigrate to France. From there, he made his way to the United States via Spain and North Africa. He returned to Czechoslovakia after the war, and from 1948 through 1951, he served as ambassador to France. He lived in seclusion after the occupation of Czechoslovakia in 1968.

Selected References:
Adolf Hoffmeister. Brussels: Palais des Beaux-Arts, 1969.

Srp, Karel, ed. *Adolf Hoffmeister*. Prague: Gallery, 2004.

František Hudeček
painter, graphic artist, and illustrator

BORN APRIL 7, 1909, NĚMČICE, MORAVIA
DIED MAY 13, 1990, PRAGUE

František Hudeček studied at the School of Applied Arts in Prague, 1928 – 1931. Influenced by the theories and new techniques of Surrealism in the 1930s, he became a member of the Umělecká beseda (Artists' Club) in 1941 and the Skupina 42 (Group 42), from 1942 to 1948. From the early 1940s on, he developed the theme of the "night walker," and his work assumed an increasingly obsessive and angst-ridden character. In later years, his work moved toward pure abstraction, and in the 1960s, his work took on the vibrancy of Op Art.

Selected Reference:
Petrová, Eva. *František Hudeček*. Prague: Obelisk, 1969.

Radovan Ivšić
poet, playwright, and translator

BORN JUNE 22, 1921, ZAGREB, YUGOSLAVIA
DIED DECEMBER 25, 2009, PARIS

A vital member of the underground avant-garde in the former Yugoslavia, Radovan Ivšić lived in exile in Paris from 1954. He was active in the Surrealist movement and contributed to the magazines *Bief* (*Canal Pound*), *La Brèche* (*The Breach*), and *L'Archibras*. In 1943, he wrote the play *Kralj Gordogan* (*Le roi Gordogane, King Gordogan*), and a 1968 French edition was illustrated with collages by Toyen. He also collaborated with Toyen on the book *Le puits dans la tour. Débris de rêves* (*The Well in the Tower. The Debris of Dreams*), 1967, and on a new edition of *Střelnice* (*Tir; The Shooting Gallery*), 1973. In 1972, along with Georges Goldfayn, Annie Le Brun, and Toyen, he founded Éditions Maintenant. He published a monograph on Toyen in 1974, and in 1999, he published a book of poems, *Reprises de vue* (*Retakes*, Prague: Střelec), to accompany Štyrský's photographs from 1934 – 35.

Selected Reference:
Ivšić, Radovan. *U nepovrat* (*Beyond Redemption*). Zagreb: Grafički závod hrvatske, 1990.

František Janoušek
painter

BORN MAY 6, 1890, JESENNÝ, BOHEMIA
DIED JANUARY 23, 1943, PRAGUE

František Janoušek studied at the Prague Academy, 1919 – 22. His early work embraced Neoclassical tendencies, but by the 1930s he had adopted an unorthodox Surrealism, which he continued to pursue for the rest of his life.

Selected Reference:
Chalupecký, Jindřich. *František Janoušek*. Prague: Odeon, 1991.

Annie Le Brun
poet, theorist, and editor

BORN 1942, RENNES, LIVES IN PARIS

Annie Le Brun was among the late advocates of Surrealism. First drawn to the circle of André Breton in 1963, she remained a member of the Paris Surrealist Group until 1969. Toyen illustrated her books *Sur-le-champ* (*Right Now*), 1967, *Tout près, les nomades* (*Close by, the Nomads*), 1972, and *Annulaire de lune* (*Moon Ring-Finger*), 1977. From 1972 on, she worked with Georges Godlfayn, Radovan Ivšić, and Toyen on Éditions Maintenant. She edited the collected works of the Marquis de Sade, wrote a number of studies on Toyen, and curated the exhibitions *Petits et grands theâtres du Marquis de Sade* (*The Small and Large Theatres of the Marquis de Sade*), 1989, and *Trajectoires du rêve* (*Trajectories of a Dream*), 2003. She wrote the anthology of poems *Pour ne pas en finir avec la représentation* (*So As Not to Do Away with Representation*), 2003, to accompany Štyrský's 1932 photographs from the Marquis de Sade's Lacoste Castle.

Selected Reference:
Rosemont, Penelope, ed. *Surrealist Women: An International Anthology*. Austin: The University of Texas Press, 1998, 306 – 9.

Bohumír Matal
painter

BORN JANUARY 13, 1922, BRNO
DIED JULY 7, 1988, PRUDKÁ, MORAVIA

Bohumír Matal studied at the Arts and Crafts School in Brno, 1937 – 41. In 1945 he became a member of the Umělecká beseda (Artists' Club) and Skupina 42 (Group 42). Influenced by Surrealism in his early years, he moved toward the loose structures of Art Informel in the 1960s. For many years, his studio in Brno was a center for progressive artists.

Selected Reference:
Císařovský, Josef. *Bohumír Matal*. Prague: Evropský kulturní klub, 1991.

Milča Mayerová

dancer and choreographer

BORN APRIL 12, 1901, PRAGUE
DIED SEPTEMBER 12, 1977, PRAGUE

A proponent of "expressive dance," Milča Mayerová was the niece of the artist Hugo Boettinger. Boettinger introduced her to the work of Jacques-Émile Dalcroze while she was still a child and further encouraged her to study with Anna Dubská in Prague and with Dalcroze in Hellerau, outside of Dresden. Mayerová completed her training in the early 1920s under Rudolf von Laban, with whom she studied in Hamburg. On returning to Prague, she began to perform at various avant-garde venues and at the National Theater. In 1926 she collaborated with Vítězslav Nezval, Karel Teige, and Karel Paspa to produce the Devětsil "alphabet," *Abeceda*, which also became part of her repertory. She further collaborated with other major figures in Prague art and theater, including Adolf Hoffmeister, Bedřich Feuerstein, and the vaudeville and film stars Voskovec and Werich. She launched her own dance company during these years as well. After World War II, she retreated from public performance but maintained her Studio Milča Mayerová.

Selected Reference:
Witkovsky, Matthew S. "Staging Language: Milča Mayerová and the Czech Book 'Alphabet.'" *Art Bulletin* 86, no. 1 (March 2004): 114–35.

Otakar Mrkvička

painter, typographer, caricaturist, set designer, and art critic

BORN DECEMBER 19, 1898, PŘÍBRAM, BOHEMIA
DIED NOVEMBER 20, 1957, PRAGUE

Otakar Mrkvička studied at the Academy of Fine Arts in Prague in 1918 and at the School of Applied Arts in Prague, 1919–22. He was briefly a member of the Umělecká beseda (Artists' Club), 1922–23, and in 1922, he was the secretary for Devětsil. From that year on, he published drawings and caricatures in a number of magazines. He cofounded the leftist satirical magazine *Trn* (*Thorn*). After dabbling in poetic Primitivism, he embraced abstraction in the mid-1920s. Among his projects as a graphic designer were collaborations with Karel Teige and the avant-garde review *Plán* (*Plan*); additionally, he worked on set and costume designs and collaborated with the Osvobozené divadlo (Liberated Theater).

Selected Reference:
Šefčíková, Dagmar. *Otakar Mrkvička*. Prague: Středočeská galerie, 1970.

Vítězslav Nezval

poet, author, playwright, essayist, librettist, screenwriter, and translator

BORN MAY 26, 1900, BISKOUPKY, MORAVIA
DIED APRIL 6, 1958, PRAGUE

Vítězslav Nezval was a leading figure of the Czech avant-garde between the world wars. In 1922, he became a member of Devětsil and contributed to the anthologies *Devětsil* and *Život II* (*Life II*). In 1924 he and Karel Teige defined a new artistic trend, *Poetismus* (Poetism). This trend found expression in Nezval's anthology *Pantomima* (*Pantomime*), 1924, which combined diverse genres. Jindřich Štyrský designed the cover for the book, and Teige the typography. Štyrský and Toyen designed the covers for Nezval's collections *Falešný mariáš* (*Cheating at Whist*), 1925, and *Menší růžová zahrada* (*A Smaller Rose Garden*), 1926. Among Nezval's most celebrated publications of this period was *Abeceda* (*Alphabet*), 1926, created in collaboration with Karel Paspa, Karel Teige, and Milča Mayerová. In 1928 Teige and Nezval prepared a special issue of *ReD* magazine with new Poetist manifestos. In 1930 Nezval published the magazine *Zvěrokruh* (*The Zodiac*), in which he included a translation of André Breton's *Second manifeste du surréalisme* (*Second Manifesto of Surrealism*). He met Breton in person in 1933. On March 21, 1934, he founded the Skupina surrealistů v ČSR (Surrealist Group in Czechoslovakia). In 1934 he attended the Writers' Congress in Moscow and, in 1935, the Congrès international des écrivains pour la défense de la culture (Congress of Writers for the Defense of Culture) in Paris. In 1938 Nezval tried to abolish the Surrealist Group in Czechoslovakia as per order of the Communist party.

Selected References:
Banerjee, Maria Nemcova. "Nezval's Prague with Fingers of Rain: A Surrealistic Image."*The Slavic and East European Journal* 23, no. 4 (Winter 1979): 505–14.

French, Alfred. "Nezval's Amazing Magician: A Czech Shamanist Epic." *Slavic Review* 32, no. 2 (June 1973): 358–69.

Jelínek, Antonín. *Vítězslav Nezval*. Prague: Československý spisovatel, 1961.

Taufer, Jiří. *Vítězslav Nezval: essai littéraire*. Paris: Unesco, 1981.

Vít Obrtel

architect, poet, architectural theorist, typographer, and set and furniture designer

BORN MARCH 22, 1901, OLOMOUC
DIED JUNE 12, 1988, PRAGUE

Vít Obrtel studied at the Czech University of Technology in Prague, 1918 – 25. In 1923 he became a member of Devětsil. He was editor of the *Kvart* (*Quarto*) review, 1930 – 35 and 1945 – 48. He showed his early Purist architectural designs at the international exhibition of architecture at the Bauhaus in 1923. He became a champion of the concepts of Neo-Constructivism and what he called Super-Constructivism.

Selected Reference:
Bregantová, Polana, Nora Obrtelová, Hana Rousová, and Rostislav Švácha. *Vít Obrtel: Architektura-typografie-nábytek* [*Architecture-Typography-Furniture*]. Prague: Galerie hlavního města Prahy, 1991.

Antonín Pelc

painter, illustrator, and caricaturist

BORN JANUARY 16, 1895, LIŠANY, BOHEMIA
DIED MARCH 24, 1967, PRAGUE

Antonín Pelc studied at the Academy of Fine Arts in Prague, 1913 – 19. From the 1920s on, he drew caricatures and political cartoons. He worked for *Šibeničky* (*The Gallows*), *Rudé právo* (*Red Right*), and *Tvorba* (*Artwork*). His painting was influenced by Cubism and Social Realism. In 1939, he immigrated, with Adolf Hoffmeister, to France. He was imprisoned in concentration camps before making his way, via Morocco and Martinique, to the United States. After the war, he returned to Czechoslovakia.

Selected Reference:
Lamač, Miroslav. *Antonín Pelc*. Prague: NČSVU, 1963.

Josef Podrabský

painter and photographer

BORN NOVEMBER 28, 1912, PRAGUE
DIED MAY 24, 1990, ČESKÝ BROD, BOHEMIA

Josef Podrabský studied draftsmanship at the Czech University of Technology in Prague, 1931 – 36. Through his friendship with Václav Zykmund, he came into contact with the Skupina Ra (Ra Group) and

began to create Surrealist collages and paintings. After completing his studies, he made Ostrava his home, where he joined the Moravské sdružení výtvarných umělců (Association of Moravian Fine Artists).

Selected Reference:
Anděl, Jaroslav, and Anne Wilkes Tucker, eds. *Czech Modernism 1900–1945*. Houston: The Museum of Fine Arts, Houston, 1989, 250–51.

Jaroslav Seifert

poet

BORN SEPTEMBER 23, 1901, PRAGUE
DIED JANUARY 10, 1986, PRAGUE

Jaroslav Seifert was one of the founders of Devětsil in 1920, and, with Teige, he edited the anthology *Devětsil*, 1922. His first anthologies, *Město v slzách* (*City in Tears*), published with a cover designed by Teige in 1921, and *Samá láska* (*Nothing but Love*), published with a cover by Otakar Mrkvička in 1923, reflected the Proletarian movement in poetry. Subsequently, he was one of the main representatives of Poetism. His anthology *Na vlnách TSF* (*On the Waves of TSF*), 1925, was published with original typography by Teige. In 1929, Seifert, along with other eminent left-wing writers, signed a protest against Klement Gottwald's leadership of the Communist Party of Czechoslovakia. In 1977 he was one of the first signatories of *Charta 77* (*Charter 77*), and in 1984 he was awarded the Nobel Prize for literature.

Selected References:
Harkens, William E. "The Czech Nobel Laureate Jaroslav Seifert." *World Literature Today* 59, no. 2 (Spring 1985): 173–76.

Iggers, Wilma A. "The World of Jaroslav Seifert." *World Literature Today* 60, no. 1 (Winter 1986): 8–12.

Levinger, Esther. "Czech Avant-Garde Art: Poetry for the Five Senses." *The Art Bulletin* 81, no. 3 (September 1999): 513–32.

Pešat, Zdeněk. *Jaroslav Seifert*. Prague: Československý spisovatel, 1991.

Josef Šíma

painter and illustrator

BORN MARCH 19, 1891, JAROMĚŘ, BOHEMIA
DIED JULY 24, 1971, PARIS

Josef Šíma studied at the School of Applied Arts in Prague, 1910, and at the Academy of Fine Arts in Prague, 1911 – 14. He fought in the war from 1914 to 1918. In 1920 he accepted a position as a designer of church windows in Hendaye, in the south of France. In 1921 he settled in Paris and became an important liaison between the Paris and Czech avant-garde, translating French authors and writing for Czech publi-

cations. In 1923 he became a member of Devĕtsil. During the 1920s, Šíma was primarily influenced by Cubism and Purism. He exhibited at the 1925 *L'Art d'aujourd'hui* (*Contemporary Art*) exhibition. He was a friend of the French poets Pierre Jean Jouve and Georges Ribemont-Dessaignes. He was interested in Surrealism, but never endorsed it fully. In 1927 he became acquainted with the group of Simplists in Reims—the poets René Daumal, Roger Gilbert-Lecomte, and Roger Vailland. Together they founded the group Le Grand Jeu (The Big Game) in the autumn of 1927. He helped to organize the Prague exhibition *Poesie 1932* (*Poetry 1932*), in which he also participated. In the tense political atmosphere of the 1930s, his paintings reflected a fascination with classical myths. After the war, he was one of the main representatives of Parisian abstract art.

Selected References:

Bydžovská, Lenka, and Karel Srp. *Josef Šíma: Návrat Theseův* [*The Return of Theseus*]. Prague: Gallery, 2006.

Linhartová, Vĕra. *Joseph Šíma: ses amis, ses contemporains.* Brussels: La Connaissance, 1974.

Liot, David, ed. *Grand Jeu et surréalisme*. Reims: Musée des Beaux-Arts de la Ville de Reims, 2004.

Pagé, Suzanne, ed. *Sima*. Paris: Musée d'Art Moderne de la Ville de Paris, 1992.

Šmejkal, František. *Josef Šíma*. Prague: Odeon, 1988. [French version 1992, Paris]

Spielmann, Peter, et al. *Josef Šíma, 1891–1971*. Bochum, Germany: Museum Bochum, 1974.

Jan Smetana
painter and graphic artist

BORN OCTOBER 3, 1918, PRAGUE
DIED APRIL 6, 1998, PRAGUE

Jan Smetana studied at the Czech University of Technology, 1935–39, at the School of Applied Arts in Prague, 1941–43, and at Charles University, 1945–46. From 1942 to 1948, he was a member of the Skupina 42 (Group 42). In 1944 he joined the Umĕlecká beseda (Artists' Club). He was interested in the milieu of the modern city and its suburbs. In the early postwar years, his paintings were inspired by his stay in Paris. In the 1960s, his work tended toward biomorphic abstraction.

Selected Reference:

Petrová, Eva. *Jan Smetana*. Prague: Odeon, 1987.

Jindřich Štyrský
painter, photographer, illustrator, set designer, typographer, poet, biographer, editor, and publisher

BORN AUGUST 11, 1899, ČERMNÁ, BOHEMIA
DIED MARCH 21, 1942, PRAGUE

One of the avatars of the Czech avant-garde, Jindřich Štyrský studied at the Academy of Fine Arts in Prague, 1920–23. In 1922 on the island of Korčula, he met the painter Marie Čermínová (Toyen), with whom he lived and worked closely until the end of his life. In 1923 he became a member of Devĕtsil, and was a frequent contributor to Karel Teige's various journals, including *Disk* (*Disc*), *Pásmo* (*Zone*), and *ReD* (*Devĕtsil Review*). He lived in Paris from 1925 to 1928, where he and Toyen developed their artistic style known as Artificialism. In 1925, he took part in the Parisian exhibition *L'Art d'aujourd'hui* (*Contemporary Art*). In 1928–29, he was head of stage design at the Osvobozené divadlo (Liberated Theater) in Prague. He edited the *Odeon* review in 1929–30, where his articles provoked a debate between generations that led to the dissolution of Devĕtsil. Additionally, he founded *Erotická revue* (*The Erotic Review*), 1930–33, and *Edice 69* (*Edition 69*), 1931–33. In 1930 he published a biography of Arthur Rimbaud, and subsequently worked on a biography of the Marquis de Sade; he was one of the first representatives of the avant-garde to photograph the ruins of de Sade's Lacoste Castle, which he visited in 1932. He was one of the cofounders of the Skupina surrealistů v ČSR (Surrealist Group in Czechoslovakia) in 1934, and participated in all of the international exhibitions of Surrealism in the 1930s, including *Poesie 1932* (*Poetry 1932*). He fell seriously ill while in Paris in the summer of 1935, and never fully recovered. After the German occupation of Czechoslovakia, the Skupina surrealistů v ČSR went underground, and Štyrský's activities were severely curtailed. In 1940 he completed the manuscript of *Sny* (*Dreams*); his final project, undertaken with Jindřich Heisler, was *Na jehlách těchto dní* (*On the Needles of These Days*), published clandestinely in 1941. Štyrský died of pneumonia the following spring.

Selected References:

Bydžovská, Lenka, and Karel Srp. *Jindřich Štyrský* [Czech and English version]. Prague: Argo, 2007.

Král, Petr. "Štyrský: le précurseur." *Les Cahiers du Musée National d'Art Moderne* (December 1983): 244–53.

Nezval, Vítězslav, and Karel Teige. *Štyrský a Toyen* [*Štyrský and Toyen*]. Prague: Fr. Borový, 1938.

Šmejkal, František, Radovan Ivšić, Annie Le Brun, et al. *Štyrský, Toyen, Heisler*. Paris: Musée National d'Art Moderne, 1982.

Srp, Karel. *Jindřich Štyrský* [Czech and English version]. Prague: Torst, 2001.

Toman, Jindřich. "The Dream Factory Had a Horror Division: Štyrský's and Toyen's Psycho-covers from the 1930s." *Umění* 48, no. 3 (2000): 170–80.

Karel Teige

critic, theorist of art, architecture, literature, and film, painter, collage artist, and typographer

BORN DECEMBER 13, 1900, PRAGUE
DIED OCTOBER 1, 1951 PRAGUE

Karel Teige was the leading theorist and organizer of the Czech avant-garde of the era between the world wars. He was the founder of Devětsil, 1920, a member of Levá fronta (Left Front), 1929, and the chief theorist of the Skupina surrealistů v ČSR (Surrealist Group in Czechoslovakia), established in 1934. Additionally, he revolutionized book design and typography, actively launching numerous publications that reached across Europe. In 1922 he helped prepare the anthologies *Devětsil* and *Život II* (*Life II*), and was the editor-in-chief of *Stavba* (*Building*). In 1923 he started to make picture poems, and with the poet Vítězslav Nezval, he invented an artistic style, *Poetismus* (Poetism), which he promoted in two manifestos, published in 1924 and 1928. His main theoretical goal in the 1920s was to unite Poetism and Constructivism. From 1927 to 1931, he edited the magazine *ReD* (*Devětsil Review*). At the turn of the 1920s and 1930s, he gave systematic attention to the theory of architecture: *Mezinárodní soudobá architektura* (*International Contemporary Architecture*), 1929; *Moderní architektura v Československu* (*Modern Architecture in Czechoslovakia*), 1930; and *Nejmenší byt* (*The Minimum Dwelling*), 1932. In 1935 he embraced the Surrealist method of collage, which became his chief means of expression in the visual arts. In 1938 he published the pamphlet *Surrealismus proti proudu* (*Surrealism against the Current*) in response to Nezval's attempt to disband the Skupina surrealistů. In 1939 he embarked on *Fenomenologie moderního umění* (*Phenomenology of Modern Art*), intended to be a comprehensive survey encompassing ten volumes. After the invasion of Czechoslovakia, he was forced to withdraw from public life. In postwar Prague, Teige attempted to reestablish his preeminent role; however, he was violently denounced by the Communist Party in 1950. Among his final projects were the samizdat anthologies *Znamení zvěrokruhu* (*Signs of the Zodiac*), 1950–51, which he undertook with a new generation of emerging artists and writers. These projects came to an end with Teige's untimely death.

Selected References:
Bohatec, Milan. *Karel Teige a kniha* [*Karel Teige and the Book*]. Prague: NČVU, 1965.

Dačeva, Rumjana, Vojtěch Lahoda, and Karel Srp. *Karel Teige: Surrealistické koláže* [*Surrealist Collages*]. Prague: Středoevropská galerie a nakladatelství, 1994.

Dluhosch, Eric, and Rostislav Švácha, eds. *Karel Teige 1900–1951: L'Enfant Terrible of the Czech Modernist Avant-garde*. Cambridge, MA: MIT Press, 1999.

Levinger, Esther. "A Life in Nature: Karel Teige's Journey from Poetism to Surrealism." *Zeitschrift für Kunstgeschichte* 67, no. 3 (August 2004): 401–20.

————. "Karel Teige on Cinema and Utopia." *The Slavic and East European Journal* 48, no. 2 (Summer 2004): 247–74.

Masheck, Joseph. "Karel Teige: Functionalist and Then Some." *Art in America* 89, no. 12 (December 2001): 100–105.

Srp, Karel. *Karel Teige* [Czech and English version]. Prague: Torst, 2001.

————, ed. *Karel Teige a typografie* [*Karel Teige and Typography*]. Prague: Arbor vitae, 2009.

Zusi, Peter. "Tendentious Modernism: Karel Teige's Path to Functionalism." *Slavic Review* 67, no. 4 (Winter 2008): 821–39.

Toyen (Marie Čermínová)

painter and illustrator

BORN SEPTEMBER 21, 1902, PRAGUE
DIED NOVEMBER 9, 1980, PARIS

Toyen studied at the School of Applied Arts in Prague from 1919 to 1922. In 1922 she befriended Jindřich Štyrský, with whom she formed a profound partnership until his death in 1942. She joined Devětsil in 1923, and adopted the name Toyen. In the second half of the 1920s, Toyen and Štyrský lived in Paris, where they developed the style known as Artificialism. In 1925 she was represented at the Parisian exhibition *L'Art d'aujourd'hui* (*Contemporary Art*). Both Štyrský and Toyen illustrated books during their Paris tenure, and on their return to Prague, Toyen contributed numerous drawings to Štyrský's *Erotická revue* (*The Erotic Review*), 1930–33, and *Edice 69* (*Edition 69*), 1931–33. In 1932 she participated in the Prague exhibition *Poesie 1932* (*Poetry 1932*). She was one of the founding members of the Skupina surrealistů v ČSR (Surrealist Group in Czechoslovakia) in 1934. In the 1930s, she participated in all of the international exhibitions of Surrealism; however, World War II forced her to withdraw from public life. In 1947, she and Jindřich Heisler, whom she had sheltered in her apartment from 1941 to 1945, moved to Paris. Toyen became an active member of Breton's postwar Surrealist circle of artists and poets, collaborating with the new generation of Surrealists, including most notably Radovan Ivšić and Annie Le Brun.

Selected References:
Bischof, Rita. *Toyen*. Frankfurt: Neue Kritik, 1987.

Breton, André, Benjamin Péret, and Jindřich Heisler. *Toyen*. Paris: Éditions Sokolova, 1953.

Bydžovská, Lenka, and Karel Srp. *Knihy s Toyen* [*Toyen's Books*]. Prague: Akropolis, 2003.

Hubert, Renée Riese. "Clandestine collaborations: Toyen, Štyrský, and Heisler," 309–44. In *Magnifying Mirrors: Women, Surrealism, and Partnership*. Lincoln: University of Nebraska Press, 1994.

Ivšić, Radovan. *Toyen*. Paris: Filipacchi, 1974.

Nezval, Vítězslav, and Karel Teige. *Štyrský a Toyen* [*Štyrský and Toyen*]. Prague: Borový, 1938.

Šmejkal, František, Radovan Ivšić, Annie Le Brun, et al. *Štyrský, Toyen, Heisler*. Paris: Musée National d'Art Moderne, 1982.

Srp, Karel. *Toyen* [Czech and English version]. Prague: Argo, 2000.

———. *Toyen: une femme surréaliste*. Sainte-Ètienne Métropole: Musée d'Art Moderne, 2002.

Von Holten, Ragnar. *Toyen: en surrealistik visionär* [*Toyen: A Surrealist Visionary*] [Swedish and English version]. Köping, Sweden: Lindfors Förlag, 1984.

František Vobecký
painter, photographer, and tailor

BORN NOVEMBER 9, 1902, TRHOVÝ ŠTĚPÁNOV, BOHEMIA
DIED APRIL 13, 1991, PRAGUE

After attending evening drawing classes in Prague (1923 – 26), Vobecký studied at private art schools in Paris (1926 – 27). He began to exhibit his paintings in the late 1920s at the S.V.U. Mánes. Over the following decade, he embraced Cubism, Surrealism, photography, and the art of assemblage.

Selected Reference:
Šmejkal, František. *František Vobecký: raná tvorba 1926–1938* [*Early Work 1926– 1938*]. Prague: Galerie hlavního města Prahy, 1985.

Alois Wachsman
painter, architect, set designer, and illustrator

BORN MAY 14, 1898, PRAGUE
DIED MAY 16, 1942, JIČÍN, BOHEMIA

Alois Wachsman studied at the Czech University of Technology, 1917 – 22, and at the Academy of Fine Arts in Prague, 1925 – 28. Wachsman was a founding member of Devětsil, 1920 – 22, and his early paintings were influenced by Magic Realism. At the end of the 1920s, he went through a Cubist period. At the beginning of the 1930s, Surrealist features appeared in his work, both in the large paintings and in the set designs. He took part in the exhibition *Poesie 1932* (*Poetry 1932*).

Selected References:
Michalová, Rea. *Alois Wachsman*. Prague: Galerie Michal's Collection, 2003.

Pečírka, Jaromír. *Alois Wachsman*. Prague: Státní nakladatelství krásné literatury a umění, 1963.

Václav Zykmund
painter and graphic artist, photographer, filmmaker, poet, author, art historian, theorist, and teacher

BORN JUNE 18, 1914, PRAGUE
DIED MAY 10, 1984, BRNO

Václav Zykmund studied at the Faculty of Science at Charles University in Prague and at the Czech University of Technology, 1932 – 37. Karel Teige, a relative of his, introduced him to other avant-garde artists during these years. In 1936 Zykmund launched the Ra Surrealist series in Rakovník, Central Bohemia, which would publish the Czech translation of André Breton's *L'Air de l'eau* (*Airwater; Vzduch vody*), 1937, with a cover by Bohdan Lacina. In the late 1930s, his paintings were influenced by Salvador Dalí. During the Second World War, Zykmund and his friends from the Brno post-Surrealist group organized two events known as "rampages," which were documented in photographs. Zykmund was also a founding member of the Skupina Ra (Ra Group), which was active from the beginning of the German occupation, although its official dates are 1946 – 48.

Selected Reference:
Valoch, Jiří, ed. *Václav Zykmund*. Brno: Dům umění města Brna, 1999.

Index

Copyright and Photography Credits

This catalogue was published to coincide with the exhibition *New Formations: Czech Avant-Garde Art and Modern Glass from the Roy and Mary Cullen Collection* at the Museum of Fine Arts, Houston, November 6, 2011, to February 5, 2012.

This exhibition is organized by the Museum of Fine Arts, Houston.

Generous funding is provided by:

The Trust for Mutual Understanding

Library of Congress Cataloging-in-Publication Data

Srp, Karel.

New formations: Czech avant-garde art and modern glass from the Roy and Mary Cullen collection/Karel Srp and Lenka Bydžovská; with Alison de Lima Greene and Jan Mergl.

p. cm.

Catalog published to coincide with an exhibition held at the Museum of Fine Arts, Houston, November 6, 2011– February 5, 2012.

Includes index.

Summary: "Offers a rare glimpse into Roy and Mary Cullen's collection of Czech modernist glass and avant-garde paintings, collages, and artist-made books produced in the first half of the twentieth century"— Provided by publisher.

ISBN 978-0-300-16996-6 (hardcover)

1. Art, Czech—20th century—Exhibitions. 2. Avant-garde (Aesthetics)— Czechoslovakia—History—20th century— Exhibitions. 3. Cullen, Roy, 1929-—Art collections— Exhibitions. 4. Art—Private collections— Texas—Exhibitions. I. Bydžovská, Lenka. II. Greene, Alison de Lima. II. Mergl, Jan. IV. Museum of Fine Arts, Houston. V. Title. VI. Title: Czech avant-garde art and modern glass from the Roy and Mary Cullen collection.

N6831.S75 2011
709.4371′0747641411—dc22
2011013029

Distributed by Yale University Press, New Haven and London
www.yalebooks.com/art

MFAH Publications Director:
Diane Lovejoy

Edited by Heather Brand
Designed by Daphne Geismar
Translations by Kathleen Hayes
Indexed by Kay Banning

FRONT-COVER ILLUSTRATION
Karel Teige, *Untitled*, 1947, collage.
See CAT. 92

BACK-COVER ILLUSTRATION
Toyen, illustration for *Sur-le-champ* by Annie Le Brun, 1967.
See CAT. 111

FRONTISPIECE
Jindřich Heisler, *Untitled,* 1943, gelatin silver print, photomontage.
See CAT. 96